The Committed Life

D0393031

The Committed Life

*Principles for Good Living from Our
Timeless Past*

Rebbetzin Esther Jungreis

HarperSanFrancisco
A Division of HarperCollins*Publishers*

A hardcover edition of this book was published in 1998 by Cliff Street Books, an imprint of HarperCollins Publishers.

THE COMMITTED LIFE. Copyright © 1998 by Rebbetzin Esther Jungreis. All rights reserved. Printed in the United States of America. No part of this book may be used or reproduced in any manner whatsoever without written permission except in the case of brief quotations embodied in critical articles and reviews. For information address HarperCollins Publishers, Inc., 10 East 53rd Street, New York, NY 10022.

HarperCollins books may be purchased for educational, business, or sales promotional use. For information please write: Special Markets Department, HarperCollins Publishers, Inc., 10 East 53rd Street, New York, NY 10022.

First HarperSanFrancisco paperback edition published 2002.

First HarperPerennial edition published 1999.

Designed by Nancy Singer Olaguera

The Library of Congress has catalogued the hardcover edition as follows:
Jungreis, Esther.
 The committed life : principles for good living from our timeless past / Esther Junzgreis. — 1st ed.
p. cm
ISBN 0-06-019136-8
 1. Jewish way of life—Anecdotes. 2. Ethics, Jewish—Anecdotes. I. Title.
BM723.J859 1998
296.7—dc21 98-27046

ISBN 0-06-093085-3 (pbk.)

02 03 04 05 06 ❖/ RRD 10 9

*Dedicated in loving memory to my husband,
Rabbi Meshulem HaLevi Jungreis.
May the memory of the righteous be for a blessing.
The Hebrew name Meshulem means "complete," and that
name personified everything that my husband was.*

Contents ↶

Acknowledgments ᗐ

The idea for this book was born on a tour bus in Israel. Since the inception of Hineni, the organization I founded for spiritual outreach twenty-seven years ago, I have been privileged to lead a group to the Holy Land almost every summer. Those of you who are familiar with group tours know that much of the day is spent traveling on buses from place to place. I was anxious to maximize every moment of the trip for our people, so in addition to pointing out the sights from the bus, I related stories—stories about life, and stories that demonstrate how the wisdom of our past can impact on our lives today. After several days of storytelling, two of my dear friends, Susan Friedman and Sheila Lambert, urged me to recount these stories in a book.

Whatever is meant to be happens, and no sooner did I return to the States then I received a call from Freya Manston, one of the finest literary agents in New York. She had read about my work and was convinced that I had another book in me. The sequence of events was striking. Freya loved the stories. "Reading them makes me feel like I'm talking to my grandmother, who was a most wonderful, wise, and kind lady," she said. Freya made many fine suggestions and brought the book to the attention of Diane Reverand, the very gifted and sensitive editor in chief at Cliff Street/HarperCollins. It was Diane who advised that the stories be categorized under the chapter headings that are found in this book. It was Diane who, after reading the manuscript, felt that the most appropriate title would be *The Committed Life.* For that, and for her many other insightful suggestions, I thank her, as I do Freya, Susan, and Sheila.

I would also like to thank my dearest friend Barbara Janov, executive director of Hineni, who has been at my side since the very genesis of Hineni, and who untiringly stayed up with me late into the nights feeding these stories into the computer. I feel it only proper at

this time to express my heartfelt appreciation to the leadership and membership of our Hineni organization. Many people have helped make this incredible outreach organization possible, and I humbly thank all of them and ask for their kind understanding if I do not mention them by name. There are, however, a few families that I must cite for they have enabled me to create and maintain Hineni over the years. I list them in alphabetical order: Pat and Jimmy Cayne, Sheila and Jeffrey Levine, Selma Meyerson Milgrim, the Pilevsky family, Jill and Bill Roberts, Elinor Wohl, Ronne and Joe Wohl, and a man who has always wished to remain anonymous but who has been a most wonderful and trusted friend throughout the years. He surely knows who he is. I would also like to express my appreciation to the editors of the *Jewish Press*, Rabbi Shalom and Irene Klass, for their long years of friendship and support.

On a personal note, I thank my dear and revered parents. My father, Rabbi Abraham HaLevi Jungreis, Z'tl (of blessed memory), was called to the Heavenly Courts eight years ago, but his spirit and inspiration surely guided the writing of this book. My dear mother, may she live and be well, Rebbetzin Miriam Jungreis, has given and continues to give me much comfort and strength. My eternal love and commitment go to my partner in life, my husband, Rabbi Meshulem HaLevi Jungreis, to whose loving memory I dedicate this book. Last, but not least, I thank my beautiful, precious children, who are my blessing, who have sustained me throughout the good as well as the difficult days of my life, and who are my dedicated partners in my outreach work in Hineni. May G-d be with them always: Chaya Sora and Rabbi Shlomo Gertzulin, Rabbi Yisroel and Rivke Jungreis, Slovi and Mendy Wolff, Rabbi Osher and Yaffa Jungreis, and all their children, my beloved grandchildren, who are following in their ancestors' footsteps and who are the greatest joy of my existence.

Above all, I would like to express my gratitude to the Almighty G-d for His many mercies, for having enabled me to write this book, which I hope and pray will reach the hearts of all His children. May He find me worthy of serving Him in truth and honor. HINENI, HERE I AM!

Introduction ✑

*T*he Talmud teaches that when a woman conceives, an angel takes the unborn soul to G-d, and G-d entrusts it with a unique mission and decides whether that soul will become a male or a female, healthy or sickly, tall or short, bright or dull, beautiful or homely, rich or poor. Then the angel takes the soul on a grand tour of Paradise and *Gehenom* (Hell), revealing the rewards and punishments that await when the soul returns to its abode after death.

Everything is predestined except whether we are going to be good or bad, or whether we will fulfill our mission or not—that is the only choice that is left to us. How wisely we will choose will depend upon our *reverence for G-d*. In the end, that is all that counts. Tragically, that is one area of which most of us have no understanding. We grope in darkness trying to make some sense out of our lives. Ours is a generation that lacks moral underpinnings. There are no values to hold onto, no role models to look up to. Movie stars, sports heros, and government leaders from presidents to royalty have become the new "fallen idols" of our age.

Our homes lack stability and serenity. Divorce and dysfunctional families have become the norm, and our schools are, at best, gateways to economic opportunity, preparing our children for careers and jobs but not for life.

Our world is an angry world, high on bitterness and entitlement and low on kindness and generosity. People are hurting because their souls are empty. They ask, What is my life all about? Why am I here? What is my mission? But no answers are forthcoming. Ours is a generation that has been described by the prophet Amos: "And days shall come upon you, saith the L-rd, and I shall send a hunger into the land. Not a hunger for bread, nor a thirst for water, but a hunger for the word of G-d."

For the past forty years I have been privileged to address audi-

ences throughout the world. I have discovered that whether I spoke to the soldiers of the U.S. Armed Forces at Fort Hood, Texas, or to students at Oxford University, or to audiences at Madison Square Garden, the Johannesburg Coliseum, or Binyanei HaOuma in Jerusalem, or to people in small communities like Wichita, Kansas, or Coventry, England, it made little difference—this spiritual hunger was prevalent everywhere. This quest transcends all social and cultural differences. Although we cannot recall our tour of Paradise and *Gehenom*, there is a hidden corner in our souls that *does* remember, that urges us to do good and not bad, that seeks kindness and not vengeance, that yearns for love and not hatred, that desires to fulfill our G-d-entrusted mission.

I was speaking in London, and the evening was especially meaningful because the entire program had been arranged and sponsored by young people. The large auditorium was packed to the rafters. People were lining the walls. It was hot and uncomfortable, but nobody seemed to mind. There was a special energy in the room that embodied this quest. I stayed long into the night, answering questions—questions that came from the inner recesses of the heart, questions that spoke of disenchantment and pain, questions on how to live a more committed life.

Andrew, a young man in his early thirties, approached me. He was the picture of success. He looked as if he had it all together, but his questions revealed that he wasn't happy with himself.

"I subscribe to everything that you said tonight. I recognize it to be true. And I would like to connect to that part of my soul that yearns to do good. I would like to understand my mission in life, but I am filled with so much animosity and resentment against certain people—how can I liberate myself from those feelings?"

"Pretend that you like them," I said.

"Pretend?" He echoed my words incredulously. "Surely you don't mean *pretend*?"

"But I do."

He looked at me quizzically.

"Let me share with you the formula our sages proposed for change and personal growth. 'A man,' they teach, 'is shaped by his *deeds* and *actions*' [*Sefer Ha Chinuch*, The Book of Education]. Now this may not sound like such a revolutionary idea, but it is diametrically

opposed to that which our secular world believes—that it is our thoughts and convictions that mold and make us what we are. It may sound like so much semantics, but there is a world of difference between these two points of view. If you follow the secular path, then before you can shed your old, bad habits and acquire new, good ones, you have to go through some sort of analysis or process of introspection, and that could take a lifetime.

"Furthermore, the mind is tricky, capable of rationalizing, playing games with ideas that the heart finds too demanding or too restrictive, and so *Sefer Ha Chinuch* advises us to bypass the cerebral, concentrate on our deeds and actions, and just do what we have to do. Through that doing, our personalities, our character traits, will be reshaped and molded until one day we will discover that we have become the new beings that we had hoped to become, that we are connecting to that goodness in our souls, and that we are on our way to fulfilling our mission in life."

"Are you telling me that I should just do, without feeling it?" he asked.

"Yes, that's exactly what I am suggesting, and I will demonstrate to you that it really works. You asked me how you could free yourself from feelings of animosity and resentment. Put a smile on your face, and force yourself to be friendly, and you will see that the intensity of your hostility will immediately diminish. If you keep up the regimen, you will one day discover that your hatred is altogether gone.

"This same logic applies to every area of life. If we are stingy and find it difficult to give, we must force our hands into our pockets and give. If we harbor resentment against our parents, we must force ourselves to relate to them with respect. If we're not in the mood to pray, we must force ourselves to open the prayer book and pronounce those sacred words. The examples are endless, but if we stay with it, if we force ourselves to live by the discipline of G-d, we will be able to tap into that pure source in our souls and become the person that G-d meant us to be."

To illustrate my point, I reminded Andrew of a wonderful story written by Max Beerbohm, one of his compatriots, that really demonstrates the efficacy of this formula. The story is about Lord George Hell, who was as terrible as his name sounded—mean, nasty, ugly, and vicious. Everyone was terrified of him.

"Well, one day Lord Hell met a beautiful maiden and fell desperately in love with her. But she wouldn't have any part of him and let it be known that the man she married would have to have a saintly, beautiful face that reflected kindness and gentleness.

"Poor Lord George Hell—to be so lovesick and to be rejected with such finality. But then he came up with an idea. He went to a master artist who knew how to make the most magnificent masks. 'Make me a mask with the face of a saint,' he ordered, 'and I'll pay you any price you demand.'

"And so it was that the artist fashioned a mask depicting a kind, gentle, handsome, angelic man. Equipped with his new face, Lord George Hell went knocking on the maiden's door, and she fell instantly in love. Soon they were married and enjoyed a wonderfully happy life. Some years later one of Lord George Hell's enemies came to their house and, in full view of his wife, stripped the mask off Lord George's face. But lo and behold, a miracle had occurred: The face beneath the mask was identical to the mask! During all those years, Lord George Hell had pretended to be kind and generous so that his conduct might be in consonance with his mask, so that his wife might not discover his deception. And lo and behold, the conditioning of years had left an imprint on his mind and soul, and he had become the righteous person he had once pretended to be."

So I said to the young people who at this point had joined Andrew and me, "It's really quite simple—you become gentle by acting gently, righteous by acting righteously, and good by acting with goodness. Now perhaps you will also understand why G-d gave us so many commandments. These commandments were given to structure us. They are the masks through which we become better people."

Over the years I have seen many blessings come to those who have adopted this formula. It has enabled them to overcome the most difficult problems and handicaps and begin a new life.

I have gathered their stories to share with you so that you too might become the person you so much wished to be when you took the grand tour of Paradise. The stories are stories of today. They are all based upon real-life incidents and touch upon the many issues that trouble and consume contemporary man. In some instances I have used actual names, and in others, pseudonyms, and the same holds true for locations and settings.

Although the protagonists in the stories draw their strength from the Torah, from the Jewish faith, the message is universal for the word of G-d speaks to all humankind. I pray that the reader may find this book to be a source of strength and be inspired to make a commitment to a committed life.

Throughout this book you will find the name of G-d hyphenated. This is based upon the teaching of the Third Commandment: "Thou shall not take the name of thy G-d in vain."

ॐ I

Commitment

"A long life is not good enough,
but a good life is long enough."

A COMMITTED LIFE

My husband was a paradigm of commitment in public as in private life, in war as in peace, in health as in illness, in life as in death. His dedication never faltered. In forty years of marriage I never heard him utter an unkind word, raise his voice, or lose his temper. He was a true reflection of his name, Meshulem, which in Hebrew means "complete," and indeed, he was a complete man.

The Mishna teaches that there are things in life that have no prescribed measure, things to which we must commit ourselves with a full heart, without reservation, without holding back. They include gifts for the poor and offerings to G-d, acts of loving-kindness, and study of the Torah, all of which make for a committed life.

Unfortunately, this threefold formula eludes most people because we live in a world in which our priorities have become skewed. We indulge in excess where we should be disciplined (materialism and physical pleasure), and we stint where we should be openhanded. We fail to recognize our responsibilities to the poor, our obligation to be generous and kind, and our imperative to study the Torah, and because of that, we do not understand the challenges of a committed life.

My husband understood. He lived by these precepts. He gave of himself above and beyond. To him, each and every person was holy. He reached out to one and all with generosity and love.

Every Friday, before the Sabbath, he would empty my freezer and take little gifts of cake and challah to the widows and widowers and those in need. You might, of course, wonder how it can be that people were in need of challah and cake in a Long Island community. Thank G-d, such abject poverty was rare, but there are many forms of need. My husband heard the silent cries of lonely, broken hearts, and he responded to them. When he visited hospitals, it wasn't just a matter of discharging his rabbinic duties, and the story of little Yaffa is a case in point.

Yaffa, a kindergartner, fell from the monkey bars in her school playground. She was rushed to the hospital and needed major surgery. Every morning, before going to services, my husband would visit at her bedside, tell her stories to cheer her up, and then would call her parents to let them know that all was well. And this very

same kindness was extended not only to Yaffa but to all those who were sick and hurting.

As for all rabbis, the High Holidays were an especially taxing season for my husband. He would return from synagogue exhausted, but he didn't permit himself to rest until he had visited every sick congregant so that they might hear the sound of the shofar. Remarkably, despite the overwhelming holiday turnout, he always knew who was missing from the services.

There are some people who extend kindness and consideration to strangers but for some reason fail to understand that acts of kindness must be offered to the members of one's family as well. My husband was the perfect father and grandfather. When the children were babies and would awaken in the middle of the night, he would say to me, "The reason why babies cry at night is so that their fathers should get up and learn Torah." With that, he would pick up the baby, put him or her in the carriage, and with one hand rock the baby back to sleep while with the other he turned the pages of the Talmud.

He was there to tell them stories and to show them how to draw and paint. He taught them the word of G-d, showed them the wonders of nature and made them marvel at the beautiful world that G-d created. When they started school, he was right there with them so that he might ease their way on that first traumatic day.

He would take the children to a pond near our house to feed the ducks. Years later, he did the same for our grandchildren. On the day of my husband's funeral, something incredible happened—the ducks crossed the road and stood at attention as the large procession, which included the Nassau County Police, passed. The police department came out in full force since my husband was their beloved chaplain. This was a sight that I had never seen in my thirty-two years of residence in the community.

My husband's pockets were always well stocked with candy so that whenever and wherever he met children, he would have something to offer them. He had infinite patience with every child, whether his own or those of a stranger. During the *shiva* period after his passing (the seven days of mourning for the passing of a spouse or blood relative), a little girl whose father was disabled cried to me, "The Rabbi helped me with my homework every night. Who will help me now?"

When I close my eyes, I see him with a baby on his big broad shoulders, but truth be told, he didn't only carry babies, he carried all of us, for such is the power of a man who lives a committed life. Even now I can hear his powerful yet gentle voice saying, "Worry? Negative thoughts? You have to banish them from your mind. Put a smile on your face even if there is no reason to smile, and G-d will give you every reason to smile."

He had this wonderful ability to make people smile. He always knew what to say to lift someone's spirits. When people called, he made them feel that theirs was the most important call of the day. It was only during his hospitalization that we discovered that a poor retarded person called our home every night, and my husband had always found the time and the patience to talk to her.

During the last days of his illness at Memorial Sloan Kettering, he told me that I should continue to raise the children with love. I in turn told him that blessed be G-d, we had already done that—to which, in his profound wisdom, he replied, "The job never ends. We are never finished raising children."

My husband was not only the perfect parent and grandparent, he was also the perfect husband. He was my third cousin, descended from the same rabbinic dynasty, and carried the same family name. He was my best friend, my partner in life, my inspiration, and my rabbi. I emphasize this because the true test of commitment to Torah values can be judged not by the way we relate to the world but by the way we interact with the closest members of our family. As strange as this may sound, sometimes it's easier to be loving and considerate of humanity than to extend that same kindness to the members of our own family.

When the idea of establishing Hineni first came to mind, he not only encouraged me but spurred me on. And so it was with all my undertakings. Whether it was my Madison Square Garden rally, writing a weekly column for *The Jewish Press*, my first book, or appearing on radio and TV, he was always there to support, help, and inspire. If I had difficult days when I felt discouraged and overwhelmed, he would cheer me on. "Of course you will do it," he would say, his voice full of reassurance and warmth.

I will never forget the day my husband was diagnosed with cancer. He went for a routine checkup. He felt strong and was in good

health, except for some indigestion and stomach pain. After giving him a battery of tests, which all proved negative, the doctor ordered an MRI. The thought of cancer was so far from our minds that I went to teach my usual Thursday Bible class, never imagining that there might be a problem, so he was all alone when the doctor broke the news that he had a tumor in the colon that looked malignant. Not for a second did my husband lose his composure or his faith. As a matter of fact, it was he who comforted the doctor, thanking him for his many kindnesses and telling him that everything was in the hands of G-d.

My husband did not call me with the devastating news. Straight from the physician's office, he headed for the Hebrew School of our synagogue to speak to the children, and from there he went to visit our grandchildren, where he told them stories from the Torah and reviewed intricate passages from the Talmud with our older grandson. He never let on that there was a problem. It was the doctor who informed me.

When G-d calls, it is often sudden and completely without warning. In an instant, our lives changed. I don't know how I got through my classes that day. I could hardly breathe. Between sessions, I sat on the phone trying to set up appointments for the morning. As it happened, the surgeon, who is a dear friend, was in Japan for a conference, but fortunately he was scheduled to return to New York that night, and an appointment was set for early the next morning at New York University Hospital. The doctor didn't have to say much. His eyes said it all. When he insisted that we immediately check in for surgery, our worst fears were confirmed. Since my husband wanted to spend the Sabbath with his family and his congregation, he asked the doctor if he could check in on Saturday night. The doctor agreed but ordered my husband to refrain from eating.

I called all our children and they came for *Shabbos.* On *Shabbos* we are not permitted to be sad, so we tried to pretend that all was well. It is a tradition for fathers to bless their children every *Shabbos* night. When my husband stood to bless our children and grandchildren, the silence in the room was louder than any cry. We didn't trust ourselves to look at one another. Our son Osher made kiddush (a prayer of sanctification over wine), and for a moment his voice broke. He swallowed hard, and our eyes filled with tears, but that was the only

concession we would make to my husband's illness. Quietly we whispered to one another stories of people we knew who had had cancer and made it. With G-d's help it will be alright, we told ourselves.

Without partaking of food, my husband sat with us at the table, singing the songs of Sabbath and expounding on the Torah. After dinner he went to the bookcase, removed a voluminous Talmud, and called our grandson to come and study.

Shabbos morning in the synagogue, my husband greeted everyone with his usual effervescent warmth. None of the congregants even suspected that their rabbi might be ill. Normally his sermons would last for fifteen to twenty minutes, but this *Shabbos* he spoke for almost an hour, pouring out his heart, asking the people to live by G-d's commandments. Following the services, there is always a social hour where people make kiddush and have light refreshments. It was then that my husband mentioned in passing, taking care not to alarm anyone, that he would have to enter the hospital for a few days.

Throughout the long painful weeks that followed, my husband's spirits never faltered. From his hospital bed he continued to teach the word of G-d with love to all those who came to visit him. He blessed them all, and the gentle smile on his face never faded.

As I was walking through the corridors of NYU, a man approached me. "Aren't you Rebbetzin Jungreis?" he asked.

"Yes, I am," I said.

"By any chance, are you are related to Rabbi Meshulem Jungreis? He was in the same concentration camp as my father."

"He's my husband."

"Oh," he said excitedly, "I can't begin to tell you the stories I heard about the Rabbi. My father told me that he was a pillar of strength in the camp. He kept everyone going with his recitation of passages from the Talmud, and even under those most trying circumstances, I was told he never ate non-kosher."

It occurred to me that my husband might feel uplifted by these stories from the past, so I invited the man to visit. My husband was delighted to meet him, but in keeping with his total humility, he would not permit him to utter any words of praise. My husband was a brilliant Talmudic scholar, who at the age of eighteen received rabbinic ordination, but there was nothing in his manner to suggest that.

From NYU, the illness took us to Sloan Kettering for the placement of a shunt for chemo. The procedure was supposed to be minor, and he was to return home the following day, but it turned out tragically. My husband never left Sloan Kettering. Throughout those last six weeks of his life, his pain was excruciating. Yet when the doctors asked, "Rabbi, what is your level of pain on a scale of one to ten?" he would reply, "Zero."

We, the members of his family, never left his bedside, but he insisted that I continue to teach Torah, so my days would commence and end at Sloan Kettering, but I would run off to my classes in the late afternoon. I remember one Thursday afternoon. . . . My husband had dozed off, as had I, sitting in my chair. Suddenly I awoke with a start. It was late. Quickly I grabbed my coat and asked the private duty nurse if she could return the following day, at which time I would pay her. Suddenly my husband opened his eyes and quoted the passage from the Torah, "The day workers must be paid on the selfsame day" (Leviticus). So I sat down and wrote a check.

When my husband learned that there was someone on the floor who had undergone major surgery and had a very large family to support, he told me to go to the wife and give her *tzedukah* (charity). Even under those harrowing circumstances, he never missed a beat. His commitment transcended his sickbed.

Whoever visited him left strengthened and enriched. To all of them he imparted Torah and blessing, and as a result, the countless young people from Hineni who came to visit him became more than ever committed to Torah. Among them was a young man named David, who had become part of our family a year earlier. He uncovered the path to Judaism quite by accident. One Sunday afternoon, while watching the football game, he surfed through the channels at halftime and discovered my Torah study program. He did not switch back to the game but stayed with me to the end of the show.

This was a new experience for David. He had never studied Torah in depth. As a young boy he had attended Hebrew school and was bar mitzvahed, but that educational experience is superficial at best. It terminates before it starts, turns children off, and most damaging of all, it does not teach the word of G-d. David decided to check me out. The following week, he came to Hineni and never left. David and my husband became very close. "At long last, I have found

my rabbi," he would say, "a rabbi I can respect and love." Every Sabbath, David would accompany my husband home from synagogue, glean from his wisdom, and bask in his loving-kindness. David now had a dream, a hope that when he married, his rabbi, my husband, would perform the ceremony.

For the longest time, things did not go too well for him in this direction. "It's not easy to find that someone special, that right girl," he would confide in us. Then one day at Hineni, I introduced him to a lovely young woman by the name of Caroline. From the moment they met, they both knew that they had found their soul mates and soon set a date for a wedding. Of course, my husband, their rabbi, would perform the ceremony, and of course, he would be out of the hospital by that time.

As the days passed, it became obvious that David's dream would never be realized. The cancer was taking its toll. Days and nights merged into unbearable nightmares. As the wedding day approached and my husband's condition deteriorated, it became difficult for him even to breathe on his own, but throughout, his mind remained alert. He asked our oldest son, Rabbi Yisroel, to perform the ceremony.

On the day of the wedding, the doctors informed us that the angel of death was already in the room, and there was no telling when he would strike. Our entire family, down to the youngest grandchild, was on constant alert. No one wanted to leave his bedside. It was difficult for Yisroel to tear himself away. "What if something happens while I am at the wedding?" he asked, his voice choking with tears.

You can imagine Yisroel's feelings as he performed that ceremony, and you can imagine how the bride and groom felt, they who so adored their rabbi. To be without him on this, the most important day in their lives, and worse, to know that their beloved mentor was at death's door, was more than they could bear.

A week earlier, when my husband discussed the wedding ceremony, he told Yisroel that he must rejoice with the bride and groom, that he must not allow his personal pain to mar the celebration, and that the wedding must not be delayed. He even wrote a message in his own hand to be read under the marriage canopy. And now, remembering his father's words, Yisroel conducted the most beautiful ceremony. When it was over, he danced with the groom, orga-

nized a minyan (a quorum for prayer), and only then did he allow himself to call the hospital. His voice breaking with tears, he asked, "How is Abba?" We told him that his father was waiting for him. He rushed back to the hospital for another glimpse of that holy man, to kiss his hand, to exchange a few words, to utter a prayer, to receive yet one more blessing.

And then, a strange sight appeared in the corridor of Sloan Kettering. Caroline in her beautiful white gown and David in his tuxedo walked down the corridor to their rabbi's bedside. They had left their wedding and come for a final blessing in their magnificent attire. My husband opened his eyes, gathered all his strength, smiled lovingly, and whispered, "*Mazel Tov*, my children."

During the early hours of that morning, my husband's pure soul left this earth. We, his family, his children and grandchildren were all there. He blessed us all, and as he did so, he called each and every child and grandchild by name. Among the many blessings he whispered were the immortal words with which Jacob the patriarch blessed his children when he was on his deathbed: "*Hamalach Ha goel . . .* " (May the angel who protected me and redeemed me from all evil throughout my life bless and protect you, my children, and may my name and the names of my fathers Abraham and Isaac be forever recalled through you.) (Genesis 48:16). This blessing has been set to a beautiful melody, and as he whispered the words, our little grandchildren softly sang the words back to him.

Throughout his lifetime, my husband lived imparting blessing, and he died imparting blessing. He lived in dignity, and he died in dignity. His life was one of commitment to others, and this commitment stayed with him to the very end. He died the way he lived, "giving above and beyond the prescribed measure."

This ability always to think of others, even on one's deathbed, is the legacy that he left behind for all of us. That legacy will forever endure, for it is a legacy to a *committed life* that is more powerful than death. His name shall surely live on, not just in his children and grandchildren but in the thousands upon thousands of people whom he touched.

Several months after his death, while going through his papers with a heavy heart, I found a note inscribed in his beautiful handwriting. It read: "A long life is not good enough, but a good life is long enough."

THE RABBI OF SZEGED

The city of Szeged, in which my father was the chief Orthodox rabbi, was the second largest city in Hungary. Prior to the Nazi invasion, Jewish boys were conscripted into slave labor battalions, which very often meant death. Szeged was a major staging point from which they were sent to the Bor copper mines.

My father was determined to save them. But how?

The only thing that would deter the Hungarians from shipping out these young men was the fear of an infectious disease that might contaminate their own soldiers. Taking this into account, my father consulted some physicians, who suggested that an injection of raw milk would induce a mysterious fever and that a paste made from soybeans and smeared on the eyelids would simulate trachoma. The problem was how to get these concoctions to the conscripts.

My parents found a way. As the rabbi of the community, my father had visiting rights, but he was always thoroughly searched. My mother finally thought of a solution. She sewed pockets into the linings of the coats of my brother and me and secreted the potions there together with some sweets and messages from home. And so it was that we accompanied our father on all his visits and passed the medicine to the boys when no one was looking.

Several years ago, when I was lecturing to a young couples' group in Englewood, New Jersey, a man in the audience asked me how old I was. Everyone was taken aback by this question. He quickly explained that he did not mean to be disrespectful, but he remembered his father relating how he was saved from deportation by a Rabbi Jungreis who came with his small children to the detention camp in which he was being held and delivered raw milk. As I looked at the young man, I saw his father's face. "You must be the son of Miklos Aaron," I said.

Suddenly the room was charged with excitement. Everyone felt the import of the moment. When he suggested that we call his elderly father in Belgium, the tension in the room mounted. There was a sense of history in the air as I greeted Miklos across the Atlantic. Miklos had heard that we had survived, but he did not know of our whereabouts, so the joy in his voice was intense, but I think he was even more awed by the fact that his son had discovered me. We spoke for a long time, reminiscing about the past and promis-

ing to see one another when he next visited the States.

As we settled back to our discussion, a woman in the audience raised a question. "How did your parents find the strength to risk their lives and the lives of their children to save others?" she asked.

To tell the truth, I had never thought that what my parents did was unusual or heroic. Even as we took it for granted that we had to eat kosher and keep the Sabbath, so too we took it for granted that we had to reach out to our brethren who were in need or whose lives were in danger. That's what Torah is all about. It was not only Miklos whom my parents saved. There were countless others. I related to her how among the many people who arrived at our ghetto in Szeged was a well-known rabbinic family. The Germans immediately deported the father and the children, but the mother, who was in her last months of pregnancy, was permitted to remain.

My father, fearing for the life of this woman and her unborn child, converted the ritualarium of our synagogue into a hospital, which made it temporarily off limits to the Germans. It was on the floor of the ritualarium that the woman, attended by my mother, bore a son. The baby needed a layette and other sundries. At the risk of his life, my older brother, Yankie, took off his yellow star and jumped over the wall of the ghetto to purchase supplies. My father arranged for the baby's *bris* (circumcision) and obtained the temporary release from detention of the Rabbi of Zenta to act as *sandek* (godfather).

That baby and his mother miraculously survived the horrors of the camps. Today he is the esteemed *Rebbe* of a great Hasidic community in Brooklyn. So, pondering over the woman's question, I simply said, "That's what Torah is all about—to love people, to help them, and to inspire your children with that same commitment."

My parents had an incredible ability to involve us in all their undertakings. Whatever they did was a team effort. We, their children, shared their hopes, their dreams, their aspirations, and that is what made us a family. That is what transmitting a heritage is all about. This sharing, this transmission of a legacy goes all the way back to our father Abraham, of whom it is written, "Father and son walked together as one" (Genesis 22:8).

This is the fabric from which families are woven. It is not just outings, ball games, and dinners that parents and children should share, but more importantly, they must be united by a higher goal, a

commitment to serve G-d by reaching out and understanding that we are all responsible for one another. Years later, my husband and I raised our own children this very same way. Many people, carrying heavy burdens in their hearts, came to our home, and we taught our children not only to feel empathy for them but to pray for them, to care for them, and yes, even to cry for them.

I remember one Sabbath eve, when lighting candles, telling my youngest son, Oshie, who at that time was three years old, to pray for the mother of one of his little friends who was very ill. His eyes welled up with tears. A house guest, who was spending the Sabbath with us, wondered out loud at the wisdom of burdening a young child with such a responsibility. "The poor little thing was crying," she protested.

"All children cry," I said, "but some cry for candy and 'give me more,' while others learn to cry because they feel the pain of those in need."

Today all my children are committed to outreach. If they feel responsible for their brethren today, I believe that it is in large measure due to those early years, when they learned to pray for someone's sick mom, and even shed a tear.

With the passage of time, as my activities expanded and I brought young people who had fallen victim to cults into our home, I did so fully confident that my children would welcome them, reach out to them, and not be resentful of the attention they would demand. One such young lady, Stacy, from Miami, Florida, lived with us for more than two years. My daughter Chaya Sora, who was the same age, shared her room with her, her friends with her—her life with her. Was that unusual? No, I never considered it so, but more significantly, neither did Chaya Sora. She came home from school one day to find a total stranger resting on her bed. Not only did Chaya Sora welcome her, but she made room in her closet and emptied out a drawer for her—no small thing for a seventeen-year-old. Now mind you, Chaya Sora was a yeshiva student, and Stacy came from a troubled cult background. They were worlds apart, but that did not keep Chaya Sora from embracing her with love.

Most of Chaya Sora's friends did not share this commitment and looked suspiciously at Stacy, wanting no part of her. Chaya Sora had to make a decision, and there was no question in her mind which way she would go. If Stacy was not included, she simply would not accept an invitation. Not only did Stacy become Chaya Sora's sister,

but she became another loved grandchild of my parents, whom everyone affectionately called Mama and Zeide (Grandfather).

When I related Stacy's story to my father, he started to weep. His tears were tears of pain for a child lost in a cult and tears of joy for her homecoming. He worried about her as he would have for his own grandchildren. When Stacy became of marriageable age, my father, like a true *zeide*, introduced her to her mate and performed her wedding ceremony along with my husband.

From culture to culture, from generation to generation, conditions change, but the commitment to reach out, to feel a sense of responsibility to others, remains.

In Szeged my parents were called upon to rescue lives from physical extinction, and in New York the challenge was to save souls from spiritual annihilation. In both cases they responded with awesome sacrifice and invited us, their children, to join them in this calling.

To be sure, not everyone can answer the challenges of the time as my parents did, but each of us can do something to reach out to others. I recall how my then five-year-old granddaughter Shaindy absorbed this teaching. My daughter Slovi, Shaindy's mother, told her to invite someone from her class to spend the afternoon. Shaindy chose a little girl whose name Slovi didn't recognize. Nevertheless, she called the child's mother to extend the invitation, and was somewhat surprised at her profuse expression of gratitude.

The following afternoon, when the school bus pulled up, Slovi understood—Shaindy got off the bus holding the hand of a handicapped child. When the day was over and the little girl returned home, Slovi asked Shaindy what had made her choose that child over all her classmates. Without a moment's hesitation Shaindy replied, "Nobody wants to be friends with her, so I invited her over."

Through that invitation, Shaindy demonstrated that she understood the legacy that her mother, the granddaughter of the Rabbi of Szeged, transmitted—to feel a commitment to others, to feel a sense of responsibility to their needs.

Consider for a moment—what are the higher goals that unite your family? What commitments do you share? And to what extent do you feel concern and responsibility toward your fellow man?

From the patriarch Abraham to my own father, Abraham, from ancient Canaan to Szeged to New York or wherever we are, this legacy can live on if we will it.

✿ 2

Inviting G-d into Your Life

*"It has been told to you, Oh man, what is good,
and what the L-rd your G-d requires of you.
Only to do justly, and to love mercy, and to
walk humbly with your G-d."*

—Micah 6:8

Run, Shai, Run

After three lively boys, my son Rabbi Osher and his wife, Yaffa, were blessed with a sweet little girl. The occasion called for a special celebration, and my son and his wife hosted a beautiful Sabbath luncheon for the people in their community.

I was greeting the guests when Rabbi Yaakov Bender, the principal of the local boy's yeshiva and a dear friend of our family, came over to extend his best wishes for a *Mazel Tov*. In the course of conversation, I told him I was writing a book, and one of the chapter headings was "Inviting G-d into Your Life."

"Perhaps you have a good story about children whose belief in G-d not only prompts them to pray and study with greater commitment but who, as a result of their faith, also relate better to their peers and play sports differently."

"No problem. I have many great stories for you!" was Rabbi Bender's exuberant reply. "But why sports in particular?"

"Because I think you can really tell a lot about children's values and to what extent belief in G-d permeates their lives if you observe them in the heat of a game. It's one thing to be considerate of a classmate, but it's something else again to extend that same consideration when, in their estimation, the stakes are high and it's win or lose.

"And frankly," I went on to explain, "I also want to depart from the usual stories of people who have found G-d. Fortunately, today more and more are making this spiritual journey, and their stories are no longer novel.

"And then there's one more factor—the experiences that these people usually relate reveal how their newfound faith has enriched their *own* lives but not necessarily how their faith has enabled them to enrich the lives of *others*. So now that I've told you all that, do you still have a story for me?"

"I have a perfect one for you," Rabbi Bender said, his face lighting up with a warm smile, and with that, he plunged into his story.

"Shai is a retarded child. Once a week, his father brings him to our school so that he may be exposed to some Jewish studies and interact with our students. This particular Sunday, during recess, the fifth graders were playing baseball. I went outside to watch. The

game was getting very intense. They were in the bottom of the ninth inning, the bases were loaded, and Shai was up at the plate. Shai barely knew how to hold a bat in his hands. He swung wildly, swinging and missing twice. Suddenly the pitcher moved closer to the plate. Two boys came over to Shai, put their arms around him, and held the bat with him. The pitcher gently lobbed the ball toward him. The boys guided Shai's arms through the swing and hit the ball down the third base line. The third baseman allowed the ball to bounce past him as all the boys began to shout, 'Run, Shai, run!'

"Shai ran past first base, and another boy caught him, turned him around so that he might touch first, and then showed him in which direction to run. Shai touched third base and turned toward home as the game reached a feverish pitch and the boys from both teams shouted, 'Run, Shai, run!' When Shai finally touched home plate, the boys picked him up and carried him on their shoulders. 'You won the game, Shai! You won the game!' they cheered.

"It was a glorious day in Shai's life," Rabbi Bender concluded, "but it was perhaps even more glorious for those fifth graders. I was very proud of my boys. So what do you think, Rebbetzin? Do you like the story?"

"I love the story," I told him, "and you certainly have a right to be proud of your boys. It demonstrates once again the truth of the teaching of our sages, 'And all your children shall be students of G-d, and great shall be the peace of your children'" (Talmud).

When children study Torah, when the word of G-d is *really* taught to them, then their thinking, their attitudes, and their entire outlook is affected. They learn to live with priorities, and early on they realize that there are things that are more important than winning—things like not hurting or embarrassing others.

We live in a culture in which sports are almost sacred, where the game becomes larger than life. For the sake of winning, anything goes and everything is justified. But if the teaching "G-d is before me at all times" (Psalm 16) is to be more than mere words, if it is to be an imperative that guides our daily conduct, then the game and everything else must take second place to His commandments. There is a higher law than winning, and that is to live by the laws of G-d, the laws of compassion and loving-kindness. That is the true meaning of inviting G-d into your life, and those fifth graders understood that.

It is written in the Torah, "You shall cling to the L-rd your G-d" (Deuteronomy 4:4).

"How," our sages ask, "can a man cling to G-d?"

"By emulating His ways."

"But can a mere mortal emulate the ways of G-d?"

"Yes," our sages respond. "By committing acts of loving-kindness. Even as G-d is merciful, we must be merciful." And our sages proceed to enumerate the many expressions of G-d's loving-kindness that we must assimilate into our own lives. The Midrash teaches that G-d prefers these acts of kindness above all other sacrifices, for the very survival of the world is dependent on them.

These values are so imbedded in our national psyche that they are intertwined with all our commandments, traditions, and holidays. Take, for example, the reason for the custom of covering the challah (special festive loaves of bread) on the Sabbath table. Our sages teach that since we bless the wine before the challah, we do not want to embarrass the challah, and therefore cover it.

Obviously, challah does not have feelings, but our sages wanted to impart a lesson to us. If bread, which is inanimate, must be treated with such care and consideration, how much more so must we be on guard not to embarrass or hurt a person.

Let us consider yet one more example: Passover is the most stringent of all our holidays, and there are many intricate laws involved in baking matzos. The men in charge of the baking in their town approached the great sage Rabbi Yisroel Salanter for last-minute instructions. "Please tell us what we should watch out for, what we should be extra cautious with."

"Be careful not to hurt the feelings of the widow who works in the bakery," the rabbi answered.

Those fifth graders came by their compassion honestly. It's part of their spiritual heritage. It's a commitment that G-d demands from those who would embark upon a G-dly life.

You might, of course, argue, "If that is so, how about all those selfish, mean people who claim to be believers?"

The answer to that is that their nastiness is an indictment of themselves, not of G-d's commandments. They are people who, even when they worship, do so only for self-aggrandizement. You can find them in every community, in every congregation, and undoubtedly

they present a bad image. But they don't represent Torah. They don't represent G-d. Time and again I am asked to explain this dichotomy: "How can people be religious and yet be nasty?" And I answer them with a story:

A rabbi and a soap manufacturer were having a discussion one day about the efficacy of religion. "If I were you," the manufacturer said, "I'd go into another profession. Look at all the people who profess to believe in G-d and yet are corrupt and unethical. Something must be wrong with religion."

The rabbi thought for a moment and then said, "Come, let's take a walk in the park, and we'll discuss it further."

It was a bright sunny day, and the park was filled with cyclists, runners, strollers, and children. Soon they passed a sandbox, where a group of toddlers were playing. The rabbi stopped and turned to his friend, "You know, if I were you, I would change my profession."

Taken aback, the man said, "What are you talking about?"

"Well, look at all those kids. They're dirty and grimy."

"Hey, wait a minute. That's not fair," the man protested. "My soap is a perfect product, but those kids aren't using it."

"Aaaaah," said the rabbi. "That's exactly it. G-d's Torah is perfect, but those people aren't using it."

Take it a step further—if Torah is taught properly, you get children who sparkle like those fifth graders.

SOMETIMES IT TAKES A CAT

There is a saying, "Different strokes for different folks." This holds true for every aspect of life, even finding G-d.

Every summer I lead a group from our Hineni organization to Israel. These trips to the Holy Land are not typical tourist experiences. Rather, they lead to spiritual self-discovery. By the end of our visit, every participant has a heightened sense of self, a better understanding of his or her roots, and a stronger connection to G-d.

Beth was very excited about her trip to Israel. She was secular in every way, but she yearned to believe and to acquire a deeper perception of her faith. She was beautiful, gregarious, extremely bright, and lots of fun to be with. When Beth was around, you could always anticipate that the unexpected would happen. She could make the most outrageous remarks, and more often than not, with one pithy phrase, she would capture the essence of a situation or the foibles of an individual. As outrageous as her remarks may have been, no one ever took umbrage, for they were always delivered with great charm. As a matter of fact, I often remarked that Beth could get away with anything. So having Beth with us lent added zest and a heightened sense of excitement to the tour. And sure enough, she didn't disappoint us.

We had been in Israel for just a few days. Every day we arose at the crack of dawn to tour. Upon our return to Jerusalem in the evening, our entire group would have dinner together. Then, at midnight, we would go to the *Kotel*—the Wall, no small feat considering that we were all exhausted. But no one complained. As a matter of fact, our nightly visits to the Wall became the highlight of our trip. The Wall is the only remnant of our Holy Temple, and the Almighty G-d promised that even if Jerusalem was razed, the Wall would remain, for it stands as witness that the Jewish people would return to their land, and the Temple would be rebuilt. And indeed, over the millennia, Jerusalem was destroyed many times and lay in devastation, but the Wall survived every conflagration. It is written that the *Shechina* (presence of G-d) has never departed from those ancient stones. And so, every night at midnight, our group would go there to pray.

But why midnight, you might ask?

There is a tradition that David, King of Israel, would place his harp on his terrace, and at midnight, as the winds of Jerusalem blew,

they would caress the strings and the harp would begin to play, beckoning the king to write his immortal, beautiful psalms. David's harp may have disappeared in the sands of time, but the winds of Jerusalem continue to blow, and if you know how to concentrate, if you know how to listen with your heart, at midnight at the Wall you can still hear the sweet music of David's harp.

At this magic hour, there are certain regulars who can be found at the Wall. I guess they can best be described as the guardians of this holy place—among them, a Sephardic Jew, who in an eerie but powerful voice cries out, "*Shema Yisrael*—Hear, oh Israel, the L-rd our G-d, the L-rd is One." He draws out each and every syllable of each and every word until it penetrates your soul. And then there is an old man dressed in white, who sits on the floor in mourning. He weeps and prays the entire night for our Holy Temple which is no more. His cries pierce the very heavens, and listening to him, you feel very grateful that he is there, for you realize that your prayers might just ascend to the Heavenly Gates on the wings of his supplications. Just being in the presence of such sanctity is so all-powerful that it can infuse you with a surge of spirituality and the ability to pray.

Beth had her own way of describing our nightly visits to the Wall. "It's strange, but in New York I partied almost every night, and the next day I didn't feel good about myself. But here, after spending the night at the Wall, I feel an exhilaration, a spiritual energy, and I can keep going the entire day without difficulty." We all agreed, once again Beth had managed to tell it like it is.

Beth was not only a people person, she was also an animal lover. One evening, as we dined at one of Jerusalem's many outdoor restaurants, she received an added dividend. Jerusalem abounds with multitudes of stray cats, and if you are dining al fresco you are sure to be visited by one of them. There are a variety of opinions as to how these cats came to the holy city. Some claim that they were imported by the British during the mandate, to combat an epidemic of mice, and others say that the cats are *gilguls*—reincarnations of souls that were sent to Jerusalem to do penance for their sins. Whatever you wish to believe, the fact is that Jerusalem has a huge number of street cats. That night, when we were having dinner outdoors, a little kitten came to visit our table. Beth immediately fell in love. She fed the kitten, held it in her arms, and decided to take it back to our hotel. It was late night by the time we left the restaurant. As we

walked, the kitten jumped out of Beth's arms and disappeared into the darkness of the Jerusalem night. Beth was devastated. She felt guilty that she had removed the cat from its natural habitat and feared for its survival. After all, it was only a kitten.

The following Friday morning, I took our group to Meah Shearim, the Hasidic neighborhood of Jerusalem. I wanted them to see and experience preparations for the Sabbath. We visited with a wonderful family, and our people were amazed to see how so many children could live in harmony in a tiny apartment and how all those things that we regard as absolutely necessary in the States are not really essential for a meaningful life.

It was about 10:30 A.M. when we visited this home, but the table was already set for the Sabbath, with its crisp white cloth and glistening candelabra. From the tiny kitchen came the tantalizing aroma of challahs and cakes baking in the oven and chicken soup and gefilte fish simmering on the stove. All that made an enormous impression on our group. We chatted for a while with the lady of the house, who told us that she has dozens of grandchildren (to protect them from the evil eye, she wouldn't give the exact number), who come every Sabbath for a blessing. Deeply moved, our young people left her apartment in awe. They realized that they had come in contact with something that was real—*emes*, and no further comment was necessary.

As we walked the streets of Meah Shearim, I pointed out the yeshiva of Rabbi Meir Ba'al HaNess. I told the group about the tradition that whenever you lose something, if you make a donation to the Rabbi Meir Ba'al HaNess Fund, you will find it. I related how, on several occasions, I myself had retrieved a lost item using this formula. With this in mind, Beth slipped away from our group and hurried to the yeshiva of Rabbi Meir Ba'al HaNess, where she made a contribution in the hope that the kitten might be found.

That evening, in honor of the Sabbath, our group returned to the Wall. The mood at the Wall was totally different on Sabbath night. A multitude of people converged there, Jews from every part of the world, speaking a variety of languages and dialects, each singing in his own way a welcome to the Sabbath Queen—"Come, my beloved, let us welcome the Sabbath Bride. . . ." Beth rushed to the Wall, touched and kissed the ancient stones, poured out her heart as never before, and begged the Almighty to return the kitten to her. Following the prayers,

we made our way back to the hotel. On this cool summer night, each of us was immersed in our thoughts as we beheld the awesome beauty of Jerusalem. After a half hour's walk, when we finally reached the hotel, an incredible sight greeted us. There, sitting at the entrance, was Beth's kitten! If we hadn't seen it with our own eyes, we would never have believed it. Overjoyed, she took the kitty to her room and fed it.

In high spirits our group proceeded to the hotel dining room for Sabbath dinner. I invited Shaindy, my nine-year-old grandaughter, who to my delight and that of our group had joined us on the trip, to share with us some Torah thoughts.

It is a timeless tradition that at every Sabbath meal, wisdom from the Torah portion of the week is discussed. The entire Torah is divided into weekly portions, the cycle of which takes a year to complete, and then the process is started all over again. Over the years I have discovered that whatever transpires on the world scene, or whatever predicament a person finds himself in, the portion of the week always illuminates with insights. So it was that our little Shaindy found an allusion to Beth's cat story in the portion that was studied that week—Deuteronomy 11:15, "And you shall give grass to your cattle and you shall eat and be satisfied"—from which our sages conclude that prior to eating, prior to satisfying our own hunger, we must first feed our animals.

"This *mitzvah*," Shaindy went on to say, "is so very important that when Noah entered the ark, G-d charged him with this responsibility. On one occasion, when Noah tarried, the lion in his hunger became so infuriated that he bit Noah, leaving him with a limp. The other night in the restaurant, Beth fed the cat before she herself ate. And so you see, everything is in the Torah portion of the week!" Shaindy concluded, with an adorable smile lighting up her face.

"This has truly made a believer of me," Beth called out with tears in her eyes. As much as our group chuckled at the story, no one could offer a logical explanation for how that kitten could have known which hotel we were staying in and found its way to us.

When our group left Israel, Beth stayed on for a few more days to make arrangements for her newfound friend to return with her to New York. And so it was that the kitten from Jerusalem became a resident of New York.

Different strokes for different folks. Everyone has a different way of coming to G-d, and sometimes all it takes is a kitten.

The formal part of our annual luncheon program was over, and I was mingling with the crowd, greeting the ladies.

"Hello, Rebbetzin, my name is Pat Cayne." The voice belonged to a beautiful young woman I hadn't seen before. "I've been watching your Torah classes on TV and I would love to learn more. Could you teach me?"

I was delightfully surprised because generally it's the other way around. It is usually I who have to invite, entreat, and cajole people to come to a class, and here was someone who actually seemed to understand the importance of learning on her own.

"It would be my pleasure, but tell me, why would you like to study?" I asked, curious to know what had motivated this secular, sophisticated woman, who seemed to have it all together, to seek Torah wisdom.

"Well, I just completed my thesis and received my Ph.D. It's been a long haul, and I thought it would give me some answers, but it hasn't satisfied me."

"What kind of answers are you looking for?"

She mulled over my question for a moment and then said, "I guess I would like to know things like Why am I here? What should my goals be? How could I feel more peaceful? And what can I hand down to my daughter that will lend substance to her life?" But she was quick to add, "I have no interest in religion. This is strictly an intellectual quest on my part."

I smiled to myself. Pat will be the perfect Torah student, I thought. Despite her protestation of religious detachment, I knew she would take to the Torah way of life as a duck takes to water. Additionally, something told me that she would not only absorb this wisdom but would share it with others as well. We set a date to meet the following Thursday afternoon at my Hineni office.

Pat arrived punctually at 4:30. She came equipped with a notebook, which reconfirmed my initial impression that she was going to be a serious student.

"We'll start at the very beginning," I told her as I opened the Bible to the Book of Genesis. "The Torah," I told her, "is different from all other studies. It is G-d's blueprint for us so that we may

learn how to live our lives. Each word, each letter, each punctuation mark and cantilation has layers and layers of meaning. The greatest minds have studied it over and over throughout their lives, and on each occasion, they find something new. The wisdom therein is infinite because it comes from an infinite source. It is not a book that can simply be read. It's a lifetime pursuit. Before we commence our studies, we are enjoined to pronounce the prayer asking G-d to grant us the privilege of understanding His holy words." And with that introduction, I opened the Book and started to teach, "In the beginning, G-d created. . . ."

On that first passage alone, we spent more than a half hour, and I noticed Pat's eyes filling up with tears.

"Rebbetzin," she said, "I can't believe this. I can't believe that all this wisdom is here and I never knew about it. We have to make this available to the world! People have to know this. I have to come back with a tape recorder. If you agree, I will tape all our sessions, transcribe them, and we'll put it into a book."

Sure enough, the following week Pat showed up with a tape recorder. Today, twelve years later, the manuscript is being prepared for publication.

Pat embarked upon her course of studies with gusto. At heart she was a student, and she wanted to find out what the Bible had to say, but she never for a moment thought that these studies would forever change her life and that of her family. To all intents and purposes, Pat had everything a person could wish for. Married to a very successful man, blessed with a beautiful daughter, and surrounded by friends, she lacked for nothing. As far as her Judaism was concerned, it was no more significant to her life than if she had been born in New Jersey instead of New York. It was just an accident of birth and of no real consequence to her. She was equally comfortable having a Christmas tree as visiting the synagogue on Yom Kippur, putting on an Easter bonnet or having a Seder. Still, there was a gnawing feeling within her that there must be something more.

Each word of the Torah found a place in her soul—hence the tears that kept flowing were tears of joy, tears of recognition that this was truth. Then something happened that caught Pat totally by surprise. Her closest friends became hostile. "What's the matter with you? Why are you going to those classes?" they badgered her. When

she told them that she had found tremendous fulfillment for her soul, they refused to believe it. "It must be that you are having problems with Jimmy," they conjectured, "and for that, you should see a therapist, not a rebbetzin."

When that didn't work, they took a new tack: "Maybe you're just having a midlife crisis. There are so many things you can do that are satisfying—but this Torah study that you're involved in is nothing but a cult!"

Pat was deeply hurt. "Why are they so angry and insulting? Why should it bother them that I am studying Torah? Why do they have to resort to branding my commitment to Torah as a cult? Why can't they understand that you can have a happy marriage, a fulfilling career, a wonderful relationship with your child, and still feel a need to turn to G-d . . . or perhaps, precisely because of that, because you realize that there must be a source for your blessings, that you want to turn to that source in awe and thanksgiving?"

I told Pat that over the years I've encountered many people with these very same reactions. They find Torah threatening because it represents a way of life that their parents or grandparents discarded, but somehow, despite everything, they sense that this Torah is the truth. That realization makes them feel guilty, and it is this guilt that is at the root of their belligerence. "Try an experiment," I told Pat. "Tell them you're studying Zen Buddhism or New Age religion or, for that matter, any subject. They will be supportive and even congratulate you. But Torah represents a threat."

"I would never have believed it if I hadn't experienced it," Pat said. "I have to show them how beautiful Torah is, how different everything can be if you invite G-d into your life. I'm going to have Torah classes in my home, and you, Rebbetzin, will teach them."

And Pat did just that. She invited everyone she knew. Wherever she went, she spread the word. She could be sitting on a plane, playing bridge at her club, relaxing at poolside in Florida, or having her hair done—she would tell them all, "Come to the Rebbetzin's Torah class."

And they came—from New York and faraway places, women of every age and background. The wisdom of the Torah entered their hearts and lent new meaning to their lives. Those friends who objected fell by the wayside, and a new group came along who shared

Pat's commitment—a magnificent group of women who united under the banner of the Hineni Torah Class.

To his credit, I must say that Jimmy, Pat's husband, was fully supportive. He recognized the wisdom and was delighted that his home had become a gathering place for the study of Torah.

Pat's beautiful daughter, Alison, had yet to be reached. Teenagers don't take easily to changes in their mom's lives. We honored Pat at our annual Hineni dinner. When she got up to speak, she spoke of her quest and her Torah journey, and then she looked directly at her daughter, who was seated at a front table opposite her. "I want one thing of you, Alison, and that is grandchildren who will continue the legacy of our people and live by the wisdom that came from Sinai."

When Pat made that request, her words were just a "shot in the dark." But today, ten years later, Alison has become a committed Torah student in her own right. At first she was a leader of our Young Leadership group. After her marriage, she and Jack joined our Young Couples class. Today they are the proud parents of a beautiful little girl who will surely walk on the path of her ancestors. Pat's wish has been more than realized.

At that dinner, I presented Pat with a Sabbath candelabra. "What is special about candles," I told her, "is that if you light just one, with that one, you can kindle many others without diminishing your own light. And as more and more candles are kindled, the light increases, the illumination expands, and that's how you light up the world with the spirit of G-d. 'The candle of G-d is the soul of man' is a teaching that has been transmitted to us from time immemorial."

Today Sabbath lights are glowing in homes where previously there was only darkness on Friday night. And it all started with those Torah classes, when the women invited G-d into their lives.

A Memory That Can't Be Erased

It happened more than twenty years ago. I had just spoken in Portland, Oregon. My children were still small, and whenever I accepted an out-of-town speaking engagement, I made certain to catch a "red eye" flight so that I might make it back in time to give them breakfast and see them off to school.

I always found these talks exhilarating. To see people who were alienated and assimilated become involved and committed has always been to me the most inspiring and awesome experience. That night in Portland was no exception. There were many questions, and I tried to stay as long as I could before having to dash off to the airport. By the time I boarded the plane, I felt drained and exhausted. I told Barbara that I just wanted to close my eyes and catch some sleep. Luckily, the plane was half empty, so I asked the stewardess for an extra pillow and blanket.

I was on the verge of dozing off when a young man approached us. I was really too tired to talk to anyone, but then again, maybe he was someone who had to be reached.

"Are you from Portland?" he asked.

"No, I'm from New York, but I was speaking there."

"Where were you speaking?"

"In the local synagogue."

"I don't get involved in any of that stuff."

"Are you Jewish?" I asked.

"I guess I am," he said.

"You only guess?"

"Yeah, it's an accident of birth. Doesn't affect my life one way or another."

Our conversation was interrupted by the stewardess, who was distributing the midnight snacks.

"Jungreis," she said, reading the label. "I have you down for kosher. . . . And what would you like to have?" she asked, turning to him.

"I'll take ham and cheese," was his answer.

"You can't have that," I interrupted.

"What do you mean I can't have it? It's my favorite sandwich."

"But you told me you're Jewish."

"So what!"

"So what? You must be kidding. You signed a contract—you sealed a covenant at Mount Sinai that you wouldn't eat that stuff. You were there. All Jewish souls that were ever to be born were there. As a matter of fact," I added, "looking at you now, I think I remember you. We all pledged to uphold the covenant."

He looked at me in disbelief. "Lady, you know something? You're nuts! You really are nuts!"

And with that, he picked himself up, walked back toward his seat, and told the stewardess as he passed her in the aisle, "That woman is off the wall!"

For the remainder of the flight, he didn't look my way.

At JFK, we met once again at the luggage carousel, and he said to me, "You know, you *are* crazy."

"Listen, my name is Esther Jungreis. Here is my card. We have an organization called Hineni, which means 'Here I am,' ready to serve my people and my G-d. We remind people of that covenant sealed at Sinai. You can check it out. It's all documented in a book called the Torah. The whole story can be found there. You will see. You really were there. If you need help, let me know."

I got back to my home and my daily routine. The children were waiting. My husband had just returned from the synagogue, and we caught up on the latest events. The phone rang, I had classes to prepare, the house had to be put in order, and I completely forgot that chance encounter in the sky.

Several years later, I was teaching my class at Hineni when in walked a man wearing a black rabbinic hat and coat.

"Rebbetzin," he said, "do you recognize me?"

"You look familiar" (my stock answer for anyone I don't really recognize and don't want to offend).

"We go back a long way," he said. "How about Portland, Oregon—the 'red eye'?"

It all came back to me. "You can't be *that* guy!"

"I am," he said, smiling. "I never forgot your words. It took me a while to work it out, but I did go to check out the Torah, and you were right. I *was* there. I signed a contract, I sealed a covenant, and now I've come to you because I'd like you to find me a girl who was also there."

Today, my friend from the "red eye" is the proud father of a wonderful family that lives by that covenant.

I have told this story numerous times, and audiences usually have a good chuckle from it. On one occasion a woman asked me, "How did you work up the courage to say those things to a stranger? For sure, I couldn't do it."

For a moment she took me by surprise. I never thought I was doing something unusual by speaking about our heritage. After thinking about her question, I shared a story about our family with her.

My great uncle, Rabbi Hillel Kalamay, was an eminent Torah sage in Hungary. One day, during the intermediate days of Passover, he was traveling by train to a rabbinic congress. In the same compartment in which he and his disciples were seated was a young Jewish boy. My uncle was discussing words of Torah with his followers when this young man reached into his knapsack, took out a ham sandwich, and started to eat.

My uncle and the members of his entourage couldn't believe their eyes. It was bad enough that he was eating a non-kosher sandwich, but on *Passover!* and in full view of the rabbi! How could somebody be so brazen—no shame, no conscience, no respect?

My uncle's followers wanted to tell him a thing or two, but he restrained them, saying that he would handle it.

"My son," my uncle pleaded, trying to talk to his heart. "Your soul was at Mount Sinai. Have mercy upon yourself. Don't betray your covenant." All his imploring was in vain.

"Rabbi, I don't believe any of that stuff. Don't waste your breath on me," the boy said as he continued to eat his sandwich.

But my uncle would not give up and kept talking to him.

The disciples couldn't bear to see their beloved rabbi degraded so. "Please," they pleaded, "It's not to the honor of the rabbi to speak to such a lowlife."

"Never speak this way," my uncle chided them. "That boy, whom you call a lowlife, is the son of a mother and a grandmother. Who knows how many tears they have shed over him? Who knows how many prayers fathers and grandfathers have said on his behalf?"

Even as my uncle spoke, his eyes filled with tears. "You should know, my children," he said, "that we have a law: 'Words that emanate from the heart must enter another's heart.' My words came from my

heart, and because of that, they will surely enter this young man's heart—if not today, maybe tomorrow, and if not tomorrow, maybe next year, but someplace, somewhere, he will remember and he will come back. So never be afraid to speak, provided the words come from your heart."

There are many ways of inviting G-d into our lives. For some of us, it's a process; for others, it's an instantaneous revelation. Others have to be in a foxhole before they can make that commitment. And still others check out the Book, and when they do so, discover a truth that is undeniable, as did my friend on the plane. But one thing is for sure: No matter how or where you discover G-d, if words emanate from your heart, they must enter another heart.

꙳ 3

Responsibility/
Accountability

*"You shall not stand idly by while the blood
of your brother is being spilled."*
—LEVITICUS 19:16

TIKUN OLAM—TO BRING HEALING TO THE WORLD

A new charity was being established in Borough Park, and I was invited as the guest speaker for its inauguration. When I arrived at the hall, it was all I could do to get through the crowd. Everybody who was anybody in the community was there, including the then mayoral candidate Rudy Guiliani. The event that sparked the creation of this new charity was a tragic one, and I guess many people felt a responsibility to participate.

It all started with a *"Mazel Tov."* A young girl from a fine, respected family became engaged, and because it was summer, the celebration was held at a bungalow colony in the Catskills where the family was vacationing. Engagements are always happy occasions, but to the people of Borough Park, where almost all the families are children of Holocaust survivors, these celebrations take on added meaning. To have escaped the gas chambers, to have seen your entire family perish, and then to behold children and grandchildren establishing new homes is an affirmation of life, a triumphant declaration of Jewish continuity.

It was Friday night, the night of the holy Sabbath. Friends and relatives gathered from near and far. Their joyous Sabbath hymns resounded in the warm summer air. The happiness of the family was contagious. Everyone was touched by it. Suddenly there was silence. The grandfather, the patriarch of the family, a respected scholar, a survivor of Hitler's camps, got up to speak. He imparted teachings from the Torah and, as is traditional on such occasions, blessed the young couple and wished them a fruitful Torah life. And then, to shouts of *"Mazel Tov!"* the men got up to form a circle and danced in thanksgiving to G-d.

If you have never seen a Jewish *simcha* (celebration), it is difficult to imagine the soaring of the spirits, the ecstasy that such dances inspire. Once you have participated in such a celebration, its memory will remain etched in your heart. It was late at night when the evening's festivities concluded with the grace after meals, and a tired but exhilarated group made their way to their individual cottages.

Then suddenly, from nowhere, this joyous night was transformed into an unspeakable nightmare. A ruthless killer made his way to the bungalow of the grandparents and brutally murdered them. To have

survived the gas chambers of Hitler only to be butchered savagely on the night of their granddaughter's engagement was a tragedy that defies comprehension. In memory of these grandparents, who had undergone so much suffering and who more than anything else wanted to see their granddaughter go under the marriage canopy, this new charity to help indigent brides was dedicated.

The room was charged with emotion as people expressed their respect and sympathy to family members. "The Jews are a remarkable people," Guiliani said. "A family experiences a tragedy too horrible to contemplate, but instead of going on a rampage and demanding vengeance and blood, they respond by creating a new charity. What an incredible people!"

I thought about the truth of his remark. In the face of calamity, most people respond negatively, but we have a mandate to make *tikun olam*—a cabalastic term meaning to make the world a better place, to bring healing to humankind, to banish darkness by lighting candles, to battle ignorance by imparting wisdom, to overcome hatred by imparting love, and to dissolve anger with kindness.

This concept has deep biblical roots. Our father Abraham combated the evil of his generation by establishing an inn that had doors on every side so that all wayfarers might find their way there, so that he might teach the pagans the word of G-d. Abraham offered free food and lodging, explaining that these were gifts from the Almighty. When his guests were ready to depart, he accompanied them to the road and, in parting, gave them a blessing that once again impressed upon them man's purpose in life: "to do justice, to love mercy, and to walk humbly with G-d."

Not only did Abraham impart these laws of loving-kindness through word and example, but he even prayed for the hopelessly wicked people of Sodom and was ready to take on G-d Himself in an attempt to save their lives. These prayers of Abraham have inspired our people throughout the centuries. The Talmud relates the story of Bruria, a brilliant woman and a great Torah scholar, whose husband, Rabbi Meir, a renowned sage, suffered greatly from an abusive neighbor. One day the harassment was so overwhelming that Rabbi Meir could no longer contain himself. In sheer desperation, he prayed to G-d that this evildoer be punished.

Bruriah, overhearing her husband's entreaty, suggested to him that with the same energy with which he sought his neighbor's down-

fall, he could pray for his salvation, for the same G-d who could decree death for this man could also sensitize his heart so that he might become a better person.

"And if you do that," Bruriah added, "you will not only neutralize your enemy, but you will gain a friend for yourself and will bring about *tikun olam.*"

At one time or another, to a greater or lesser extent, we all experience some evil, some injustice in our lives, but it is not the evil or the injustice that we suffer that is at issue, for that is beyond our control. What is within our control is *how we react to it.* Undoubtedly the people in that bungalow colony could have rioted, destroyed stores, burned houses, overturned cars, and beaten up everyone in their path. But what would they have accomplished by it? How would the world have been improved?

During the Holocaust, everyone in my father's family perished. My father, the only surviving son of my grandfather, could have been filled with hatred and rage, but he responded to this satanic evil by calling us, his children, to his side and telling us that henceforth our mission would be to make an extra effort at *tikun olam*—to bring healing to a world that had gone mad.

In view of the cataclysmic evil of the Holocaust, you might wonder how it was possible for us not to be filled with venom and hatred, but here again our response had deep biblical roots. At the very genesis of our history, we experienced the inhumanity of Egyptian slavery. We saw our infants cast into the Nile, our little ones bricked into the walls. Day and night, we felt the stinging lashes of our Egyptian taskmasters, and yet, when we emerged from that brutal bondage, the Almighty commanded us "not to abhor the Egyptians" (Deuteronomy 23:8) and charged us with the mission of *tikun olam* at Sinai. To this very day, on Seder night, when we recall the plagues that were visited upon Egypt, we spill a drop of wine from our cups to teach us that our joy can never be complete if others are suffering, even if those "others" are our enemies.

It was in this spirit that in our own time, Golda Meir, Israel's prime minister, declared that the day might come when we will forgive the Arabs for having murdered our sons, but we will never forgive them for having forced our sons to kill.

Now this is not to say that we countenance evil or injustice. On

the contrary, the Torah demands that we establish courts of law and hold criminals accountable for their crimes. By exhorting us to bring healing to the world, the Torah protects us from succumbing to the evil that surrounds us. To respond to hatred with hatred can only beget further hatred and reduce the world to chaos. Whenever possible, we have to try to communicate by using the formula of our father Abraham by attempting to awaken the Divine spark even in the darkest of souls.

I experienced a tragicomic aspect of this teaching when, some years ago, the application of this formula literally saved my life.

It was Friday, a day we call *Erev Shabbos*—a day designated for preparations for the holy Sabbath. On *Erev Shabbos* I always do major cooking and baking. There are children, grandchildren, and guests who join us at our *Shabbos* table, so it is a happy but busy time, when I race against the clock to get everything ready before lighting candles at sundown. On this particular Friday, Barbara offered to help me out by taking care of my supermarket shopping.

Delighted, I accepted, thinking it would give me some extra time in the kitchen. It was about noon when she returned, laden with bundles. The Hineni phone rang in the kitchen. Barbara dropped the packages and ran to answer it, not realizing that she had left the front door open. A woman who looked vaguely familiar walked into the house, but that did not alarm me. I was accustomed to having people come to our home whom I barely knew. Besides, I assumed that she was someone Barbara had met and invited back to the house. Still, there was something eerie about this woman. Without saying a word, she made her way to the dining room and sat down on a chair.

"Hello," I greeted her. "Can I help you?"

She stared at me with blank eyes. "I have come to kill you," she said in an emotionless voice, pointing a knife at me.

Then I recognized her. She was a mentally ill woman who lived in our neighborhood. Barbara, engrossed in her telephone conversation, was unaware of what was transpiring. I felt my heart racing, but years of training stood me in good stead. I grew up in a home where my parents offered refreshments to everyone and anyone who crossed their threshold, including delivery men. To be sure, I was petrified, but instinctively I extended the hospitality that my parents had taught me from childhood on.

"Can I offer you some coffee and some delicious cake?" I asked. "I just baked it. It's fresh out of the oven."

I made my way to the kitchen and gave Barbara, who was still on the phone, a nudge. At last she realized what was going on and quickly called the woman's husband, who came running with the police and had her hospitalized.

How did I think of responding with cake to an invitation to be murdered? I guess, as I said, it is centuries of training going back to our father Abraham that put me on automatic pilot.

Admittedly this was not a typical situation, but whether it is something as extraordinary as this was, or the agony of painful illness, or any trauma for that matter, the principle remains the same. It's not the given situation but our response to it that counts— whether we are willing to see the challenge as an opportunity for *tikun olam* or whether we will allow anger and bitterness to take hold of our lives.

On a personal level, I can tell you that I have seen much suffering in my life—my own and my family's internment in a ghetto and a concentration camp and, in this country, the anguish of seeing those nearest and dearest to me succumb to long, painful illnesses.

I recall my father telling me one day that perhaps the reason why the Almighty G-d visited so many different illnesses upon him was so that he might teach others how to cope with their pain. And indeed, my father did just that.

I remember rushing to his bedside when he had his first coronary. "My dear child," he said, "I will be alright, blessed be G-d, but there are so many people on this floor who are really hurting. Go visit them, cheer them up, and then go home to your husband and children."

In contrast, I also saw patients who berated the members of their families: "What took you so long to get here?" "Where were you?" Once again, it's not the illness but the manner in which you respond that counts. And that is the bottom line.

Some years after my father's passing, a member of my husband's congregation, Herman Harris, decided to visit nursing homes for the holiday of Chanukah to distribute boxes of cookies to the residents. After he had finished giving out his gifts, he found himself with one last box of cookies. Rather than take it home, he looked

for a kindly staff member to give it to. Suddenly he noticed a black nurse lovingly cajoling an elderly lady into finishing her lunch.

"Excuse me," he said to her. "May I give you this for a happy holiday?"

"Oh, *Baruch HaShem*," she said in Hebrew, smiling gratefully.

"What did you say?" Herman asked, somewhat taken aback.

"Baruch HaShem, thank G-d."

"How do you know that expression?" he asked in wonderment.

"I learned it from a patient I once had, a holy man, a great rabbi, who was filled with the spirit of G-d. He suffered greatly from many ailments, but he always smiled and said, *"Baruch HaShem*—blessed be G-d."

"What was his name?"

"Rabbi Abraham Jungreis" was the reply.

Yes, my father may have suffered, but with his *"Baruch HaShem*," he brought *tikun olam*—healing to the world—and touched countless lives.

This then is our challenge, a challenge for which we will be held accountable by G-d. Will we have brought *tikun olam*—improvement to the world, healing to mankind—or will we allow the darkness to envelop us and create more darkness in the process? We each have a choice. It's up to us.

But It's Not My Fault

Larry Berk was a man most people would describe as a "real sharp guy." From his Gucci loafers to his Armani jacket, he looked like the embodiment of success. He was well groomed and charming and had the gift of gab.

Then one day I saw a news item about him in the daily paper. Larry had been apprehended for fraud. The article also revealed that Larry already had a record in another state. I was shocked. Could this be the same Larry who from time to time had come to my classes? Everything checked out—there was no escaping the sad fact that it was he. What a pity, what a waste of talent, I thought to myself.

A few days later I received a phone call. It was Larry.

"Rebbetzin, can I come over? There's something I would like to discuss with you."

When Larry walked into my office he looked as if he didn't have a care in the world. He seemed as confident as ever.

"I'm sorry I haven't been able to attend your classes regularly, but I've been very busy," he said, as he settled into a chair opposite my desk.

I had a lot to say on that, but I decided to remain silent and see where the conversation would go.

"You may be wondering why I asked to see you," he continued. "I don't know if you read about it in the papers, but I had some business problems lately. It's very involved. If you like, I'll tell you about it. Bottom line, though, I need your help."

"How do you envision that I can help you?" I asked.

"Well, you could give me a character reference for the judge who's presiding over my case."

"With all due respect, Larry, how can you expect me to write such a letter? I hardly know you."

"Well, what would you like to know? I'll tell you all about myself."

And with that, he launched into his history. "I had a tough childhood. My parents never got along. At one time my father made a lot of money, but then he lost his business, although his lifestyle never changed, so I guess he had plenty stacked away . . . not that we ever

saw a penny of it. He was an abusive man and he walked out on us.

"My mother was an alcoholic—a good woman, but I could never talk to her. Whenever I came home from school, she was in bed with the curtains drawn. The housekeeper told me that she wasn't feeling well. . . . I myself am divorced. It was one of those things. . . . I was young and lonely. I didn't know what I was doing and married the wrong girl. So you can see, I had some tough breaks. I guess I also made some mistakes, but I'm certain you can appreciate why. If you like, I'll give you the name of my therapist. She can verify all this."

"Well, I can see that you've had some serious hardships to deal with, and you are what you are because of your background, but Larry, that doesn't mean that you are doomed, that you have to stay that way. Impediments were given to us to overcome, not to wallow in."

"You don't seem to understand, Rebbetzin. I was an abused child."

"I *do* understand, but let me tell you about our father Abraham. He was probably the most abused. From the moment he was born, he was hunted by Nimrod, the cruel despot of that day. For the first years of his life, he lived in a cave, in darkness, and when he emerged and proclaimed his belief in G-d, his own father had him arrested and thrown into a dungeon for ten years.

"And that wasn't all. Nimrod had him cast into a fiery furnace, yet this was the man who established for all humanity the laws of *chesed*, the Hebrew term for loving-kindness. Not just kindness, Larry, but *loving*-kindness. I don't question that you were abused, but I do question your attitude. Precisely because you have experienced first-hand the pain, the ugliness of the dark side of life, you should feel committed to kindle a light."

"Well, that's a new twist on things," Larry interrupted with an edge in his voice.

"It's nothing original," I assured him. "Whatever I say is based on the Torah." And with that, I opened the Bible on my desk and made him read aloud Exodus 23:9. "And you shall not oppress the stranger, for you know the feelings of a stranger, for you were strangers in the land of Egypt."

"We were abused and brutalized in Egypt, and we could have taken that experience as license to brutalize others. We could also have said, 'Check it out with our therapist. He will verify our story.

We can't help it. We are what we are.' But G-d demanded that we take that experience, turn it around, and use it to reach out to others with compassion."

"Well, maybe I'm just not on the level of those people," Larry retorted, tossing my words aside.

"But you *are*, Larry. We are all judged in accordance with the generation in which we live. Our sages teach that Jepthah, who was a minor prophet, was to his generation what Samuel, a major prophet, was to his. Nobody expects you to be like Abraham or like our ancestors who came forth from Egypt, but you *are* expected to realize your responsibilities as Larry Berk and leave a positive imprint on this world."

But Larry would not give in. He still played the victim who had been given a raw deal, so I told him one more story—this time about Eleazar Ben Dardario, a man described in the Talmud as the most immoral person of his time. One day, while in the company of a prostitute, he experienced a moment of truth when she turned to him and said, "Eleazar Ben Dardario, you are beyond salvation. You will surely rot in hell."

Her words had a cataclysmic effect on him. He ran out of her apartment, determined to repent. "Hills and mountains," he cried, "plead on my behalf." But there was only silence.

"Heaven and earth, seek mercy for me!" But still there was silence.

Then he turned to the stars and constellations, begging them to intercede, but they too remained silent.

"If that's the case," he said, "the matter rests entirely with me. It is only I who can plead my cause."

At that moment, a heavenly voice was heard, "Eleazar Ben Dardario's repentance is accepted."

Larry looked puzzled. It was obvious that he didn't understand the meaning of this tale, so I proceeded to explain to him that hills and mountains are symbolic of parents. Eleazar Ben Dardario tried to shift the blame for his corruption and his immoral acts to his parents, but the heavenly court would not accept that rationalization, so he tried again. This time he blamed heaven and earth—his environment, his school, his friends, but that too was rejected out of hand. He tried again and pointed to the cosmos, complaining that he was

born under an unlucky star and his conduct was not his fault, but once again his plea went unheeded.

It wasn't until he found the courage and strength of character to say, "It's all my fault. I can't shift the blame to anyone else; it is I and only I who must accept responsibility," that Eleazar Ben Dardario's repentance was accepted.

"And this, Larry, is what separates the men from the wimps, for a real man is someone who is willing to accept accountability. As long as a man blames others for his own shortcomings, he will continue his aberrant ways. The moment he sees himself for what he really is, that moment the healing process commences and a new person starts to emerge. His new self-awareness inspires him to redress his wrongs and to help others who suffer from the same weakness. If he can do that, he can convert his failures into assets."

Larry was silent for a moment. He was obviously pondering my words, but then he reverted to form by coming back at me with, "This guy from the Talmud, whatever his name is, was immoral, and there was no excuse for his behavior, but I had a very tough life."

"I'm sorry, Larry, but I see that you're not getting it. Let me try again."

This time I told him about Adam and Eve. "Do you know what the real sin of Adam and Eve was?" I asked. "Surely you remember it from your Bible stories."

"Yeah, they ate that forbidden fruit."

"That's how it appears, Larry. That's how most people interpret it, but if you study the text carefully, you will realize that G-d did not banish them from the Garden of Eden until after He had a conversation with them, so obviously something must have taken place in that exchange that was the straw that broke the camel's back. Do you know what that was, Larry?"

His expression betrayed his impatience, but I chose to ignore it. Once again, I took out my Bible to show him the exact passage in Genesis 3.

"'Where are you?' G-d called out to Adam, who, following his sin, went into hiding.

"Now surely the Almighty knew where Adam was, but He wanted to give him an opportunity to confess so that he might rectify the wrong that he had done. Instead of rising to the occasion,

Adam made a lame excuse. When G-d forced him to confront the truth by asking him, 'Did you eat from the tree that I forbade?' Adam had the *chutzpa* to say, 'The woman whom you gave me, it is she who told me to eat from it!' And when G-d challenged the woman, she in turn blamed the snake.

"Sound familiar Larry? Shifting blame, shirking responsibility, and being an ingrate to boot? Everyone can make mistakes, but few know how to admit to them, to confront them in their naked truth without excuses or rationalizations. Can you imagine, Larry, how different the course of humanity would have been if Adam and Eve had had the strength of character to say, 'We have sinned. Forgive us, oh G-d. Help us to make amends'?

"The man who taught humankind to do that was David, King of Israel, and that's precisely why he was worthy of being king. When Nathan, the prophet, came to rebuke him, he cried out in anguish, 'I have sinned!' No ifs, no buts, no excuses. Although he could have ordered Nathan's execution, David humbly accepted his chastisement and cried out from the depths of his soul, and from that anguished cry, he created psalms that to this very day enable every man to search his heart and to emerge a greater human being.

"And that's what you are going to have to do, Larry. Not on the level of David—that none of us can do, nor are we expected to— but on *your* level. You must at least try to feel contrition in your heart and, yes, try to cry. You will discover that your soul is a reservoir of untapped strength from which you can bring healing to yourself and to others. Some of the greatest people, Larry, have sprung from failure, heartbreak, and suffering. Why not you?"

Larry's eyes told me that I was finally getting through. That arrogant, know-it-all look was not so blatant.

"Well, the Bible has some good stuff, and I must admit that I would like to study it one day, but right now I'm just too busy."

And then, as if he had second thoughts, he asked, "How is studying the Torah going to help me, anyway?"

"That's the only thing that can help you," I said, "because genuine study of Torah is like a spiritual magnifying mirror that allows you to see all your failings."

"Why would I want to do that?" Larry asked, half jokingly.

"Why does a woman use a magnifying mirror when she fixes her

makeup?" I asked. "It's the same logic. Even as we want to look our best physically, so it's to our advantage to be at our best emotionally and spiritually. On this basis, if you agree, I can write a letter for you to the effect that you are starting to study, that you are trying to find out what Larry Berk is all about. And with G-d's help, from that experience, a new Larry will emerge, a Larry who will be a source of blessing to himself and to others."

✌ 4

Charity—*Tzedukah*

"Charity saves from death."
—Proverbs 10:2

Everybody Has to Give

It was just before the High Holy Days, and I had to go to Borough Park to pick up some Judaica gifts. This vibrant Hasidic neighborhood in Brooklyn offers the largest selection of holiday items in New York.

I always enjoy a visit to Borough Park for there is something special about a trip there. The streets teem with people: young mothers wheeling baby carriages with four or five little ones trailing behind; schoolgirls dressed modestly in their uniforms, walking arm in arm, with an air of innocence that is so refreshing in today's society; Hasidim standing on street corners exchanging words of Torah. And now, before the High Holy Days, the streets exuded a special energy.

So, after battling traffic and circling for about twenty minutes, Barbara and I finally found a parking space on 13th Avenue—an ideal spot, for that is where most of the shops are located. I was fascinated by the scene on the street. Noticing my absorption, Barbara suggested that I remain in the car while she picked up the things we needed. In Borough Park you can always count on something happening—something that will give you a story and put a smile on your face. And sure enough, I wasn't disappointed. Standing a few yards from our car was an elderly woman, dressed in an ill-fitting black coat, her head covered by a turban. She clutched an open pocketbook in her hand, and as people walked by, she called out, "*Tzedukah—tzedukah*—charity—charity," and almost without exception, passersby dropped some money in her handbag.

Tzedukah is one of the pillars of Jewish life. Although it is best to give without the recipient knowing who you are and without your knowing his identity, nevertheless, no request for help can be ignored, and most importantly, the gift must be offered warmly, graciously, and with a smile. Before the High Holy Days, special efforts are made to intensify one's contributions, so I wasn't surprised to see even little children respond to the woman's call. I was about to open the car window to beckon to her, when a teaching of our sages flashed through my mind: "The poor are put to shame when they are forced to go begging. Don't add to their ordeal. Bring your gift to them." So I walked over to her, wished her a blessed New Year, and placed some money in her bag.

As I continued to watch as people gave her *tzedukah*, it occurred to me how very grateful to G-d we must be for having endowed us with a way of life that *demands* that we give.

Suddenly I noticed a change in her facial expression. With a resolute look, which seemed to say, "OK, that's enough for now. I need a break," she leaned against the wall of a building, took some crackers out of her pocket, and began munching on them. Then something strange happened. Another beggar walked down the street calling "*Tzedukah, tzedukah.*" Not realizing that she was a competitor, he approached the woman, holding out his hand. What is she going to do now, I wondered.

My little woman opened her pocketbook, took out a coin, and dropped it into the man's hand. I felt like giving her a hug. Good lady! I thought to myself. That coin, coming from her, was perhaps more significant than a major contribution from a wealthy man. Although she herself was a beggar, she totally understood the essence of *tzedukah:* Every person, no matter what his or her station in life, must give.

There is a story told of Rabbi Akiva, a great Torah luminary, who until the age of forty was an illiterate, impoverished shepherd in the employ of Kalba Savua, one of the wealthiest men in Jerusalem. Rachel, the beautiful young daughter of Kalba Savua, recognized Akiva's potential and was prepared to marry him provided that he would agree to pursue a life of Torah study.

Kalba Savua would not hear of such a match and disowned his daughter. The young couple were left destitute. In order to support her husband, Rachel became a laundress. She happily accepted her lot. Knowing that her husband was studying Torah was all the reward she desired, but still there was one thing that bothered her, and that was that she no longer had the means with which to give *tzedukah*. The Talmud teaches that if one really desires to give *tzedukah*, G-d will enable one to do so. Thus one night Elijah, the prophet, disguised as an elderly beggar, came knocking on their door.

Rachel and Akiva welcomed him and bade him enter. Regretfully they told him that they had nothing much to offer him. Elijah looked about and saw that their bed was a heap of straw. "I don't even have that," he said. "Could you share some of your straw with me?" Joyously they handed him some of their straw, and as they did

so, they thanked G-d for having afforded them the opportunity to give.

But what if you don't even have straw to offer? What if you are so impoverished that you have nothing to share? Our sages teach us that even then you can fulfill the commandment of *tzedukah* by offering comforting and encouraging words, thereby raising the spirits of those in need.

A Roman nobleman once challenged Rabbi Akiva, "If your G-d is so concerned for the poor, why did He create them?"

"For the same reason that He didn't create bread trees," came the answer. "G-d wants us to join Him in partnership to continue the work that He began. Through the act of giving, we become kinder and better people and can make *tikun olam*; we can participate in the process of perfecting the world.

"Can you imagine what the world would look like if we were all self-sufficient and never needed one another? Can you imagine the selfishness, the greed, and the baseness if no one ever felt compassion or gratitude? Therefore the Torah teaches that 'the poor shall never cease to exist in the land. . . . You shall surely open your hand to your brother, to your poor, to your destitute' (Deuteronomy 15:11).

"Indeed, it is through the act of giving that humanity is elevated and the spark of G-d lying dormant in the soul becomes visible."

The Torah teaches that when we give, we get, and in the end, that which we give away is the only thing we really have. This point was brought home to me by Nate Appleman, whom I met through his daughter, Jill Roberts, my very dear and precious friend. Nate was on in years and ailing with cancer, but his childhood memories were vivid. I was very much taken by his stories. In the course of one of our conversations he told me about an incident that truly reflects the Torah attitude toward *tzedukah*.

Nate's parents had come to this country from Lithuania and settled in Marietta, Ohio, joining a small group of Jewish families who were committed to upholding the traditions of their ancestors. The community flourished, and they prospered in the oil business.

"My father," he told me, "was a strong disciplinarian. He demanded that we respect our faith and remain loyal to its teachings, and he taught us the meaning of *tzedukah*. Times were not always easy.

I remember the years of the Depression. My father lost everything, and we were really struggling. I was in my twenties, full of ambition, and like all young people I had my conflicts with Dad. One day when my father was experiencing much stress in his business, I couldn't help but remark, 'Dad, can you imagine how great it would be if you could have the $75,000 that you gave to charity in the past?'

"My father looked at me very sternly. I will never forget the expression in his eyes or the tone of his voice. 'Son,' he said, 'I'm going to tell you something now, and never forget it. The only money that I do have is the $75,000 that I gave away, and my only regret is that I didn't give more.'

"I was young and I didn't understand the full implication of my father's words, but with the passage of time I have come to appreciate his wisdom. What we give to others is really the only currency that we have, and I guess that's the only thing I will be able to take with me."

Nate passed that teaching on to his children, and my friend Jill epitomizes that legacy.

The Hebrew word *tzedukah* means something far deeper than "charity." *Tzedukah* comes from the word *tzedek*, which means "justice or righteousness," telling us that to give is an obligation to do justice. The word *tzedukah* reminds us that what we have is not really ours but has been given to us in trust by G-d for distribution.

"For Mine is the silver, Mine is the gold . . . " (Haggai).

It all belongs to G-d, and when we give, we are only returning that which He gave to us. Charity, on the other hand, is a totally different concept. It is derived from the Latin word *caritas*, meaning "love," suggesting that we have an option—to give to those we love and to withhold help from those we dislike.

In the world of *tzedukah* such options do not exist. Whether we like someone or not, we have a responsibility to give, for that is the correct thing to do, and for this we do not merit any special credit, even as we deserve no reward for paying our taxes.

The wisdom that Nate gleaned from his father was the common heritage of all our people. Thus it was not by coincidence that throughout the millennia, in every Jewish home, there were *tzedukah pushkas* (charity boxes). These *pushkas* accompanied our grandparents when they came to this country. Early on, children were trained to

think of the needs of others and to drop coins into the *pushkas*—a far cry from the piggy bank, whose purpose is self-focused: "Save your money for a rainy day," "Save your money for something special." Whatever the purpose, the very name *piggy bank* bespeaks self-indulgence. *Pushkas,* on the other hand, have an entirely different shade of meaning. In our home, as in all traditional homes, money was saved to help the poor. Every week, collectors would come from societies that cared for the sick, the impoverished, the homeless, and yeshivas here and in Israel. They would gather up the coins in the *pushkas* and give a receipt and a blessing.

These *pushkas* served a double purpose. They were constant reminders to the members of the family of their responsibility to give, and they also protected the anonymity of the needy, who were thus spared the embarrassment of having to confront their benefactors.

The impact that *pushkas* had on Jewish life reached far beyond the confines of *tzedukah.* The extent to which this was so became apparent to me when I met Robert, who had just emerged from a nasty, painful divorce. His wife had left him for her tennis instructor, but amazingly there was a calmness and even a gentleness about Robert. I didn't detect any of the cynicism or bitterness that usually accompanies such an experience.

"How did you manage to maintain your positive outlook?," I asked curiously.

He pondered my question for a moment and then said, "I guess it's something I learned from my mom."

"Tell me about it. I would like to know."

"My parents were poor people," he began. "My father was a laborer, and with six children there wasn't much to go around. But my mother had at least a dozen *tzedukah pushkas* lined up on her windowsill. Every Friday, before she lit the Sabbath candles, she would put money in each of the *pushkas.*

"I remember on one occasion, it must have been a year after my bar mitzvah, Dad had a particularly bad week. As I watched my mother drop her coins into the *pushkas*, I wondered out loud whether it was necessary to put money into all of them.

"My mother picked up on my muttering and chided me. '*Boruchel,*'—she always called me by my Jewish name—'you never have

to be afraid of giving *tzedukah*, for whatever you give away, G-d will give back to you a thousandfold. And when things get tough, that's when you really have to double your efforts. If you do that, you will see that G-d's blessing will always be with you.'

"So Mom kept filling up her *pushkas* throughout bad times as well as good ones, and somehow we always managed. My mom's teaching stayed with me. No matter what happens, no matter where life takes you, you must continue to give. So I guess that throughout my painful experience, the image of Mom dropping those coins in the boxes even when we ourselves were deprived kept me going. I told myself that if Mom, with all her problems, was able to give, then I too must continue to give, no matter what.

"I was always active in charities, but when my wife left me and my world fell apart, I became even more involved. And that, Rebbetzin, saved my life. I guess that is what prevented me from becoming bitter and depressed."

At one time or another we all experience personal crises. At such times we have the option of indulging in self-pity and succumbing to depression or of remembering that we have a mission—to make *tikun olam*—to perfect the world by giving. If we can live by that commitment and remember to help others when we ourselves are in need of help, we will be able to weather the storm and discover that the teaching of King Solomon, "Charity saves from death," is true in more ways than one.

MAMA

My mom is a tiny lady whose beautiful face is marked by many wrinkles. She is a bundle of energy and lovingly called Mama by all who know her. The reason why she is everyone's Mama is simple enough—that's what she is. She adopts those who come her way and makes them part of her life. If you have a problem, just discuss it with Mama. She'll give you the best and most down-to-earth advice—advice that will put everything in its proper perspective—advice that is always given with a blessing and love.

Mama is ninety years old. Among the many ailments from which she suffers are crippling osteoporosis and arthritis, but her mind and heart are perfect. Before illness took its toll on her, she would get up every day at the crack of dawn. There was work to be done. People needed help. Mama was busy. She supervised the cooking of the lunches for the children of our yeshiva, which was founded by my parents when they arrived in the United States for children from low-income homes.

She collected used clothing, laundered it, and sorted it for newly arrived Russian immigrants, who visited her regularly. Mama gave her visitors free run of the house. "Look around and take whatever you like," she would say.

Well, one year, just before Passover, she couldn't find her dishes (Jewish dietary laws require that different dishes and utensils be used for the holiday of Passover). She called me, all upset. "Where could my dishes be? I turned the house upside down and still I cannot find them."

"Mama," I said, "I'll bet you gave them to one of your Russian visitors."

"Oh!" Mama said, relieved. "*Baruch HaShem*—thank G-d. Let them use them in good health!"

Whether it was her dishes or her own dresses from the closet or a jacket that one of my children took off while visiting at Mama's house, everything was fair game, because to give was Mama's greatest pleasure. Although she is no longer as active, there are still some things that she likes to do, like distributing clothing to the poor.

A couple of years ago, Mama had to undergo surgery. Her recovery was agonizingly painful, and so during that period I tried to pro-

tect her from these pressures and didn't bring bags of clothing to her house. But Mama became depressed. "What's the point of my life if I can't help people?" she wailed. "I sit here like a vegetable. My life isn't worth anything."

Seeing that I had no option, I started to gather the *schmattas* again. Mama could hardly move. Every step was painful. But she would sit with her bags of clothing, sorting them, deciding which articles would be most appropriate for her needy Russian families.

"Mama," I protested one day, "this is too much for you. You don't have the *koyach* [Yiddish for strength] for it anymore."

"*Koyach!*" she retorted, "*Koyach* you get from giving. When a mother nurses her child, the more the baby takes from her, the more milk G-d gives her. G-d gives *koyach* when *you* give.

"I don't have money," Mama went on, "so the least I can do is help this way." And there was no arguing her point.

From the earliest days of my childhood, I remember Mama giving. I was just a little girl when World War II broke out, but I vividly recall awakening to the delicious aroma of honey cookies baking in the oven. Hungary was one of the last countries to be invaded by the Nazis, but even before the occupation Jews were the victims of terrible anti-Semitic persecution. Those were dark days. Since our home town of Szeged, the second largest city in Hungary, was a center for the deportation of young Jewish boys to slave labor camps, Mama's work took on new dimensions. Mama adopted all of these unfortunate boys and made them part of our family. She cooked for them, did laundry for them, and as they were shipped out, presented them with her special packages of honey cookies, which have a long life and are nourishing. For Mama, this was a labor of love. She would rise at dawn and work steadily. It never occurred to her that she was doing something extraordinary.

During our internment in Bergen-Belsen, a group of young Polish boys were brought to our camp. They had witnessed the savage murders of their parents. They were emaciated, terrified, and utterly alone. Mama adopted them, gave them endearing Yiddish nicknames, and whenever possible tried to get something extra for them from the kitchen where she had volunteered to work so that she might be of help to others. Years later, when I was in Israel, I ran into some of these young men, who by now were on in years, and they

told me that they still keep those nicknames by which Mama so lovingly called them.

Mama's response to crisis has always been to find someone to help and to give to. I remember many years ago when, one cold winter night, my parents were visiting my home for a family celebration. Suddenly the phone rang. The voice at the other end gave ominous news. Congregation Ateres Yisroel, the synagogue that my parents had built, was on fire. Some young street hooligans had set the holy ark ablaze. You can imagine our feelings—we who had seen our synagogue consumed by flames in Hungary were once again confronted by fire.

The short drive from our home in Long Island to Brooklyn seemed to take forever. There was silence in the car. No one spoke. Each of us was enveloped in his or her own thoughts.

Memories of Europe kept flashing back. When we finally arrived, we found our synagogue in ruins, but thank G-d one of the neighbors had managed to rescue the Torah scrolls. My father started the painful process of sifting through the ashes to see if he could salvage anything, but Mama went into the house. Now what would you imagine that Mama would do under such circumstances?

She went into the kitchen to bake cookies, and as she baked, the tears kept flowing from her eyes.

"Mama, what are you doing?" I asked.

"People will come to help us," she answered. "We have to offer them some refreshments."

Yes, Mama is old and sick, but Mama is vibrant and alive because her life is one of giving.

Like Mama, perhaps you too are not in a position to give monetary gifts. But like Mama, you can make a commitment to help through deeds of loving-kindness. There are so many projects that you can commit to: visiting the sick, comforting the elderly, tutoring children, and if nothing else, learning to be a warm, loving, compassionate person. A kind gesture can go a long way—not only in giving hope and good cheer to others but in helping you become a more fulfilled and joyous individual. When you are kind, you are, in essence, emulating our Heavenly Father and connecting with the source of all goodness.

King David, in the Book of Psalms, wrote, "G-d is your shadow"

(Psalm I2I). Whatever you do, your shadow reflects. The way you interact with people is the way G-d will interact with you.

Keeping this in mind will help you to be kinder and more understanding, even under provocation and difficult circumstances.

Every day try to do at least one act of kindness, and through that act, you will come closer to your Heavenly Father and become a better and gentler person.

CHARITY BEGINS AT HOME

Pearl called for an appointment. She had many problems and needed help. When she arrived at my office, she apologized profusely for troubling me. "I just needed someone to talk to," she confided.

At first glance, she appeared to be a well-put-together young woman, but a closer look revealed fear and anxiety.

"Relax," I said, reaching out for her hand and trying to reassure her. "Take a deep breath and tell me what is troubling you."

"Oh, Rebbetzin," she wept silently. "I'm ashamed to burden you with my silly problems. I know that there are people who are much worse off than I am." She paused for a moment, fished a tissue out of her handbag, and wiped her eyes.

"Pearl," I interrupted, "don't be too hard on yourself. Knowing that someone else has more trouble than you doesn't minimize your pain. I never quite bought the old adage that says, 'I complained that I had no shoes until I saw a man with no feet.'"

Pearl was visibly taken aback by my words, so I explained.

"What comfort can a decent person derive from knowing that someone is worse off than he or she? To be sure, you feel pain for the man who has no feet, but that doesn't put shoes on your *own* feet. Your problem still remains. Precisely because it is your problem, it hurts you the most. So don't feel guilty for being upset. Tell me what is troubling you, and let's see what we can do to help you."

"Thank you, that makes me feel better," she said with a sigh of relief. "I always feel like such an ingrate when I complain. I realize that I have much to be grateful for. I have my health and three adorable children, but I am in a catch-22 situation and I just don't know what to do. My husband is out of work, and my own earning capacity isn't too great. I never had any special training. My youngest child is six months old; if I take a job, between taxes and child care, there'll be nothing left. It's just one big mess."

"What does your husband do?" I asked. "Perhaps we can net-work for him."

"He's a lawyer."

"Well," I said, trying to pick up her spirits, "it shouldn't be too difficult to find a position for an attorney."

"Oh, Rebbetzin," she wailed, "you're right. It shouldn't be too

difficult, but for my husband it is. I can't begin to tell you how many positions he's lost already. I don't know what it is. I guess he just doesn't have what it takes. He's not a go-getter, and somehow he always manages to say the wrong thing, to be in the wrong place, and to get on people's nerves. My family calls him a loser, and they tell me I should get rid of him."

"Do you want a divorce?" I asked gently.

"I really don't know what I want. That's why I came to you."

"Is he good to you? Is he good to the children?"

"Yes," she responded. "He's very kind. He loves me very much and he's a great father. The children adore him."

"Well then, why break up a marriage?"

"I really don't want to, but my family is driving me crazy, and meanwhile we can't pay our bills."

"Well, there must be some sort of job that he can take, and perhaps it should not be as an attorney. Let's brainstorm a little bit over this. Perhaps there is someone we know who could offer him a job."

"Oh please, Rebbetzin," she said embarrassedly, "I hope you didn't misunderstand. I didn't come here to burden you. I just need some spiritual strength."

"That's all well and good," I said, "but let me tell you the story about a man who came to a rabbi and asked if it was permissible to use milk for the Passover Seder rather than wine.

"'Why,' the rabbi asked, 'would you want to use milk?'

"'I can't afford to buy wine.'

"With that, the rabbi gave him his silver goblet. 'Go and buy yourself wine,' he said.

"Later, the rabbi's wife, who had witnessed the exchange, protested. 'You didn't have to be that generous. He could have bought wine for less money than the cost of that goblet.'

"'If a man is asking whether it is permissible to use milk rather than wine for the Seder,' the rabbi responded, 'then you can rest assured that he doesn't have chicken either.'

"So I appreciate, Pearl, that you came to me for spiritual strength, but you need some concrete help as well. We have to try to find a way out of this. So let's think, who can provide a job for your husband?"

"My brother Harry ___," she answered. I recognized the name

immediately. He was a very wealthy man who was known to have many business interests. "Well, if he's your brother, there really shouldn't be a problem. He can certainly offer your husband a job," I said.

Pearl gave me a sad smile. "I wish that were true. I just mentioned his name, but he'll never help. He's one of those in the family who thinks I should get a divorce, and since I haven't taken his advice, he doesn't want to hear of my difficulties."

"Can't your parents talk to him?" I asked.

"That would really be a long shot. My parents think he is the most brilliant person alive and would never contradict anything he says."

"Well, what if I call him?" I asked.

"Oh, please don't," she protested. "You don't know my brother. He can be very insulting."

"I'm not afraid of that," I assured her. "I'll call him right now, and while I do that, why don't you get yourself a cup of coffee and browse around in our library?"

I had met Harry in the past on a few formal occasions, but aside from exchanging some perfunctory greetings, I had never really spoken to him. He had a reputation for being tough but also charitable to causes he believed in. Well, I thought to myself, he should certainly believe in helping his family! Fortified by that thought, I called his house, and luckily, he himself answered the phone. After the usual niceties, I got to the point. "Your sister came to see me. She's having a hard time of it." Silence. "I'm certain that you're not aware of it," I continued in an upbeat voice, trying to give him an out. The silence at the other end of the line became even more pronounced, but I was determined not to allow him to discourage me.

"I certainly am aware," he suddenly snapped, "but obviously *you're* not aware, and with all due respect, Rebbetzin, you really shouldn't involve yourself in situations that you know nothing about."

"What's there to know?" I asked, telling myself to keep calm. "Her husband is out of a job. She has three small children, one of them only a baby, and she needs help, and if anyone is in a position to help, it is you."

"There's a lot more to know," he said irritably. "And I really don't

think that it's any of your concern, but if you insist, I'll tell you. My sister married a bum. He can't hold a job. She should have gotten rid of him a long time ago."

"But she told me that he's a kind husband, a loving father, and a good man," I said.

"Well, if he's such a *good* man, let him make a *good* living for her. This man has held dozens of jobs and lost all of them. I have no intention of supporting him and his family. If she doesn't want a divorce, let them go on welfare."

I was getting nowhere fast, and my father's teaching flashed through my mind. "If you want to discuss something serious, something sensitive, never do it over the phone. It's different when you see a person face to face, when you can calm someone down with a smile."

"Perhaps we can meet and discuss this personally," I now said.

"There's no chance of that," he answered curtly. "I have no intention of discussing this subject any further."

Despite his abrasiveness, I wasn't about to give up, so I tried to appeal to his ego. "Didn't I read about you recently? If I'm not mistaken, you gave a very generous donation to ___. I'm certain that a man with your sensitivity to philanthropy will do right by his sister."

"That's different! Look, Rebbetzin, I don't want to be rude, but you are trying my patience and this conversation has gone far enough."

"Do you realize that our Torah teaches that *tzedukah* starts at home?" I asked. "That first and foremost, we have a responsibility to the members of our immediate family, then to our extended family, then to our community, and only then to the community of mankind?"

"That's good in theory," he answered, "but it is not realistic. You have to teach people accountability."

"That's exactly it!" I exclaimed. "You just said the most important word in this entire discussion—*accountability*. You are a philanthropist, but first and foremost your responsibility is to help your sister and brother-in-law. And by the way, that's not my opinion— that's Torah law, and I'm happy to give you the exact quote: 'Between relations and poor strangers, relatives come first' (Talmud)."

"Look, Rebbetzin, I'm a self-made man. I worked very hard for

my money, and nobody's going to tell me how to spend it."

I saw what I was up against, so I decided to take my chances and go for broke. "I can appreciate that you have worked very hard for your money, but despite all your hard work, that money is not yours."

"What? What did you say?" he shouted at the other end of the phone.

So I tried to explain as calmly as I could that all our possessions were given to us by G-d, that it was not his hard work that earned him his money—after all, countless people had invested just as much time, effort, and energy as he did without getting anywhere, so obviously, G-d blessed his work so that he might share this blessing with others. Therefore to give or not to give is not an option; it's not philanthropy but a *responsibility.*

"You don't seem to get it, Rebbetzin. I don't like my brother-in-law."

"Oh, that came across loud and clear, but as I said, this is not philanthropy, a word derived from the Greek *philo,* which means 'love,' and *throp,* which means 'man.' This is not a matter of loving a man, Harry, this is *tzedukah*—justice, an obligation to do the right thing."

"Next thing I know you'll tell me how much I have to give," he said sarcastically.

"As a matter of fact, that too is stipulated—ten to twenty percent. But in your particular case, your obligations are different. You should offer your brother-in-law a job. That's the highest form of *tzedukah.*" And to my astonishment, Harry started to laugh.

"Rebbetzin, you have an incredible amount of *chutzpa.* I'll tell you what. I'll give *you* a job, and let's forget my brother-in-law!"

"Thank G-d, I don't need a job," I answered, determined not to be diverted, "but even if I did, the Torah would still obligate you to offer the job to your brother-in-law first. As I told you, these considerations are not options. Maimonides cites the various levels of giving *tzedukah,* which are designed to protect the dignity of the recipient, and the highest rung on the *tzedukah* ladder is to offer someone a job or to make a loan available to him so that he might start his own business."

"And that's in the Torah also, right?"

"Yes, of course," I answered. "Look it up in Leviticus 25:35,

'And if your brother becomes poor and cannot maintain himself, then you shall surely assist him.' The *mitzvah* is to preserve the needy person's self-respect, so that he should feel that he's contributing to the world rather than taking from it."

"But what if I tell you that I have no job openings?"

"Then create one. Let him shuffle papers. Whatever it is, give him something to do, Harry. You have a fantastic opportunity here that very few people are privileged to have."

"Tell me, I can't wait to hear this one," he said wryly.

"If you give your brother-in-law a job, you will not only fulfill the highest level of *tzedukah*, but you will also have the *mitzvah* of saving your sister's marriage, and that combination guarantees you a ticket to the world to come. And who knows," I added, "maybe it was for this that G-d granted you success." And I reminded Harry of the teaching of the prophet Jeremiah:

"Let not the wise man glory in his wisdom, let not the rich man glory in his wealth, but he who wishes to glory, let him glory in this . . .

That he understands and knows Me, for I am the L-rd who exercises loving-kindness, justice, and righteousness in the earth, for it is in these things that I delight, saith the L-rd."

"Think about those words, Harry. Most people who make it glory in their accomplishments, never realizing that their success was given to them by G-d so that they might share it with others. To have been given money is an awesome test that all too few pass. You have an opportunity, Harry, to pass that test by helping your brother-in-law. To help him, not necessarily because you want to, but because it's the right thing to do."

"You *are* persistent, aren't you? Well, OK. We'll give it a try. Tell my brother-in-law to call me."

In almost every family, there are those who shun their own kin while they reach out to help strangers. It appears that it is easier to love humanity than one's own brothers and sisters, and that is precisely why the Torah calls upon us to commit to *tzedukah*, for only through such commitment can we know where our priorities should lie.

Before concluding this chapter, there is yet another factor that

must be pondered. Pearl's husband was a good man, devoted to his wife and children. Because he couldn't earn a living, he was held in contempt. Were he a ruthless, nasty, but successful businessman, no one in the family would have suggested to Pearl that she seek a divorce. There is something profoundly wrong with a value system that measures a man not by what he *is* but by what he *has*.

Kindness and goodness are the most important goals a man can aspire to, but sadly, these are values that are rarely taught. We push our children to achieve, to get ahead, to be tough and cunning in their pursuit of success, and then we wonder why relationships break down, why people are abusive, why there is no commitment.

~ 5

Peace

"So great is peace that G-d's Name is Peace. . . . So great is peace for all blessings are to be found within it."

—TALMUD

Making Peace in the Family

"My cousins Jennifer and Monica are fighting, and it's destroying our family," Marcia complained bitterly, her voice choked with tears.

"Fights are always very unpleasant, but when family members are involved, it's doubly so," I replied. Still, I tried to calm Marcia down and convince her that she shouldn't allow herself to get so upset.

"This is not just a petty squabble between cousins," Marcia explained. "It has gone beyond that. It's literally tearing our family apart, and it's affecting me personally."

"How?" I asked.

"Well, we have always been a close-knit family. We may scream and yell at one another, but it's all in good fun. In any event, we always get together for the holidays. Next month I'm supposed to be hosting our annual Chanukah party. I sent out the reminders. I put my order in with the caterer. But now I don't know who will come, and it's all because of their stupid fight."

"What are they fighting about?" I asked, trying to make some sense of the story.

"I wish I could tell you. I don't understand it myself, and I don't think they understand it either. It's just one big mess, and the worst of it is that everyone has become involved and is taking sides. Either you're with Monica or with Jennifer, and if you just talk to one of them, you become suspect by the other. Would you believe, Rebbetzin, that they are each sending me threatening messages that if I invite one, the other won't come? I would tell them both to go to the devil were it not for the fact that they have split our entire family down the middle, and the latest is that they are each planning to make their own separate party. Where in the past we used to have one big celebration, now there will be three. And frankly, our family isn't big enough or strong enough to sustain that."

Marcia's story reminded me of the last will and testament of the patriarch Jacob, who on his deathbed implored his children to remain united. How incredible, I thought, that despite the passage of time, nothing has changed, and the simple lesson of the patriarch remains as elusive as ever. Families and communities remain fragmented and through their contentiousness bring unnecessary pain upon themselves—unnecessary because this type of suffering is not

an act of G-d but a self-inflicted curse that robs us not only of peace but of our health and happiness as well. Too late do we discover the bitter truth of the Midrashic teaching "If there is no peace, there is nothing." All our attainments, all our accomplishments become meaningless when our families are torn by strife.

"Tell me," I now said to Marcia, "have you tried to talk to Monica and Jennifer?"

"Have I! But it's like talking to kindergartners, except that these kindergartners are in their thirties!"

"Has anyone tried to make peace?"

"Everyone has gotten involved."

"Maybe that's the problem."

Marcia looked puzzled, so I tried to explain to her that when many people get involved in controversies it often exacerbates the problem.

"You're right—the whole thing has gotten out of hand. The phones are constantly buzzing, rumors are flying, and everyone's embellishing the story. If this were a soap opera I might find it entertaining, but it's my *family*, and that's not funny. Just to tell you what happened yesterday . . .

"I had to make a bank deposit, and who do you think I saw standing on line but Monica. So I said to myself, this is my opportunity, it's meant to be, that's why I had to make this deposit today, so that I might meet Monica and speak to her. I walked over to her, and she gave me a cold hello, her voice dripping ice. I surmised—and later found out I was right—that someone had told her I was siding with Jennifer, but I pretended not to notice anything and gave her a hug and a kiss. After some small talk, which was mostly a monologue on my part, I told her that it was a shame such a close-knit family as ours was falling apart.

"Oh, so you're blaming me for all the problems," she snapped.

"Not at all," I tried to protest, "I was just thinking that it would be nice if you and Jennifer could get together."

"Well, maybe you should tell that to Jennifer."

"And then, of all the crazy things, she asked if Jennifer had put me up to this, if I was speaking on her behalf. In vain did I try to disabuse her of this notion. I pointed out to her that our meeting was quite by accident, and I couldn't possibly have known that she

would be at the bank, but there was no talking to her. She wasn't listening."

"You were wrong," I told Marcia. "You should have told Monica that yes, you *were* speaking on Jennifer's behalf, that Jennifer was terribly sorry and felt ashamed to approach her directly but that she realized she was in the wrong and had asked you to convey that message. And then I would have suggested that you go to Jennifer with the same story."

"But Rebbetzin, that would be an outright lie."

"No, Marcia, not quite, but admittedly an embellishment of the truth. In social or family situations, for the sake of peace, the Torah not only sanctions such embellishments but actually encourages them. We learn this from Aaron, the High Priest. Whenever he heard of a controversy between two people, he would approach them individually and speak to their hearts until he convinced them that the person they had quarreled with was remorseful and desirous of making peace. Thus when the two warring parties ultimately met, they were easily reconciled.

"Aaron's unique ability to make peace between friends, husbands and wives, and family members endeared him to everyone and made him the most beloved leader of the Jewish people. When he died, the *entire* nation mourned and wept, for they had lost their most wonderful friend—a friend who was determined to bring peace to his brethren.

"If Aaron were here today," I told Marcia, "the fight between your cousins would never have gotten so far. He would have immediately visited both Monica and Jennifer and persuaded them that the other was sorry and anxious to make up.

"Nowadays, however, not only are there no Aarons around, but there is no lack of troublemakers who in the name of 'honesty and truth' incite controversy and hatred. Their insidious and damaging remarks can run something like 'I don't know if I should tell you, but . . . ,' 'Do you know what she *said* about you?' 'I don't want to disillusion you, but if you *think* he's your friend . . . ,' and 'If I were you, I would never talk to her again.' And so a fire that could have been contained becomes a major conflagration because there are people who are fanning it."

"That's not a very pretty picture you're painting."

"I'm afraid that human nature isn't always pretty. We are born with an evil inclination that the Torah enjoins us to curb and discipline, but most of us never recognize that challenge. We are in denial about our baser instincts and refuse to concede that we derive perverse pleasure from other people's problems. We love to gossip and refuse to realize that gossip is not an innocent, harmless pastime. Through our chatter we sow dissension and wreak havoc among our family and friends, but no matter, we just go on indulging this predilection for nastiness."

"I must admit you're right," Marcia conceded. "That's exactly what has happened in our family, but I still have a problem telling Jennifer that Monica wants peace, or vice versa, when I know it to be a lie. How can lying be countenanced?"

"Hold on," I told her. "Don't take this as blanket approval to utter falsehoods. *Emes* (truth) is one of the pillars of Judaism. Only under specific circumstances, in which the peace and harmony of family or society is at stake, does *emes* take a backseat to *shalom* (peace). Even then we are not permitted to tell an outright blatant lie but must find a way to embellish upon the truth."

"How does this apply to my cousins," Marcia wanted to know.

"Very simple. I can assure you that in their hearts, both Jennifer and Monica, just like others who are caught in altercations, regret their behavior. They may have started the controversy, but now that they are in it they feel miserable about it. It's constantly on their minds, and it gives them no respite. Of course they want to get rid of all this anger and hatred. Of course they want to make peace."

"So why don't they? What's stopping them?"

"Their egos, their pride, and the wagging tongues of others who make it difficult for them to back down. As I said earlier, when other people are involved, things have a way of getting out of control. But if you follow the teaching of Aaron, you will enable them to make peace without compromising their pride, and you will also bypass the troublemakers. Will you be lying? Absolutely not, for in their heart of hearts, both Jennifer and Monica wish for peace.

"The Talmud cites several examples in which, in the interest of peace, the telling of partial truths is permissible, and these examples must serve as role models from which we can learn when and how to speak and when to remain silent.

"For example, our tradition calls upon us to make the bride joyous at her wedding and proclaim her beauty and grace. But what if the bride is homely? What if she is really unattractive? Is it permissible to lie about her appearance?

"There were two great rabbinic schools, and they debated this very subject.

"'No,' said the House of Shamai, 'we are not permitted to tell an untruth, and therefore praise of the bride must be modified.'

"'Yes,' said the House of Hillel, 'it is perfectly valid to describe her as beautiful and splendid, and doing so does not constitute a lie, because we can assume that to every bridegroom, his bride, no matter what she looks like, is comely.' Jewish law follows the teaching of Hillel.

"This teaching has many applications. The baby you are looking at may be not at all cute, but you can sagely tell the mother that the child is adorable because in the eyes of the mother, it *is* . . . and so on.

"I will share yet another example with you—this one from the Bible: In the Book of Genesis, G-d informed Sarah, who was eighty-nine years old, that she would become the mother of a son. Astonished, she wondered at the possibility of such a miracle occurring, not only because of her own advanced age, but also because her husband Abraham was well on in years (ninety-nine).

"When G-d conveyed Sarah's concern to Abraham, however, he omitted her questioning of his ability to father a child and spoke only of her doubts concerning herself.

"Now surely Abraham would not have harbored resentment had he known the truth. He loved his wife deeply, was totally committed to her, and would certainly have understood her intent, but still G-d teaches us how very cautious we must be in conveying information so as not to cause even an iota of hurt or engender bad feelings that might jeopardize relationships.

"Was this a lie? Absolutely not. In the interest of peace, G-d just didn't tell Abraham the whole story. Can you imagine how differently things would have turned out in your own family had they followed this biblical example and not repeated to Jennifer and Monica the hurtful remarks that each had made about the other? And not only that, but you can rest assured that any one of those people who carried a story to them also took one back, adding their own pieces of juicy gossip to it.

"So why don't you try Aaron's formula on your cousins?" I challenged Marcia, "It does work, you know."

And it did! Marcia's cousins were reunited and her Chanukah party went on as scheduled.

Our sages charge each and every one of us with the responsibility of becoming a disciple of Aaron—not only to advocate and love peace but to pursue and promote it—in our families, in our communities, and then worldwide. Peace is our most precious hope. Without it, nothing has meaning, nothing is worthwhile. Not only do we have to work for peace and strive for it, but above all, we must also learn to *sacrifice* for it, and when necessary, back down. This message is impressed upon us in our daily prayers. At the conclusion of the silent meditation, we beseech G-d for the blessing of peace. Even as we pronounce those words, our tradition requires us to take three steps backward. In the end, in order to achieve peace and maintain peace, we have to be prepared to take three steps backward, forgive slights, swallow our pride, and back down. And that's the essence of commitment to peace.

Shalom—More Than Hello

Kathy, a thirty-year-old young woman, was anxious to meet someone and to get married but loathe to attend social functions.

"I hate the singles scene. I hate the parties," she confided.

"Why are you so allergic to them?" I asked.

"Oh, Rebbetzin, you have to see the events from where I stand. I could walk into a room full of people, and if I'm lucky someone who is not a total nerd will say hello, but even as he does so, his eyes are scanning the room to see if there is someone more attractive to talk to, so I stand there like a fool. And there are times when I don't even get that far. Nobody bothers to say hello, so once again I stand around, not knowing what to do with myself. And you know what I discovered, Rebbetzin? It's not just strangers who lack manners—friends and acquaintances can be equally rude.

"Just take this past Wednesday. My mother called me at work. She asked that I come over immediately. My father was complaining of chest pains, so we rushed him to the hospital. Thank G-d, it turned out alright—it was just indigestion—but the experience left me all shook up and emotionally drained. On my way home, I bumped into an old acquaintance. We greeted one another, and he asked how I was. I felt a need to talk, so I told him that I had had a real tough day, and would you believe what his response was? 'Well, I'd better get going—see you around.'

"He never heard a word I said. He never asked what I meant by a tough day. So can you blame me for being disillusioned? I don't know what's the matter with people these days. Hasn't anyone ever taught them manners—how to say hello? how to listen? They don't have a clue."

That conversation with Kathy prompted me to conduct a seminar that I called "*Shalom*—How to Say Hello."

"You shall greet everyone with a friendly and warm countenance" is the teaching of the Mishna. Now this dictum is not a theoretical concept, some pollyannalike saying. Our sages discuss it in all its practical ramifications, even going so far as to consider what to do if you dislike the person you are encountering. Are you still obligated to greet him with a smile?

Yes, is the ruling, to the point where that person should not sus-

pect from your facial expression that you are not pleased to see him. People who master such discipline, our sages teach, foster good, warm feelings and establish friendly relationships. On the other hand, the converse is also true. An angry, bitter expression generates resentment and creates hatred and the breakdown of relationships.

Our facial expressions are not our personal, private concern. Our faces are in the public domain and, one way or another, affect others. Who cannot identify with being in a great mood, surging with positive energy, only to have someone come along with a *farbissener* (Yiddish for sourpuss) face? This *farbissen* person could be a member of your family—your husband, your wife, your child—or your coworker, your boss, or your friend. Sourpusses rob you of your good feelings, sap your energy, and pull you down.

It's strange that we can all understand how it's just plain bad manners, not to mention unhealthy, to cough or sneeze in someone's face, spreading germs, yet we fail to understand that it's equally damaging, if not more so, to infect someone with our venom, our anger, our depression, and our bitter moods.

"As you can see," I would tell my seminar participants, "to greet every person with a smiling countenance is not just an empty saying but a Torah imperative. Our sages enjoined us always to be the first to extend a greeting and not wait to see what the other party will do. And should it happen that the person does not return your hello, the onus of responsibility is on him or her, and he or she is to be regarded as a thief who has stolen your good feelings.

We live in a high-pressure world, and most of us have little patience for such niceties. We rationalize that *busy people* are just too involved to pay attention to greetings, but in the Torah world, just the opposite holds true. The greater the man, the more careful he is to greet each and every person with graciousness and warmth, and my father and husband were living examples of this. This teaching was so much a part of my family that I remember my younger brother, Binyamin, at the age of two putting on my father's rabbinic hat and extending his hand to everyone with *"Shalom aleichem."*

My father's commitment to greeting every individual did not diminish with the years, but its far-reaching consequences were first brought home to me when one summer I took a position lecturing at a Catskill resort. Our children were small—too young to send to camp

but prime candidates for a country vacation. Not being able to afford a summer house, lecturing at a hotel seemed an ideal solution. Additionally, I was thrilled when the owner of the hotel kindly consented to having my parents join us for weekends, enabling them to escape the merciless heat of the city. So it was that every Sabbath was a wonderful experience, with our entire family seated around the table.

After every meal (depending upon the location of our table), it took us an hour or more to wend our way out of the dining room. My father would stop to greet every guest we passed and inquire not only about the welfare of each but about their aunts and uncles as well. And if we encountered children en route, as if by magic my father would produce some candies and lollipops from his pocket.

One Sabbath a newly arrived guest who was seated at our table walked with us as we left the dining room. Amazed at the many greetings my father extended, he tried to hint ever so gently, and I must say, most respectfully, that my father try to spare himself the burden of greeting so many people.

"Burden?" my father repeated. "Burden? G-d forbid! It's a great *mitzvah*, a privilege, to acknowledge every person. *Shalom* is not just 'hello,' but it is one of the names of G-d, so when we greet someone, we impart G-d's blessing to them." And with that, my father proceeded to explain to this man the various meanings of the word *shalom*.

"The simple translation is 'peace,' but the root word is *shaleim*— 'whole,' teaching us that when we greet someone, we have a responsibility to make them feel special and complete, so you can't just say a cursory hello, but you must focus on the person, convey your interest, ask about his or her welfare, and through your smile indicate that you really care. Such greetings make people feel better about themselves, and therefore more at peace.

"It is written in the Talmud: 'One who shows the white of his teeth does more for him than if he would have given him a drink of milk,' reminding us of the importance of giving emotional support and love. And to illustrate," my father said, "you have only to imagine a baby who is nourished with good white milk but never sees a smile—the white of someone's teeth. How will such a baby develop? How will such a baby fare? The best milk in the world cannot compensate for that deprivation."

"I can't argue with that, Rabbi," the man said. "I take it all back!"

The far-reaching impact of my father's greeting was brought home to me when I met a physician who told me that he had worked summers at that hotel. "I wasn't particularly observant or interested in Judaism at that time," he confided. "I took the job because I needed the money. But I got more than money working there, Rebbetzin. Your father touched me right here," he said, pointing to his heart. "I would be cleaning off the tables, and believe me, not too many of the guests so much as bothered to look at me, but your father always stopped to greet me, to find out how I was, to ask about my family, my plans for the future. Your father's warmth and love inspired me, and if today I am an observant Jew, it's largely because of him."

With the passage of time, my father's health deteriorated, and my parents could no longer join us in the country. As often as we could, we would send our two older children, Yisroel and Chaya Sora, to them, ostensibly to help them out but in reality to offer our children the opportunity to bask in my parents' presence and glean from their wisdom.

During the High Holy Days, my son Yisroel had a special task—to escort my father as he made his way back and forth between two synagogues—one in which he conducted services and the other in which my brother did. You might, of course, wonder why it was necessary for my father to visit there as well. It was simply to say shalom and greet everyone.

Now there was a shortcut from my parents' home to the second synagogue, and Yisroel tried to prevail upon his grandfather to take the shorter route, but my father wouldn't give in. "How can I do that, my child? Think of all the people on the street I would miss saying *shalom aleichem* to."

And so, slowly and laboriously, my father and Yisroel would make their way, stopping a thousand and one times to greet everyone. Many years have passed, but those walks remain etched on Yisroel's memory. Today he tells the story to his children and teaches them to say shalom.

My husband, whose kindness and love knew no bounds, was equally committed to this tradition. His greeting encompassed the mailman, the bank clerk, the sanitation man, the doorman—every-

one he encountered. Long after my father had departed from this world, when we returned to the hotel during the summer months, my husband, always with a grandchild in his arms, would continue my father's tradition and go from table to table, greeting everyone. This desire to bless others with shalom was so embedded in his soul that even in his final days of illness at Sloan Kettering, as he walked slowly and painfully through the hospital corridors, even there he would stop, and despite his suffering, greet everyone he encountered with a loving, warm shalom.

During *shiva*, literally thousands of people came to visit. Among them was a young couple who momentarily I had difficulty placing until they reminded me that they had been guests at the hotel. Then the whole scene came back to me. They were different from the other vacationers. They sat by themselves at a little table in a corner. The other guests ignored them and passed them by, but my husband not only stopped to greet them, he felt their need, and so he would sit down at their table to converse, to impart words of Torah, and to make them feel wanted and loved.

"There is no way we can tell you what the Rabbi meant to us," they told me. "Although we live out of state, when we heard that he had passed away, we had to come."

To think that just through words you can make a person feel better about himself is awesome. It's such an easy way to help someone. And it's regrettable that so few take advantage of it. Think about it—just one kind word can make a difference in someone's life. No special education or training is required. The only prerequisite is a little commitment and love in your heart.

But Who Wins?

The prophet Jeremiah proclaimed, "Shalom, shalom—peace, peace, and yet there is no peace." Everybody desires peace. Even warring nations will protest, and sincerely so, that they seek only peace, and yet, as the prophet proclaims, there is no peace. Peace eludes us on a national as well as on a domestic level, and yet we fervently aspire to it. Why then do we have so much difficulty realizing it?

There is a story about a butcher in a *shtetel* who came to the rabbi with a question in regard to the kosher status of his cow. In Europe, for a butcher, such a question was no simple matter. If the rabbi judged the cow to be non-kosher, the monetary loss could put the butcher out of business. To his credit, when the rabbi declared the cow to be non-kosher, the butcher accepted his decision without a murmur.

A few months later, this same butcher found himself in a dispute with one of his neighbors. There was no comparison between his present situation and the previous one, for the controversy was over an inconsequential sum of money that would not affect his lifestyle one way or another. The rabbi heard out both litigants and ruled in favor of the butcher's neighbor.

Once again the butcher was the loser, but this time he became livid with rage and refused to accept the rabbi's decision. People in the community were astonished. How could it be? A few months previously, this same man had accepted the rabbi's judgment with grace and equanimity, although it meant an astronomical loss, but now, for a mere pittance, he seethed with anger. No one could understand it, so they asked the rabbi for an explanation.

The rabbi smiled sadly. "Herein lies the reason why people have such difficulty making peace," he said. "When the butcher lost his cow, although it was a terrible financial blow, no one won, but in this case, although the loss was negligible, his *neighbor* won, and that the butcher couldn't bear. Very often in altercations people delude themselves into believing that there are real issues and principles at stake, but most often it's all a matter of egos and personalities, and the entire controversy can be reduced to one question: Who wins?"

Those of us who are active in community life accept such conflicts as the norm—the inevitable fallout from people working together.

Very few of us are willing to concede that such politics can invade our very personal relationships, even our marriages.

Gayle and Josh came to see me. They had been married just a few years and were seriously considering divorce. To all outward appearances, they were an ideal couple—good-looking and athletic, with successful careers and many friends. Prior to their marriage, they had been in a relationship for more than two years and were confident that they knew everything there was to know about each other and that they would make it. No sooner did they tie the knot than their marriage fell apart. They had consulted marriage counselors and therapists, and now, as a last resort, they came to see me.

"So who will begin?" I asked.

"Please," Josh turned to Gayle with a wave of his hand, indicating that she should start. A little exchange ensued between them. Gayle wanted Josh to be first, but then, thinking better of it, she reached into her bag and took out a pad. "I guess I'll start," she said. "I made some notes. I don't want to forget anything," she continued, half apologetically.

"That's good," I said. "It's very important to be organized."

She scrutinized her notes, took a deep breath, and said, "I think the main problem we are having is that everything has to be Josh's way, from little things, like raising and lowering the air-conditioning, to more important things, like who we should socialize with or where we should go on vacation. It's always a hassle, and it always has to be his way."

"That's not true," Josh interrupted. "If I don't agree with Gayle, she becomes hysterical, accuses me of not loving her, curses, cries, and gets totally out of control."

"If I curse, it's only because you get me so angry, and it's true, if you really loved me you would try to be more understanding. Rebbetzin, shouldn't a husband want to please his wife? I mean, what was the point of my getting married if my husband doesn't give me the love I need? For all that, I could have remained single."

"Love," I answered, "is not a scorecard on which one tallies what he or she is doing for me. The Torah definition of love is based on the Hebrew word *ahava*, which is derived from the root word *hav*—'to give.' If you would learn to love each other the Torah way, the question of who is getting his or her way would never come up. You'd just be happy to please one another."

"I always thought marriage was supposed to be a fifty—fifty partnership," Gayle protested.

"Maybe in marriage manuals," I said, "but not in real life."

"Why not?"

"Because it doesn't work—you'd have to hire a live-in accountant to keep a tally of who gave what, when, and how much."

"Well, what *does* work?"

"Giving all you've got, giving above and beyond."

Gayle gave a bitter laugh. "In our marriage, that would be a one-way street."

"That's not true, Gayle," Josh interrupted. "Didn't you have your way on our last vacation? Didn't we go to Bermuda instead of to Aspen?"

"Big deal! That was on one occasion. But how about the time I went with you to visit your aunt? When I asked you to come with me to Marilyn's party, you refused."

"That was different. Going to my aunt was an obligation. She'd been sick and we had to visit her."

"That's not the point at all!"

"Then what *is* the point?"

"That you always have to have it your way. And you always come up with some reason to prove that you are right."

"I'm sorry I don't have a tape recorder," I said, "because if you could hear yourselves you would realize why the fifty-fifty partnership can't work. Gayle, you don't need a better reason to visit Josh's aunt than that it would please Josh. And Josh, you don't need a better reason to go to the party than that it means a lot to Gayle that you do so. If a marriage is to work, you cannot ask whose turn it is to get his or her way. Rather, you will want to ask, 'How can I bring pleasure to my spouse?'"

I told Gayle and Josh that their problem was one that affects many young couples who've been led to believe that in a good marriage, two people should become one. Difficulty sets in, however, when each of the spouses thinks that he or she is the one that the other should become, and so, very often, conflicts develop that are just smokescreens for "Who wins?"

"That's exactly it, Rebbetzin," Gayle said. "Josh always has to win."

"It's just the opposite," Josh interrupted. "It's Gayle who always

has to have her way, and if she doesn't, she becomes totally unreasonable."

"When Josh upsets me, I have to express my feelings, and if I use strong language, so what? I feel relieved. It's cathartic. After all, we're not living in the dark ages."

"Rebbetzin, I can't take the cursing. It turns me off. It makes me mad."

"Josh, instead of telling Gayle, 'It makes me mad,' you would be better served if you said, 'It makes me sad.' It's a much more effective way of communicating."

"I don't see much difference," Josh said.

"There is an enormous difference. When you say that you are mad at someone, Josh, you are declaring war. People who are mad at one another stop communicating. They sever relationships, and I'm certain that that's not your intent. On the other hand, when you say, 'I'm saddened by your words or actions,' you convey that you are not pleased by what is happening but at the same time you still care, you want the relationship to continue."

As Josh was absorbing my words, I turned to Gayle. "It's not the Dark Ages that declared cursing wrong but the Torah. Speech is a sacred gift from G-d. It distinguishes us humans from all other creatures. Words are powerful. Even as they can uplift and inspire, they can degrade and destroy."

"But it helps me to relieve my tensions," Gayle protested. "I think it's important to let go and not keep everything all pent up."

"Yes it is, Gayle," I answered, "and the Torah advocates just that, but the Torah enjoins us to communicate our thoughts and feelings in a soft, calm voice, never with vituperation and anger. When you yell and curse, people tune you out, and in their minds they say, 'There she goes again.' Still worse, they come to resent and dislike you. So you see, Gayle, even if momentarily you may feel that cursing relieves your tensions, in the long run it has just the opposite effect. The more you give in to your anger, the more your anger will take hold of you, filling your mind, your heart, and every nook and cranny of your life with venom."

"But everyone curses today," Gayle continued to protest.

"Not everyone, but even if they did, that wouldn't make it right. We have a higher law that defines for us what is right and what is

wrong, and that is the law of G-d. If you would submit to His teachings, this 'war game' of 'who wins' would be over."

"Is the Torah really against cursing?"

"So much so, Gayle, that we are not even permitted to curse a deaf man (Leviticus 19:14), and if that's the case in regard to someone who can't hear, can you imagine how the Torah views cursing in the presence of a person who *can* hear?"

I went on to explain to Gayle that in the Hebrew language, in which G-d proclaimed the commandments, there are no curse words.

"So how do people in Israel curse?" Gayle said, half jokingly.

"Let's hope they don't, but those who do must borrow from other languages. The Torah admonishes us time and again to be careful about the words that emanate from our lips—so much so that in describing the animals that Noah was to take into the ark, *not clean* is substituted for the word *impure*.

"Frankly Rebbetzin, I don't see any difference," Gayle interjected.

"Do you see a difference between calling someone not beautiful rather than ugly," I asked.

"There are many ways in which we can express ourselves, and the Torah teaches us to choose the most positive expressions and to shun the negative ones. Now if this be the case with what we consider to be perfectly proper words, can you imagine how curse words are regarded by the Torah? And the problem is exacerbated by the fact that cursing inhibits our ability to connect with G-d and pray."

"I don't understand that."

"Well, think about it, Gayle. If your lips are defiled by curses, how can you expect to use them for prayer? It's like trying to make a phone call with a faulty instrument."

"But I don't pray. I'm not religious," Gayle protested.

"You may not be observant, but you *are* religious. Everyone is. Everyone's soul yearns to pray and connect with its source, with the Almighty G-d."

"I don't feel it."

"Just because you don't feel it, Gayle, doesn't mean you don't need it. If you were able to make that connection with G-d, you'd be more peaceful. You wouldn't have all this terrible turmoil in your heart, consuming you day and night."

"Don't you think I want peace? Don't you think I'm suffering?" Gayle said, trying to hold back her tears.

"I know you are, sweetheart, I know you are, and that is precisely why I'm trying to help you and Josh. If you are to find healing for your pain, you will need G-d's help and guidance, and precisely because of that, you can't afford to have a 'defective instrument' when you pray. As I said before, you can't invoke the name of G-d with the same lips with which you curse.

"G-d created the world through the power of speech," I went on to explain to Gayle. "This is very difficult for us to conceptualize, but suffice it to say that the Bible teaches that the world came into being through ten different expressions of G-d. For example, 'And G-d said, "Let there be light."' Though we cannot know how this process took place, we *do* know that words are powerful, that even on our human level they can create certain energies. Loving, kind words create a loving, kind atmosphere, and curse words create a mean, hostile environment. You are yearning for peace, Gayle, but unknowingly you are militating against it, creating your own hell. It's a sad fact of life, but 'Curses curse their utterers' (Leviticus, Midrash). Unwittingly you are choreographing your own problems.

"One day, Gayle, you will want to have a family. Do you want your children to hear foul language from your lips? Do you want your home to be a place where shouts and curses are daily fare? And should you argue that you wouldn't curse in front of your children, you know that you're kidding yourself. You just can't turn it on and off like that. No one can.

"Start training now. When you get upset, don't answer right away. Do something to calm yourself. Go into another room. Wash your face. Ask G-d to help you, and make yourself a promise that no matter what, you will not resort to gutter language. At first it will be difficult, but eventually you'll succeed, and by the time your children come, you'll be ready for them.

"You see, this is not about who wins, but rather about what is the truth, what does the Torah say? And if it means admitting that you were wrong, then thank G-d that you can do so now, before you destroy yourself and your marriage."

I explained to Gayle and Josh the teaching of our sages from the

Mishna. "'Who is wise?' they ask. And they answer, 'He who can fore-see the future.' Now obviously, the sages were not referring to prophets who could predict events, but rather to those wise people who, before acting or speaking, stop to consider the consequences of their words and actions. You were contemplating divorce. Let's consider for a moment what would happen if you actually took that drastic step.

"So now you are divorced. You went through the whole painful process, and you start socializing again. Imagine, Gayle, that you are at a singles party, and you look around, and there is just no one that you can relate to. Your heart sinks. You have this sick feeling in the pit of your stomach, and you have second thoughts about your divorce. And then someone points out Josh's double to you. He is handsome, successful—you flip! But then they tell you that he has a 'thing' about women cursing and that he always likes to have his way. You know what you'd answer? You'd say, 'It's OK. I can handle it. Let me just meet him.'

"Now let's play it your way, Josh. You're at the same party. You are also overcome by this terrible feeling of frustration, and you wonder what the whole thing is about. You're ready to leave, but then your eye catches this beautiful girl who could be Gayle's double. She's everything you ever dreamed of. But then they tell you that there's a hitch. Gayle has a short fuse and can really lose herself. You know what you would say? 'It's OK. I can handle it.' And the truth of the matter is that you can *both* handle it. You found each other. You are married. You just have to turn to G-d, seek His help, and He will guide you. It's a pity to destroy the happiness that could be yours."

I taught Gayle and Josh the meaning of *shalom bayis*, Hebrew for "peace and harmony in the home," which is the ultimate goal for every married couple to strive for. "To keep your focus," I told them, "just look at the mezuzah [parchment placed on the doorpost with the Name of G-d and the basic tenets of our faith written on it]. It will remind you how you are to live your lives. There were two opin-ions as to how to place the mezuzah—vertically or horizontally. To resolve this conflict, a compromise was made, and the mezuzah is placed on a slant, reminding husband and wife that in a successful marriage, it's not 'I win' or 'I have to have it my way' that counts, but rather, we have to bend to a higher law. We have to bend to a higher wisdom, a wisdom that comes from Sinai, from G-d Himself."

In the secular world, love is the ultimate goal to strive for in marriage, but in the Torah world, that higher law advocates that *shalom bayis* come first, teaching us that it is only in an atmosphere of peace that love can flourish and grow. If *shalom bayis* is a goal in and of itself, then no matter what the provocation (and in marriage there are many), both spouses will try to retain their equilibrium and commit to it. But in relationships where love is the be-all and end-all, as soon as one of the partners feels that his or her needs are not being met, they also assume that their love has waned and their marriage has no future. I pointed out to Gayle and Josh that *shalom bayis* is not an idyllic state. It must be worked on and sacrificed for.

It took many discussions, but they came to understand that decision-making in a marriage has nothing to do with winning or losing, that if you live by Torah standards, both husband and wife automatically win, and *shalom bayis* can become a reality.

ॐ 6

Prayer

*"G-d is near to all who call upon Him, to all
who call upon Him in truth."*

—Psalm 145

Storming the Heavens

My mornings always commence with prayer . . . and then come the phone calls. First I call my mom to find out how her night went, and one by one, my children check in with me.

On this particular morning it began with my younger daughter Slovi.

"Ema," she said, her voice full of excitement, "I have some great news for you. You're going to be a *bubbie* again!"

My heart sang with joy. With G-d's help, this would be Slovi's first child. Though the arrival of every baby is always exciting, there is something special about the first.

I immediately volunteered to accompany her on her first visit to the doctor. He had delivered some of our other grandchildren, and over the years we had come to trust him.

Mother-daughter expeditions are always fun and very meaningful, but a visit to an obstetrician to confirm a pregnancy is especially so. We set out in high spirits, planning to go for a celebratory lunch afterward.

As always, the doctor's office was full, but this was one occasion on which I didn't mind waiting. Finally it was Slovi's turn. I sat back relaxed, waiting for the good news to become official. After a while I became uneasy. It seemed to me that she was in the examining room for an inordinate amount of time. I consoled myself with the thought that often you sit on that table just waiting, while the doctor goes from patient to patient. Finally the door opened, and the doctor appeared.

"Congratulations, Slovi is pregnant," he said.

I sensed something guarded in his announcement. It must be my imagination, I told myself. He's probably just stressed out. Maybe he was up all night with a delivery. Stop reading into things.

"I think it would be best if you came into my office. We have to talk," he now said.

My heart began to pound with apprehension. My intuition was right. Oh G-d, something is wrong!

"I'm sorry to tell you this," he said, as he settled into his chair, "but it looks like we have a problem."

I couldn't respond. I couldn't find my voice. I just sat there frozen with fear.

"Slovi has a lump in her throat," he continued. "I think it should be looked at immediately by an oncological surgeon. Do you have someone you would like to take her to?"

Do I have an oncological surgeon to whom I would like to take my daughter? He must be kidding. Slovi is twenty-one years old. Who takes a twenty-one-year-old girl to an oncological surgeon? I felt as if I had been hit with a ton of bricks. I had difficulty breathing. This must be a nightmare—it cannot be true.

The doctor's voice forced me back to reality. "I really don't think you can afford to wait with this. If you wish, I will try to make an immediate appointment with Dr. ___. He's a very fine surgeon. If he's available, I think you should go right over."

Numbly, I nodded my head. I watched him dial. I heard him describe the case to his colleague, and I felt sicker by the moment. He handed me a piece of paper. "This is the address. Dr. ___ is waiting for you. You're very lucky that he can see you immediately."

I looked at him in disbelief. Lucky! I thought to myself. The irony of his words jarred.

In the interim, Slovi had emerged from the examining room, white as a ghost, her eyes brimming with tears. We tried to be brave for each other's sake.

"The whole thing is nonsense"—I tried to sound reassuring— "but if he wants you to see this doctor, we'll go. Big deal!"

Slovi just nodded her head, not trusting herself to speak.

"Let me call Abba," I said, "and tell him that I'll be late."

"I'll call Mendy" (her husband), Slovi said in a tearful voice.

I called not only my husband but my father as well. As soon as I heard their voices, all the floodgates opened. Through my sobs, I told them what had happened. "You have to storm the heavens with your prayers," I cried. "Go to the synagogue. Open the ark. We need a miracle."

It felt good to talk to them. They gave me strength. Their faith infused me with courage, and more than ever before I understood how important it is that in times of crisis, when everything around you seems to collapse, there be someone to give you hope, someone who will say with confidence, "It's going to be alright. G-d will help."

That reassurance means everything, but sadly, so few know how to impart it.

Mendy, my husband, and my parents all wanted to meet us at the doctor's office, but we told them that it would make no sense. We were just a few minutes away. By the time they arrived, we would be finished.

During the short drive to the oncologist, we were mostly silent, lost in our thoughts. And then Slovi turned to me and said, "I am sure that with G-d's help everything will be alright. I just don't know why this had to happen to me."

Before I could even respond, Slovi answered her own question. "I know, I know . . . sometimes *HaShem* [G-d] gives us a scare to bring us closer to Him, but why couldn't He bring me closer in a different way?"

Coming close to *HaShem* has never been easy. Our patriarchs, our matriarchs, who were spiritual giants, underwent many trials and tribulations. G-d promised them that their children would be as numerous as the stars in the heavens and as the dust of the earth, and yet, for many long years, they were denied the gift of children. Their disciples, their neighbors, their friends were all having children without difficulty, but they had to beg, supplicate, and weep. Only when their hearts were saturated with prayer did G-d grant them their wishes. The Torah teaches us that true prayer is the "labor of the heart." It is only when we pray from the depths of our beings that our prayers can awaken our hearts to the call of G-d.

Chana, who was childless, prayed in this manner. Her intensity was so overwhelming that Eli, the High Priest, couldn't comprehend it and momentarily mistook her for a drunkard.

I shared these thoughts with Slovi and said, "If these giants couldn't come close to G-d without pain, what can you and I hope for? We need only follow their example, pray with all our hearts and not give up. That's what Psalm 27 is all about: 'Trust in the L-rd. . . . Strengthen your heart. . . . Trust in the L-rd,' meaning pray to G-d, and if initially He doesn't answer you, be strong, persevere, and pray again."

And so, as we pulled up to the doctor's office, we were determined to fight by using the most awesome power in the world—prayer.

When we entered the office, some people in the waiting room recognized me. "Oh, Rebbetzin," a woman said, "I read your column

every week in *The Jewish Press* and I watch you on TV. I'm so sorry—I didn't know that you were sick, but thank G-d you have a beautiful young daughter to give you support."

Her words fell like salt on an open wound, and I was reminded of the wisdom of our teaching—"Life and death are in the tongue." Why can't people learn to keep quiet, I wondered.

The nurse now called us in.

"I understand that you are pregnant and have a lump in your throat," the doctor said matter-of-factly.

What does he expect us to answer to that, I wondered. He examined Slovi carefully, looked into her throat, palpated the lump, and recommended surgery as soon as possible.

"How will this affect my pregnancy?" Slovi asked in a voice that was hardly audible.

"Our first concern is to save your life," he said in a clinical voice.

Why can't he be a little more kind, a little more compassionate, I asked myself.

"Could it be possible that it's something else?" I asked.

"I'm afraid not," he said. But he must have reconsidered, for a few moments later he asked if Slovi had been exposed to any illness.

"Yes, some weeks ago I spent time with my nephew who has mono," Slovi volunteered.

"Well, it's a long shot, but let's do some blood work."

I never thought I would pray for mono, but there I was, begging G-d that it would be just that.

And now came the waiting period—long, agonizing days, during which time our entire family went to battle. We prayed and prayed and then prayed some more. We applied the time-tested formula of our faith: "Repentance, prayer, and charity cancel the evil decree." We took on additional *mitzvos* (commandments), intensified our Torah study, the Book of Psalms became our constant companion, and we gave *tzedukah* (charity). And all the while, our normal daily routines had to continue.

I usually spend most of my day teaching, listening to people unburden themselves, guiding them, counseling them, writing, and preparing my lectures and television program. I was listening to a young woman relate her story when my private phone line rang. It was the doctor.

"Well, Rebbetzin Jungreis, I just spoke to your daughter and I have good news and bad news. The good news is that she *does* have

mono, but the bad news is that mono, in the first trimester, can be very dangerous to the fetus, and the chances of her having a healthy child are minimal."

I felt as though we had gone from the frying pan into the fire.

"I think you should take your daughter to a hematologist," that clinical voice at the other end of the wire went on. "I am quite sure that he will concur with my diagnosis."

"What diagnosis?" I asked dumbfounded.

"At this stage of pregnancy, it's really a simple procedure to abort the fetus. She could go in as an outpatient and return home the same day."

The words *procedure* and *fetus* were such comfortable euphemisms for destroying a life. I had heard enough. I wanted to put an end to this conversation, so I thanked him for his efforts and explained that to us, life was precious, and abortion was simply not an option.

To be sure, there are exceptional circumstances under which abortion can be justified, but that has to be determined by rabbinic authorities and not by individuals, no matter how well intentioned.

So now we entered phase two of our agony—the hematologist.

As we made our way to his office, I reminded myself of the story of a man in our community who was asked what his hobbies were.

"Going to doctors," he replied.

At that time I thought that he was being witty, but now his words took on a different meaning. Slovi and I were emotionally drained and "doctored out."

As expected, the hematologist concurred with the oncologist's recommendation. When we told him that we would not consider abortion, he was visibly annoyed. "I can't understand why you would take a chance like this," he said to Slovi. "You are young. You can have many other children without this risk."

But Slovi would not be budged. She let him know that she would do everything humanly possible to preserve the life of her baby.

Seeing that he could not prevail upon her, he tried to convince me. "Rebbetzin, perhaps you can talk some sense into Slovi. I'm really concerned for her."

But I just reiterated Slovi's stance.

Realizing that we would not be swayed, he sent a strongly worded letter to the obstetrician stating that he wanted it on record

that he unequivocally recommended the termination of this pregnancy, and since we were not prepared to act upon his advice, he was formally disassociating himself from the case.

Every time Slovi went for her monthly checkup and was taken into the examining room to wait for the doctor, her chart lay on an adjacent countertop, and there, staring her in the face, was the letter from the hematologist. This went on for nine long, torturous months.

Slovi made a promise that she would name her child for my brother-in-law of blessed memory, Rabbi Moshe Nossen HaLevi Jungreis, a great Torah sage who was killed in Auschwitz sanctifying the name of G-d.

The birth of a child is the most awesome experience that any mother or father can have. When you see that precious new life emerge from the womb, you are witness to an open miracle of G-d. For Slovi and Mendy, this miracle was multiplied tenfold. As Slovi held her perfect son in her arms for the first time, she counted every little finger, every little toe. She was overcome by feelings of thanksgiving. Her heart burst with joy and gratitude to G-d. She wanted to shout from the rooftops and sing praise to the Almighty.

> I love the L-rd, for He hears my supplications.
> Because He has inclined His ear to me, I will call upon Him
> as long as I live.
> —*Psalm 116*

Nurtured by prayer in his mother's womb for nine long months, Moshe Nossen today follows in the footsteps of his illustrious forebear.

> Give thanks to the L-rd for He is good . . .
> —*Psalm 118*

Sometimes the Answer Is No

If there is any one man who was able to effect miracles with his prayers, it was my husband. I could fill volumes with the many stories of how his prayers brought blessing and healing to countless people. Even as I write these lines, I can see him in my mind's eye. Enveloped in his beautiful *tallit* (prayer shawl), he would concentrate with such intensity on the name of the person needing help and pronounce each word of his prayers with such awesome fervor that you just knew that the Heavenly Gates would open for him.

And indeed, his prayers were always answered. As the rabbi of a congregation, chaplain of the police department, and a well-known and revered leader of the Jewish community, people came to him from every walk of life with all kinds of crises. From business and family problems to terminal illnesses, he helped all of them. The miracles always took place.

I remember when five-year-old Andy was in the hospital in a deep coma. Every day my husband would visit him and pray, but the boy did not respond. Some members of the hospital staff tried to convince him that the child was not aware of his presence and could not hear his prayers, but that did not deter my husband. He would sit patiently at the child's bedside reciting psalms, beseeching G-d to have mercy on this sweet little innocent soul.

Then one day, most unexpectedly, while my husband was praying and the members of the immediate family were gathered in the room, the miracle occurred. Andy opened his eyes. He looked around and smiled at my husband. His first words were directed to him: "Rabbi, don't you ever get tired of praying?" he asked.

"No, my child," my husband answered, tears of joy filling his eyes. "We are never permitted to get tired of praying. Prayer is the greatest gift G-d gave us."

No, my husband never got tired of praying, but when it came to his own illness, when deadly cancer consumed his body, he could not accomplish for himself what he did for others.

My husband's life was hanging by a thread. The prognosis was bleak. We prayed, we gave charity, we intensified our commitment to G-d and to His Torah, but with each passing day his condition deteriorated further.

In a final desperate effort, we came up with a strategy. Our oldest son, Rabbi Yisroel, would go to Hungary, the country where our grandfathers had been rabbis and heads of yeshivas for many generations. Although most of our family had been murdered in Auschwitz, the graves of our great and great-great grandfathers could still be found in the villages and cities where they had been spiritual leaders and loving, loyal shepherds of their flocks. Our plan called for Yisroel to visit these grave sites and pray there in the hope that our ancestors would intercede in front of G-d's holy throne in this terrible time of sorrow for our family.

This was by no means a simple undertaking. The Jewish cemeteries were abandoned and overrun by weeds and brambles. Anti-Semitic hoodlums had overturned and destroyed many tombstones, so finding the graves would be an almost insurmountable task. Moreover, it was January, and Hungarian winters are bitter and cold. Yisroel would have just two days to go from one end of the country to the other to find the grave sites. And to complicate matters, he didn't speak or understand a word of Hungarian.

Our younger son, Rabbi Osher Anshil, enlisted the yeshivas, rabbinic schools, and synagogues here in the United States to recite special prayers for his father's recovery. In keeping with the tradition of adding a new name to that of someone who is critically ill, he gave an additional name to his father.

Our son-in-law Mendy traveled to Israel seeking the blessings of all the sages and visiting the grave sites of the holy people who are buried there.

Our son-in-law Shlomo made special prayer sessions every night at my husband's bedside.

Our daughters, Chaya Sora and Slovi, and daughters-in-law, Rivki and Yaffa, organized women's prayer groups, which are meeting to this very day in Slovi's home, to recite psalms.

We did everything humanly possible. We pulled out all the stops, and miraculously, each of our children accomplished what they had set out to do. Yisroel found a driver who, despite the snow-covered icy roads, managed in two days to travel from one end of Hungary to the other, and incredibly, in every hamlet, in every village, in every city, he found the graves. For two days, he literally did not sleep. He just poured out his heart on this foreign soil, which was so alien to him.

Despite all these herculean eforts, the angel of death insistently pounded away and visited my husband's room at Sloan Kettering at the end of January.

Were all those prayers in vain? Why didn't G-d answer us?

While all this was happening, in the midst of my husband's suffering, I didn't quite understand, but I have since thought a great deal about this entire incident. The biblical teachings regarding the last days of Moses gave me some insight.

Throughout his life, Moses prayed for his people. Never did he make a request for himself, but when G-d told him that his final day was quickly approaching, for the first time in his life, he pronounced a prayer on his own behalf. He begged G-d to allow him to enter the promised land so that he might behold its sanctity. Moses prayed 515 different ways. He wouldn't give up. He prayed and prayed again, but his prayers could not change the Heavenly decree. So it appeared as if G-d's answer was no, but then again, how could that be? Is it not written that "G-d fulfills the desire of those who revere Him. He hears their cry and saves them" (Psalm 145:19)?

How do we resolve this puzzle?

In essence, G-d did say yes to Moses but perhaps not in the way that Moses would have wished. Moses wanted to see the promised land, Jerusalem, the Temple; he wanted to see his people settled on their own soil. So G-d told Moses to ascend the mountaintop, and there He showed him not only the holy land but the entire history of our people until the day of the coming of Messiah. So in a sense Moses' prayers were answered, and perhaps in a sense G-d answered our prayers as well.

G-d is not a waiter to whom you give orders. Yes, we can beseech, we can request, we can pray, but the ultimate decision as to how He will fulfill our request lies with Him.

This past year, for the first time, our Hineni organization held High Holiday services. These services were conducted by my children. They were the most spectacular and inspirational services that I or for that matter anyone else who participated had ever experienced. They touched the hearts and souls of everyone. One young man described it as a "spiritual explosion that made his heart feel twice its size and his soul totally at peace."

As I sat there praying, watching my children, listening to them

quote their father's teachings, it occurred to me that G-d had indeed hearkened to our prayers. We had prayed that my husband might live, and through our children he was more alive than ever before. They have taken on his mission. They are following in his footsteps and imparting his teachings.

Those prayers that emanated from their innermost hearts as their father wrestled with death expanded their souls and transformed them into great spiritual teachers who inspire and serve their people, bringing them closer to G-d, even as their father had done.

Indeed, that is the true meaning of the Kaddish prayer. Contrary to what most people believe, Kaddish is not a prayer for the dead but a pledge to continue the legacy of our ancestors, to sanctify and glorify G-d's holy name, to live for the Almighty even as our forefathers did.

At one time or another, everyone has to meet his or her Maker, and when that time comes, it's never convenient. No one ever feels that he has accomplished all he set out to do on this earth, and that adds to the intensity of pain that comes with death. But if you have children or grandchildren who will continue where you left off, then you did fulfill your mission, and then you live on. My husband, I truly believe, lives on.

We all must return our souls to our Creator, but whether our souls are returned in empty solitude or on the wings of prayer will make all the difference. Not only did my children and untold others pray on behalf of my husband, but he himself prayed as no one else could have. As the end drew near, he actually shed his physical self and became a totally spiritual being through prayer.

> The soul that You gave me, G-d, is pure. You have created it, You have formed it, You have breathed it into me. You pre-serve it within me, You will take it from me and restore it to me in the hereafter.
>
> —*Talmud*

How you return that soul is what counts. So, no, those prayers were not in vain. They purified and elevated us here on earth, and they enabled my husband to enter the Heavenly Gates in holiness and sanctity.

JUST GIVE ME A CALL ONCE IN A WHILE

Harry Morgan was a high-powered businessman. I didn't know him personally, but he was reputed to be tough, secular, and totally uninterested in Jewish charities. When one of our regular Torah students told me that he was friendly with Harry and that Harry wanted to speak to me, I was somewhat surprised. He was, I thought, probably the last person who would be interested in seeking my help.

Harry was a big, burly man, and when he walked into my office, his sheer physical size dominated the room.

"Rebbetzin," he announced in a booming voice, "they tell me that you can work magic with kids. Well, I have a problem with my daughter, and I want you to straighten her out.

"Denise is high-strung and anorexic. She doesn't get along with my new wife, so she moved in with her no-good boyfriend, took a job as a salesgirl in a dress shop, and cut her ties with me."

"That's a tough one," I said. "Each of the issues that you mentioned is a problem in and of itself. It reminds me of the Passover Seder song 'Dayenu' but in reverse."

He looked at me uncomprehendingly, so I explained that *dayenu* means "enough." "At the Seder we thank G-d for His many bounties, and as we enumerate each miracle that He bestowed upon us, we say, 'If He had given us just that one blessing, it would already have been enough for us to be eternally bound to Him. How much more so, then, when we consider the multiple miracles He performed.'

"Similarly, Mr. Morgan, if you consider each of the problems that you mentioned regarding your daughter—the fact that she's anorexic, that she doesn't like your wife, the fact that she moved in with this boy and severed her ties with you—each of these situations is overwhelmingly painful, and on each of them we can say *dayenu*— it's enough!"

"*Dayenu*," Harry repeated, tasting the word on his tongue. "It's *dayenu* alright. Well, will you speak to my daughter?"

"I can certainly try, but you know there are no guarantees," I said.

"That's good enough. When can you see her?"

"Let her come to my class this Thursday evening, and afterward I'll speak to her privately in my office."

"You must be kidding, Rebbetzin! There's no way she will come

here, and she will definitely never come to a class!"

"I don't know what to tell you then. I can't help her from long distance."

"Well, I thought you might walk in on her at the shop where she's working."

I looked at him and tried to find the words with which to explain why such a plan would never fly.

"Do you imagine even for a moment that I can walk in on your daughter while she is attending to customers and have a conversation about the most sensitive issues in her life? Even if I knew her well, such a scenario would not be tenable. How much more so since I am a total stranger."

"Oh, you can do it," he interrupted.

"I *could* walk in there, that's true. But to what end? I wouldn't accomplish anything. Look, Mr. Morgan, I have been doing this work for a long time. Over the years I have discovered the perfect setting for reaching people, and that is *in this office,* and *only after they attend a Torah class.*"

The look on his face told me that he was annoyed, so I tried to explain. "If a surgeon is to perform a successful procedure, he must have the proper instruments and be in the proper setting. Similarly, if I'm to reach your daughter and make her rethink her lifestyle, I have to have my tools. She must first attend a Torah class. It's not my words that work magic but the word of G-d. Once she absorbs that, then the rest of the pieces fall into place. That's how powerful Torah study is. So, Mr. Morgan, you have to find a way to bring her to me."

"There is no way that Denise is going to come here. I can't even get her to talk to me, let alone come to a class and to your office," he protested.

We had come to an impasse. As patiently as I could, I tried to tell him that I would be happy to accommodate him, but walking in on Denise was not a solution.

"There is no way I can get my daughter to come here," he said. "No way. If I call her, she hangs up on me. If I try to see her, she turns her back. Can't you just try?" he begged. "You are my last hope."

I felt sorry for him. His pain was almost palpable. This was not a man who was accustomed to begging. So against my better judgment,

I asked, "If I go, what would you have me tell her?"

"Just convince her to be in touch with me. If she doesn't want to come home, it's OK, I'll take a place for her, but she should move out of the apartment of that bum. He's no good. He's an addict. He could give her AIDS."

"Can't she move in with her mother?" I asked.

"My ex is remarried and lives in France with her new husband. Denise can't possibly go there."

As Harry Morgan spoke, it occurred to me that I was witness to a new version of the American tragedy. Here was a man who had built an empire but couldn't keep his own house together, and his daughter, probably an heiress, was living in a dingy walk-up with a junkie.

"Here's the address of the store where she works," he said insistently, interrupting my thoughts. "Tell her that she should just be in touch with me. It doesn't have be every day either, but we must be in contact. I want to know that she's alright. After all, I'm her father."

As much as I didn't think his plan would work, at this point I didn't feel comfortable about not trying.

"OK," I said. "I'll go. But in order for me to succeed, I will need a miracle, so you will have to pray for me."

For the first time, I heard him laugh.

"You have the wrong one for prayer! I'm not religious."

"Harry," I said, dropping the Mr. "Has it ever occurred to you that your Father in Heaven is saying, 'Tell him that he must be in contact with me. I want to know that he's alright. After all, I'm his Father'? That's what prayer is all about—being in contact with your Father."

For a moment, Harry was silent. "OK, you got me. I can't fight that, but like I said, I don't come from a religious background. I wouldn't know how to pray."

"You learn to pray by praying," I said.

"Even if I don't feel it? How can I pray to G-d if I don't *feel* G-d?"

"Harry, you told me that Denise is anorexic, that she just doesn't eat. If you'd ask her about it, she would tell you that she's not hungry, and she'd be telling the truth, because once you stop eating, after a while your stomach shrinks, and you don't feel a need for food anymore.

"What happened to Denise happened to your *neshama*—'soul.' Prayer, for the soul, is what food is for the body. Your soul has been starved for such a long time that it has become anorexic and no longer feels a desire to pray. But you can't live without prayer. It is a basic human need. Just watch a child—when in trouble, he or she will instinctually cry out for help. There are no atheists in foxholes, and right now, Harry, you're in a foxhole. You need G-d's intervention because that's the only way we'll reach Denise."

Harry mulled over my words.

"Let me tell you a story," I said. "Stories speak volumes. There was once a father, who set out on a trip with his son. Their journey took them through a beautiful forest, where they came upon the most luscious fruit.

"'Father,' the son said, 'allow me to get off the wagon and pick some of these delicious fruit.'

"The father agreed, but warned the son not to tarry, for they had to be on their way to reach their final destination. The boy went off to gather the fruit and soon became so absorbed that he forgot his waiting father.

"'My son, my son,' the father called urgently. 'Come back, it's getting dark.'

"But the son did not heed his father and went deeper and deeper into the forest. The father, fearing for his beloved child, cried out to him, 'My son, I see that you are not willing to listen to me. You have been captured by the allurements of this forest. I am afraid that you will get lost and not know how to find your way back to me, so I will give you lifesaving advice. When you call out, 'My father, my father,' and do not hear me respond, know that you have strayed too far and are in danger. If that happens, then run with all your might, and as you run, keep calling, 'My father, my father,' until you hear me answer, 'My son, my son!'

"It's a parable, Harry, but in this parable is the answer to your question. The reason why you don't feel G-d is because you got lost in the forest and no longer hear His voice. You have been spiritually starved for so long that you no longer crave nourishment for your soul, but if you call out, 'My Father, My Father,' slowly your soul will be nursed back to health, and with each passing day, you will come closer to G-d."

"But how will I get that feeling?"

"You have to pray for it, Harry. As strange as this may sound, you have to pray for the ability to pray. Our tradition teaches that the pious men of old would meditate one hour before prayer to prepare themselves for their audience with G-d, and they would stand for one hour following the service, taking leave of G-d.

"Don't get scared, Harry. I'm not suggesting that you do that. But prayer is the most powerful tool that we have. You have to learn to use it properly, so you should spend at least a few minutes in meditation before you commence your prayers, asking G-d to open your lips and your heart."

For what seemed to be the longest time, Harry just remained silent, and then said in a low, resolute voice, "OK, I'll give it a try."

I gave Harry a prayer book and showed him which prayers to recite morning, afternoon, and at night.

"Take it easy," Harry protested. "Aren't you supposed to pray just once a week, like on Sabbath?"

"Harry," I asked, "is it enough to eat just once a week? Remember what we just discussed. What food is for the body, prayer is for the soul. Besides, can you expect to come close to G-d by saying just a few words one day in seven? No doubt in the beginning it will be hard. You will have to make a commitment to prayer and block out time. Three times a day you will go into seclusion with G-d and call out, 'My Father, my Father,' until you hear Him respond, 'My son, My son.'

"Once you master this discipline, a great transformation will take place in your life, and miracles will start happening."

Armed with his prayer book, Harry got up to leave. He thanked me profusely. The process had already begun.

A few days later, I walked in on Denise. I picked her out immediately from the three girls behind the counter. She looked exactly like her father.

"Could you spare me a few moments? I would like to discuss something personal."

Denise looked at me suspiciously.

I introduced myself and told her, "It's about you and your father."

"There's nothing to discuss," she snapped.

"I realize that, but I have something to tell you. Your father came to see me. He wants you to know that he loves you very much and that he's worried about you."

"Give me a break," she said cynically.

"Can't we just talk about it for a minute?" I insisted.

"Look, I'm busy. I have to get back to my customers. My father and I don't get along. He may tell you he loves me, but he sure has strange ways of showing it."

"Your father is changing."

"Oh sure, what else is new?" she asked mockingly.

"Denise, look at me," I said, taking her hand in mine. "Your father is really trying. He's praying every day."

"That's the funniest thing I ever heard," she said. "He doesn't even believe in G-d."

"Denise, he *didn't* believe in G-d, but he is trying. He's really praying, and he is on his way to finding Him. Let me pick you up after work and tell you about it."

For a second she hesitated. Then she shrugged her shoulders and nodded.

Slowly we became friends. I invited her to my Torah classes, and after a while, Harry joined us for the sessions. Through Torah study, Harry and Denise found a new way of relating, and the wounds and scars left by many years of bitter fighting started to heal.

One of the Hebrew expressions for prayer is *tefilah* (to stand in judgment), for indeed, when we stand in front of G-d in prayer, we go through an introspective process of self-scrutiny, and that is the most humbling, awesome experience that we can have. The more Harry prayed, the more he came in touch with his feelings, with his spiritual self. It didn't happen overnight, but eventually the prayers worked. Harry became a different man. He discovered that it was not G-d who needed his prayers, but it was he who needed to pray.

7

Forgiveness

"He who forgives will himself be forgiven."
—TALMUD

Why Should I Make the First Move?

The ten days between Rosh Hashana and Yom Kippur are traditionally known as the Ten Days of Repentance. This is the most awesome time of the Jewish calendar year, when we are called upon to evaluate our lives and our relationship with G-d and our fellow man.

Introspection is not enough. The moment demands that our faults, our shortcomings, and our sins be rectified. The law clearly states that although G-d can forgive transgressions committed against Him, He cannot pardon injustices that we may have inflicted upon our fellow man. Before Yom Kippur, the pressure is on to make that phone call to the friend or relative with whom we no longer speak, to express appreciation to that person who rendered us a favor but whom, in the rush of things, we neglected to thank, to visit the cemeteries to ask pardon from those who are no longer here, and in general to make amends to anyone we may have offended during the course of the year. This reconciliation process is a two-way street. Not only must we reconcile with those we are no longer on good terms with, but we must also allow ourselves to be reconciled.

After having explained all the intricacies of these laws at our High Holy Day seminar, I was approached by Judy Cantor, one of the participants. She had a problem she wanted to discuss.

Judy is a high-powered, talented young divorcée who at the age of thirty-four has already been made full partner in a law firm. For her to concede that she needed help was out of character, so I was somewhat surprised when she approached me.

"Rebbetzin, how serious is this business of reconciliation before Yom Kippur?"

"Very serious, Judy."

"Well, there is something I would like to have your input on. Eight years ago, my mother died. She had been ill for a long time and lived with my sister. I couldn't take care of her because I was having problems in my marriage. There was no way that my ex would have tolerated her presence.

"Unbeknownst to me, my sister pulled a fast one. She persuaded my mother to appoint her executor of her estate and convinced my mother to leave the greater part of the assets to her. When the will was probated after her death, and the news came out, I confronted

my sister. She tried to play Miss Innocent, protesting that it was all Mom's idea, but of course she couldn't fool me. I took legal action, and there was a court settlement. We haven't spoken since."

"Was the suit settled to your satisfaction?"

"No, but it was settled. Don't get me wrong, Rebbetzin, this is not about money. I made it on my own. I don't need anything from anyone. It's the principle of the thing. My sister was always a user, and her husband is the same. He has gone into several businesses and couldn't make a go of any of them, so they decided to become rich by taking advantage of my mother and stealing my rightful inheritance. And as if this weren't enough, they had the audacity to turn it all around and accuse me of being mercenary because I took legal action against them!"

"Are you satisfied in your heart that you did the right thing?"

"What are you trying to say, Rebbetzin?" Judy's eyes flashed with anger.

"Nothing beyond what I said. I only wish that you had thought this out more carefully."

"Well, I did think it out, and I came to the conclusion that I had no other options."

"In that case, I'm sorry that you didn't have the benefit of advice from someone with a Torah background, for it's not the Torah way for sister to sue sister."

"Well, how else could I have resolved this?" Judy asked indignantly.

"There are many things you could have done before taking such a drastic step. You could have talked with each other, you could have tried to work things out, and if all attempts at reconciliation failed, you could have asked a Torah authority to mediate. But that's all in the past, Judy, and the only reason why I brought it up is so that you can try to do what is 'Torah correct' now. But before we go on, let me ask you, do you have any other siblings?"

"No, it's just the two of us."

"So now that your parents are gone, there is no one left. There is no family."

"I guess not, but that's how it goes. It was my sister's choice."

"In all these eight years you never called her?"

"*Me* call *her*? Rebbetzin, I told you, she tried to steal what was

rightfully mine. It's only because I had my wits about me that I was able to retrieve some of it. I couldn't care less if I never see her again."

"So actually, what was it you wanted to discuss with me?" I asked.

"Well, as I said, I wanted to know how serious this pre-Yom Kippur business is because I've been told that she became religious and is very active in her synagogue. I guess with her newfound money she can afford to give contributions and play the big shot. In any event, she must have heard from her rabbi what I heard from you."

"Are you hoping that she'll call and apologize?" I asked.

"It's beyond that. At this point she doesn't mean a thing to me. In the beginning, if she had said that she was sorry, it would have been different, but now it's too late."

"I don't think it's too late at all, Judy. I think that the entire situation is sad and very much on your mind, and I think that the correct thing for you to do now would be to call her and resolve it once and for all."

Judy gave a bitter laugh. "As far as I am concerned, she doesn't exist."

"When you approached me a few minutes ago, you told me that you would like to have my input. Did you really mean that?"

"Well, of course."

"All right, then. I'm glad because, as I said earlier, I think that you should call your sister—mind you, not only for her sake but for yours as well. You claim that as far as you are concerned, she doesn't exist. Well, I think that despite your protestations, you are very much tormented by the whole situation. With everything, she is your sister, the only family you've got."

"That may be true, but it doesn't mean that I want to see her."

"Listen to me, Judy. For many years now I have been dealing with all sorts of family problems, and I can tell you that this is destroying you. You have become a prisoner of your own anger. This fight with your sister is obsessing you, sapping you of your energy, and making you bitter and resentful."

"Yes, I feel resentful, Rebbetzin, yes, I am obsessed, but not because I was wrong, but because what she did was a terrible thing."

I chose to ignore Judy's protestations and told her that if she could find the inner strength to make that initial call to her sister, she would be on her way to liberating herself from the hatred that was poisoning her.

"If I made that phone call, I wouldn't feel liberated, but I would feel like a fool. Besides, why should I make the first move? It's *she* who wronged *me*, and it's *she* who must apologize."

"Our sages teach that all those who are willing to forgive will in turn be forgiven by G-d. We have a concept—'measure for measure.' The way we conduct ourselves is the way G-d deals with us. Based on this, I'm telling you that you'll be getting the better part of the deal if you make that initial call. You'll get more than the few dollars you went to court for."

Judy smiled ruefully. "At this point, Rebbetzin, I just wouldn't know how to make that call."

"Judy, let me tell you a Hasidic story that should help you. A man once came to the Rabbi of Rizin. 'I would like to repent,' he said.

"'So why don't you?' the Rabbi asked.

"'I don't know how,' came the answer.

"'And how did you know how to sin?' the Rabbi asked.

"'I did it inadvertently.'

"'Well, then, do the same,' the Rabbi said. 'Repent inadvertently, and everything will fall into place.'

"Please don't take offense, Judy, but you had no difficulty knowing whom to call and how to call when you wanted to sue your sister. This call, compared to that one, will be a piece of cake, and as an added incentive, think of what this phone call will do for your mother's soul. Don't you think that she's suffering greatly when she sees her two daughters divided by hatred? That's the nightmare of every parent. But with just one phone call you can bring healing to her soul. So how can you refuse?"

"For one thing, I don't know if I believe in an afterlife. Besides, my mother should have foreseen this problem and not allowed my sister to manipulate her."

"Let me try to answer you on both counts. You claim that you don't know whether there is an afterlife, but neither can you say with certitude that there isn't. And if there is, are you prepared to take the

chance of inflicting this suffering on your mother? Not to mention the accounting that you will have to give to G-d when you are called.

"As to your mother's thinking, it's not for children to pass judgment on their parents, but let's try to consider the situation objectively. I didn't know your mom, nor am I familiar with the dynamics of your family life, but our sages teach that 'we are not permitted to judge a person until we are in their exact situation,' which is virtually impossible. But just for argument's sake, has it ever crossed your mind that you may be viewing this entire problem from the wrong perspective?"

Judy looked at me with annoyance. "Oh, please!" she shrugged.

"Just hold on and let me explain. Could it be that since your mother lived with your sister for many years and saw how she struggled, she sincerely felt that your sister was more in need of help than you? After all, you made it. How many women become partners in a law firm at your age? Could it be that your sister was really telling the truth, that she did not pressure your mother in any way? Could it be that your mother had such confidence in your generosity that she was convinced you'd be happy for your sister to inherit the larger portion of her estate, especially since she knew that you were financially secure?

"Or let's take the worst scenario. Your sister and brother-in-law manipulated your mom. Could it be that they felt they had a right to that money since they took care of your mom for so many years, and they were in need and you were not?

"You said, Judy, that this is not about money but is a matter of principle. What principle, Judy? If you are truly interested in fighting for principles, then forgive and love. Those are principles that are worth fighting for."

"I have difficulty accepting all this, Rebbetzin. You're telling me to forget all the hurt I've suffered all these years. You don't begin to know how my sister treated me. You can't even imagine the things she said to me, the names she called me. And not only that, she incited her children, my niece and nephew, against me. And what didn't I do for those kids? I never visited them empty-handed, and I took them to all the best places, but they turned on me, just like their mother and father. So I should forgive my sister? I'm ready to call many people to wish them a Happy New Year, but not her."

"Judy," I said, "listen to your own words. We just spent an entire evening studying the laws pertaining to forgiveness as a component of atonement prior to Yom Kippur. The very word *forgiveness* implies that you feel that someone wronged you, but despite that, you are prepared to forgive and forget and start anew. So of course you have to reconcile with those with whom you've had a falling out. Who *else* would you call if not your sister, with whom you haven't spoken for the past eight years? What's the point of calling other people?"

And with that, I reached for a prayer book and opened to the prayer that we recite every night before going to sleep.

"Read it, Judy, and allow each word to enter your heart:

> Master of the Universe, I hereby forgive anyone who angered or antagonized me or who sinned against me . . . whether against my body, my property, my honor, or against any thing of mine.
>
> Whether he did so accidently, willfully, carelessly, or purposely. . . Whether through speech, deed, or thought, . . . I forgive.

"This prayer is recited every night of the year, so you can imagine what our responsibilities are before Yom Kippur. When our sages wrote our prayers, they were very much aware that sometimes real and serious wrongs are committed against us by our fellow man, but the only way for us to deal with them is through forgiveness, lest our hatred imprison and consume us. And that is what happened to you during these past eight years. Think about it logically. What benefit will you derive from nursing this hatred? It will embitter you further and alienate you from others. So for your own sake, make that call and let Yom Kippur free you and unite you with your family again."

Judy did make that call and was relieved when a machine picked up.

"Well, I tried," she said to me in a subsequent conversation, "but no one answered."

"Come on, you know better," I told her. "You have to try at least three times to make a reconciliation, and on each of these occasions, you must speak to the *person* and not to a *machine!*"

It took some prodding, but Judy finally did it. The sisters agreed

to meet for lunch, and from that meeting a relationship slowly began to grow.

To forgive is to emulate G-d. To harbor resentment is to be a prisoner of your own hatred.

As a postscript, I must add that although it may appear from this story that I was able to convince Judy to make that phone call in the course of a quick conversation, it was by no means so simple. It took a lot of persuasion and cajoling. Judy's resistance reflects a cultural bias that views making conciliatory calls as acts of weakness. In the Torah world, however, just the opposite holds true. He who is able to humble himself, suppress his ego, and forego his honor is the true hero. These precepts are inculcated into children from early on. To what extent such values affect them was brought home to me through a little incident that occurred at my grandson Yaakov's bar mitzvah.

It was one of those scorching hot summer days, but the joy of the bar mitzvah celebration made us oblivious of the heat. My son Yisroel and his wife, Rivke, had organized a beautiful day, and their attention to the smallest details was evident in the seamless way it progressed. Most meaningful of all was the Torah dissertation that Yaakov delivered with ease and eloquence.

There was only one flaw, and that was the terrible void we all felt from the absence of my husband. He had such a special way about him—the manner in which he greeted everyone, his inspiring words that just entered your heart, and the way he would dance with the men in a circle with his eyes closed, giving thanks to G-d. It is always at *simchas* (celebrations) that loved ones are missed the most, but then again we kept telling ourselves that we should be grateful for the memories of the years that we had him with us.

The celebration was coming to a conclusion. People were saying their good-byes, and I looked around for my littlest grandchildren. "Where are they?" I asked Rivke.

"Oh, they became restless and went out to play."

Earlier, upon arriving at the synagogue, I noticed that there were many Hasidic boys playing outside. I have always found something very endearing and charming about these children playing their games and having their arguments in Yiddish. I loved watching them, engaging them in conversation, and challenging them with Torah

questions, so I was debating whether, despite the heat, I should join my grandchildren and see how they interacted with their newfound friends, when my five-year-old grandson Yosef, Yaakov's younger brother, came running to me and settled the matter.

"Bubba, come quickly!" he called out. "Some boys are making fun of Akiva." Akiva is my daughter Slovi's five-year-old, and the two little cousins are great friends.

"What?" I exclaimed, in an intentionally dramatic voice. "That's terrible! How can yeshiva boys do such an awful thing—and on *Shabbos* to boot! Come, let's go investigate."

With a satisfied smile, little Yosef took my hand, confident that I would take care of the matter. Yosef led me outside, and sure enough, we found Akiva standing by himself and looking downcast.

"Did someone make fun of you?" I asked.

Akiva just kept staring at the sidewalk and wouldn't answer.

"Yes," Yosef interjected. "I'll show you where those boys are." And there, just a few steps away, standing where I had seen them earlier, was a group of six to eight little boys. They were the most adorable children you could wish to see. Dressed in their *Shabbos* best, with their long side curls and big black yarmulkes, they looked like a picture.

"Could it be that, G-d forbid, someone here made fun of Akiva?" I asked in Yiddish.

There was silence as they all stared at me in wonderment.

"If you didn't do it, tell me," I continued, "but if you did, you must apologize. You all know what a terrible thing it is to hurt someone. You must have learned in *cheder* [Yiddish for school] that no one is ever allowed to shame someone. It's the biggest sin to do that!"

Still there was only silence.

"Who will be the first," I asked, "to show the *derech* [Hebrew for correct conduct] and ask Akiva's forgiveness?"

Not waiting for an answer, I turned away and walked toward Akiva, who was still standing by himself. Without exception, the boys followed me, and each of them approached Akiva and said, "I'm sorry."

I laughed with joy and marveled once again at the power of Torah education. Had I approached any other group of children with the same request, chances are that they would have responded

disrespectfully, but these little boys, because of their Torah background, without exception came to ask forgiveness. As I watched them, in my mind I heard the song that we sang in synagogue in honor of the Torah during the services: "It is a tree of life for those who hold on to it. . . . Its ways are ways of pleasantness, and all its paths are peace."

Had Judy received a Torah education, I wouldn't have had to work so hard to convince her to call her sister. Like those little Hasidic boys, she would have understood that to make the first move, to say, "Forgive me," is never a sign of weakness but one of honor and strength. But then again, if she had had that Torah commitment, perhaps this story would never have occurred, for she would have understood that sisters don't sue sisters.

SEVEN TIMES A RIGHTEOUS MAN FALLS

In Israel, we visited the female compound of Ramle prison in the heat of a scorching summer day. Accompanying me were my daughter Slovi and Barbara, who was carrying heavy recording equipment to tape the meeting for radio. Not being able to park within the prison compound, we were obliged to walk quite a distance, and as we trudged along, I heard Barbara mutter under her breath, "I don't know how I ever got involved with you. You could have spoken in a normal place, like Jerusalem or Tel Aviv. Why did you have to decide to come to a prison in this G-dforsaken place to speak to a few inmates?"

Though it was true that fortunately, there weren't too many prisoners, our Torah does not consider numbers to be a criterion in determining the value of people. Each and every soul is a world unto itself, and "if you save just one, you save a world." I didn't bother getting into all that, for I was lost in my own thoughts, trying to figure out what I would say to the inmates. As much as I racked my brains, I couldn't come up with anything that would be instructive yet not condescending, meaningful yet not judgmental.

As we finally reached the prison gates, I still did not have the foggiest notion what my message would be. Barbara rang the bell. As the large gate slowly rolled up, she started forward, not seeing the long iron bar at the bottom of the gate, tripped, and fell flat on her face. The prisoners, who were assembled to await our arrival, stood aghast as the guards rushed forward to help. Barbara got up, brushed the dust off her clothes, and tried to cleanse her scrapes.

Suddenly it occurred to me that I had my speech. I proceeded to introduce Barbara to the inmates and explained that in all the years that we had worked together I had never seen her take a flop like that. "But perhaps," I said, "it was meant to be that this should happen here in full view of all of you, so that you might see that it is possible for anyone to fall—but if you do, you have to stand up, cleanse yourself, learn from the experience, and start over again. That's my message," I concluded. "Now I'll take questions."

Of all my programs in Israel that summer, it was perhaps that little speech in the dust of Ramle that was my most moving experience. We stayed there the entire afternoon. The women had numer-

ous questions. They wanted to start classes, study, and find their way back to G-d.

There was one girl, however, Irit, who did not get involved in the discussion. I noticed her right away. She had a beautiful face, with smoldering, angry eyes, and she sat there smoking one cigarette after the other.

"This is all talk," she called out. "No one will ever give us a second chance. You're all wasting your time listening to her."

"What you say may be true in the secular world, but not in G-d's world," I responded. "In the Torah world, things are different," and with that, I proceeded to tell her the story of Rabbi Yochanan and Reish Lakish.

"Rabbi Yochanan was one of the most handsome men in all of Israel. It is said that women would gaze at his beauty in the hope of having beautiful children. Well, one day, Rabbi Yochanan was accosted by a gang of bandits.

"'What a pity to waste such a handsome face on a Torah sage,' the leader of the bandits, Reish Lakish, said.

"'And what a pity to waste such strength and such a fine mind on robbery,' Rabbi Yochanan answered. Then he added, 'If you think that I am handsome, you should see my sister. If you were a Torah scholar, you might have the opportunity to marry a girl like that.'

"Reish Lakish took Rabbi Yochanan up on his challenge and started to study. He became one of the most celebrated sages of his generation, and he married Rabbi Yochanan's beautiful sister. Throughout his life, he and Rabbi Yochanan, who had become his best friend, studied Torah together.

"So you can see, Irit, that not only did the Torah world offer Reish Lakish a second chance, but it accepted him as a Torah sage as well. And more, Reish Lakish was able to convert all the negative experiences from his past life into positive teachings from which everyone could benefit. So, if you turn to G-d, the miracle can occur for you as well. 'Make for me an opening as small as the eye of a needle, and I will pull you through,' G-d says.

"Try it, Irit. You'll see. It will work."

"Yeah, and everything will be forgotten and just fine and dandy," Irit scoffed.

"Yes, that's exactly right," I said, deciding to ignore her sarcasm. "'Even if your sins be as red as scarlet, I, the L-rd your G-d, will

make them white as snow' is His promise if you follow the formula."

"And what's the formula?" another girl interjected.

"It's a threefold process," I said, "repentance, prayer, and charity. Repentance entails your taking a good, long, and honest look at yourself, admitting where you went wrong, feeling remorse, and resolving never to repeat that act again, and in general committing to G-d's commandments—observing the Sabbath and living a life of integrity.

"Prayer is something you should do on a daily basis, ideally three times a day—morning, afternoon, and night. Prayer will nourish your soul even as food sustains your body.

"And the third step, *tzedukah*—whatever little you have, you must share, and if you do so, in time G-d will give you more. But I must remind you," I added, "of something that I say in all my classes. *Tzedukah* doesn't mean only monetary gifts but giving of yourselves, showing kindness and consideration to others. Perhaps when you leave here, you will do volunteer work with troubled girls and thus convert all this negativity into something positive. The idea is to learn from every life experience, and sometimes you can learn more from failures than from successes."

"Well, I sure had many failures," Irit volunteered.

"Don't be dismayed by them. King Solomon taught that 'Seven times a righteous man falls, and seven times he stands up,' meaning that a righteous man is not necessarily someone who is born righteous but rather someone who *becomes* righteous by standing up *despite the fact that he has fallen.*"

"But why seven?" someone asked.

"Seven," I answered, "because seven represents the days of the week—this world, a world in which we are bound to fall but in which we are nevertheless capable of standing up. G-d judges us not so much by the mistakes that we make but by how we deal with those mistakes, by our willingness to redress wrongs and make amends."

We went on talking for a while. When we finally got up to leave, Irit approached Slovi. "We don't want to impose upon your mother," she said, "but could you please take this note to Jerusalem and place it in a crevice in the Western Wall on our behalf?"

On the note was written: "Almighty G-d, forgive us," and the names of all the girls were signed on it.

Those words, "Forgive us, oh G-d," are not mere words. Rather, they make us aware that we are accountable, and if we fail, we must stand up and chart a new course. Through that effort we can become better, stronger, more giving, more compassionate, and more committed to the Laws of G-d, even if we fall from time to time.

Most of us have an image of righteous people as superbeings who are born perfect and virtuous and go through life always doing the right thing. But what King Solomon taught us was that even the righteous have to struggle to become righteous. They, too, have their ups and downs, their failures and successes. They, too, can fall, but because they persevere, they can start anew and thus become righteous.

So you lost your job, so you didn't do well in school; your marriage is on the rocks, you failed with your children; you and your best friend have had a falling out, you behaved stupidly. Don't throw in the towel. Don't be too hard on yourself. But remember that even the righteous can fall, even they have to struggle to get there.

A famous poet once wrote that in a desert there is always sunshine, but for growth you need rain, and for creativity, you need a storm. So in times of stress, when you realize that you have made grave or silly mistakes, don't fall apart, don't indulge in self-recrimination or depression, but remember that if you learn from your mistake, you will emerge stronger and wiser for the experience. In short, it's OK to fall. To make mistakes is human, but to institutionalize those mistakes and to make them part of your personality and character is to deny the image of G-d in which you were created.

This concept of asking for forgiveness and thereby canceling out the past and starting all over again is one of the pillars of our faith through which we are able to liberate ourselves from the darkness of our yesterdays.

David, King of Israel, was perhaps the greatest of men, not just in Jewish history but in the history of all mankind. He had astounding triumphs on the battlefield. He singlehandedly defeated the giant Goliath. Yet it is not for these feats that he is glorified in history. Rather, he is remembered as "the sweet singer of Israel," the author of the psalms. It was David, through the Book of Psalms, who taught us how to open the Heavenly Gates, to approach G-d in prayer, to cleanse our souls with our tears, and to say those most powerful words: "Forgive me, oh G-d."

No Soul Is Ever Lost

I was on my way to Washington. Menachem Begin, then prime minister of Israel, was in town, and I was scheduled to meet with him at Blair House. We had been in the air for no more than a few minutes when a gentleman approached me and asked, "Aren't you Rebbetzin Jungreis?"

"Yes," I said, "I'm pleased to meet you."

After an exchange of pleasantries he said, "I have a job for you. You must go to Las Vegas immediately."

I was somewhat taken aback, and my expression must have conveyed that, because he went on to explain that he had just returned from a trip there, not to gamble, he hastened to assure me, but for a business convention.

"I met a young man there. He's all messed up, but he comes from a good family. My gut feeling is that if someone doesn't get to him soon, he's headed for real serious trouble. You could reach him, Rebbetzin. You should go there."

By this time I was used to having people approach me to seek help for troubled youth in almost every part of the globe, but unless I had a speaking engagement in that particular community, it wasn't very realistic for me to go there, so I suggested that he bring the young man to me.

"Forget that," he said. "He'll never listen to me. If anything, he'd probably laugh in my face."

Before we knew it, our short shuttle flight had reached its destination and the steward requested that everyone take his seat for the landing.

This chance meeting was all but forgotten by me, when a few weeks later a dignified woman who appeared to be in her late forties came to see me at my Hineni Torah class, which in those days was held at my father's synagogue in Brooklyn.

"Rebbetzin," she wept, "I have terrible *tsoris* [Yiddish for real serious problems]. I have a son—a good boy, but he got involved with the wrong group of friends and left home. It's a long story, but we went through a lot of things—I can't even begin to tell you, but the end of the matter is, he's in Las Vegas."

Suddenly the conversation that I'd had on the plane to Washington came back. The coincidence was striking.

"And as if things were not bad enough," the woman continued, "he got himself into some trouble with the police! I don't know what to do, Rebbetzin, I just don't know what to do. My husband says that he's ready to give up on him and write him off, that he's beyond help. What do I do?"

"No parent can ever give up on a child," I said. "We have no option but to try to help him. Do what you have to, but get him back to New York, and when you do, bring him to me."

"But what do I tell my husband?"

I thought for a moment and recalled a story I heard from my maternal grandfather, Rabbi Tzvi Hirsh Kohn. It was about the Rabbi of Tzernovitz, who also had a rebellious son. The members of the congregation were so outraged by the boy's behavior that they appointed a committee to take the matter up with the Rabbi himself. They were certain that once he was made aware of the problem, he would banish his son from the community.

It was a few days before Yom Kippur when they came to the Rabbi's house. They found him immersed in penitential prayers.

"Almighty G-d," the Rabbi's voice came piercing through the door. "I know full well that we, Your people, are not deserving of Your favor. I admit that we have transgressed Your commandments, but nevertheless, I beseech You to bless us with a year of good and plenty. And should You argue that I have no basis on which to make such a request, because we are not deserving of Your favor, then I will tell You frankly that others may not, but I, the Rabbi of Tzernovitz, do for I too am a father, and my son has also rebelled against me. And yet, I tell You, my G-d, that if someone were to suggest that I disown him, that I cast him away from my sight, I would throw that person out, for *no matter what, he is my son.*"

The members of the committee, hearing the prayer of their Rabbi, trembled with shame. Without uttering a word, they left.

Now unbeknownst to the Rabbi and to the committee, the errant son also heard his father's prayer. Unable to contain himself, he broke down and wept inconsolably. In the midst of his tears, the boy made a silent vow that he would justify his father's unbounded love.

"Oh, Rebbetzin," the woman cried, "I'll tell this story to my husband. I hope he will accept it. But do you think you will be able to reach my son?"

"We have to pray for it," I told her. "We need a miracle. I can assure you that I will try my best, and let's hope that G-d will grant me the words with which to open his heart."

Several weeks passed and I didn't hear from her. I only hoped that everything was alright. Then one morning the phone rang.

"Rebbetzin, we brought him back!" she said excitedly. "He's here with us, but I'm very nervous. I'm so afraid that he'll slip back and disappear again. When can we come to see you?"

"My Torah class tonight at Hineni, and he'll have a chance to meet my father too. He needs a blessing."

As soon as I walked into the room, I picked him out, which wouldn't have been hard to do even if he hadn't been sitting next to his mother. He was tall, dark, and handsome, with that sleek "cool" look. Despite the fact that it was night, he wore designer sunglasses.

I began to teach, but because his eyes were shielded by those glasses I couldn't tell whether he was listening. After the class, from the corner of my eye, I saw his mother prodding him in my direction. Some heavy discussion ensued between them. She looked very nervous. There was a lot at stake. But finally, slowly and reluctantly, he followed her and came up to speak to me.

"Rebbetzin, this is my son," she murmured.

"I'm pleased to meet you," I said. "What's your name?"

"Mario," he answered.

"Mario can't be your name. That's a facade, a pretense. Tell me your *real* name—the name that your mother and father call you by. Tell me your Jewish name."

"Anshie," he muttered.

"Anshie," I repeated. "That can't be. Anshie always goes with something else. Now give me your full name," I persisted.

"Osher Anshil," he said reluctantly.

For a moment I stood there nonplussed. I felt my heartbeat accelerate. Osher Anshil was the name of my great-great grandfather, who was known throughout Hungary as the Miracle Rabbi, and my own son, as well as my nephew, were named after him. Those who carry that name are usually somehow connected to him.

"How did you get that name?" I asked.

"I don't know," he shrugged. "Ask my mother."

"Tell me," I turned to her, "how did you come to give that name to your son?"

"It's a long story," she said, her eyes full of tears. "When Anshil was born, he was a twin. His sibling died, and he was very ill. I went to my rabbi and asked him for a blessing, and he suggested that I give him the name Osher Anshil, after the Miracle Rabbi, so that he might pray on his behalf."

I felt overwhelmed. The whole story was awesome, a jigsaw puzzle spanning oceans and continents, and now the pieces all fell into place. The conversation on the plane to Washington, the mother coming to seek my help, and now, Osher Anshil himself arriving.

"Why are you wearing sunglasses?" I asked.

He just stood there, unresponsive, and shrugged his shoulders.

"Take off your sunglasses," I said.

But he didn't answer.

"You heard me. Take off those shades!" I commanded, deciding to take a tougher tone.

"Why should I?" he challenged.

"Because I want to see your eyes. Your eyes are the windows of your soul."

He shrugged and slowly took off his sunglasses. He gave me a half smile, which was more like a sneer.

"Listen to me," I said. "I'm the great-great granddaughter of that rabbi after whom you were named. It's no coincidence that you are here. There are no accidents in G-d's world. The blessing that you received when your mother gave you that name has served you well. You have come home, and we will try to help." And with that, I took him over to my father, who was in his usual seat near the holy ark.[1] My father enveloped him in his arms, kissed him, and prayed that G-d grant him the privilege of starting a new Torah life.

"You received a blessing from Zeide," I now said. Everyone called my father Zeide (Yiddish for grandpa), for although he was a

[1] If you could envision how the Patriarchs of the Bible looked, then you would see my father. His long white beard, gentle serene countenance, and warm, penetrating eyes made you feel that you were in the presence of sanctity.

renowned sage, he was first and foremost a loving *zeide* to his people. "Now we have to make that blessing work for you." I called over my dear friends Roy and Linda Neuberger. I had met Roy and Linda some years ago when I lectured at a synagogue in Newburgh, New York. At that time Roy was the editor of the local newspaper, and he came to cover the story. A few days later I received a letter from him. "You opened a world to me that I never knew existed. I must learn Torah. I must find out more."

Roy was an Oxford scholar. He possessed great intellectual integrity and was in search of truth. His quest led him to explore different philosophies and lifestyles, but he didn't find any of them satisfying until the Torah touched his soul, as no other study had. He and his beautiful wife, Linda, who was gifted in her own right, drove from Newburgh, New York, to Brooklyn every week (no small feat considering that this occurred during the energy crisis). That was the beginning of a friendship that forever changed not only their lives but the lives of countless people who, over the years, Roy and Linda took under their wings and welcomed into their home.

Many people discover Torah; many people come to G-d; but there are very few who understand that faith in Him entails a commitment to reach out to others. Roy and Linda understood this, and because of this I felt that they would be the perfect surrogate parents to this, my latest challenge.

"Do you think that Osher Anshil could come and stay with you?" I asked.

"Of course," Roy said, his face lighting up with a smile. And he immediately went over to Osher Anshil and put his arm around him.

"It will be our privilege," added Linda graciously.

And so it was that Osher Anshil joined the hundreds of young men and women who have come to Roy and Linda's home to discover the beauty and sanctity of the Sabbath and the holidays. They all find a warm, loving home there, staying on for weeks, months, and sometimes even years. This hospitality is offered freely by Roy and Linda in a spirit of love, and Osher Anshil, like all the others who crossed their threshold, was deeply touched by it. He was treated like one of their own children and given guidance and discipline that was laced with much love.

Things don't always turn out as we would like. Too often we experience painful disappointments with our children, and the hurt is very deep. If we have patience and reach out to them with understanding and forgiveness, they will return to us. No soul is ever lost. We are never to give up.

≈ 8

Banishing Fear

"G~d is with me, I shall not fear."

—Prayer Book

IT'S ALL FOR THE BEST

Our Hineni summer tour of Israel was over. The group returned to the States, but I stayed on with Barbara to attend to the needs of our Jerusalem chapter and to deliver a series of lectures.

It was Friday morning, a day in Jerusalem when everything shuts down early in preparation for the Sabbath. I planned to spend that morning with my grandson Yosef Dov, who had just arrived for a year of study in Jerusalem. I was anxious to see him and show him the breathtaking sights, so we arranged to pick him up at his yeshiva and take him to the Holy Wall and on a tour of the Old City.

When we drove up to the yeshiva, I got out of the car and ran toward him, never realizing that the steep stone road was slippery. Suddenly I began to slide as though on a ski slope. I lost my balance, and feeling myself falling, I put out my arm to break my fall. I thought that I would faint from the pain. I immediately knew that I had broken my wrist.

In the wink of an eye, all my carefully laid plans had come to naught. Instead of introducing Yosef Dov to the beauty and grandeur of Jerusalem, I took him on a tour of Hadassah Hospital. After dealing with the initial pain and the wait in the emergency room, annoyance set in. Why did this have to happen to me?

During our tour, I had climbed every mountain, crept into every cave, and never once stumbled. Now that the tour was over and I had a few hours of private time to spend with my grandson, I had to be handicapped by a broken wrist. All kinds of thoughts ran through my mind. The following night I was scheduled to deliver a major address in Jerusalem. How would I do it now? How could I function without my right hand? How would I take care of my personal needs?

Automatically, from years of training, the words of our sages came to mind: *Gam zu l'tova* (This too is for the best). From childhood on, these words were etched on my heart. "No matter what happens, it's always for the best," my parents and teachers had taught me. "G-d's providence is always guiding us; there is always a reason for everything that happens, and even if initially we do not understand it, in the end it will all turn out for the best."

I now repeated the phrase in my mind and tried to find some

redeeming feature in my broken wrist, but to no avail. I recalled the wonderful story from the Talmud, of Rabbi Akiva, who undertook a long and treacherous journey. He traveled by donkey and took all his possessions with him: his books, a candle to study by, and a rooster to awaken him in the early hours of the morning. As night fell, he became tired and hungry and decided to seek lodging in a small town. He knocked on the door of a little house, hoping to be allowed to stay the night. A woman opened the door, but just as quickly slammed it in his face. And the same scene was repeated at every door on which he knocked.

Taken aback by this lack of hospitality, Akiva became somewhat despondent, but he consoled himself with the thought that there must be some reason that this was happening. So, wearily, he mounted his donkey and made for the forest, where he spread a mat on the ground, lit a candle, opened one of his books, and began to study. Suddenly he heard his donkey bray. There was a great uproar. Akiva ran toward his beast, but he was too late. A lion had come and devoured it. Things seemed to be going from bad to worse. Now he would have to travel on foot, and who knows how long it would take him to reach his destination?

But Akiva murmured to himself, "*Baruch HaShem*, blessed be G-d. Whatever He does is for the best."

He was about to return to his studies when there was yet another disturbance. This time it was the cock who fell dead. Was this the reward of a man who undertakes an arduous journey for the sake of Torah?

Akiva could surely have become cynical and renounced his faith, but instead he kindled his candle and continued to study. The wind blew so fiercely that it was impossible to keep the candle lit, and finally, in sheer exhaustion, he fell asleep.

The following morning he resumed his journey, stopping at the village where he had been refused lodging the night before. A horrible sight greeted him. Robbers had come during the night and plundered and destroyed everything in sight. With a heavy heart, Akiva whispered to himself, "G-d's guiding hand is always there. It was meant to be that I was not extended hospitality in this village; it was meant to be that I lost my donkey and rooster, and it was even meant to be that the wind blew out my candle, for had the robbers found me, I would not be here now."

Akiva continued on his journey. As he walked, he uttered a silent prayer, "Blessed be G-d. All that He does is for the best."

As I looked at my swollen arm encased in a heavy plaster cast, I tried to emulate the teaching of Rabbi Akiva and say, "*Baruch HaShem*, blessed be G-d," but frankly, I still could not understand what benefit could possibly accrue from my broken wrist.

The following night, when I arrived at the hall where I was scheduled to speak, I noticed many young people in the audience whose dress and behavior told me they were street kids with a history of drugs and alcohol. I thought to myself, maybe this is an opportunity for me to make an omelette out of a broken egg by using my broken wrist as a prop to convey a message to them. Pointing to my cast, I said, "That which holds true in the spiritual world is also valid in the physical one. Breaking a bone was very painful. Similarly, breaking with your past is also painful. But I went to the doctor and he set my wrist. By the same token, when we break with our past we have to go to the Doctor of Doctors, and He sets us forth on a new path. In the hospital, I was told that if I wanted my wrist to heal, I should keep my hand elevated. Similarly, we have to keep looking up for guidance from G-d.

"Whenever people see me with my cast," I told the young men and women, "they wish me a complete and speedy recovery. When you break with your past you will discover that you are not alone. There is a whole network of good people out there ready to lend you strength and support."

Yesterday I had wondered how I would ever be able to make a speech with a broken wrist. Now I discovered that not only was I able to do so, but that which I thought would be a handicap turned out to be an asset in communicating my message. So I was truly able to say, "Blessed be G-d," with feeling and confidence.

When we returned to New York I consulted an orthopedist, a young physician who had spent many Sabbaths in our home. He expressed concern. He didn't think my wrist should have broken so badly from that fall, so he suggested that I take a bone density test to determine whether I was experiencing bone loss.

My mom suffers from osteoporosis, and because of that, many times in the past I had thought of going for a bone density test, but somehow I just never got around to it. Now my broken wrist forced

me to take the matter seriously. Sure enough, the test showed bone loss, and I was immediately placed on a therapeutic regimen to stave off osteoporosis. Now I could truly echo the words of our sages: *Gam zu l'tova*—it's all for the best, Blessed be G-d.

Often in life we are overwhelmed by fear, and we feel bitter and angry at the fates that befall us. It is rare that we get to see the blessings in our pain as quickly as I did through my broken wrist. Most often it is only years later, and sometimes not even in our own lifetime, that we discover that that which we thought was to our detriment was, in essence, to our benefit. The job that was lost, the relationship that fell apart, the plane that we missed were all blessings in disguise. What it amounts to is that everything has a purpose. There is divine providence even for a blade of grass, even for an insect.

King David once questioned G-d regarding this. "Of what purpose is a spider?" he asked.

"There will come a time when you will need it," G-d answered. And so it happened that when Saul was in hot pursuit of him, David quickly ran to hide in a cave. Saul searched everywhere and came upon the cave. He would have entered were it not for the fact that G-d sent a spider to spin a web across the entrance, which led Saul to believe that no one could be inside.

In an expression of gratitude and wonderment at G-d's awesome ways, David sang a song of praise.

Everything has a purpose in life—even a spider. How much more so that which befalls you and me? Obviously a broken wrist is no big deal. As a survivor of the concentration camps, I am the first to concede that. But I share the example of my broken wrist with you because it makes it so obvious and clear that there *is* a reason for everything. When difficult days come upon us, we have to bear in mind that even during those challenging times of illness and death, there is a reason, although it may elude us.

I lost my beloved husband to cancer. My pain and grief were devastating, but even at such a time, our tradition demands that we pronounce a blessing, an affirmation of faith, "Blessed be the righteous Judge." I recited that affirmation in the midst of tears, and that very act reminded me that even in that terrible darkness, G-d was there, that there was nothing random in the world, that everything

that befalls us occurs through His decree, and that very knowledge infused me with strength and banished my fears.

We cannot hope to comprehend G-d's ways. Even as a small child does not understand why his mother takes him to the doctor for a painful vaccination, so we cannot know why G-d challenges us, tests us, and chastises us. What is important to bear in mind is that ultimately it will all turn out to our benefit and that He would never burden us with that which we cannot sustain. So if fate decrees that you are to be tested, just keep in mind *Gam zu l'tova*—it's all for the best. Even if you do not quite understand why, call upon G-d, and He will help you pass the test. You are not alone. Never be afraid.

You Need Only Do, and the Blessing Will Come

My parents, two brothers, and I arrived in this country in 1947 and settled in Brooklyn. When we were enrolled in school, my father said that his aspirations for us were not in the professions or the world of business. Rather, he hoped that we children would devote our lives to rebuilding and rekindling the faith that was snuffed out in the flames of Auschwitz.

My father gave me my first job. He wanted me to invite all the children on our block for *Shabbos*. I was mortified. We had just arrived. The new kid on the block is never comfortable, but I was the new kid on the block with many impediments. I barely spoke English, and I was dressed in *schmattes* that my mother had gathered from here and there. In short, I was totally outclassed. Additionally, we lived in a basement, and I was embarrassed because everyone else lived in nice apartments or homes. So how could I communicate with these kids? How could I invite them for *Shabbos*? Nevertheless, if this was my father's request, I couldn't very well say no. So off I went to invite them, and to my surprise, they were delighted to come. And that is how our *Shabbos* table became the place to be on Friday night.

Many years later, when I was married with small children, I was invited to speak at an intercollegiate convention. A few hundred students had gathered, and as I spoke, I felt a sense of frustration. "Why don't you do something?" I challenged. "You condemn those who were silent when six million were taken to the gas chambers, but look about you. Look at what is happening today. The great majority of our people have no connection to our faith, no knowledge of our Torah or our heritage. They are disappearing in assimilation. Why don't you seek them out? Why don't you reach out to them?"

"What can we do?" the students asked, throwing the ball right back into my lap.

"Well, if I had an organization like yours," I answered, "I would take Madison Square Garden and call for a Jewish happening. I would gather our people from high school and college campuses. I would invite them all and tell them that it's time to wake up, that if we want our people to survive, we must reaffirm our Jewishness."

The students were fired with the idea, and right then and there they endorsed it. Being familiar with organizational life, I knew that

no sooner would the convention end and the releases be given to the papers than the entire matter would be shelved and forgotten.

A few days later, at my son's bar mitzvah, one of my friends jokingly announced the Madison Square Garden program. Without even consulting me, he invited those present to my house so that we might start the ball rolling. I laughed to myself, convinced that no one would come. Besides, I had enough responsibilities without looking for additional burdens. But that which is meant to be happens, and incredibly, that very evening, a group showed up at my home to plan what someone present called "the Jewish event of the century."

One of the men pointed out that since the Jewish community was very polarized, each group vying with the others, it would be best to form a new umbrella movement.

"Call it *Hineni*, 'Here I am,'" he suggested, and the recommendation was readily accepted.

Hineni is the biblical term with which all the great prophets of Israel responded to G-d's challenge. Abraham, Isaac, Jacob, Moses, Samuel, Isaiah, Jeremiah, all affirmed their faith with "*Hineni*" (Here I am). It speaks of total commitment to the service of G-d and man.

I loved the name, it expressed my beliefs, but frankly, I still did not regard any of it with seriousness.

When it became apparent that I didn't have an organization or any backing or money to make this type of event happen, everyone went home—except Barbara. She was immediately taken with the idea and wouldn't let go until we went to the Garden to explore it further.

I don't know what came over me, but I signed a contract. And then I became terrified. I was filled with fear. I consulted my father and he said to me, "My child, it is written that 'He shall bless you in everything that you shall *do*.' So do not be frightened, you need only *do*, and the blessing will come."

I was still petrified. "What are you worried about?" my husband asked. "Just focus on what is written in the Torah." And he reminded me of the daughter of Pharoah who went down to the river to bathe. She saw a small basket floating on the water with a child in it. She wanted to pull it to shore, but the basket was too far out. Nevertheless, she reached out, and miraculously her arm extended

and she brought little Moses to dry land. The lesson is obvious. You need only reach out, and G-d does the rest.

"And remember King David," my husband continued. "Prior to his becoming king, the Jewish people were challenged by Goliath, who demanded that they send a representative to battle him. There were no volunteers. The men of Israel froze in terror. King Saul offered his own armor to the man who would fight the giant, but still there were no takers until David came forth. David was short and stocky. Saul, on the other hand, was a tall, imposing figure. Saul's armor couldn't possibly fit David. Miraculously, when David donned the armor, it fit like a glove. The rest is history."

What my husband was reminding me of was that if we really believe, if we really have faith, then G-d will help us. We need not fear.

The Garden was a "first." It had never been done before. We had no precedent to follow, but I put on my armor and extended my hand, and miraculously things fell into place.

To be sure, before the program took place I panicked a million and one times. I had terrible visions of an empty house, of standing up there and not being able to speak, of being booed, jeered at, and heckled. And more, I worried about what I would say to make people understand.

On November 18, 1973, we opened at the Felt Forum of Madison Square Garden. I was waiting in my dressing room when my father came in to tell me that it was standing room only and there were lines of people waiting outside trying to get in.

The crowds were now making their way through the lobby, stopping at information booths, asking questions, discovering their Jewish roots. Inside the Garden, Jewish music was playing. There was a true celebration.

Suddenly the music stopped. The time had come for me to speak. There was a knock on the door, and there was Barbara, with the security people right behind her.

"It's more than we could ever have hoped for," she said, her voice full of excitement. "Everybody is waiting for you. Go with *mazel* [luck]."

We looked at one another and our eyes filled with tears. It had been a long, grueling year. There were days when we worked twenty-four hours and didn't get to sleep at all. Now the moment had come, and I could only hope that I would be worthy of reaching the hearts of our people.

I had a sick feeling at the pit of my stomach. My mind went blank. What would I say to all those thousands of people? I forgot everything that I had planned. I looked around for my father, and as if he sensed that I was searching for him, he appeared at the end of the corridor and slowly made his way toward me.

"May angels of mercy accompany you, my precious child," he whispered as he placed his hands over my head in blessing. "May G-d give you the words with which to reach every heart."

The stage was pitch black. I searched in vain for some familiar face, but the spotlight hit me and I felt blinded. I had never before spoken in total darkness. For a moment I froze, and then I started to speak.

"You are a Jew . . ."

I felt as if my heart had stopped beating. My voice quavered, but I mustered my courage and continued: "You are a Jew. You have created civilizations. You have given birth to every ideal that has shaped mankind: Justice, peace, love, the dignity of man have all had their genesis in your Torah. But above all, you have been given the unique mission of proclaiming the Oneness of G-d!

"You are a Jew. You have traveled the four corners of the earth. You have become a part of every people, and yet you have remained a people apart. You have known every form of oppression. Your body has been scorched by fire. You have forgotten your past. But there is one prayer, one little prayer that you cannot forget, a prayer that keeps you linked to the faith of your ancestors, a prayer that speaks of your own mission in life: *Shema Yisrael*—Hear, oh Israel, the L-rd our G-d, the L-rd is One!"

Suddenly the entire audience repeated those immortal words, words that are inscribed in the Torah, words that were first proclaimed by the patriarch Jacob, words through which throughout the millenia our people have sanctified the Name of G-d. *Shema Yisrael* resounded throughout the Garden. The walls themselves seemed to tremble with the song of our people. It was a spontaneous affirmation of faith. Now everyone was singing, "Hear, oh Israel, the L-rd our G-d, the L-rd is One!"

Those who were there that night will never forget. It was not something that we could ever duplicate. It was the beginning of Hineni.

AFRAID TO LIVE

Carol was attractive, vivacious, active in dozens of charities, and very popular within her circle of friends, but there was another side to Carol that very few were privy to, and that was that she lived in a constant state of fear. What, you might ask, was Carol afraid of? Everything. Afraid that something would happen to her children, afraid to get into a car because she might have an accident, afraid of getting on a plane, afraid that her husband's business would go belly-up, afraid that she had cancer, that she would have a heart attack. No sooner would we resolve one fear than another would crop up. Carol would call me almost daily, just for reassurance. Her concerns had no basis in fact, but nevertheless they were paralyzing her.

Fear and man's conscience are intertwined. In the Bible we find that the first to experience fear were Adam and Eve. After committing the sin of eating from the forbidden fruit, they went into hiding.

"Where are you?" G-d called out to them.

"I heard the sound of your voice in the Garden and I was afraid," Adam answered (Genesis 3:9).

Afraid of what? Certainly Adam had heard the voice of G-d before, and he had never expressed fear. What brought on this change? Why was he afraid now?

Our souls are the breath of G-d. They are pure and holy and prod our consciences. If we betray G-d's commands, if we sin, our souls become blemished and an angst sets in, which we identify with fear. Carol was obsessed with this fear, and her worries bordered on the neurotic.

Most of us just have this gnawing feeling that we can't quite make out. We don't like to admit to fear, but it is nevertheless there. It gets in our way and doesn't allow us to function.

Before she learned to trust G-d, Carol was a chronic worrier. One morning when she called my house, my husband picked up the phone, and I overheard him say in his warm, loving, but powerful voice, "Carol, what are you worried about? If it already happened, forget it. Worrying about it won't change matters. And if it didn't happen, you surely have nothing to worry about! Do you know what the psalmists would say to you? 'Cast your burden upon G-d' (Psalm 37). Trust Him. That's the way to go, Carol. You do what you have to

do, and let G-d do the worrying." In time, Carol learned to do just that.

Fear has become a real problem for our spiritually alienated generation. It's not only in the areas Carol wrestled with that people are afraid, but fear has become the biggest obstacle to commitment. People are afraid to commit to marriage, to having children. One young woman pleaded for understanding, but the only thing she told me she could commit to was a cat. Most tragic of all, however, is the fact that people are afraid to commit to G-d. The *one Source* that can help them overcome their fears, they are also afraid of, so a vicious cycle sets in.

If man is to have inner peace and live free of fear, he must be in harmony with his Creator. But every sin and every rebellious act creates a blockage in his soul, which over a period of time becomes a massive wall separating him from his Heavenly Father. Alone, the universe becomes a very frightening place, but with G-d, the possibilities are infinite.

"Though I walk in the valley overshadowed by death, I shall not fear, for You are with me" (Psalm 23). These immortal words of King David have sustained man throughout the centuries, giving him hope and enabling him to banish the darkness. Through the Book of Psalms, I taught Carol to call upon G-d and find healing for her troubled soul. Through a regimen of prayer, her entire life changed, and she was able to deal calmly and confidently with the daily challenges of life, which had previously thrown her off balance. Through prayer, Carol discovered that G-d is a forgiving, compassionate G-d who does not take pleasure in the suffering of His children. His only desire is that His children return to Him and live.

I was explaining all this at one of my seminars, when Sid, a young man in his thirties, confided that he also was consumed by fear, although different from the one I described. He simply could not handle the pressures of his office. He felt overwhelmed and lived in constant terror of finding a pink slip in his pay envelope.

"We have a wonderful teaching," I told him, "which enables me to cope with my own hectic schedule, and that is 'Blessed be G-d, day by day.' Just take things step by step.

"I never worry about things I have to do tomorrow. As a matter of fact," I shared with him, "I don't even worry about things I have to do on that self-same day. I just apply myself to that which I have

to do immediately, and when that is accomplished, I move on to the next. Think of your tasks as a phone book. Can you possibly read the phone book? No, but if you look for just one name at a time, you'll find it. Never think of all the things that remain to be done. Just do what you have to do and say, 'Blessed be G-d, day by day.'

"This advice is borne out in every situation. If you would like to climb a mountain, and you focus on the peak, you will become terrified. 'How can I do it? How can I climb so high?' A good mountain climber just starts to climb step by step, slope by slope.

"And as you make that climb," I told Sid, "it is important never to look down and never to look up. If you look down, you will feel faint—neurotic thoughts will enter your mind: How easy it is to fall. How easy it is to lose the job. And if you look up, you will once again become frightened: There's so much more that needs to be done. How will I ever do it? The idea is, step by step, thanking G-d for each moment, each hour, and each day that you can accomplish. And once again the psalmist helps:

> I look up to the mountains, from whence shall come my help.
> My help shall come from the L-rd.
> —*Psalm 121*

Sidney was not only overwhelmed by his work, but he had very little savings and feared for the future.

"How much is enough," I asked him. "How much would you need to feel really secure?"

He thought for a moment and then said, "I guess about a quarter of a million dollars."

"Sid," I said, "I guarantee that if you had a quarter of a million dollars in the bank, you wouldn't feel any more secure than you feel right now. I can introduce you to countless people who have that much and have the same complaint as you. 'What's a quarter of a million dollars today?' they will tell you. And the sad part of it, Sid, is that this mind-set holds true no matter how much money you have. Ask the man who has millions if he has enough, and he'll tell you 'What's a million today?'"

"Who is rich?" our sages ask. "He who is content with his lot," they answer (Ethics of the Fathers).

Unquestionably, man is greedy by nature, so contentment is not easily achieved. But it is achievable if you learn to *trust G-d*. That is precisely why, at the genesis of our history, G-d trained us to trust Him. It is written in the Book of Exodus that during the forty years of our sojourn in the desert, G-d gave us manna to *test* us. At first glance, this is difficult to understand. How could the manna have been a test? Can you imagine a gift more wonderful than that—having your bread fall from the sky every day without having a care? Could anything be more perfect?

But strangely, the Torah not only refers to the manna as a test but also as an *affliction*. How can we understand that?

The manna was one of the most severe ordeals that our forefathers experienced because the manna had to be gathered *daily*. And if you took more than your daily share, your manna turned wormy and gave off a putrid stench. G-d wanted to train us in trust. Trust in G-d implies that you rely on Him to provide for your needs each and every day. Trust implies that you place your confidence in G-d and do not allow your insecurities and greed to control your life.

On only one day of the week did G-d permit us to gather a double portion of manna, and that was on Friday. In honor of the Sabbath, the manna remained fresh. But other than that, we had to rely upon Him to provide our daily needs, day by day, step by step.

Unfortunately, over the centuries, we have forgotten this lesson of the manna. We gather and we hoard, but no matter how much we have, it's never enough. We feel so insecure about our future that we can't enjoy our present. We are so worried about what we don't have that we can't take pleasure in what we do have. Our holdings become putrid and wormy, because the more we have, the more terrified we become of losing it.

Trust in G-d is the credo of our faith. The knowledge that help from G-d is forthcoming has enabled us to commit to meeting the many challenges of life with confidence and strength. Those who have this trust are not afraid to commit to marriage, to bringing children into the world, to leading fulfilled lives.

Fear is probably the most futile, the most counterproductive emotion that we can allow in our hearts. It paralyzes us. It saps us of our energies, and it robs us of precious time. What's more, if we take a good hard look at ourselves, we will realize that ninety-nine per-

cent of the things we worry about never materialize. So if we look back on our lives and realize all the time we wasted worrying about what could be or what might be, we would feel devastated at the thought that we had squandered G-d's most precious gift to us—the days of our lives.

Let's take a lesson from the manna and rely upon G-d to provide for us each and every day.

୬ 9

Compassion

"I am with you in your suffering."
—Psalm 91

FEELING YOUR BROTHER'S PAIN

I bumped into Mike at the supermarket. My heart went out to him. How does he go on, I wondered. And as if he had read my mind, he said, "Rebbetzin, I must tell you, if not for your Rabbi, Shirley and I would never have made it. Please convey our appreciation to him."

Mike and Shirley had suffered a terrible tragedy. They had lost their one and only child in a horrible car accident. They were not members of our congregation, but that did not make any difference to my husband. When he heard their tragic story, he went over to their house and spent time with them every day of the *shiva*.

Consoling mourners is always difficult, but when a child is involved, it is doubly so. Such a death upsets the natural order of the world, in which it is children who are called upon to say Kaddish (the mourner's prayer) for parents, and not parents for children. I reminded myself of Aaron, the High Priest, who upon hearing of the loss of his two sons remained silent, underscoring the wisdom of silence. Under such circumstances, there is really nothing that one can say, but still, here was Mike telling me that my husband had brought some healing to his anguished soul, so I couldn't help but wonder what his words of consolation might have been.

That evening, I told my husband of my chance encounter. "Mike is so grateful to you. What exactly did you tell him that he found so helpful?"

My husband just looked at me and shrugged his shoulders. "Nothing," was his reply. "What could I have possibly said? What could anyone say under such circumstances?"

"Did you tell them the story of Rabbi Meir and Bruria?" I asked.

"No," he answered. "Perhaps I should have, but somehow the timing was never quite right."

The Talmud relates that Rabbi Meir and Bruria were blessed with two wonderful sons who tragically passed away one Sabbath afternoon.

When Rabbi Meir returned from synagogue, he asked Bruria, "Where are my boys? Why weren't they in synagogue?"

Since the Sabbath is a day of joy on which we are not permitted to impart sad news, Bruria said, "Make the prayer of farewell to the holy Sabbath, and then I will tell you."

Rabbi Meir made the appropriate blessing, and once again he turned to his wife and asked, "Where are my boys?"

"Before I tell you about the boys, I have a question that requires a rabbinic decision," she said. "Some years ago, a man came and entrusted two precious jewels to me for safekeeping. Today he came and demanded that I return them to him. Am I duty bound to return those jewels?"

"Bruria, I can't believe that you're asking such a question," Rabbi Meir said. "Of course you must return them."

"I thought you'd say that," she whispered.

With that, Bruria asked her husband to accompany her to the boys' room. There, lying on the bed, were the two children. Rabbi Meir gave out an anguished cry, "My sons! My sons!"

Sobbing, Bruria said, "Did you not tell me that when the owner comes and asks for the jewels, they must be returned? Should we not be grateful for the years that they were entrusted to us?"

"You have comforted me," Rabbi Meir said through his tears.

Jewish tradition teaches that when we recall those who passed away, we pronounce a prayer, "May their memory be for a blessing." But if we are overcome by the tragedy of death, those words become difficult to express. Our sorrow becomes so all-encompassing that instead of remembering the smile, the sweetness, the joy that once was, we recall only the striking rod of the angel of death. If, however, in the midst of our pain, we remember Bruria's words and focus on the precious jewels that G-d granted us, even if only for a brief moment, we will understand that their memory is a blessing that lives on. So it is that the teaching of Bruria has sustained and given comfort to bereaved families throughout the generations.

My husband, however, didn't relate this story to Mike and Shirley, and I was really at a loss to understand what he could have said to them. This was not idle curiosity on my part, since many people turn to me in times of distress, and I was anxious to know how he had comforted them so that I might apply it to others in such circumstances.

As things turned out, a few weeks later Mike called and asked if he and Shirley could come over and visit with us. Of course, I answered, and we set a date for the following Sunday night.

When Mike and Shirley rang our doorbell, my husband was still

at the synagogue, and I thought to myself that this would be the perfect time to find out exactly what had transpired during those *shiva* nights.

"Mike, do you remember when you told me how comforting the Rabbi had been?"

"Oh, he saved our lives," he interrupted.

"What did he actually say? Can you recall his words?"

Mike was silent for a while, as if he was searching his memory. Then he swallowed hard and said, "Nothing. I know it sounds crazy, Rebbetzin, but really, nothing—that is, nothing that I can quote."

He must have noted the puzzled look on my face because he explained. "When the Rabbi entered our house, he walked straight up to me, put his arms around me, and then," Mike added, his voice filled with emotion, "the Rabbi broke down, and cried with me."

Mike paused for a moment, took out a handkerchief, and blew his nose. "Rebbetzin," he said, "no one cried with me like that, except Shirley. The Rabbi came every night and he took on my pain. I will never forget it as long as I live."

"But do you know what I think it was that made all the difference?" Shirley interjected. "He didn't have to say 'I'm sorry.' We *felt* he was sorry. He hardly knew us, but he took us into his heart, and just knowing that he was there made it easier. He's the most compassionate man that we have ever met," Shirley added.

The Hebrew word for compassion is *rachamim*, derived from the root word *rechem* (womb), teaching us that genuine compassion is akin to the feelings of a mother toward the child she carries. This holds true not only in times of crisis and anguish, such as were experienced by Shirley and Mike, but also in normal day-to-day situations. If you wish to touch people, nothing can substitute for a heart that feels another's heart. That's the meaning of compassion; that's the feeling that entitles a man to assume the mantle of leadership.

The Midrash relates that G-d chose Moses to be the leader of His people because one day while Moses was shepherding the flock of his father-in-law, Jethro, in the desert, a little lamb ran away. Moses, concerned for his charge, went in search of it. After a while, he found the kid drinking at a brook.

"My poor little lamb," Moses said, reaching out to it. "I didn't know that you were thirsty. Forgive me, you must be weary." And

with that, he picked up the lamb, placed it on his shoulder, and carried it back to the flock.

Then a Heavenly voice was heard: "This is the man who is worthy of shepherding my people."

Moses was brilliant, strong, handsome, and powerful. The Bible testifies that no man ever lived who even came close to his greatness. Yet that which rendered him worthy of leadership was neither his brilliance nor his strength, but the tenderness with which he carried that little lamb on his shoulder.

It is this trait of compassion that separates one man from another and endows him with greatness. Moses came by this feeling naturally. It was a part of his spiritual heritage, a legacy from his great grandfather, Levi. In contrast to the other tribes in Egypt, the Levites were never enslaved, but Levi, the patriarch of the tribe, felt the impending bondage with such intense pain that when his sons were born, he gave each of them names that would remind them of their people's suffering.

Moses was raised in the palace of the Pharaoh. He was a royal prince, an heir to the throne of the mightiest empire in the world, and yet he chose to give it all up so that he might join his oppressed brethren in the slave camps. To feel your brother's pain—that is the meaning of compassion, and that is the stuff that great parents, great teachers, and great leaders are made of.

When the Holy Temple stood in Jerusalem, while the High Priest was conducting services he was not permitted to wear shoes.

Why, you might ask, was there such a prohibition?

Although there may be many reasons, the most salient one is that he who walks barefoot feels every little pebble, every little grain of sand, reminding the High Priest that as the leader of his people, he had to feel the heartbeat of every person, hear his cry, and see his tears.

There are, of course, those who might argue, "Of what avail is it to assume someone else's pain? If you can't eliminate their suffering, why cause yourself distress?" The Midrash teaches us that such was the thinking of Job.

Pharaoh had three principal advisors—Bilam, Jethro, and Job. When the "Jewish problem" came up for discussion, Bilam recommended the murder of all Jewish male infants. Jethro (the future

father-in-law of Moses) protested and had to run for his life. Job, upon witnessing all this, concluded that it would be futile for him to speak up and remained silent. And it was for this silence that he was later punished.

It's natural for people who experience pain, even from a minor injury, to cry "Ouch!" Such a reaction is an involuntary reflex. The one who is hurting does not calculate "What's the point of my crying 'ouch'? It won't help anyway." His reaction is automatic, beyond his control. If he remains silent, if he does not cry out, we can assume that he did not feel the pain with any degree of intensity. Job remained silent when Jewish blood was shed, but when, in another time, in another age, his own children were dying, he cried out in torment.

There were others in the palace who, even as Job, had to make choices. Two Jewish midwives, Shifra and Pua (pseudonyms for Yocheved and Miriam—future mother and sister of Moses), were summoned to the palace. Under pain of death, they were ordered to kill all newborn male children. These two women not only protested the evil of Pharaoh, but they did everything to subvert it. Not only were they determined to preserve the life of every child, but they went a step further and beautified and shaped (Shifra) and energized with loving, cooing sounds (Puah) every Jewish infant.

These two little ladies took on Pharaoh and his royal legions as well as the entire Egyptian empire to save innocent little lives. Their inordinate strength stemmed from their reverence for G-d and compassionate, loving hearts.

As a survivor of the Holocaust, I always wondered about the shameful silence of the world. "What could we have done?" people ask. You could have tried to emulate the two little ladies in Egypt and found ways to save our lives, but at the very least, you could have cried "Ouch!" You could have said, "I feel your pain, I heard your cry."

Hungary was one of the last countries in Europe to be occupied by the Nazis, but as I mentioned before even prior to the German invasion, Jewish young men were conscripted for slave labor. My husband related to me how one day the Hungarian gestapo came to take away his older brother, Yosef Dov. A brilliant young Talmudist, the author of many scholarly dissertations, Yosef Dov was held in high esteem and respected by everyone. When the Hungarian anti-

Semites came, they shaved off his beautiful rabbinic beard and beat him for good measure. They forced him onto a truck that raced off at high speed. My husband told me that that night his mother, the Rebbetzin Chaya Sora, did not go to bed but sat in her chair the entire night, weeping and praying for Yosef Dov. Days turned into weeks, weeks into months, and the bed of my mother-in-law remained unslept in.

A year earlier, my husband's father, Rabbi Osher Anshil Jungreis, a rabbi of great eminence and scholarship, had passed away in a hospital in Budapest. As the youngest son, my husband was the only male remaining at home. He felt a responsibility to care for his mother, and ever so gently, he tried to suggest that she needed her rest and should lie down in her bed.

"How can I rest? How can I lie down in my bed when my Yosef Dov is not here?" she wept. And so, she sat in her chair, night after night, until the day that the Nazis came and deported her, my husband's sisters, their small children, and all those who remained in their town to the gas chambers of Auschwitz.

What is the meaning of compassion—*rachamim*? To feel for another as a mother feels for her child.

My husband, a descendent of the tribe of Levi, the son of Rebbetzin Chaya Sora, felt the pain of Mike and Shirley, and that knowledge that someone felt with them made their pain somewhat easier to bear.

If someone you know is hurting, just remember Mike and Shirley. You may not be able to remove their suffering, but you can help them shoulder their burden by being there for them, by feeling their pain, by extending your hand. That's the meaning of compassion.

ACTS OF LOVING-KINDNESS

Goldberg was the butt of our neighborhood pranksters in Brooklyn. Children would make fun of him, throw debris at him, and tease him. In short, he was a pitiful figure. In his younger years, he had been a successful boxer, but then he took one blow too many to the head, and this last injury left him disoriented and mentally unbalanced. He would sit in the street, disheveled and dirty, muttering to himself.

Then one day my father discovered him. He brought him home, sat him down at the table, and made him lunch. We children were annoyed at Goldberg's presence. He was coarse and ill mannered, and we were not used to seeing adults act this way. Most of all, however, I was irritated by his crudeness. I couldn't bear to hear him yell, "Rebbe, more coffee!" The thought that my father, the holy sage, the great Torah scholar, should be addressed in this manner was just too painful. Not once, but many times, I felt tempted to tell him off and throw him out.

One day when he was especially obnoxious, I voiced my feelings to my father. "My child, you are wrong," he answered patiently. "Goldberg is not being disrespectful—he does not know any better. He is a tragic, lost soul, and we must try to help him."

"But Tatie," I pleaded, "why must a Torah sage be his waiter?"

My father smiled. "Don't worry about my *kavod* [honor]. It is our privilege to serve him. Didn't our father Abraham wait upon strangers? Didn't he extend kindness to each and every person who came his way? Didn't our teacher Moses serve his guests? And doesn't G-d serve us every day? Now then," my father concluded, "take Goldberg into the kitchen and help him wash his hands ritually so that he can come to the table and partake of bread."

Jewish tradition mandates a special ritual washing of hands prior to partaking of bread. Since the destruction of the Temple, the table has been considered an altar, and every meal is regarded as a service to G-d, with appropriate blessings and prayers recited. In the past I had shown Goldberg this process many times, but this time it was different. My father's words left me humbled and challenged.

For many years Goldberg would come to our home, and my father would painstakingly teach him to read the letters of the

Hebrew alphabet, to make blessings, to pronounce prayers. And then one day in the synagogue, Goldberg was called up to the Torah and celebrated the bar mitzvah he had never had as a child. As Goldberg pronounced the ancient words, he broke down and wept, and many in the synagogue wept with him.

From that moment on, Goldberg became a new man. He walked straighter, he felt pride in himself, and with seriousness he applied himself to being counted in a minyan (the quorum needed for daily prayer). Goldberg felt needed. Through his presence, through his prayers, he felt he contributed to G-d's master plan.

Then one morning Goldberg failed to show up at services. My father went to his little apartment and knocked on the door, but there was no answer. He called the superintendent, who opened the door, and there was Goldberg, lying stiff on the floor, dead. On the night table next to his bed was the open prayer book from which my father had taught him to pray. That prayer book was more than a book. That prayer book enabled Goldberg to find meaning and dignity in life.

Our Torah teaches that G-d built the world on acts of loving-kindness. There are few things that make sense in our earthly existence, but that which makes life precious and worthwhile is the ability to give, to reach out to others, and to continue G-d's creative process, through fostering generosity and committing to acts of loving-kindness.

In our society we tend to associate giving with money, but more than money, we are called upon to give of ourselves. The Talmud teaches that for monetary gifts one receives six blessings, but for acts of loving-kindness, eleven (almost double) are granted. Sure, it takes less effort to write out a check than to give of your heart, but still the most enriching experience is to give of yourself. Admittedly, reaching out to the Goldbergs of the world is, to say the least, not easy. You must have a deep commitment to G-d to see beyond their repulsive appearance. My father, a true servant of G-d, was able to do that, but for most of us, such goals are unrealistic. Nevertheless, we can learn to extend a kind word and a helping hand, and at the very least, to give a smile to the many people who are suffering from that painful condition—loneliness. Such expressions of love and concern can literally infuse them with new life and hope.

I was addressing a singles convention when a woman who appeared to be in her forties approached me. "Rebbetzin," she said meekly, "I thought you might be the one to give me an honest answer."

"Tell me," I said.

"I would like to know," she said haltingly, "if something is wrong with my face, or with the way I look, the way I dress?"

Taken aback for a moment by the hurt that resonated in her question, I assured her that she had no basis for doubting herself.

"Then how do you explain," she asked, "why it is that in the six years since my husband died, I have attended many gatherings and social functions, but no one has ever come over to say hello to me."

This woman was not asking about dates. That's a separate issue. She was just craving for some friendship, for some gesture of kindness. So what is the answer to her question? Can it be that in our quid pro quo society, friendship with her would not justify the effort? A quiet widow, without any special assets or connections—why should anyone exert himself to befriend her?

In the Torah world, giving in general and extending friendship in particular are viewed from a totally different perspective. The Hebrew word for giving, *natan*, is a palindrome (a word spelled the same way backward and forward), teaching that everything that we give comes back to us a thousandfold. That which we spend on ourselves—the jewelry that we buy, the restaurants we frequent, the vacations that we take—may give us momentary pleasure, but the excitement soon fades. By contrast, that which we give to others stays with us forever: the memory of a smile, the happiness in the eyes of those we touched with a gesture of kindness and love will never be erased. Ultimately, it is we who receive when we give. It is we who are granted the gift of life.

When G-d commanded Moses to kindle the menorah lamp, G-d instructed him to "take the oil for lighting for himself" (Exodus 27:20). Our sages commented upon the apparently superfluous words *for himself*, explaining that G-d wished to impress upon us that it's not for *His* sake that we kindle the light but for our own illumination. When you bring light to the dark chambers of a lonely, hurting heart, that light will be reflected in your own soul forever in blessing.

Love Him More

A mother once consulted my husband about her wayward teenage son, and he advised her to follow the teachings of the Hasidic rabbis, "Love him more."

We live in a difficult generation. There are so many pulls tugging at the hearts of our children, so many temptations drawing them, that it becomes very easy for them to stray. The teaching of the patriarch Jacob, when on his deathbed he reprimanded his son Reuven, comes to mind.

Our sages ask, "Why didn't Jacob admonish Reuven immediately when he acted inappropriately? Why did he wait so long?"

The answer given is that our patriarch feared that if he spoke critically to his son, Reuven would abandon his father's home and take up residence with his evil uncle, Esau. Today that fear is multiplied a thousandfold. There are many uncle Esaus out there waiting to pounce upon our children and take hold of their lives. We can't afford to come down too hard on our grown sons and daughters. If discipline is to be effective, it must be administered at a young, tender age, when children are still pliable and their character traits are not yet fixed. Once they become young adults, however, the only way to relate to them is with compassion and love.

Unfortunately, in our society just the opposite holds true. When our children are small, we indulge their impudence and regard it as cute and clever, and when they become older, we wonder how they ever got that way. Young adults cannot be badgered into compliance. If we do not see eye to eye with our children, the only way we can hope to reach them is through compassion and love. Time and again I have been asked what arguments I use to convince people to give up their errant ways. Truth be told, I try to keep low on arguments and high on kindness and love.

Adults who in their youth have never been taught the meaning of their faith will not respond to harsh statements, tongue-lashing, or admonishment. Only through understanding and compassion will their hearts be touched.

There is a telling story of a young Jewish boy in Russia who heard that he was on the list for conscription into the Tzar's army. The boy panicked. He knew only too well that this meant a living

death sentence. Jewish boys in the Tzar's army were held in servitude for many years. Some of them never saw their families again and were forced to give up their faith. This was one of the cruelest periods in Russian Jewish history.

What could this poor boy do? How could he save himself from the brutality of the Tzar's army? In desperation he decided to seek out the rabbi of his town for a blessing. Who knows, he said to himself, maybe, just maybe, the rabbi's blessing will work and they won't take me away.

"My son," the rabbi asked, "do you keep the holy Sabbath?"

"No," the boy answered shamefacedly.

"Do you keep kosher?"

"Sometimes," came the weak answer.

"Do you pray? Do you make blessings?"

"Not really," the boy said in a low voice. His heart sank. He knew he would never be given a blessing now.

The rabbi studied the young man for a few moments and said, "My son, I give you the blessing that when the conscriptors of the Tzar come for you, they should be as disappointed in your answers as I am."

It took a few minutes for the boy to absorb the rabbi's words. Then his face broke out in a grin. He realized that the rabbi had given him a wonderful blessing. The rabbi's choice of words was also not lost on him. He didn't say, "I'm disappointed in you." Rather, he said, "I'm disappointed in your *answers*," a method learned from our patriarch Jacob, who when criticizing his sons Simon and Levi condemned their quick tempers but never their persons (Genesis 49:7).

Obviously the rabbi could have admonished the boy and chided him for his infractions, but what good would have come of that? The boy would only have become more embittered. By relating to him in kindness and compassion, the rabbi awakened a spark in the boy's heart that hitherto had been dormant. The boy made a silent pledge that he would justify the rabbi's confidence and make him proud of him.

"Love him more," the rabbis said. My husband, in reaching out to the members of our congregation, did just that. How do you get people to pray who never prayed before? How do you explain to them the importance of silence during services when they are accustomed to chatting all the time?

Instead of berating people for being noisy, my husband would tell them of a special blessing reserved for those who refrained from conversation during prayers. Instead of castigating them for not coming to synagogue regularly, he would tell them how wonderful it was when they did come. "Your very presence," my husband would say, "brings joy in the heavens above." So it was that he was able to inspire the uncommitted to commitment.

Our family's way of reaching out through love and kindness has been taken over by our children, so when this past year our Hineni organization decided to hold High Holiday services at a hotel in New York City, I just knew that special things would be happening. No sooner did we announce our plans than our young people responded most enthusiastically. What was truly inspiring, however, was to behold the eagerness with which they shared their newfound faith with their parents.

In past generations, the opposite was true—it was parents who tried to inculcate faith in their children. Many explain this phenomenon by citing the prophecy of Malachi that speaks of the advent of the Messianic period, when the young shall bring the word of G-d to their elders. However you choose to interpret the signs of our times, the fact remains that our young people are inspiring their parents to commit to G-d and His Torah, and that is something that never happened quite this way in our history.

Stanley was part of our Hineni Young Leadership group, and he was anxious to share this spiritual experience with his father, so he eagerly made High Holiday reservations for his entire family.

"I want Dad to experience a true Yom Kippur. I'm hoping the services will bring him closer to G-d. I want to share my love for Torah with him. It has brought so much joy into my life. I want him to have the same feeling."

The impact of the services was more than we could have hoped for—so much so that although there was a break the afternoon of Yom Kippur, no one wanted to leave, and I conducted a special seminar on the Book of Jonah. We were all on a spiritual high, and despite the fact that everyone was fasting, we were loathe to see the day end. When the services were over, in the rush of exchanging wishes for a good New Year, I didn't have the chance to find out from Stanley how his father had fared. A few weeks later, however, at

our Succos holiday celebration, Stanley came over to me and said, "Rebbetzin, I have something incredible to share with you. That Yom Kippur service just went into our souls, but I don't trust myself to tell you about it now because I might just get too emotional."

Anxious to know what had transpired, I pulled him to the side and invited him to tell me the story then and there.

"I was sitting next to my father, and throughout the services I felt a tremendous kinship with him. Then your son Rabbi Osher came over to us. He had discovered that we are Kohanim [belonging to the priestly tribe], and he wanted us to come up to the ark to pronounce the priestly blessing. My father was taken aback. 'I can't, I'm not observant,' he said. 'I'm not worthy.'

"Rabbi Osher put his arm around my father's shoulders and said, 'It's Yom Kippur. Today we are all worthy; today we are all forgiven.' And then he escorted my father and me to the ark. The congregation rose for the blessing, and as my father pronounced the ancient words together with the other Kohanim, I felt his body tremble. My father was weeping, and I wept with him. Somehow I felt as though with our tears we had wiped away all those years that we had been away from our faith. Something special happened between my father and me on that Yom Kippur—something that has changed our lives and brought us closer than ever before."

How can you reach this generation? How can you have an impact upon those who are disconnected? Make a commitment to love them more. Put your arm around their shoulders and speak to them with kindness and compassion.

ಲ್ 10

Faith

"In the struggle with evil, only faith matters."
—Ba'al Shem, founder of the Hasidic movement

How Can You Believe?

I was asked to address the students at the Bronx High School of Science at a Holocaust Remembrance program. The audience was multinational, with Asian-Americans predominating. A speaker always knows when an audience is with him or her, and though I couldn't see all the faces in the vast auditorium, I felt a oneness with the students as if they were drawing each breath with me. I saw many of the girls in the front row take tissues from their pockets, and the eyes of the boys were moist as they tried to control their tears.

A student choir sang beautifully, in perfectly accented Hebrew, "*Ani Ma'amin*," the song the martyrs sang as they were marched to the gas chambers. *Ani Ma'amin* is one of the thirteen principles of the Jewish faith. It means "I believe with perfect faith in the coming of the Messiah, and although he may tarry, nevertheless, I believe." With that song, our holy martyrs triumphed over evil and imparted a legacy of faith for all time.

Following my address, Stanley Blumenstein, the principal, a scholarly, refined gentleman, asked if my schedule would permit me to visit the school's Holocaust museum and meet with the students of the Holocaust Studies program in the faculty dining room. I readily acceded. Whenever I address an audience, I always try to leave time for questions and answers and one-on-ones. I find these exchanges very rewarding for it gives me an opportunity to get to know the people and to respond to their concerns. The students at the Bronx High School of Science were bright and well informed, and I was looking forward to our discussion.

"Could you describe a typical day in Bergen-Belsen?" one of the boys asked.

For a moment I was taken aback by the question, for though I have spoken extensively on the Holocaust, no one has ever asked me to be quite so specific. The words echoed in my mind—"a typical day in Bergen-Belsen." How could I even begin to relate to these young people what life was like in Bergen-Belsen? To this very day I myself have difficulty comprehending it.

"Every morning," I began slowly, "at the crack of dawn, we were awakened for roll call. With shaved heads, dressed in rags, covered with lice, we stood at attention waiting for our 'masters' accompa-

nied by their German shepherds to inspect us. When they finally appeared, bedecked in their immaculate uniforms and shiny boots, armed with pistols and whips, shouting '*Achtung! Heil Hitler!*' terror froze our hearts. They called us '*Judishe schweinhund*' (Jewish pigs) and did all they could to degrade us, but no matter what they chose to call us or do to us, they could not destroy our spirit. We always knew who we were."

The remainder of the day, I told the students, was a blur in my mind—a blur of darkness and suffering. A simple thing like relieving oneself was a frightening experience. The latrines were hazardous; the stench was overpowering and rodents were a constant menace. I was always petrified of falling in, and even walking to them was an act of courage.

Going to sleep at night was another form of torture. We slept on bunkbeds, on wooden slats, without mattresses, suffocated by the foul odor of unwashed, diseased bodies. Several people were assigned to each bed, and we were packed so tightly that we couldn't stretch or turn over. I was on the bottom level, and above me was a woman with her small children, who invariably "showered" me during the endless night.

To add a little humor, I related to the students that a few years ago, at a lecture in Brooklyn, a heavyset, elderly woman approached me, enveloped me in a bear hug, and said in a strong Hungarian accent, "Esterke, you may not remember me—when we last met you were just a little girl—but my children and I slept in the bunk above you in Bergen-Belsen." I assured her that I had never forgotten!

"How did you keep alive? What did you eat?" asked another student.

"We were always starving. We received a daily ration of bread, which looked and tasted like sawdust, and then there was some putrid liquid, which they called coffee or soup, and a concoction made from animal fodder. Initially we couldn't eat it, but as our hunger intensified, we actually came to relish it.

"I remember on one particular day, there was an inspection by the Red Cross. To demonstrate that we were well fed, our captors brought in barrels of cooked snails! We were emaciated and starving. Anything would have looked tempting, but snails are not kosher, although under the circumstances no one would have condemned us

for eating them. Nevertheless, we did not touch them. We simply could not bring ourselves to transgress the commandments."

"With all that suffering, how did you manage to retain your faith?" asked a girl with warm, sensitive eyes.

I pondered the question for a moment. It never occurred to me that there was something remarkable about my keeping my faith. To me, believing in G-d like breathing. How else could I have survived? My faith was not based on blind acceptance of some dogma but rather upon the knowledge of our collective experience at Sinai, when G-d revealed Himself and proclaimed His commandments. This knowledge is the heritage of all of our people, so much so that until assimilation made its inroads, belief in the existence of G-d was never an issue. Our trust and our level of commitment may have been questioned by our prophets and sages, but never did they fault our belief. I wasn't planning to get into all that with the students, though. Understanding what motivated their doubt, I answered their question with a question.

"If not G-d, what could I have believed in? Humanity? I may have been young, but I understood only too well that what the Nazis did to us had the tacit approval of the civilized world.

"I come from Hungary," I told the young people. "Hungary was one of the last countries to be occupied. Toward the end of the war, the Nazis realized that they were losing, so Adolph Eichmann, who was in charge of the deportation and extermination of Jews, called in Dr. Kastner, the president of the Hungarian Jewish community, and tried to make a deal with him. 'Goods for blood; blood for goods,' Eichmann offered. 'You can take them from any country you like, wherever you can find them. Whom do you want to save? Men who can beget children? Women who can bear them? Old people? Children? If you tell me that my offer has been accepted, I will close Auschwitz and bring ten percent of the promised million to the frontier.'

"Joel Brandt was commissioned to go to Turkey and contact the Allies on behalf of the Hungarian Jewish community. For the first time, the deportations slowed down and we saw a glimmer of hope, but both London and Washington categorically refused the offer to redeem us. The news quickly filtered back to Budapest, and once again the trains rolled full speed ahead to Auschwitz."

This, I told the students, was just one small example of the free world's policy vis-à-vis Jews.

"In 1941 the *Sturma*, a ramshackle cattle boat, sailed from Romania with seven hundred and sixty-nine people crammed on board, in a desperate attempt to reach Palestine. The conditions aboard were abominable, but miraculously the ship reached Turkey. Turkish policemen forced their way on board, tied it by cable to a tug, and towed it into the Black Sea where it was sunk.

"Think about it," I told the students, "through herculean efforts, seven hundred and sixty-nine Jews escaped from Hitler's inferno and miraculously reached the shore of freedom, only to be drowned.

"And then there was the *St. Louis*, a ship that left Hamburg, Germany, at the very beginning of the war with nine hundred and thirty passengers on board. They were among the privileged few who had Cuban visas as well as American immigration quota numbers. Despite this, Cuba and the United States refused them sanctuary. They were forced to return to Germany, and Hitler got the message loud and clear—no one would resist the extermination of Jews.

"In view of all this," I told the students, "how could I possibly have placed my faith in humanity? In what and in whom could I believe if not in G-d? And for those of you who are under the impression that education can civilize a man and render him a compassionate being, allow me to remind you that it was scientists, engineers, and chemists who built the gas chambers and devised ways to convert our skin into lampshades, our fat into soap, and our bones into fertilizer. Highly educated and cultured people, with impeccable manners, sensitive to music and art, inflicted a thousand and one deaths upon us. So what could I believe in," I asked the students once again, "if not G-d?"

"Truth be told, with all the progress of civilization, nothing much has altered since the day when Cain, the first murderer, slaughtered his brother. When G-d challenged him with 'Where is your brother?' he responded audaciously, 'Am I my brother's keeper?' (Genesis 4:9), insinuating that he was not responsible and that G-d should have prevented him from killing.

"Like Cain, modern man plunders, murders, and rapes, but instead of accepting accountability for his heinous deeds, he shifts the blame to G-d. 'Where was G-d?' is the post-Holocaust cry. In

response I, who was there, ask, 'Where was man?'

"You ask me how I could have faith? How could I not? It is only faith in G-d that kept us sane in those days of darkness. It is only because of G-d that we, the Jewish people, have survived because had man had his way, the Jews would all have perished."

There was silence in the room, and I sensed that the students wanted to hear more, so I went on.

"G-d has endowed man with a great gift, and that is free choice. 'Behold, I set before you today blessing and curse. Blessing if you shall listen to the commandments of the L-rd your G-d, and curse if you do not listen' (Deuteronomy 11:26–28). It is for us to choose, and we must accept accountability for that choice.

"If there is any one teaching I hope you will take away from our talk, it is that G-d charged each and every one of us with the responsibility to make this world a better place, and if we betray that responsibility, then we have no one to blame but ourselves. We can't have it both ways—we can't accept credit for our accomplishments and blame G-d for our failures. You, the students of the Bronx High School of Science, enjoy a great reputation for scholastic excellence. One day you will most likely be leaders of society, and if you remember this lesson—to choose blessing and to be prepared to sacrifice for that blessing—you will surely make a difference in the world."

"But isn't this a hopeless mission?" one of the girls now asked. "Didn't you just tell us that you lost your faith in mankind?"

"Not quite. I may have lost my faith in humanity during the Holocaust, but that doesn't mean that that loss of faith is permanent or that man cannot alter his behavior. Dormant within every human being is the spark of G-d, and if we plug into that energy, the voltage is infinite. It really is quite simple. We need only follow the path of blessing that our Bible has prescribed, and we will discover that even in the darkest moments we have a choice—to invite G-d in or to banish Him from our lives. Let me tell you one final Holocaust story to illustrate my point:

"One of the first American Jewish chaplains to arrive at the concentration camps was a well-known rabbi named Eliezer Silver. The sight that he beheld was beyond description—piles of dead bodies strewn all around, and those who were still alive were living skele-

tons, so emaciated that they didn't even cast a shadow. With tears in in his eyes, the rabbi went from survivor to survivor, speaking to them, comforting them, trying to infuse them with life. Those broken souls were all deeply grateful for their deliverance and expressed thanks to G-d, but there was one man who was very angry.

"'I have no use for rabbis,' he said bitterly. 'After what I saw, I'm through with religion.'

"'Would you like to tell me about it?' the rabbi asked patiently.

"'I'll tell you alright,' he retorted. 'There was a religious Jew in our camp who somehow managed to salvage a prayer book. And do you know what he did with it? If anyone wanted to pray from his book, they had to give him their portion of bread. And you should have seen all the people whose bread he took! Well, after seeing that, I have no use for religious Jews.'

"'My son,' Rabbi Silver answered gently, 'instead of thinking about that one man who demanded bread for every prayer, why don't you think about the hundreds of Jews who were willing to give up their bread in order to pray from that prayer book.'

"That's what it's all about," I told the students. "You can either look at one wretched man, see evil, and justify your own cynicism and bitterness, or you can search for the spark of G-d within the soul of man, choose the path of blessing, and build on it."

Putting Yourself on the Line

If you were to choose just one word to describe Sandy, it would have to be *maddening*. She had this uncanny way of saying and doing things that could drive you up a wall, but she did it with such charm that even if you wanted to, you couldn't get angry with her. She was kind, generous, and always full of fun.

I first became involved with her when she started to attend my Torah classes. She was bright and quick to apply her newfound knowledge to her daily life. The only area that she had difficulty with was curbing her tongue. Time and again I would explain to her that Torah law is very stringent in this regard. She tried, she really did, but her natural temperament always surfaced.

Sandy had two teenage daughters. As she became more and more involved in Judaism, she regretted never having had a son. "If you would give me a blessing that I have a son, Rebbetzin, I would have another baby immediately," she said.

"Sandy," I told her, "I'll gladly give you a blessing, but there are no guarantees. We can pray, but we can't dictate to G-d what He should do."

Sandy refused to accept this. In her book, a blessing was a guarantee, and she blamed me for not being more definite. No matter, I loved her and was prepared to accept her on her terms.

Then one day I made a special celebration in honor of my son Osher Anshil's third birthday. The third is a very significant birthday. It is then that a little boy gets his first haircut. It is then that he puts on a yarmulke and starts learning the sacred Hebrew letters of the *aleph-beit* and is launched on the path of becoming a Torah scholar. I wanted this celebration to be as beautiful as it could be. My maternal grandfather, Rabbi Tzvi Hirsh Kohn, was old, frail, and ailing. In my heart of hearts, I sensed that this would be the last family gathering he would be able to attend, and unfortunately, my fears proved to be well founded.

I was in the midst of my preparations, hurrying to get everything ready, when the phone rang. It was Sandy. I asked her to excuse me, explaining that I was expecting company and couldn't talk, but that didn't deter Sandy.

"Who is coming?" she pressed.

When I told her, she became jubilant. "I can't believe it," she said. "Three holy rabbis in one room—your grandfather, your father, and your husband. It's like a rabbinic court. I'm coming right over to get my blessing. Now I'm sure I will have a boy!"

We were in the midst of the festivities when Sandy rang the doorbell. My grandfather was offering Oshie special cookies baked by my mother in the shape of the Hebrew letters, and as he gave him each cookie, Oshie called out the sound of the letter while we applauded and cheered him on.

"Oh, how beautiful," Sandy exclaimed, her eyes filling with tears. "When my baby is three years old, I will also make him a party like this," and with that, she beseeched all three rabbis for a blessing that she might have a boy.

My grandfather, together with my father and husband, blessed her, and Sandy, exuberant, ran to the phone to call her husband.

"Honey," I heard her say, "we're having a boy." And there was no convincing Sandy otherwise.

Sure enough, she became pregnant and gave birth to a little boy, to whom she gave the Hebrew name Tzvi Hirsh, never knowing that that was the name of my sainted grandfather, who passed away a month before the child was born.

I have often thought about Sandy. She may have lacked polish, and at times she may have been pushy, but she had total faith in G-d, something that is sadly lacking in our sophisticated world.

In our culture, we tend to associate such faith with a certain simplemindedness, if not outright foolishness, but in the Torah world, our scholars are not only people endowed with brilliant minds, but they also have souls that throb with unconditional faith and belief in G-d. Such was the great master teacher Reb Zundel, who was the dean of a yeshiva in Europe.

The yeshiva was very impoverished, and often the boys had to go without dinner. One day, news reached Reb Zundel that in a neighboring *shtetel* there was a philanthropist who was very generous. Reb Zundel decided that he had no option but to make the journey. Reluctantly he bade farewell to his disciples and made his way to the railroad station. While he sat there waiting for the train, one of the town's outspoken cynics came by.

"Reb Zundel," he exclaimed, "what are you doing here?"

"I am going to the next town to try to raise some funds for the yeshiva," Reb Zundel replied.

"Have you bought your ticket already?" he was asked.

"No," Reb Zundel responded.

"What do you mean? The train can pull in any minute!"

"I have no money," Reb Zundel explained, "but I am not worried. *G-t vet helfen*" (Yiddish for G-d will help).

The cynic shook his head and muttered under his breath, "These religious Jews are all crazy." And then he thought to himself, Let me have some fun. I'm going to wait until the train arrives. I want to see for myself how his G-d will help him.

Sure enough, a few minutes later a whistle blew and the train pulled into the station.

"Tickets, tickets," the conductor called loudly. "Get your tickets ready."

To the man's amazement, Reb Zundel got on line. I can't believe what I'm seeing, he said to himself. "Reb Zundel!" he called out. "Do you have your ticket?"

"No," Reb Zundel replied.

"Then why are you standing on line?"

"*G-t vet helfen*," Reb Zundel answered with quiet dignity.

The cynic scratched his head in perplexity. "I can't believe this," he muttered. "This rabbi is mad!" Then, approaching the rabbi, he said in a voice filled with exasperation, "Alright, Reb Zundel, I'm going to give you the money for your ticket now, but don't count on me again. You can't be so naive as to believe that G-d will help!"

The cynic was so blinded by his bias that he never realized that he was the instrument through which G-d sent help to Reb Zundel and his entire yeshiva.

G-t vet helfen is a teaching with which I grew up. Time and again, when our situation appeared hopeless, as in the days of the Holocaust, or when illness or sorrow struck, my father would reassure us with "*G-t vet helfen.*"

I remember our arrival in the United States, when my father came face to face with the terrible state of assimilation in the Jewish community.

"We will build a yeshiva," he announced, "and teach American children Torah."

"And from where will you get the money?" my mother, who was the pragmatist in the family, asked.

"*G-t vet helfen*" was my father's simple reply.

And G-d *did* help. My father built the yeshiva, and when things seemed desperate, G-d always sent another messenger to help, even as He did for Reb Zundel.

No one expects us to have Reb Zundel's or, for that matter, my father's faith. We are simply not on that level. We won't get on line for a train without a ticket in our hands. We will not build a yeshiva unless the seed money is in the bank. We may have dreams, but we do not have the faith to act on them. Still, we should bear in mind that even if we lack such intense faith, we are never alone. G-d's providence is always guiding us. He is aware of our every tear, our every sigh. We need only call unto Him and He will answer. "G-d is near to all those who call upon Him, to all those who call upon Him in truth" (Psalm 145).

Do Religious People Also Have Spiritual Conflicts?

Miriam was twenty-eight years old. She complained that she felt spiritually dead. While such a condition may not be unusual for some people, for someone in Miriam's circle it was highly irregular. Miriam was born into a religiously committed family in which the word of G-d was studied daily, where grandparents, aunts, uncles, and cousins were part of a warm extended family, where parents lived and breathed for their children.

Miriam attended parochial schools and was surrounded by a battery of good friends who shared her values. How then, you might ask, could a girl like this be spiritually burned-out? Do religious people also have spiritual conflicts?

"I was married at the age of twenty-one to a most wonderful man," Miriam confided. "He was kind to me, considerate of my parents, and charitable to those in need. He attended synagogue, studied the Torah, and in general lived by the laws of G-d. I considered myself the luckiest of people, but then misfortune befell us." And with that, Miriam related an unbelievable chain of events that led from one tragedy to another.

"My father-in-law died suddenly the night our first child was born. My husband lost three jobs in five years and at one point was out of work for over a year. My own father was diagnosed with cancer and had to undergo two major procedures, but all this was simply an introduction to my biggest test. I was nine months pregnant with my second child when it was discovered that I had a tumor that turned out to be cancerous. I saw six doctors in six days and was given a week to decide whether I wanted to have surgery, radiation, or chemotherapy—and how and when to have my baby.

"I ended up with a C-section and, a week later, had surgery at a different hospital. I then underwent six months of chemotherapy once a week as well as six weeks of daily radiation treatment, which, by the way, is one of the most humiliating experiences imaginable."

"Miriam," I said, reaching out for her hand, "just listening to your story is painful."

"That's alright," she responded. "That's not why I'm seeking your help. Thank G-d, I have since been given a clean bill of health. I could handle all this were it not for the fact that I have come to feel

spiritually burned-out. I pray, and I don't feel anything in my soul, and that frightens me."

"You can't always have a spiritual high when you pray," I told her.

"But people who went through what I went through should," she protested. "When I was a teenager, I had a very good friend. I will never forget her. She was the most righteous person I ever knew, and it never ceased to amaze me that an ordinary person could be so good.

"And then I learned that she had been close to death as a child and had undergone many serious medical treatments, so I reasoned that a brush with death was a surefire way to become close to G-d— guaranteed inspiration.

"But here I was, years later, lying on a table in a big room by myself, allowing poison to be injected into my body day in and day out for six months to fight a potentially fatal disease. While I did ask G-d to help me during that time, I didn't feel inspired. I'm no closer to G-d now than I was before I got sick. I pray, but I don't feel anything. I visit sick people, but I derive no satisfaction from it. I'm afraid this is proof that I am spiritually dead, and to me, that is a very frightening prospect."

"Miriam," I assured her, "I think that you are a most spiritual person."

"You're just trying to make me feel better," she protested.

"Not at all. Here you are, a young woman, having gone through so much—financial problems, serious illness, loss of loved ones— but despite everything, your only complaint is that you feel spiritually burned-out. I have a feeling that even as you admired your teenage friend and considered her a righteous person, so too many people look at you in the same light."

"Oh, Rebbetzin, please, that's too much!"

"Not at all," I told her. "How do you know what went on in your friend's heart or for that matter in anyone else's heart? A righteous person is not necessarily someone who never experiences spiritual crises but rather someone who despite crises remains committed to G-d. Righteous people are not perfect beings who never make mistakes, who never experience burnout. Rather, righteous people are those who despite everything, despite falling, despite burnout, stand up, start all over again, and continue to express their loyalty to our Heavenly Father.

"There is a tendency among many people to portray the righteous as superbeings who never had to struggle, who never experienced temptation, and who were never guilty of any errors. Well, that's simply not so, Miriam. Our sages teach that the greater a person is, the greater his evil inclination. In other words, if you have a highly developed soul, you must also have, as an opposite pole, strong negative pulls. Therefore to struggle is normal, but to yearn for faith and inspiration is the stuff that the righteous are made of.

"The Hebrew word for faith is *emunah*. It is connected to *omanut*, which means 'creativity'—a work of art. Even as an artist has to work painstakingly at his art, so every person who wishes to find faith must give his all to achieve a relationship with G-d. And as in all endeavors, it is not always smooth going. There are ups and downs and many frustrations, but an artist never gives up. He may have setbacks, but he keeps going. His profession is his life's calling.

"*Emunah*—faith—is also connected to the word *Amen*. Our sages teach that there are times when one is not capable of intense and meaningful prayer. Nevertheless, by uttering that one word—*Amen*—we remain connected. And finally, *emunah*—faith—can only be said in the feminine gender, which should serve to remind you that as a female and a mother, *emunah* is part of your spiritual genes, even if you feel burned-out. So keep praying, recite psalms, study G-d's Book, and involve yourself in acts of kindness. And whenever you feel a sense of futility, try to remember the following story:

"There was once a village that had every type of artisan and craftsman in its midst—tailors, carpenters, shoemakers, silversmiths, and so on. There was only one trade lacking—watchmakers. As the years passed, the clocks and watches of the villagers broke down, until none showed the correct time, so some of the villagers stopped winding their watches altogether.

"'What's the point?' they reasoned. 'They're not accurate anyway.' But a small number of people kept winding their timepieces in the hope that eventually a watchmaker would come to town and set things right.

"So it was that one day a watchmaker did arrive, and the people lined up to have their clocks repaired, but he was able to fix only those that had been kept wound. The others were rusted beyond repair.

"It's only a parable, Miriam, but it speaks to all of us. Our watches, our hearts, do not always give us a proper reading, but if we keep winding them, if we keep them going, then eventually, when the Watchmaker—G-d—comes, He will set our hearts right and connect us to Him. So just keep up with your prayer and good deeds, and ask Him for the gift of faith, for in the final analysis, faith in G-d is the only thing that gives substance and meaning to our lives.

"You, Miriam, through your search for spirituality, have demonstrated that that faith still burns in your heart."

❧ II

Hope

"As long as there is life, there is hope."

—TALMUD

THE SHOFAR OF BERGEN-BELSEN

The day is vividly etched in my memory. I was running up the steps to our house, anticipating my mother's usual loving greeting, "Esterka [a Hungarian term of endearment for Esther], tell me, what did you learn in school today?" As she spoke, she would offer me the most delicious fresh home-baked cookies.

I was in first grade, school was still something to be fussed over, and my mother treated every lesson as though I had made a new discovery. But as I entered the house, my mother did not call out. I went in search of her and found her weeping silently in the kitchen.

I became frightened. I had never seen my mother like this. "What happened?" I asked.

"No more school, Esterka," my mother wailed in an anguished voice. "No more school."

I couldn't understand why my mother was so distraught. I didn't think that not being able to go to school was so tragic, but since my mother was crying, I too began to cry. Hearing the weeping, my father walked into the room from his study and in his gentle, strong voice tried to reassure us.

"With G-d's help you will go to school, my precious child," he said. "We are organizing classes right now. The study of Torah will never cease."

My mother's tears would not stop, and I sensed that something was desperately wrong. The next day I learned that the Nazis had occupied our city, Szeged, shut down all Jewish shops, prohibited all Jews from practicing their professions, banned all Jewish children from schools, and forbade prayer and study. At the risk of their lives, our people continued to defy them. My father, together with other community leaders, established a clandestine school in the ghetto. My mother ran a communal kitchen and organized a self-help society to assist the orphans, the widows, and the sick.

Our school in the ghetto was short-lived, for very soon the deportations began. Our family was taken to Bergen-Belsen concentration camp. Even there, under the most brutalizing conditions, my father somehow managed to teach us.

I remember the weeks that preceded Rosh Hashana. Secret meetings were held by the rabbis in our barracks to determine how a sho-

far and a holiday prayer book might be obtained. There was a black market in the camp, and for a price, things could be acquired. And so it was that through a heroic effort, the people in our camp amassed three hundred cigarettes (an enormous sum in those days) to buy a shofar and a *machzor* (holiday prayer book).

The news of our purchase spread quickly through the camp underground. Adjacent to our compound was a Polish camp, and they somehow got wind of our treasure. As the piercing cry of the shofar was sounded, they crept close to the barbed wire fence separating us so that they might hear the ancient call of their ancestors. The Germans came running and discovered these boys. They began to beat them mercilessly, but even as the truncheons were falling on their heads, they cried out, "Blessed art Thou, L-rd our G-d, who has commanded us to listen to the sound of the shofar."

The *machzor* presented another problem. We were able to obtain only one prayer book for our entire compound. Who should pray first? Who should pray last? How could one prayer book be passed through so many hands? My father, together with other rabbis, took counsel and decided that we would all learn at least one prayer by heart. But what prayer would it be? Which psalm? Which blessing?

And then they made their decision: *"L'bochen L'vovos"* (Let us pray to Him who searcheth hearts on the Day of Judgment).

Yes, we invited G-d to come to Bergen-Belsen to search our hearts and determine for Himself whether, despite our pain and suffering, we wavered even one hair's breadth in our faith and love for Him.

Many years later, I was lecturing in Israel in a village in Samaria called Neve Aliza. It was late summer, just before the High Holy Day season, and I felt a need to tell the story of the shofar of Bergen-Belsen. When I finished, a woman in the audience got up. She had a strong, handsome face and appeared to be a little bit older than I.

"That shofar that you spoke of," she said, "I know exactly what you are talking about because, you see, my father was the rabbi in that Polish compound. You may not know this, but the shofar was smuggled into our camp in the bottom of a large garbage can filled with soup, and on the second day of Rosh Hashana my father blew that shofar for our camp."

I looked at her, dumbfounded. I couldn't find words, but my skin prickled with goosebumps.

"And that's not all," she went on to say. "I have that shofar in my house, here in Neve Aliza. When we were liberated, we blew the shofar again and took it with us."

With that, she ran to her house and returned a few minutes later with the shofar. We wept, we embraced, we reminisced, all the time clutching the shofar in our hands.

The miracle of that shofar left us breathless. The entire world had declared us dead. Hitler's "final solution" had taken its toll. Millions were gassed and burned in the crematoria, but we never gave up hope. The shofar, the symbol of Jewish sacrifice, triumphed over the flames. And as if in vindication of that triumph, G-d granted me the privilege of rediscovering that shofar in the ancient hills of Samaria, to which our people returned after more than two thousand years of wandering, darkness, oppression, and Holocaust: the miracle of our time.

FROM THE OTHER END OF THE HEAVENS

On one of my trips to Israel, I was asked by *Kol Yisrael* (Radio Israel) to say a few words to our brethren behind the Iron Curtain. It was a brief message but one charged with deep emotion. After two thousand years, Jerusalem had been liberated, and I, a survivor of the concentration camps, was in Jerusalem. The experience was awe-inspiring. Jews from the four corners of the world gathered at the Wall in prayer and supplication, drenching the ancient stones with their tears.

In those days, Radio Israel was beaming messages of hope regularly to communities throughout the world where Jews lived in isolation. One of these broadcasts was heard in Red China by a young man by the name of Boris Gurevitch-Ling, who was playing with his home-built shortwave radio when he picked up the voice from Jerusalem and heard of the miraculous victory of the few against the many during the Six Day War. He felt something awaken in his soul, a yearning within himself, something calling him. He couldn't quite understand it, so he shared his feelings with his mother.

"What does it all mean, Mother?" he asked. "What is it that is pulling at me? Where is this place, Jerusalem?"

His mother remained silent for the longest time. Then she got up, closed the door, and swore him to secrecy. "My son, I have a story to tell you," she said, with tears in her eyes. "I am Jewish—my parents were Jewish. When I was a little girl in Russia, my parents were killed and I was taken in by a gentile family. They raised me and sent me to school, but I was always 'that Jewish girl'—an outcast. They made my life miserable. So when I was sixteen, I mustered up the courage to run away to Moscow. There I met your father, who was from Red China. I never told him I was Jewish—I was afraid to do so. I married him and came to China, but I never forgot that I was a Jew, and you, my son, are also a Jew. That is why you have those feelings.

"My grandmother," she continued, "would tell me about Jerusalem, a far-off magical city where the sun always shone, where prophets and kings walked, where our Holy Temple stood, and where we would one day return to worship G-d.

"It was also Grandma who taught me the prayer *Shema Yisrael* that

I would say with you every night before you went to sleep. I don't quite know what that prayer means, but Grandma used to sing it to me and said that it would always connect me to G-d. That's why I taught it to you. And now, listen to me, my son. I never told anyone that I am a Jew, but I never gave up hope of rejoining our people, so I applied for exit visas for us, and since I am not a native of China, we might just get them. It may take a long time. It will not be easy, but with G-d's help, we will do it. In the interim, I ask just one thing of you. Keep this secret locked in your heart and never forget that you are a Jew."

Ten long years later, Boris arrived in the United States and found his way to Hineni. "Teach me," he said. "I want to know how to live as a Jew. I am thirty-one years old, and I have a lot to make up for."

I was overwhelmed. A passage from the Bible came to my mind: "Even if your remnants shall be at the other end of the heavens, from there the L-rd your G-d shall gather thee and from there He shall bring thee" (Deuteronomy 30:4).

Our sages ask, "Why from the other end of the heavens? Why not from the other ends of the earth?"

Because it is not only those who are physically distant who shall come back, but even those who have been spiritually cut off—they too shall find their way back. And here was Boris, standing in front of me, the living fulfillment of that prophesy.

I told Boris that we were going to be taking a group from our Hineni organization to Israel that summer and invited him to join us. "How would you like to be bar mitzvahed at the Wall in Jerusalem?" I asked.

For the longest time he remained silent, and then, in a voice that was hardly audible, he said, "Oh, if only I could do that. It would be a dream come true." My son Rabbi Yisroel taught him, and miraculously, the ancient words of the Torah came easily to his tongue.

Joining us on that same trip was a lovely young girl named Debbie. I soon noticed that Boris and Debbie were spending quite a lot of time together. I became nervous. "Do you think your parents would approve?" I asked her.

"Of course," she answered. "My parents are very understanding. They will love Boris. The fact that he's Chinese won't matter to them at all."

Thousands of years ago, our prophets proclaimed that Jerusalem would be totally destroyed, razed, and ploughed but that despite everything, the Western Wall would never be destroyed, that it would stand as testimony to G-d's eternal presence, watching, guiding, caring for His people, and awaiting their homecoming, which would be climaxed by the rebuilding of the Third Temple.

And now, thousands of years later, our Hineni group was in Jerusalem. We saw the archeological digs, which showed layer upon layer of destruction, but most important, we stood in front of the holy Wall that had withstood the onslaughts of the armies of the nations. We were a small group, but we represented Jewish history: I, a survivor of the Holocaust; Boris, a survivor of atheist Communist China; and the others, survivors of the assimilation of Western culture. The Wall united us all. Our hearts throbbed with emotion as we were overcome by the sanctity of the place. But it was Boris who best expressed our feelings when he said, "In China, we have the Great Wall, which spans thousands of miles, a wall that most certainly dwarfs this Wall here in Jerusalem. But it is this Wall that penetrates my soul. It is this Wall that stirs my heart. These stones here in Jerusalem speak to me of the eternity of our people, and in a sense I too am like them for I too have survived the centuries. So I beseech You, Almighty G-d," he whispered, "make it happen. Allow me to marry this girl. Allow me to be accepted so that I may continue the legacy preserved for me by my mother."

That day Boris was bar mitzvahed at the holy Wall, and the Israeli media covered the event. One reporter headlined the story: "A Jew Is Always Bar Mitzvahed at 13." Boris was thirty-one at the time, and thirty-one reversed is thirteen.

A few days later we arrived at Kennedy and Debbie's parents met Boris. It was not as smooth a ride as Debbie had predicted. Yes, Boris was a very fine young man, but Debbie's parents hadn't quite anticipated a Chinese son-in-law, albeit Jewish. It took some adjustment, but to their credit the marriage took place with great joy just a few months later. My father and my husband had the privilege of performing the ceremony, and today Boris and Debbie are raising a beautiful family of sons and daughters who continue the legacy. Boris's prayer at the Wall was heard and accepted.

Often when I think of Boris and Debbie, Yogi Berra's famous

line comes to mind: "The game ain't over 'til it's over." When Boris's grandparents were killed in Russia, to all intents and purposes it appeared to be over for the Gurevitch family. But there is a secret to Jewish survival that transcends the laws of nature. It is based upon a promise proclaimed by the prophet Isaiah: "This is My covenant with them, saith the L-rd. . . . And the words that I shall place upon your lips shall not depart from your lips, nor from the lips of your children or your children's children, thus saith the L-rd, forever and evermore" (Isaiah 59:21).

The story of Boris and Debbie is the miraculous story of our people, for no matter how we may have been oppressed, no matter how far we have distanced ourselves from our faith, we never gave up hope of reclaiming our spiritual inheritance.

IT'S NEVER OVER

The year was 1973, and the news from Israel was bleak. The Yom Kippur War had left many dead and wounded in its wake. I felt that I wanted to do something to show, if only symbolically, that we cared, that we felt their pain.

Our Hineni organization was in its very inception. In those days, all kinds of trinkets ornamented with logos and slogans were in vogue. We had Hineni buttons, bumper stickers, and T-shirts, and my husband, who had a wonderful artistic flair, designed a Hineni medallion for me in the shape of a flame spelling out the word *Hineni* in Hebrew.

It occurred to me how wonderful it would be if I could present the many wounded soldiers in the hospitals with such medallions. Our tradition teaches that if you really want to do a good deed, then G-d will help you to accomplish it. No sooner did I conceive of this idea than I met a man who was a jeweler. Upon hearing of my plan, he volunteered to make up the medallions in silver.

And so we set out to visit the hospitals and recuperation centers of Israel. I was accompanied by my daughter Chaya Sora, who was just finishing high school, and, of course, Barbara. A heartbreaking scene awaited us—men and boys without limbs, boys who had lost their eyesight, their brokenhearted wives, children, and mothers hovering over them—the terrible price of war.

When making these visits, we wanted to create an atmosphere of good cheer and hope, so we engaged some musicians to accompany us and also took trays of refreshments along. The soldiers were brought into the solarium—some in wheelchairs and some in their hospital beds. The musicians played while Chaya Sora, with her sweet smile, distributed refreshments. Then I would begin to speak. I shared with them teachings from our Torah and tried to bring them a message of hope and faith. Following the program, I distributed the medallions.

There were a number of wounded who were too ill to be brought into the solarium, and the head nurse asked if I would like to visit them in their rooms. "Of course," I said. "That's why we're here."

We entered a room in which the light had been dimmed. The patient lay immobile in his bed, wrapped in bandages like a mummy. "Shalom to you," I said. "My name is Esther Jungreis. We came from the States to bring you greetings and blessings."

There was no answer.

"What is your name?" I asked.

Still the boy did not respond.

The nurse explained that he had been badly burned in a tank battle on the Golan. "I'm sorry," I said. "I know that it sounds hollow, and it's only words, but please know that we mean it. We have brought you a little token, a symbol of blessing." And I held up the medallion.

For the first time, the young man spoke, "Take your medallion. It's of no use to me!"

"I understand that you are hurting, but I'm going to leave it on your night table anyway. You might just need it one day."

"For what?" came the angry answer.

"For an engagement gift," I said.

He let out a bitter laugh. "Who will marry me?"

"It is written in our holy books that every person has someone destined for him."

"Yeah—that's if they're a person. I'm a vegetable. No one will ever marry me."

"Listen to me," I said. "It *will* happen. We are never allowed to give up hope. You will see that in time you will meet a girl, and when you do, you must tell her that a Rebbetzin from the United States visited you and told you that you have special merit before G-d, that you are ready to transmit that merit to her, and this medallion is a symbol of that."

"Rebbetzin, if I said that to any girl, she'd think I'm crazy."

"You're wrong. Someplace, somewhere, there is one girl who will understand, and you need only one." And with that, I left his room.

A year later we were once again in Israel. This time our first stop was an army recuperation center near Haifa. It is a tradition in Israel to present guest speakers and artists with a bouquet of flowers. At the conclusion of my program, a soldier in a wheelchair was brought up to the stage to make the presentation.

"Do you recognize me, Rebbetzin?" he asked.

"You look familiar. Please help me out," I said.

He smiled and pointed to the nurse standing behind his wheelchair. "I would like you to meet my wife."

I looked at the smiling face of a young Yemenite woman, and there, around her neck, was the Hineni medallion.

≫ 12

Gratitude

"Give thanks to Him. . . . Bless His Name."

—PSALM 100

The Two Most Important Words

When we arrived in the United States in 1947, my parents rented a small, dilapidated basement apartment in the East Flatbush section of Brooklyn.

My mother immediately went to battle against the cockroaches, scrubbed and cleaned, made curtains for wall partitions so that we all had our own little cubbies, and with the secondhand furniture collected by some of our neighbors, she managed to convert our basement into a warm, loving home.

We had been in our new residence no more than a few weeks when suddenly I fell ill. It was one of those common childhood diseases. Whether it was chickenpox or mumps, I don't quite remember, but I was running a very high fever, and my parents didn't know where to find a doctor. An angel of mercy, one of our neighbors, Mrs. C., appeared at our door. She called her doctor, asked him to make a house call, took care of the bill, and in every way proved to be a precious, supportive friend, not just on that occasion but throughout the years.

I share all this with you because my parents never allowed me to forget Mrs. C.'s kindness. Every Friday, when my mother baked the special *Shabbos* cakes, there was a package for Mrs. C., which I had to deliver. Years later, when I was married, she was seated in a place of honor at my wedding.

In retrospect, one might argue that Mrs. C. didn't do anything that remarkable. A family of Holocaust survivors arrives from Europe, broken and destitute. Their little girl falls ill, and they don't know where to turn. You have to have a heart of stone not to help. But my father taught us never to take any act of kindness lightly. Gratitude is one of the pillars of Judaism upon which our entire faith is based. From the moment we awaken in the morning to the time we go to sleep at night, we are called upon to declare praise and thanksgiving to G-d. Our first words must be a proclamation of appreciation to the Almighty for having returned our souls and given us yet another day. No aspect of life is to be taken for granted—a glass of water, a tree in bloom, the rainbow in the sky must all be acknowledged with a blessing to G-d.

We proclaim praise because G-d commanded us to do so, but

the benefits that accrue for our lives are infinite. Through this process, we learn to see good in the myriad things that most people take for granted. There is no room for melancholy or depression, because throughout the day we must focus on our blessings and give thanks. Even a physical function such as answering the call of nature must be acknowledged with a prayer of thanks. Admittedly those who are not familiar with the Torah way of life might smile or even laugh at this, but can there be a greater blessing than a body that is functioning well?

The Torah teaches that one of the reasons why our suffering in exile was decreed was that we did not rejoice in all the good that G-d had granted us (Deuteronomy 28:47). At first glance it might be difficult to understand why we would be so self-destructive and not take pleasure in the many gifts of life, but by nature humans are malcontents. No sooner do they acquire something than they want something more. "He who has one hundred desires two" is a teaching of our wise men.

The Torah therefore prescribed for us a way of life in which we must be constantly focused on the blessings that are part and parcel of everyday living. The what-did-you-do-for-me-lately? philosophy simply doesn't exist in Torah vocabulary. Any favor rendered, no matter how long ago, must be remembered and acknowledged.

Thousands of years ago G-d brought us forth from Egyptian bondage, and to this very day we thank Him—not only on Seder night but every day in our prayers and through our *mitzvos* (commandments performed in memory of our Exodus).

It is not only to G-d and our fellow man that we must express gratitude, but the Torah teaches that we must show appreciation even to objects. Moses was not permitted to strike the Nile when the plagues descended upon Egypt, because as an infant he was saved by those very waters. This concept of gratitude is probably the most important lesson a human being can internalize, for once mastered it guarantees happiness and a meaningful, joyous life. People run here and there, they dabble in every available therapeutic program, and they fail to understand that happiness is waiting for them right in their own minds and hearts. They need only acquire the attribute of gratitude and learn to thank G-d for the many blessings of life.

I recall when my husband had his first surgical procedure at New

York University Hospital. To tell you that he thanked his doctors and his nurses a thousand and one times a day goes without saying. Even in the recovery room, when he was still heavily sedated, he never forgot this imperative, so deeply was it ingrained in his being.

I was standing outside of the recovery room waiting to be admitted, when Mrs. L. passed by.

"Rebbetzin, what are you doing here?" she asked. "Who is sick?"

"My husband just underwent surgery."

"Is he in recovery yet?"

I nodded my head, not trusting myself to speak. She must have felt my tension and fear because she immediately said, "Come, I'll take you in to see him."

Mrs. L. is in charge of *Bikur Cholim* (the visiting the sick society) in many New York hospitals. The Talmud teaches that visiting the sick is a precept that is so important that reward for its performance is given in this world, but the principal remains intact in the world to come. From time immemorial, Jewish communities have had *Bikur Cholim* societies, dedicated to helping patients and assisting family members. Mrs. L. and her staff of volunteers bring home-made lunches and dinners to the patients, help those who have financial problems, and in general try to make the ordeal of illness a bit more tolerable and dignified.

"Come," she said to me now in her effervescent manner. "Let's put on surgical gowns and we'll go in to see the Rabbi," and with that, she pressed the door buzzer.

When the nurse came to the door, Mrs. L. explained that we were there to see Rabbi Jungreis, and although it was obvious from the nurse's expression that she didn't approve, she escorted us to my husband's bedside. Mrs. L. commanded respect in the hospital.

My husband appeared to be sleeping, but he must have sensed our presence because he opened his eyes, and when he saw us, his face immediately lit up with his beautiful smile.

Mrs. L. walked away to give us some privacy.

"Call her back," my husband whispered. "I have to thank her for bringing you in."

"I thanked her already," I assured him.

"But *I didn't*," he responded.

Not only did he thank her, but he mustered his strength to bless her as well.

In his final days of illness at Memorial Sloan Kettering, my husband desperately wanted to breathe some fresh air, to feel the wind on his face, to see the sky and birds flying by, but for the patients' protection, the windows at the hospital could not be opened, so we asked permission to wheel him out to the street for a few minutes.

It was January, and it was an especially bitter-cold winter. The snow just kept falling, but we were determined to grant my husband's wish. I brought his long, heavy coat, his sweater, and hat, and when the nurse dressed him, I had to turn away because I couldn't hold back my tears. He had lost so much weight, his body had shriveled to nothing. His hat and coat just hung on him.

Slowly my sons wheeled him to the front entrance of the hospital. It was a gray, overcast day. It looked as if it was going to start to snow again, but to my husband, the sky was beautiful. Gratefully he breathed in the cold air and thanked us profusely for having made it possible for him to see G-d's wondrous world one more time.

To my husband, saying thank-you came naturally, but for many of us these two little words are very difficult to articulate. This may appear paradoxical—gratitude would render us much happier people. Then why do we fight it? Why can't we say thank-you?

Our sages, through the Hebrew language, give us an insight. In Hebrew, the word *modim* (thank-you) has two connotations. Thank-you also means "to admit," for in essence thank-you is an admission that we are in need, that we are vulnerable, that we cannot do it alone—and that is something we do not like to concede. We hate feeling beholden, especially if the favor extended to us was significant. Therefore the greater the kindness, the closer our relationship, the greater our reluctance to reveal our weakness by pronouncing those two little words. People who have no problem saying thank-you to a waiter in a restaurant, a telephone operator, or a salesgirl have difficulty saying those very same words to those who are nearest and dearest, because thank-you to them would be an admission of need.

This inability to express gratitude has many ramifications and is perhaps one of the reasons why there are so many bitter people around. People who cannot acknowledge kindness always find something to grumble about, something to criticize. They make miserable marriage partners, tyrannical parents, and selfish friends. They are

convinced that everything is coming to them, that they are entitled to all the goodies in life simply because they are alive. No matter how much they are indulged, they are never satisfied. They just keep taking without feeling a need to give back.

"Who is rich?" our sages ask. "He who is content with his lot." How can you learn contentment? By mastering the art of gratitude. And how can you master the art of gratitude? Start with little things, and slowly build up.

My son Rabbi Yisroel, in an effort to focus on this concept of gratitude, suggested one evening at our Hineni Young Leadership seminar, that everyone make a point of saying thank-you to the guard at the door as they left.

At the end of the evening, as we were leaving the building, the guard approached us, beaming from ear to ear. "Rabbi, Rebbetzin, what happened tonight? Everybody came over to me to say thank-you! That was really very nice."

The following week Yisroel told the people how appreciative the guard was. "What an easy way to have made him feel happy. Now can you imagine the joy we could bring to our loved ones if we were to say thank-you to them? Think about it," he challenged them. "When was the last time you said thank-you to the person you share your life with—your spouse, your parent, your child?"

To develop a heightened sense of gratitude you might also try to keep in your mind's eye the image of my husband sitting in a wheelchair in front of Sloan Kettering on a cold, gray day in January, thanking G-d for the wondrous sky. I must tell you that my husband's appreciation of nature had nothing to do with illness. He always took great pleasure in contemplating G-d's creations, and he taught our grandchildren to do the same. I remember Shaindy, at the age of five, saying upon visiting a nature preserve, "I'm so glad *HaShem* (G-d) gave me eyes so I could see all these beautiful things."

Why then, you might ask, do not more people share this joy of gazing at the sky and seeing G-d's beautiful things? The answer may be that most people like to have something exclusive, and if everyone else has it, they just can't derive pleasure from it. If you truly love people, if you are truly committed to them, your pleasure will intensify in the knowledge that they too are benefiting from that which

you appreciate. Even as parents are happiest when they can share with their children, the committed person will find happiness in the gifts of nature that can be shared with others.

By taking moments each and every day to focus on G-d's gifts, by thanking Him for His many kindnesses through blessings and prayers, and by saying thank-you to those who are near and dear to us, and to everyone else, we can acquire the attribute of gratitude.

Almost two years after my husband passed away, I decided to move so that I might live closer to my children and grandchildren. You can imagine how difficult such a change was for me. There were many friendships, many associations. For thirty-two years my husband had been the spiritual leader of his congregation, and it was not simple to pack all that up and put it in a box.

In all our years of marriage, my husband and I never exchanged a harsh word. There was only one area in which we had conflicts—his papers. He was a collector. Nothing was ever discarded, and his papers, with voluminous notations, were scattered all over the house.

My children came to help, and as we organized the papers, we felt as though we were carrying on a conversation with him. Every notation was a message. It was so clear, so obvious.

Then I came across one sheet on which he had written in his beautiful bold handwriting, "The two most important words to remember, 'Thank you.'"

Cast Your Bread upon the Waters

After our first Madison Square Garden program, I received a call from Shlomo Levin, the Israeli consul in New York. He invited me to his office to meet with him. There was a pressing matter that he wanted to discuss.

"Rebbetzin," Shlomo said, "I heard you at Madison Square Garden, and I think that our troops in Israel would greatly benefit from your message."

I was taken aback—*me* speak to the Israeli army about Torah? As much as I would have loved to, I didn't think I could do it, and so I demurred.

Unbeknownst to me, however, Shlomo had sent a publicity shot of me, mike in hand, taken at Madison Square Garden, to the Israeli Army Entertainment Corps, and they mistakenly thought that I was a singer. Some weeks later I received a call from army headquarters in Tel Aviv asking how many performances I was prepared to do. I had no idea that they really didn't have a clue to what I was all about. I was so moved by the fact that they had invited me that I had difficulty finding words, so in a voice choked with tears, I accepted. After the initial excitement passed and reality set in, I also realized that I had a few hurdles to overcome.

Prior to my speech at the Garden, there was a half hour of Jewish music and song to create a warm ambience. Not being familiar with the situation in Israel, I wondered who would play for me there. And then, as if G-d heard my thoughts, I received a call from a lawyer in Miami, a man I had met when I spoke at the Convention Center.

"Rebbetzin," he said, "I hear you're going to Israel. My sons and I would love to join you. Our hobby is jazz, but we'll practice and pick up some Jewish songs. We would feel so honored to play for the soldiers."

Truth be told, I would have much preferred a band that was proficient in Jewish music, but having no other options, I convinced myself that it might just work. In any event I had no other volunteers, so I accepted their offer.

My first program was in Ramat David, one of the largest air force bases in Israel, and I must admit I was nervous. I had heard

that Israeli audiences were not inclined to be polite, and if they didn't like a program, they didn't hesitate to let you know.

The band was a great hit, and they couldn't wait for me, the "singer," to begin my "act"! I froze in terror and wondered how in the world I had ever allowed myself to get into this. I tried to recall my father's blessing in my mind: "Angels of mercy go with you, my precious child. May G-d give you the words to reach every heart." If ever I needed that blessing, it was now.

I heard them announce my name, and I wanted to run, but it was too late. I had no choice but to go on. "You are a Jew," I said in Hebrew. As I began to relate the story of our people, I spoke of our covenant, of our Torah, of our long and painful saga, of our hopes and dreams, and I spoke of our return to the land of Israel after two thousand years of absence. And as I looked out over the audience, I realized that they were in shock! At first they didn't know what to make of me, but then I noticed tears in their eyes.

Despite all my apprehensions, they understood. The spark from Sinai may have been dormant, but it was there in their hearts.

We became an overnight success in Israel. Invitations kept pouring in from army bases as well as from the municipalities of Jerusalem, Tel Aviv, and Haifa. Our plans had called for a ten-day tour, but the pressure was on to extend our visit.

I called my husband back in New York. "What should I do?" I asked.

"Is that a question?" he replied. "Of course you must stay. The children are in camp and I'm just fine. Speak in as many places as you can."

"But I have a problem," I told him. "My musicians have to return to the States, and there is no one to replace them."

"Don't worry," my husband said. "G-d will send you someone."

That Sabbath eve, as we sat in the dining room of our hotel in Jerusalem, the maitre d' came to inform me that there were some yeshiva boys in the lobby who wanted to speak to me.

I went out to greet them.

"Rebbetzin," one of them said, "we are yeshiva students and we have our own band. We came to welcome you to Jerusalem and to offer our services."

"That's wonderful," I said. "How did you know I needed a band?"

"Well, actually, we didn't know. We just wanted to participate and help."

"Thank you so much," I said.

"Aren't you going to ask why we are volunteering?" their leader asked.

"I know why. You are aware of the importance of reaching out."

"Yes, that's true, but there is an additional reason." And with that, he proceeded to tell me his story.

"A few years ago, I lived in New York. I was totally assimilated. I had no understanding of Judaism. My life was music, and I was on my way to Paris to continue my musical studies. I was walking on Kings Highway in Brooklyn when suddenly I heard a crash and the screech of brakes. I looked up, and there in the street, covered with blood, was a rabbi who had been run over by a car. I rushed to his side and tried to talk to him, but he didn't respond, so I stayed with him and held his hand until the police and an ambulance came.

"As he was lifted onto a stretcher, I noticed that his lips were moving. It seemed like he wanted to tell me something. I leaned down and bent my ear close to his lips so that I might hear him. Rebbetzin, you'll never believe what the rabbi said to me." For a moment, the young man paused. Then he swallowed hard and continued with his story.

"'Sonny, are you Jewish?' the rabbi asked me in broken English.

"'Yes, Pop,' I answered. 'I am Jewish.'

"'Sonny,' the rabbi whispered again—although it was obvious that it was very painful and difficult for him to talk. He mustered all his strength and said, 'You must go to Jerusalem and study Torah.'

"Can you imagine? There was this rabbi, suffering from multiple fractures, his body bloody and bruised, and in his pain what does he do? He tells me to go to Jerusalem and study Torah! That experience changed my life. I realized that I had met a saint, a man who was so committed to his faith that he was able to overcome his suffering to reach out to me. So now you know why I'm here. The rabbi saved my life, and I want to give back."

I had difficulty answering him. I recognized that story—I knew it well. That rabbi was my father. When he recovered from that accident, he told us of the incident and asked that we try to find the young man to thank him for his kindness in staying with him until

the ambulance came. We never did find him, but now, years later, here in Jerusalem, the holy city, he came to thank me and offer his services in gratitude, and I was able to thank him in the name of my father.

The words of King Solomon came to mind: "Cast your bread upon the waters, and in days to come, you shall find it."

No act of kindness is ever lost.

ꙅ 13

Time

"For everything there is a time and a season. Everything is beautiful when done in its proper time."
—Ecclesiastes

THE HOLINESS OF TIME

In one of the first encounters that Abraham had with G-d, he was told that he would be a source of blessing, and all those whom he blessed would be blessed. Through the patriarch, G-d endowed us with the gift of imparting blessing to others, and we have always regarded this privilege with seriousness and awe.

In 1972 when the thought of establishing Hineni first came to mind, I was frankly frightened. I sensed that the idea was right, but there had been no precedent for such outreach. How would I implement it, how would I do it? And then it occurred to me that first and foremost I must receive the blessings of the Torah sages of our generation, so I asked my father if he could arrange introductions to those spiritual giants—Rabbi Moshe Feinstein, the Satmar Rebbe, Rabbi J. B. Solevetchik, and Rabbi Henkin. My meetings with them were memorable experiences that I will cherish for the rest of my life. Not only did they give me their blessings, but Rabbi Feinstein and Rabbi Solevetchik, who were deans of yeshivas, also offered the assistance of their rabbinic students for our Madison Square Garden program.

It was a blistering hot summer day when we went to see Rabbi Henkin, a man in his nineties, who was the oldest of the sages. We were spending the summer at a hotel in the Catskills where I was lecturing, and I had a terrible premonition that if I didn't go to see the rabbi soon, I might just be too late. And indeed, shortly after we met, he passed away.

So it was that I took the bus from South Fallsburg to meet my father at the housing project on the Lower East Side of Manhattan where Rabbi Henkin lived.

"Don't be shocked, my child, when you see Rabbi Henkin. He's very frail and ill and has lost his eyesight," my father told me as we entered the humble apartment. A man who was the rabbi's aide respectfully welcomed us.

"Please take a seat. Rabbi Henkin will be with you very shortly."

I looked around and saw a room full of books and a small ark that housed a Torah scroll. My father explained that since Rabbi Henkin had become ill, daily services were held in his home. Soon we heard the slow, shuffling sound of footsteps in the hall.

"Come," my father said, "let's rise in honor of the sage."

Rabbi Henkin was led in by his aide, who pushed a trolley from which an IV hung. My father and Rabbi Henkin embraced. They had been close friends for many years.

"My daughter, Rebbetzin Esther, is also here with me. She has founded a new outreach organization, Hineni, and has come to seek your blessing."

Rabbi Henkin's gaunt, pale face broke into a warm smile. "Any project undertaken for the sake of G-d will surely succeed. G-d will be with you and bless you in all your undertakings," he assured me.

"I would, however, like you to do one thing. When you speak, tell the people what you saw here today. I am old and blind, and my body no longer functions. Whatever I know, whatever knowledge I have, I acquired when I was still able to see. The years pass very quickly, and one day every person will find himself in a similar situation in which the body just disintegrates, so tell people to study while they still have the energy and the tools with which to learn G-d's wisdom."

And with that, Rabbi Henkin and my father sat down to exchange words of Torah. As their discussion became more involved, Rabbi Henkin reached for a book, and with his sightless eyes found the page he was looking for. I sat there in awe, and then, as if to reinforce his previous statement, he said, "You have to study while your eyes still see so that you have something to remember when they grow dim."

I have often thought about Rabbi Henkin's message, especially when I see people squandering their days. Time is the most precious gift that G-d gave us, yet we abuse it the most. If we were to see a person throwing his money away, we would regard him as insane, but strangely enough, we think nothing of throwing our hours, our days, our years away. Moreover, monetary loss can be retrieved, but time that is wasted is gone forever.

Ours is a generation that has more time on its hands than our grandparents ever dreamed possible. Modern technology has liberated us from the drudgery of our daily chores, yet we have less time to spare than they did. This is partially due to the fact that we have developed an entire industry centered around "killing time." The most pointless and inane activities have been devised to keep us occupied and anesthetized.

When I was a little girl, my mother would always say to me, "Don't sit with folded hands," and indeed I never saw my mother inactive. From the moment she woke up in the morning, which was always at the crack of dawn, until she went to sleep at night, she was always involved in doing something for the welfare of others. Today her body is crippled by illness, but she will tell you that more than physical pain, she suffers the most from her inability to be active.

"Mama," I have often said, trying to calm her, "it's OK, you are entitled to some rest," to which she would immediately retort, "Rest? That's for the next world. In this world, we have to accomplish!"

My mother's sensitivity to time is not unique to her but rather is a reflection of our ethos as a people. The very first commandment that G-d gave us after our departure from Egypt focused on time: "This month shall be unto you . . . " (Exodus 12:2). Through that commandment, we were charged with the awesome responsibility of setting the calendar and the holy days of the year.

When we were slaves in Egypt, our days meshed one into the other. Every day was painfully and monotonously the same. In the lives of slaves, there is no creativity, there is no hope, there is no future. But free men have choices to make, and the most important choice is to use time wisely. Of all G-d's creations, man alone is aware of time. Though animals may be sensitive to climatic changes, they have no appreciation for the meaning of time. Only man lives by the clock—only man marks the milestones of life—only man finds time crawling slowly by when in distress and fleeting all too quickly when joyous. Only man can utilize time for spiritual development. Greater perhaps than the miracles of the ten plagues and the splitting of the Red Sea was our transformation from a nation of slaves into a priestly kingdom, and that metamorphosis took place in seven short weeks through our harnessing of time.

As we left Egypt we were commanded to count forty-nine days so that we might be worthy of receiving the Torah on the fiftieth. With each day we shed some of the squalor and crassness of Egypt; we learned that time offers a unique opportunity for growth and healing, and if we channeled it properly, we could accomplish in weeks that which would normally take centuries. To this very moment, we count forty-nine days from the second day of Passover to the holiday of Shavuot, the festival of the giving of the Torah,

and as we do so, we search our hearts, comb our minds, and throw off the shackles of our contemporary bondage: anger, jealousy, depression, bitterness—self-destructive traits that diminish us as human beings and build walls between ourselves and G-d.

You might wonder why it is necessary to count days in order to free ourselves of negative attributes. The idea of undertaking a total character change is so overwhelming that you would give up without even attempting it. However, if you undertake just one change and grow day by day, you'll make it. That is the meaning of counting days and using time wisely.

The Torah, our most sacred book, begins with time—"In the beginning . . . "(Genesis I:I)—and ends with what will occur at the end of time, when the Messianic era will be ushered in by Elijah the prophet. And precisely because of that, every second is holy for it represents a challenge to labor toward that ultimate goal when G-d's kingdom is established here on earth.

Being sandwiched between the past and the future keeps us spiritually anchored and imbues us with indelible faith. I have often been asked how we survived the war years—the ghettos, the concentration camps. I truly believe that it was this concept of time that enabled us to transcend our environment. Our past imbued us with purpose and faith, and our future enabled us to dream of a better tomorrow.

Through the Torah, we learn to regard time on yet a different level. That first commandment after our departure from Egypt charged us with the mission of sanctifying time and making it holy. From the moment we kindle our Sabbath and holiday lights, we are enveloped in the sanctity of time. Geographic and cultural boundaries disappear. We become one, and through that oneness we are spiritually uplifted and enveloped in sanctity.

The Torah requires us to be sensitive even to the most minute changes in time; the passage of every second is significant. In rabbinic terminology, the concept of time is referred to as *z'man*. For example, we are commanded to kindle the Sabbath lights at a specific *z'man*, but once that moment passes, we are forbidden to light them, teaching us to be alert to the opportunity of each and every moment and not allow it to escape us. Everything is proper only when carried out in its allotted time.

King Solomon, renowned for his wisdom, in his Book of Eccle-

siastes focused on this concept of time. He wrote that there is "a time to be born, a time to die . . . a time to laugh, a time to weep . . . a time to plant, a time to reap . . . a time to be silent, and a time to speak." Enumerating these and many more contrasts, he teaches us the beauty of everything in its proper and designated time. Thus there are times when silence is golden, but there are also times when we must roar like lions. In other words, everything is timing. If we are sensitive to this concept, then we will also learn how to live wisely.

Our Hineni Heritage Center houses a multimedia museum, and one of the exhibits centers on this very teaching of King Solomon. When students from various schools visit, I always urge them to engrave this wisdom on their hearts so that they may learn to navigate life's troubled waters.

"A time to weep, a time to laugh." When your pain is so overwhelming that you feel you can no longer go on, then bear in mind that the same G-d who designated your time of sadness has also made provision for your time of laughter.

"Look at me," I would tell the students. "Do you think that in Bergen-Belsen I ever thought that I would be able to laugh again? But here I am. So when difficult days come upon you, just hang in there. G-d will give you cause to laugh again."

"A time to be born, a time to die." Life is a series of tests. When we are young, we are tested as to the sort of children we are. When we get older, the question is what sort of wives, husbands, or parents we become. Every period has its own challenges, and if we bear that in mind, we will come to understand that time is a precious gift, a G-d-given opportunity for growth and self-improvement.

"A time to be born, a time to die." Life is very short. It sounds trite, but we have yet to grasp the full meaning of this truth. We are all here on temporary visas. From the time that we are born, the death process commences, and we never know when G-d will call us. Therefore our sages teach us to "repent a day before we die," and since we have no clue to when that day will come, the teaching reminds us to live every day as fully as we can.

When people have near-death experiences, they make all kinds of resolutions: "If only G-d will give me another chance, I will do things differently." Usually as soon as the crisis passes, their resolu-

tions, as sincere as they may have been, are also forgotten.

The wise man remembers that the day will come when G-d will call him, and he does not fritter his time away. He is aware that he is a tourist in a foreign land, and he will try to get in as many sights as possible and make the most of every moment before his visa is up.

There is a wonderful story about one of the greatest Torah sages of modern times, known by his monumental literary work, the *Chofetz Chaim*, who lived in Radin, Poland, just before World War II.

An American visited him to seek his counsel and blessing. When he entered the modest home of the sage, he was shocked to see that it was practically empty.

"Rabbi, where is your furniture?" he asked.

"Where is yours?" the rabbi asked in turn.

"Well, I'm just passing through," said the visitor.

"So am I," the *Chofetz Chaim* said. "I too am only passing through!"

That's what this world is all about. We are all just passing through, so we must make the most of every moment, live a committed life, and thus sanctify the time that G-d granted us here on earth.

IF ONLY

I was invited to speak at a synagogue in Great Neck. As often happens on such occasions, a lively question-and-answer period followed. I always enjoy this give and take because it allows me to get to know the people in the audience and gain a glimpse of what is on their minds. As the program came to an end and I prepared to take my leave, a handsome, well-put-together woman who appeared to be in her mid-seventies came over to me and introduced herself. "My name is Anna Stein," she said. "I enjoyed your message immensely. You really got to me, my dear. If only I had met you forty years ago."

I reached out for her hand and said, "If only *I* had met me forty years ago."

Anna looked at me quizzically, not understanding what I was getting at, so I explained, "Forty years ago, I did not know what I know today, and believe me, if I had, I too would have done many things differently. It is futile and self-destructive to dwell upon the if-onlys or I-should-haves. Futile because what was, you cannot undo, and self-destructive because such thoughts consume your energies and make you depressed. There is a well-known Talmudic teaching that we should all remember—'What was, was.' In other words, we have to forget the past, get on with it, and learn to deal with the here and now."

"It sounds good," Anna said wistfully, "but it doesn't quite work out that way."

"Why not?" I asked.

"Why not?" she repeated my question.

"Yes, why not?" I pressed.

"Because I just can't help thinking about all the stupid things I did, the time I wasted. Oh G-d, what a mess I made of my life!"

"Anna, what you said just proves my point. It's self-destructive to dwell on past mistakes. What good does it do you?"

"Not much," she said with a bitter laugh.

"Not much *good*, Anna. But it does do a lot of *harm*. You are making yourself a prisoner of your failures, and your worrying about it will not change anything, but it *will* make you sick."

"I guess you're right," she conceded. "It's just conditioning. I think it's our Jewish way of dealing with problems. Look how we

still mourn the destruction of the Temple, breaking a glass at every wedding. Like I said, it's the Jewish way. We don't forget, we don't let go. It's all that Jewish guilt."

"Now wait a minute. Wait just one minute," I said. "That's a total misinterpretation of our mourning. We don't remember so that we might wring our hands and make ourselves miserable with the if-onlys. Rather, we are called upon to remember so that we do not repeat the mistakes of the past. The Temple was destroyed because of the animosity, jealousy, and downright hatred between people, and we must remember that so that we may purge our own hearts of those ugly feelings.

"And as far as 'Jewish guilt' is concerned," I continued, "that's the most positive sentiment that you can have in your heart. It prompts you to redress the wrongs of your past, to chart a new course, to build a better today and tomorrow. If, however, you throw up your hands in despair and give in to depression, that's neurotic guilt, and that has no place in Judaism. So let's try to apply what I told you to your own life. You have regrets about your past. You made mistakes. What can you learn from those mistakes?"

"Nothing," she said with sad finality. "That is, nothing that could have meaning today."

"Come on, Anna, that can't be. Tell me what it is that you regret."

"Oh," Anna sighed, "that would be a whole megillah."

"Just give me one incident, one example. Let's see how our Torah way of dealing with guilt and remembering could help you."

"OK," Anna said, "take my daughter. I raised her without any religious training, and now she's raising her children the same way. They don't even know that they are Jews! There's nothing I can do. It's too late."

"Anna, listen to your own words. You raised your daughter without religious training and, instead of learning from that experience, you are repeating the same mistakes today—doing nothing for your grandchildren. Remember what I told you about the destruction of the Holy Temple. We have to remember it so that we might become better people and be worthy of its rebuilding. Similarly, the only way it makes sense for you to remember the mistakes you made in raising your daughter is not to repeat them in your grandchildren's lives."

"Oh, Rebbetzin, that's totally different. I'm a grandmother, an

old lady. What could I possibly accomplish today?"

"A lot. Grandmothers have a power all their own. In certain situations, they are even more effective than parents. I can't begin to tell you how often I meet young people who remain connected only because of a grandparent. So for starters, why don't you make *Shabbos* dinners for your grandchildren?"

"I wouldn't know how to make a meaningful *Shabbos* experience for them."

"That's easy enough to correct. There are many people in your community who could help you and teach you how to create a *Shabbos* ambience, or if you wish, you can come to Hineni, and we'll teach you. The main thing, Anna, is to do something positive rather than say, 'If only . . . ' "

Anna took me up on my invitation. Not only did she come, but her grandchildren joined us as well. Today they are part of Hineni, and Anna couldn't be happier.

The if-only syndrome doesn't affect just people like Anna who have reached their senior years. People of all ages and backgrounds rationalize their inertia and their resignation to the status quo with if-onlys. "If only I had studied," "If only I had taken that job," "If only I had made that investment," "If only I had married him or her," "If only I had gone to law school." If-only, if-only—it goes on ad infinitum. Most often people do not have the energy to do something positive about their failures, so they take a somewhat perverse comfort in bemoaning their fate with if-onlys.

But what constructive outcome can result from such self-flagellation?

The Torah teaches us that it is self-destructive to allow the mistakes of the past to paralyze and depress us. We must learn to regard each and every day as a new beginning, a new opportunity to start all over again. Indeed, our entire New Year service is dedicated to this concept, for although the Jewish New Year calls for self-examination and scrutiny of our past, it is not the past that the liturgy focuses on but on *Hayom* (Hebrew for today). *Hayom* is repeated again and again throughout the service, for there is only one way to cancel out the mistakes of yesterday, and that is to create a better and more meaningful today.

In the Book of Genesis, we find that during the destruction of

the cities of Sodom and Gemorah, Lot's wife was told not to *look back*, but she failed to heed the admonition and was punished by being turned into a pillar of salt. Now, G-d does not punish us. Rather, our punishment is self-inflicted, the result of our action or inaction. Salt is symbolic of that which is ossified. By looking back, Lot's wife allowed herself to become ossified, frozen in the evil of her native city. Instead of going forward, she remained inert. Instead of seizing the opportunity of the moment to forge ahead and join G-d in partnership to create a new and better world, she dwelled on the past and was consumed by it.

It's not just when brooding over the past that the if-only philosophy can wreak havoc. Equally hurtful are the if-onlys of the future. People have a tendency to say, "If only I could find the time, I would do such and such."

I remember years ago there was a gas station near our synagogue to which my husband would take his car for service. Joe, the proprietor, was a hardworking man, putting in long hours seven days a week. My husband was pained to see a man so enslaved by his job that he didn't even know when the holy Sabbath and the holidays came.

"Joe," he would say to him, "why don't you come and join us at our *Shabbos* table? Bring the wife and kids. We'll have a beautiful *Shabbos* together."

"You're right, Rabbi. I wish I could do that." Joe would smile. "If only I could find the time, I would take you up on your offer, but one of these days, when I retire, I'll join you."

Well, "one of these days" came, and Joe did retire, but not quite the way he anticipated. He suffered a coronary in his sleep and never woke up.

Think about your own if-onlys. "If only things would calm down at work, I'd visit my mother more often," "If only I didn't have such a heavy load to carry, I'd spend more time with my children," "If only I didn't have so many obligations, I would take some time for prayer and Torah study."

If-only does not work. It is *today* that we have to seize the moment. Therefore our sages in the Mishna taught, "If not *now*, when?"

ॐ 14

Gaining Control over Yourself

"Who is mighty?"
"He who masters control over himself."
—Mɪsʜɴᴀ

LIFE AND DEATH ARE IN THE TONGUE

It was the morning of the last day of *shiva*. Multitudes of people had come to express their condolences and respect for the memory of my dear, revered father. I was talked out, cried out. I had been drained of my last ounce of energy, but still people kept coming, and I felt a need to respond to all of them, to acknowledge their kindness, and to share with them stories about the holy sage who was my father.

A face I didn't quite recognize sat down next to me. "Rebbetzin, you probably don't remember me," she said. "My name is Susan Shapiro. We met six years ago when you were lecturing in the Catskills." As she recalled some incidents, I began to place her. How considerate, I thought to myself, that she came. After all, I hardly know her.

"Rebbetzin," said Susan, breaking into my thoughts, "I came to see you because I wanted to tell you something." She hesitated for a moment, then took a deep breath and said, "I have to ask your forgiveness."

"For what?" I asked in surprise.

"For speaking *loshen hora*" (a generic Hebrew term for gossip, encompassing any and all negative talk about others). Even as she spoke, she started to fidget with her fingers, betraying her nervousness. "I spread some rumors about you, and it's been on my mind for the longest time." She hesitated for a moment and then said, "I thought that in the morning not too many people would be here, and it would be a good time to speak to you."

Susan's words hung in the air. As I looked at her pretty face, I wondered how she could be guilty of such nastiness. On the other hand, I said to myself, it was quite big of her to come to ask forgiveness. Still, I was hurt.

For a moment I was tempted to ask her what possible rumors she could have spread, but that would only have compounded the *loshen hora*. Mama, my wise and beautiful mother, always warned me not to be so sensitive. "When you are in the public eye," she would say, "people will always talk about you. They don't know you, they haven't the faintest idea of who you are or what you are all about, but they are all experts on your life, especially when it comes to tearing you apart. So you just have to learn to ignore them."

Intellectually I understood that Mama was right, but I had difficulty dealing with it emotionally. Why should people be so vicious?

Even as I thought about it, I realized that I knew the answer. It's an easy way for people to bolster their egos. My husband would often say that there are two ways for a person to become taller: the first by climbing a ladder and the second by pushing others down. Obviously it takes less effort to knock people down than to exert oneself by climbing a ladder. There is also a jealousy factor involved. People derive perverse pleasure from defaming those who are successful. Then there are those whose lack of education limits the scope of their conversation to gossip. Finally, there are those who think they will achieve popularity and fame by revealing secrets about others. Whichever way it goes, *loshen hora* is an ugly business, and you have to feel sorry for anyone who has a need to indulge in it.

All this was running through my mind as I turned to Susan and said with a full heart, "Of course I forgive you, and I appreciate your coming. Still, I feel a responsibility to discuss with you the terrible consequences of *loshen hora*, which, as you may know, is considered to be far worse than the three cardinal sins of murder, idolatry, and adultery combined."

"Why," Susan wondered, "are mere words regarded as more detestable than hateful deeds?"

"Perhaps," I told her, "because the man who is guilty of contemptible acts, in his heart of hearts realizes that he acted despicably and eventually may express contrition and repent, but he who speaks *loshen hora* seldom considers himself to be guilty. The average person will agonize more over a scratch on his car than over the cutting words with which he sliced up another. So I really appreciate your coming, Susan. I know it took real courage.

"There are more laws regarding speech than any other commandment," I continued, "and the Torah is very stringent in this matter, so much so that our sages advise us to refrain from all conversation that centers around people."

"All conversation?" Susan asked in surprise. "What's wrong with saying something nice?"

"At first glance, nothing. But when you speak of someone's virtues, someone else could use that as a springboard to discuss their flaws. So you see, you cannot be too careful when it comes to speech.

For example, in our society, what may be considered innocuous, good-natured, or even fun remarks may be viewed as transgressions by Torah standards. Ranking someone out, painful jibes, ridicule, innuendo, and carrying tales, all go under the heading of *loshen hora*, and it doesn't end with that. Fishing expeditions are also prohibited."

"*Fishing expeditions?*" Susan asked.

"Let's say you heard that your friend lost his job, or that your girlfriend was having problems with her boyfriend, or your neighbor's child was put on probation by his school. Don't call up with 'So what's doing?' or 'What's new?' Making such fishing expeditions is very painful for the people involved. So you see, Susan, *loshen hora* is not just spreading rumors—it entails much, much more."

"I'm not sure I want to hear more," Susan said, half jokingly. "By the time you're finished telling me all the laws, Rebbetzin, I'm afraid I won't have anything left to talk about."

There was a sad irony to Susan's words. We live in a world in which people feel that if they don't gossip, their social life will suffer. The ability to gossip is regarded as a social asset, and those who are really proficient at it can build highly successful careers. They become gossip columnists, talk show hosts, or write "tell all" best-sellers.

In our society, not only do we not have a cultural frame of reference to discredit *loshen hora*, but we teach our children that *loshen hora* is harmless. "Sticks and stones may break my bones, but words will never hurt me" is the jingle that our children grow up with. Our Torah, however, teaches just the opposite. Though it is true that sticks and stones can break our bones, bones can be set and mended, but hurtful, abusive words leave deep and lasting scars that never heal, scars that destroy individuals and families. To illustrate, I told Susan a story.

"There was a man whose every conversation was laced with *loshen hora*. He spread many rumors and destroyed many reputations. One day something stirred in his soul, and he felt that he wanted to make amends, so he went to the rabbi to ask for forgiveness. 'Whatever it takes—fasting, prayer, giving charity—just tell me what I should do, Rabbi, I'm ready.'

"'None of that will be necessary,' the rabbi assured him. 'Although the sin of *loshen hora* is the most reprehensible of all trans-

gressions, you will not have to take any such extreme measures. Instead, fill a bag with feathers, and then go to every house where you have spread gossip and leave a feather at each door.'

"The man could not understand how such a procedure could cleanse him, but if that was what the rabbi prescribed, that was what he would do.

"'When you have emptied the bag, come back to me and we will talk further,' the rabbi concluded.

"So the man departed and did as he had been told. After placing the last feather, he rushed back to the rabbi's house and said, 'I did what you told me. Am I forgiven now?'

"'There's just one more thing that remains to be done,' the rabbi responded. 'Take your empty bag and return to all the homes at which you left the feathers, gather them, and bring them to me.'

"Once again puzzled at this strange request, the man went forth to do the rabbi's bidding. But to his chagrin, when he arrived at the homes where he had left the feathers, the feathers were gone! Troubled, he returned to the rabbi and told him that the wind had blown all the feathers away.

"'That's exactly it, my son,' the rabbi nodded sadly. 'That's the tragedy of the sin of *loshen hora*. As much as you might wish to repent and ask forgiveness, there's a limit to what you can do. Just as you cannot find the feathers that were blown away by the wind, so too you cannot recapture words and undo the harm that you inflicted with your tongue.'"

Susan was visibly troubled. "So what should I do?" she asked.

I thought about it for a moment and told her that in addition to refraining from speaking *loshen hora*, she should actively combat it whenever she heard it spoken.

"How do I do that?" she asked.

"Well, for starters, share this discussion that we are having with others."

With that, Susan reached into her bag, took out a pad, and asked if I minded if she took notes.

"Mind?" I said. "I'm delighted." I was truly touched that she was taking the matter so seriously.

"We have fourteen positive and seventeen negative commandments," I explained, "all concerned with speech. To honor one's word

and to offer words of encouragement are examples of positive laws. Not to carry tales and not to mislead are examples of negative laws. There is a wonderful book on the subject, written by Rabbi Yisroel Meir HaCohen, known as the *Chofetz Chaim*. He was one of the greatest Torah luminaries of modern times, and he devoted his entire life to combating *loshen hora*. The book is available in English, and you should study it. I'm afraid, however, Susan, that all the studying in the world will not suffice. *Loshen hora* has such an insidious hold on people that even the intellectual cognition that it is wrong is not enough of a deterrent to control it. We have to pray to G-d to help us. Three times a day, at the conclusion of the silent meditation, we beseech Him, 'My G-d, guard my tongue from evil and my lips from speaking deceitfully.' Without His constant help, we cannot do it. The temptation to speak *loshen hora* is just too great for anyone to control on his own. This prayer is based on Psalm 34, which you should commit to memory, Susan:

Come my children and hearken unto me: I will teach you reverence for G-d.

Who is the man who desires life, who loves days that are good?

Guard your tongue from evil and your lips from speaking deceitfully."

"I hope I will be able to do it," Susan now said.

"Of course you will," I answered. "G-d did not give us laws that are beyond our reach. Even our physiological makeup is designed to help us guard our tongues. Just consider—every organ in our body is either external or internal (for example, the eyes and nose are external; the heart and kidneys are internal). The tongue, however, is both external and internal and is protected by two gates—the mouth and teeth, teaching us that before we use it, we must act with discretion, for the tongue is a most powerful instrument, and with it we can either kill or impart blessing. That's the meaning of the teaching of our sages: 'Life and death are in the tongue.'

"And that, Susan," I added, "is no exaggeration. Hitler was one of the most evil men ever to have walked on this earth. He killed millions of people. But did you ever ask yourself, Susan, how he

killed them? Was it Hitler who drove our people into the gas chambers? Was it Hitler who beat our babies into pulp? Was it Hitler who commanded the firing squads? No. He never came in personal contact with his victims. It was with his tongue that he slaughtered millions; it was with his tongue that he unleashed poison into the world; and it was with his tongue that he created a nation of killers—Hitler's willing executioners.

"Let's go back to the beginning of time, Susan, and consider the first sin that man ever committed. Was that sin born of an act of violence or lust? Or was it fashioned by the evil tongue of the serpent? You know the answer. You remember your Bible studies. The serpent in the Garden of Eden did not coerce, beat, or badger Eve into submission. He just seduced her with his evil tongue. Speech, Susan, is the most powerful instrument with which G-d has endowed us. With it, we can bring blessing or destruction to mankind."

We had been talking a long time, and our conversation was now being interrupted by the constant flow of people coming to pay their condolences. Susan got up. "I guess I'd better get going," she said. "There are other people waiting to talk to you. Thank you so much, Rebbetzin. This morning has been very meaningful for me, and I won't forget it. I just hope I'll be able to do it."

"Of course you will, Susan. But don't be too hard on yourself. You're not supposed to speak *loshen hora* about yourself either. You must have confidence and trust in G-d that you will make it. No one expects you to make a one hundred and eighty degree turn, Susan. If you can refrain from speaking *loshen hora* for at least part of every day, you will have already accomplished something. If every day before you get on the phone, you make a conscious resolve not to speak *loshen hora*, that will be an achievement. If before you sit down to dinner, you plan your conversation so that *loshen hora* will not be spoken, that will be a coup.

"What I am telling you, Susan, is that every attempt to improve, to change your life, to make a commitment not to speak *loshen hora*, even if it is only a little bit at a time, is an accomplishment. To make that commitment means to change your present direction, and it doesn't matter whether that change entails one step or two. The important thing is that you change."

As Susan left and someone else took her seat, it occurred to me

that most of us could make similar pilgrimages to ask forgiveness, that if we were called upon to place feathers on the doorstep of every person against whom we spoke *loshen hora*, we would probably have to fill up many bags.

Is it not time for all of us to remember that life and death are in the tongue, and that we should make a commitment to change our ways?

"I'd just like to say good-bye. I won't be in class for the next two weeks," Alice announced.

"I'll miss you. Where will you be?"

"Herb has vacation time coming, so we're going to Florida."

"That's great! But why do you look so glum?"

"I'm sorry. I didn't realize that I looked like that," she answered. "I guess I'm just not that excited."

"But why not? Most people are delighted to get away."

Alice smiled wryly. She was a woman in her early fifties who had worked in the public school system as a guidance counselor for most of her adult life and had recently retired. Her husband, a CPA, was employed by one of the "Big Six" and did quite well. Their two children were married and on their own, so they could afford to vacation with an easy mind and heart. Why then was Alice so down, I wondered.

"I don't mean to press, and if I'm out of order, please say so, but somehow I sense that you're not too happy about going away."

"You're right, I'm not. I would very much prefer staying home." She paused for a moment and looked as if she wanted to tell me something, but apparently thought better of it. "Never mind," she muttered under her breath.

"Is there something you'd like to share with me?"

"Maybe one of these days, but you are busy now, Rebbetzin."

"It's true, I am, but if something's bothering you, tell me. With G-d's help, I'll find time for you."

"Well, to tell the truth, I've been thinking about consulting you for a while now, but somehow I never got around to it."

"Come," I said, "let's go up to my office and talk. It's four flights up, so if you like, you can take the elevator, but I usually take the stairs. That's my exercise for the day."

"No, no, I'll go with you," Alice said.

By the time we reached my office, we were both somewhat out of breath.

"Phew!" Alice breathed as she settled into a chair. "That was tougher than I thought. I guess I'm not in such great condition."

"If you're not used to walking stairs, that's what happens, but

you'll be going on vacation, so you'll have an opportunity to get yourself in shape."

"I doubt that very much. If this vacation is like those in the past, I'll probably be too miserable to do much."

"That's what I picked up when we spoke downstairs. You're not happy about going away. What's the problem?"

"Oh, Rebbetzin, it's a long story, and I guess after more than thirty years of marriage, I should be used to it. It can probably be summed up in one sentence: I'm married to a man who has a vile temper, and he makes everything miserable for me."

"Tell me about it."

"Herb always had a short fuse. I saw it before we were married, but I was young, in love, and I guess I confused his temper with strength. The slightest thing can set him off. He just goes into a rage and terrorizes everyone. To tell the truth, many times I seriously considered divorce."

"So what happened?"

"When I was younger, there were the kids, although I guess it's not fair for me to use them as an excuse, because they suffered from his temper as much as I did. So if I really want to be honest about it, I never took that step because, despite everything, I love him. There is another side to Herb that is very sweet, and if you catch him in a good moment, he'll give you the shirt off his back. As the saying goes, 'When he is good, he is very, very good, but when he is bad, he is horrid.' And finally, I guess I was and still am just plain scared of being left alone. So many of my friends divorced, and I saw that there were no great bargains waiting out there for them. As a matter of fact, had they met someone like Herb, they would probably have grabbed him and considered him a great catch! So I stayed put and decided to hold onto my assets and build a life for myself."

"Has it worked?"

"Yes and no. Most often, I manage. I have a nice group of friends, and before I retired, I really enjoyed counseling. But when I have to go on vacation with him—it's murder. It's not like I am at home and can go into a different room or go and visit my grandchildren or meet friends for lunch. It's constant togetherness, and that's tough with a man like Herb."

"What actually happens when you go away? Give me an example."

"Give you an example?" Alice sighed in exasperation. "Oh G-d, where do I start?"

"Let's start at the beginning. You packed and went off to the airport. Now what?

"Oh, Rebbetzin, you have to backtrack. There are many scenes before we are on our way to the airport. Usually I pack for the two of us and leave Herb's suitcase open so he can throw in some last-minute odds and ends. Invariably he finds something to criticize. Either I packed too much or too little, and why did I pack this and not that? I know you'll say to me, 'Why do I bother? He's a big boy. Let him take care of his own things.' You're right, but it's too late for that now. I got him used to it, and that's how it is.

"Now Herb doesn't like to waste time waiting at the airport, so we always leave the house at the last minute. But then, as we hit traffic, he goes crazy in the car—cursing and yelling, 'What the hell are all those idiots doing on the road!'

"My daughter, who usually comes along to drive the car back home, said to him on one occasion, 'Daddy, those "idiots" are probably asking the same about you!' But he didn't get it. As far as Herb is concerned, the highways were built exclusively for him.

"And don't think, Rebbetzin, that I haven't thought of going by car service or cab. I have, but that was even worse. He'd yell at the drivers—either they drove too fast or too slow, or they didn't take the shortest route. It was just mortifying. Should I continue? Do you have the patience to listen to all this?"

"I'm here for just that," I assured her.

"OK," she continued, "so now we're at the airport trying to get to the gate, but here too there are complications. Herb is a photography buff, so in addition to his camera, his case is full of lenses, filters, and a supply of film. Now this presents a problem at the security check-in because he absolutely refuses to let his film go through the x-ray device, so everything has to be hand checked, and he gets nervous about the way they handle his equipment, causing more delay and yet another scene.

"On one vacation in Europe he made such a fuss that we were almost ejected from the plane. And this is just the beginning, Rebbetzin. We haven't even reached our vacation spot yet. By the time we arrive at the hotel, I'm drained. The room, the view, the house-

keeping, and then, the dining room—the location of our table and who we are seated with—are all potentials for explosions. Over the years, Herb has managed to alienate our children. They have no respect for him. How could they? He hardly has friends, just a few hangers-on who stick around because they think he's successful, and the worst is, he doesn't see it."

"And how do you react to all this?"

"Not too well. There was a time when I was able to control myself, but it's gotten more and more difficult. You see, it's not just that Herb has this violent temper, but he has a way of reversing things and blaming me for everything that goes wrong. I find myself reduced to such a state of anger that there are times when I could just kill him. I hate myself for losing it, I hate the scenes, I hate the shouting, I hate the fights, I hate the cursing. It negates everything that I believe in, everything that I taught my students, but when he goes after me, I become like a wild woman."

My heart went out to Alice. One of the most terrible ordeals for a woman is to live with a man with a violent temper and if his anger transforms her into an angry woman, then her anguish is compounded and an entire life comes into question. I also felt sorry for Herb. I have known men like him. They alienate everyone around them and then wonder why they are not well liked.

"You can't go on this way," I now said to Alice. "It's bad for your heart, it's bad for your mind, it's bad for you, and it's not the Torah way."

"What is the Torah way?" Alice asked sadly. I reached for my Book and had Alice look up Genesis 4:5–8. "Do you remember who the first angry man was?" I asked her. "Let's read about him: 'And Cain became exceedingly angry, and his countenance fell . . . and Cain rose up against his brother, Abel, and killed him.'

"Just keep this image in mind, Alice, next time you feel your blood boiling over."

"Oh, Rebbetzin, she protested, "when I said that I felt like killing Herb, that was just a figure of speech."

"Of course, Alice. But in a moment of rage we become blinded, and there but for the grace of G-d go you and I. Every person can become a Cain. He who becomes angry loses control over his emotions and because of that is compared to one who worships idols."

"I realize that losing yourself is terrible," Alice said. "Don't forget that I was a guidance counselor. But Cain . . . idol worship . . . isn't that rather extreme?"

"Well, think about it. Can you control yourself when you are in a fit of temper? Can you be responsible for that which you do or say in a moment of rage? Can you kill with words? Can you raise your fists in fury? Are you that far from Cain?

"As for idol worship, the moment you give vent to anger, you banish G-d's presence from your life and another force takes hold of you, a force that we call blind rage, or in Talmudic language, idol worship, the evil impulse. If the spirit of G-d is to guide you, Alice, if you are to have some sanity and serenity in your life, discipline and control are prerequisites."

"You're right, Rebbetzin, but what can I do?"

"There is much that you can do. For starters, let me give you a few pointers: Never speak or act in a moment of anger. As a child, I remember my father telling my brothers and me that before reacting to something that upset us, we should sleep on it. 'What you don't say today, you can always say tomorrow, but once it's out of your mouth, you can't take it back.'

"Besides, anything said in anger is bound to result in unnecessary, foolish, and hurtful words. So when you feel that Herb has driven you to the edge, don't respond, but do something to cool your temper. Wash your face, go into another room, and most important of all, ask G-d to help you, ask Him to give you back control.

"There are many stories of great rabbis who, upon becoming angry at the conduct of their children or disciples, would wait days and even weeks before addressing the problem so that they might be certain that they were not speaking out of anger."

"Do you always have to suppress anger? Isn't anger ever justified?" Alice asked.

"Yes, there are occasions when we must register our displeasure. We have a responsibility to our children and to our students to condemn unacceptable conduct, but we have to be on guard that while we convey anger by our expressions, we should never be overcome by anger. That's why the rabbis waited, so that they might purge it from their hearts. In other words, the Torah permits you to *feign* anger but never to actually *be* angry."

"But what if someone wronged you?" Alice pressed.

"Then try to rectify that wrong. But it won't be rectified by cursing, yelling, and in general, losing yourself. If somebody does you an injustice, what do you gain by harboring anger against him? Will your anger bring about the retribution that you seek? Will it in any way affect the person who hurt you? The only one who will be injured is you, Alice, because your anger turns inward and poisons your heart and mind until it dominates your existence, while the person who offended you walks around free and clear. So bottom line, Alice, the only one who stands to lose is you."

"It makes sense, and I'm the first to admit it. Like I told you, I hate myself when I lose my temper, but Herb has made me a victim."

"Nobody can make you a victim, Alice, but yourself. Try to remember that when Herb criticizes you, when he flies off the handle, it's not so much that he's finding fault with *you* but with *himself*. Angry people usually have very low self-esteem, so with all his bombast, Herb is probably a very insecure person who tries to compensate for his lack of confidence by venting to others, especially you, who are nearest and dearest to him. Try not to take his outbursts personally, and try to bear in mind what you told me—that there's another side to Herb that's very sweet.

"I realize that it's easy enough to tell you this in my office, but it's something else for you to remember it when the onslaught starts. Nevertheless, when he is burning with wrath, the best thing you can do is to ignore his offensive remarks. Our sages teach that you cannot appease an angry person in his moment of ire, and if you try, for sure you will have World War III played out in your home every day."

"Are you telling me that I should take all this bullying in silence?"

"Not quite. What I'm suggesting is that you follow the example of those rabbis who, before they spoke, waited until they were calm and the person whom they addressed was also calm. To respond in a moment of heat can only fuel the fire. There is a great teaching on this in the Bible.

"When the plague of frogs came upon Egypt, initially one huge frog emerged from the river, which, the Midrash teaches us, the Egyptians tried to kill. Incredibly, however, as they struck that frog, it split and multiplied, and the more they hit, the more frogs came forth, until Egypt was swarming with them.

"Now the Egyptians were no fools. This action was carried out by the wisest men of the empire. They saw with their own eyes that their violent reaction just produced more frogs and intensified the plague. So you might ask why they didn't stop striking the frogs. The answer, Alice, is that their rage blinded them. They lost all control— all reason and all logic.

"The worst thing you can do is follow the example of the Egyptians of old and react to Herb's anger in kind, banging away until everything explodes. From a small fire that could have been contained, a major conflagration will erupt, and that's the lesson of the frogs of Egypt that you should keep in mind."

Alice nodded her head. "There's nothing that I can say, Rebbetzin. You're right. I can't argue that, but I'm not twenty years old, and I don't know if I can change. As the saying goes, you can't teach an old dog new tricks."

"You may not be able to teach an old dog, Alice, but a human being, created in the image of G-d, is capable of constant growth and development. When in a temper, learn to remain quiet, and every day practice the art of silence. It's a wonderful exercise for inner discipline with many side benefits. Learn to speak to everyone, especially those who irritate you, in a gentle, soft voice. 'A soft reply turns away anger' (Proverbs 15:1). You will discover that if you maintain your composure, it will be easier for you to communicate in dignity with Herb. And finally, Alice, you will have to learn patience, because despite all your good intentions, you are bound to have relapses, but stay with it, and eventually you will make it. Patience, perseverance, and trust in G-d will change your life."

"But even if I do everything that you suggest, how will all this change Herb?"

"Ideally, it would be wonderful if someone could speak to him, if he would come to study, but since that doesn't seem to be happening, you can only hope that by *your changing*, he will be influenced. Perhaps if Herb sees that you are in control and speak in a gentle, warm voice, he might just react positively. A soft, calm voice makes a far greater impression than a raucous outburst.

"But let's consider the worst scenario: He remains as he is. Does that mean that you should also destroy yourself? If he shouts and screams, does that mean that you should yell louder? If he curses,

does that mean that you should also be vituperative? Why should you reduce yourself to that? Why should you continue to be a victim of his anger?

"A woman once came to my husband with a problem similar to yours. Do you know what my husband told her? 'G-d gave us two ears so things should go in one and out the other; two eyes so that we might close one while keeping the other open.' In other words, you don't have to hear everything, you don't have to see everything, you don't have to react to everything, but you do have to *always be in control.* Work on it, Alice, and never forget that he who is not in control is like one who lives without G-d."

Of all the many problems of people suffering from bad tempers that have come my way, I have chosen to tell the story of Herb and Alice in the hope that through them we will recognize how ludicrous we look when we lose ourselves. Just think of Herb, cursing his way through traffic, making a scene in a hotel dining room because he doesn't like his table, yelling at his wife because his suitcase wasn't packed right. You must recognize how awful and embarrassing it is when we allow rage to take hold of us.

Most things that cause us to fly off the handle are just not worth getting angry about. If we look back upon our lives and recall incidents that really upset us, we will have to concede that most of them were sheer nonsense, and to think that we allowed ourselves to get worked up over them is, in retrospect, downright embarrassing. Anger demeans us. It robs us of our dignity and self-esteem.

So the next time you are provoked, ask yourself, will this have significance with the passage of time? What possible benefit will I derive from screaming and carrying on? On the other hand, what damage will I do to myself and to the person upon whom I vent my anger? Is this worth losing my temper over?

If you learn to think along these lines and commit yourself to control and discipline, you will succeed in banishing anger from your life.

Overcoming Depression

As soon as the Adlers walked into my office, I realized that something was wrong. Freddy looked as if he was on the verge of collapse. His eyes were dull and unfocused, and Nancy was as tense as a coiled spring.

"Rebbetzin," she began, "thank you so much for seeing us. I really would not have imposed upon you were it not that I am afraid for Freddy's well-being."

Freddy, a man in his mid-fifties, was well dressed and would have been rather distinguished looking were it not for the dark, depressed look on his face.

"Would you like to tell me about your problem?" I asked. But he just shrugged his shoulders and suggested that it would be better if Nancy spoke.

"My grandmother used to quote a Yiddish proverb," Nancy said, "which I can't recite verbatim, but it went something like this: 'We could live and be well if we didn't make problems for ourselves,' and that, Rebbetzin, sums up our situation."

"Fill me in."

"I guess I should start at the beginning," Nancy said, taking a deep breath. "Fred and I have had a very good life. Our children are successful and doing well. In fact, our daughter just became engaged to a very fine young man. Everything would be perfect if not for Freddy's having sunk into this horrible depression. And it's not anything physical. It's not as if he needs medication. His internist and his psychiatrist both checked him out. It's all in his mind. It's 'self inflicted.'"

"Would you like to tell me what's troubling you?" I asked Freddy again.

He hesitated for a moment as if he was about to speak, but then he turned back to Nancy. "You tell the Rebbetzin. I can't talk about it."

"You see what I mean? He won't even talk. But OK, honey, if that's what you want, I'll tell the story.

"For the past twenty years, Freddy literally gave his life to his company, and he was next in line to become CEO when, out of the blue, there was a takeover, and Freddy was let go. Everything in our life fell apart, and it's not just the job, Rebbetzin. Our social life and

our standing in the community have also been affected. Freddy has been an active board member of at least half a dozen charities. In the past he was hardly ever home in the evening—there were always meetings. Now he's always home. People used to call seeking his advice and help. But now no one calls, and worse, he doesn't go anywhere. He just sits around the house and broods. It's gotten so bad that when my sister and brother-in-law came to visit the other day, he refused to come out of his room. He took this idea into his head that no one respects him anymore, that no one cares for him, and most terrible of all, he's talked himself into this depression."

"Has all this resulted in any financial problems?"

"Well, of course we feel the strain," Nancy answered. "There are a lot of things we did in the past that we can no longer afford to do, but the children and I understand, and we're prepared to tighten our belts."

"Did you try to look around for another position?" I now asked Freddy.

Once again, Nancy had to answer for him. "I'm glad you brought that up," she said, "because he has been offered a job with another company on a lower level, and he refuses even to consider it. He feels that it would be a comedown." For a moment there was silence. Then Nancy broke down. "I can't take it anymore. I just can't take it anymore. I can't stand seeing him just sitting there day in and day out feeling sorry for himself. I assure him of my love, the children assure him of their love, but nothing seems to make an impression on him. What else can I do?"

"Freddy," I said, turning to him. "I want you to listen to me closely because I am going to share something with you from my personal life.

"My father was the Chief Orthodox Rabbi of Szeged, the second largest city in Hungary. It was a prestigious, honored position. When we came to this country after the Holocaust, he had to find a way to support his family, so my father, a great sage, went from door to door carrying bottles of wine to sell. Never for a moment did he think that this was beneath him, never for a moment was he depressed. Rather, he went about his task cheerfully, grateful to G-d for every day.

"My mom, who in Hungary had enjoyed household help, took a

job behind the counter of a kosher luncheonette near Brooklyn College, and never thought it was demeaning to do so. My husband, who was an outstanding rabbinic scholar, arrived in this country penniless, without family or friends. Do you know what that great man did to support himself? He became a bellhop, and it never occurred to him to complain."

"That's different," Freddy objected. "It was after the war and they had no choice. But I was *demoted.*"

"*Demoted?*" I said. "You must be joking. They lost everything. In Europe they enjoyed prestigious positions. Not only did they lose them, but they also lost their homes, their families, their communities. Although I must admit that in a sense you're right—everything is different, and no two situations are exactly the same, but as you can see, there's a common denominator. By a twist of fate, they lost everything, and by a twist of fate, you lost your position, which to *you* is everything. The difference is that they never allowed their losses to affect their outlook on life, while you, with much less cause, have fallen apart. You are ready to give up, and they mustered their inner strength to go on. What does that tell you, Freddy?"

"It tells me that they're made of stronger stuff than me," he said sardonically.

"Freddy, it's all a matter of attitude. G-d planted that 'strong stuff' in all our hearts and souls. We need only bring it forth."

"How?"

"By connecting to something that's spiritual, something that's bigger than you, so that if things collapse around you, you will not be affected. You, Freddy Adler, are surely more than a position in a company. Positions come, positions go, but you are a man, a creation of G-d with a special mission. You have no right to be depressed."

"No right?" Freddy exclaimed.

"No, Freddy, no right. Throughout our Holocaust experiences, the ghettos, the deportations, the concentration camps, I never saw my parents depressed. Yes, they were hurting. Yes, they were filled with pain. Yes, their eyes overflowed with tears. But depression? Never! That's not a Torah way of responding to problems."

"Well, I guess I'm not on the level of rabbis like your father and your husband."

"Freddy," I told him. "I was a little girl when the Nazis invaded

our city. They awakened us in the middle of the night. I grabbed my doll as they threw us into the street. Our neighbors came to gape at us. Among them was the daughter of the superintendent of our building. She came over to me and snatched my doll from my hands.

"'What are you doing?' I said. 'That's my doll.'

"Her father spat in my face and said, 'Dirty Jew, where you're going, you won't need toys.'

"I cried. I hurt. But depressed? Never!"

"You're making me feel ashamed," Freddy now said.

"G-d forbid, Freddy. That's not my intent. I just want you to understand that losing things is only losing *things*—it's not losing your life. You cannot confuse the two, and if you do, it means that you never developed your spiritual resources, that you don't really know who you are, that you have no real commitments. Let me tell you a story about the legendary Yiddish town of fools, Chelm. That will explain it better.

"One day one of the wise men of Chelm decided to go to the *schvitz*, the town steam baths. When he undressed, he became frightened. Everyone here looks the same, he thought to himself. So how will I know who I am? Being a wise man of Chelm, however, he came up with a solution. He would tie a green string around his big toe, and that way he would know who he was when he emerged from the water.

"But in addition to everything else, this man of Chelm was a *schlemazel*, an accident-prone loser. As luck would have it, when he emerged from the *schvitz*, the string was gone!

"And worse, not only was it gone, but it had wrapped itself around the toe of another man!

"'Oy,' the man exclaimed. 'What do I do now?'

"So he went over to the fellow with the string on his big toe and said, 'Excuse me, I know who you are, but can you tell me who I am?'

"Unfortunately," I said to Freddy, "many people in our world are no different from that citizen of Chelm. They too need a string to identify themselves. The string could be anything from a house to a yacht, to status in the business world, to becoming a CEO. If the string is lost, they panic and become convinced that they are worthless, that they have no identity and have lost their place in society. Like the wise man of Chelm, they ask, 'Who am I?'

"That is what is so desperately wrong in our world, Freddy.

People have no spiritual underpinnings or commitment to values. They don't know who they really are. They can function only when propped up by their strings. But surely, Freddy, your life is more than a string."

As I said that, Nancy reached out for Freddy's hand. "The Rebbetzin is right, honey. I've been trying to tell you this all along. Your life is more than that string. Who really cares about that stupid CEO promotion? We love you for yourself. You must believe that."

Freddy was visibly moved, but he remained silent.

"Let me tell you one more little story," I said. "I once took a man who had a problem similar to yours to my father for guidance and blessing. My father spoke Yiddish, and this man spoke only English, but I knew that my father would find a way to communicate with him that would be by far more powerful than any words. And he did.

"As soon as I explained the problem, my father went into the kitchen, took a box of matches from the drawer next to the stove, and emptied them onto the table, leaving just a few inside. 'Listen to it rattle,' my father said. Then he filled the box compactly and demonstrated that this time the box did not rattle.

"The teaching was obvious. If you do not want to be depressed, if you do not want to fall apart, you have to live a full and constructive life, and that has nothing to do with financial attainments, a position on the board, or being CEO."

I pointed out to Freddy that whenever the Torah refers to happiness, it is in the context of spiritual achievements, for that is the only area in which a man can be truly happy. Physical pleasures and material possessions by their very nature must leave us dissatisfied, for no sooner do we have them than we crave for more, and that craving is endless and leaves us restless.

"So, Freddy, apply my father's teaching to your life. Fill that matchbox, and don't give yourself room for depression. 'Serve the L-rd with joy' (Psalm 100). Try to become a more spiritual person; learn to derive pleasure from your relationships with family and friends. You will be surprised and pleased to discover the wonderful feelings awakened in your heart if you just learn to let go and experience the joy of caring for others. The spiritual elevation that results from the study of Torah, prayer, and the observance of the Sabbath is so powerful that it will enable you to deal with your present

predicament without succumbing to depression. It's only in the absence of spiritual underpinnings that people fall apart, because if they lose their string, they have nothing to fall back on."

"I don't want to digress," Nancy interrupted, "and if I'm out of order, please tell me, but aren't there instances when depression is justified—like, G-d forbid, when you lose a dear one in your family? You see, I've been telling Freddy that such depression is understandable, but not when you fall apart over a job."

"Depression," I told Nancy, "is never an answer. Depression can only make a bad situation worse. If, G-d forbid, you should lose someone dear and precious, be grateful for the time that G-d allotted you with them, and make a commitment to live for them, to perpetuate their life's work. Retreating into a shell is self-indulgence and not an answer to anything. The depressed person is not capable of functioning. He becomes a burden to society, to his family, and worst of all, to himself. He can't even pray or serve G-d, because his mind can't focus. We have been granted a spiritual legacy, and that is what we must develop if we are to live our lives with commitment."

As Fred and Nancy got up to leave, I told Fred that this could very well be the best thing that ever happened to him because it could inspire him to change his outlook on life and become altogether a different person. In parting, I told him one last story from the Talmud.

"It is related that Elijah the prophet was once walking with the sage Rav Broika when they encountered two men. Elijah pointed to them and said, 'They have a special place of honor reserved for them in the world to come.'

"Rav Broika wondered why these two men merited such a great distinction, and he approached them. 'Tell me,' he asked, 'what is it that you do?'

"'When we see people who are depressed, we make them happy,' they answered.

"Unlike these two men, Freddy, you don't have to search for depressed clientele. You have one waiting right here—waiting to be liberated from self-inflicted, needless misery. It's all up to you. Banish your depression and make yourself happy with *real things* rather than *fragile strings*."

OVERCOMING TEMPTATION

Sylvia and Matt Black begged me to help their son.

"Ian could be the most wonderful boy," they told me. "He's bright, good-looking, and skis like a pro, but he's bent upon destroying himself."

"What does he do?" I asked.

"Drugs," came the sad answer.

"I'd be more than happy to try to help," I assured them, "but don't you think he should be under the care of a physician or a professional familiar with drug problems?"

"Oh, he is. As a matter of fact, it was his doctor who suggested that we come to see you. He feels that Ian would benefit from a spiritually structured program."

"Tell me something about him. How did he get so messed up?"

"G-d only knows," Sylvia responded. "Throughout high school he was in honor classes, great in sports, always popular and well liked, but when he went off to college, something happened—whether it was friends or some other influences I can't tell you.'"

"How did you discover that he was taking drugs?" I asked.

"He couldn't hide it too long. He was failing his courses, cutting classes. We went up to the school and tried to get help for him, but nothing worked. Then one day he just dropped out altogether and disappeared. We finally found him in a crack house in San Francisco."

"How did he support his habit?"

"My father left him some money," Matt volunteered. "He blew the whole thing."

My heart went out to Sylvia and Matt. To be blessed with a bright, talented, handsome son and then to see him destroy himself is more than any parent can bear. What a waste of a life . . .

"So what's happening now?" I asked.

"Ian was arrested, and it was probably the best thing that could have happened because it enabled us to bring him home. He's in a rehab program. His doctor is quite satisfied, but as we said earlier, we would like to see him involved in some sort of program that would give him spiritual strength, so if you can help us, Rebbetzin, we would be most grateful."

"I don't know if I can, but I will certainly try," I promised.

The following week, Ian came to Hineni. He was even more handsome and charming than his parents had pictured him. If I didn't know something of his history, I would never have guessed that there was a problem.

Ian's quick, keen mind absorbed the lessons, but still I felt uneasy about him. I didn't think that a once-a-week Torah class sufficed, but I could not persuade him or his family of that. I was especially edgy when at night, after our class, he would return home to his Manhattan apartment. I felt that there were just too many temptations waiting on the streets, so I asked Jonathan, one of our regulars, who was a very sensitive and caring person, to befriend him and accompany him home. This went on for several weeks, until one day Ian complained that I had appointed Jonathan as his watchdog.

"I really resent that, Rebbetzin. I feel like a fool," he protested.

"G-d forbid," I told him. "I would never want to make you feel foolish, but you have come such a long way, and I wouldn't want anything to happen to set you back."

"Rebbetzin," he assured me, "you don't have to worry about me. I'm finished with all that stuff."

"I know that you are finished with it, Ian, but I am afraid that it is *not finished with you*. The evil inclination never gives up. As a matter of fact, our sages refer to it as a king and as an old man: A king because it controls you and an old man because it is with you from birth until the day you die."

"Well, it's not controlling me, and it's not with me anymore. You can trust me on that!"

"I do trust you, Ian. I know that you are sincere in what you are saying right now, but in addition to being a king and an old man, the evil inclination is also compared to a fly."

"A fly?" Ian repeated and laughed.

"Yes, a fly, and don't laugh, because that disguise is the most insidious and dangerous of all. A fly comes in unnoticed. It gets through every little crack, nook, and cranny. Even if you chase it away, it comes right back again. A fly has incredible *chutzpa*. It doesn't take no for an answer, it doesn't give up, and that, Ian, is the evil inclination."

"Maybe that's a problem for some, but I'm an expert fly catcher," Ian said.

"Let me tell you a story about this young man who was studying in Jerusalem. Even as you, Ian, he came from a difficult background. Although his story was somewhat different from yours, there are many similarities. In any case, he was well on his way to starting a new life when he received an invitation from his old buddies for a reunion celebration. He asked his rabbi for permission to go.

"'Will this gathering be only for men?' the rabbi asked.

"'Oh no, girls will be there as well.'

"'And how will these girls be dressed?'

"'Well, it's a party, Rabbi, and you know how some girls dress for parties. But those things don't bother me anymore,' the young man responded. 'I'm over that.'

"The rabbi thought for a while, and then said, 'OK, it's alright for you to go, but first you must call this number and speak to my friend.'

"The young man, didn't quite understand the rabbi's intent, but he took the number and made the call.

"The following day, he returned to the rabbi. 'There must be some mistake. You must have given me the wrong number because when I called, a nurse answered and said that I had reached a doctor's office.'

"'No, my son, that was the right number,' the rabbi assured him. 'If you can tell me that going back to your old environment and see-ing all those girls in seductive clothing doesn't entice you, then some-thing is wrong. You need a checkup. I'm an old man, but if I were to see those girls, it would certainly bother me!'

"The moral of the story is, Ian, that you should be careful not to place yourself in a position in which you could be tempted. G-d knows, there are enough temptations that you have to contend with during the course of a normal day, you certainly don't need addi-tional ones, so that's why I asked Jonathan to accompany you home. You know where the pushers can be found, you know where drugs are available, and G-d forbid, in a moment of weakness, you might just succumb."

"Let's face it," Ian argued, "If I wanted to slip away, I could do it any time. A hundred Jonathans couldn't hold me down."

"That's true," I agreed, "and if it were up to me I would move you out of the city altogether and settle you with a responsible, com-

mitted family, but since that isn't happening, I have to do what I can to protect you."

"Rebbetzin, wasn't there anyone in the Bible who faced temptation and said no? Maybe I have their genes?"

Ian was being clever and throwing my own teachings back at me. Time and again I had taught that the heros of the Bible, the patriarchs and matriarchs, were our role models, and their spiritual genes are imbedded in our souls. Therefore, I would say, we are not to feel hopeless about our weaknesses, for we have a built-in ability to overcome them. And now Ian was turning that lesson on me.

"Well," I said, deciding to take him seriously, "there *was* a man who passed every test, who was able to conquer all temptations, and that was Joseph." And since I always like to substantiate my teachings with the written text, I had Ian turn to Genesis 39, where we read how Joseph, a lad of seventeen, bereft of family and alone in Egypt, said an unequivocal no to the seductive advances of Potiphar's beautiful wife, and when she persisted, he ran for his life.

"Joseph's self-control was so awesome that he was dubbed the Righteous One, but if Joseph, who possessed such incredible moral strength, had to run from temptation, how much more so do ordinary mortals like you and me? So why place yourself in jeopardy, Ian?"

For a while all went well. Ian cooperated with Jonathan. But then one night he missed class. I was worried. He was nowhere to be found. After I finished teaching, I made Barbara drive through the less savory streets of New York, which have a reputation as a haven for young druggies, but we saw no trace of him.

A few days later I discovered his whereabouts and asked Barbara and Jonathan to accompany me to the foul-smelling tenement in which he was staying. We climbed four flights of rickety stairs, and there, lying on the floor on a filthy mattress with vacant and glazed eyes, was Ian. I couldn't bear the pain of seeing him this way, and although Ian was out of it, I somehow sensed that he was ashamed to have me see him in this condition. I had brought food with me and forced him to eat.

By some miracle, I convinced him to let me take him to the hospital for help. Through another miracle, I got him into the car, but every time we stopped at a light I was petrified that he might bolt, so

I was doubly grateful to have Jonathan sitting next to him in the backseat. Finally we arrived at the emergency room, which presented yet another problem. The tedious paperwork and endless waiting to see a doctor were too taxing for someone in Ian's condition. For a while it was touch and go. Every minute he rose and threatened to leave, so I stayed with him until he was finally admitted.

It was a long haul. After a stay at the hospital, Ian was transferred to a rehab facility, and when he was finally released, we started all over again. My previous experience had taught me a lesson. I insisted that he move in with Roy and Linda, who would keep a constant watchful eye on him. I also prevailed upon him to enroll in a daily Torah study program instead of the once-a-week class he had attended previously.

"Torah is not just a study but a way of life, an antidote to the evil inclination," I told Ian. "Torah study will keep you anchored to our timeless values and will remind you of G-d's constant presence."

Fortunately, Ian agreed to give it a try. Today he is married, with a growing family, living in Israel.

But the questions still remain: Why would an intelligent person, of his own free will, opt to wallow in a filthy tenement with roaches swarming all around him when he could reside in a beautiful apartment, have a successful career, and be a source of pride to himself and to his family? Why do people make such terrible choices, and how can they protect themselves from being so self-destructive?

The strength of the evil inclination is in its ability temporarily to blind a person and deprive him of his ability to think. It seizes his heart and demands instant gratification—I want it now, I want it all, and I'll worry about the consequences later. And like the fly, it doesn't take no for an answer. Had Ian just stopped for a moment and contrasted the fleeting high of drugs with the rewards of a moral, meaningful life, had he considered the ruination that he would bring upon himself and his family, he would have fled like Joseph. As it was, the evil inclination held him hostage and didn't allow him to think. The Torah teaches us that Joseph was able to summon the inner strength to resist Potiphar's wife in his moment of temptation because, in his mind's eye, he saw a picture of his elderly father and everything that he represented. That image of the patriarch prompted Joseph to ask himself, "Is it worth it? Is it worth giving up my heritage, my covenant, my self-esteem, for this?"

Once that question is asked, the contest is over, and the evil inclination is defeated. This holds true for all forms of temptation. Just consider those prominent people whose sexual escapades make headlines all over the world. Had they only stopped to ask themselves, Is it worth it?, had they contrasted that moment of gratification with the shame, the scandal, the potential ruination of their careers, the pain and suffering of their families, they would never have succumbed.

Take the person who has this terrible need to smoke. Were he to pause for a moment and contrast in his mind the pleasures derived from tobacco with the very real possibility of heart disease or lung cancer, he would immediately throw away his cigarette.

But, you might argue, don't we instinctually know the difference between right and wrong? Even if our thought processes are blocked, doesn't our conscience prod us?

The answer to that is yes and no. For a very brief moment there is revulsion—a small still voice that whispers, "You can't do that!" But once the evil inclination is indulged, it takes over and convinces us that not only are we right, but all those who do not agree with us are hypocritical or incapable of enjoying life.

This may all sound rather hopeless, but it's not. The evil inclination is conquerable. Just remember Ian's story. You need only ask G-d for His guidance and commit to His commandments, and you will discover that you have an enormous reservoir of inner strength—the power to take charge of your emotions rather than letting your emotions take charge of you.

"Who is powerful?" our sages ask. "The person who is able to subdue his desires."

꩜ 15

Committing
to Marriage

*"Therefore a man shall leave his father and
mother and cleave unto his wife."*

—GENESIS

MATCHMAKER, MATCHMAKER

Finding one's life partner has never been a simple matter. The Bible relates that Isaac, who was the most eligible bachelor of his time, the scion of the greatest family in his generation, brilliant, handsome, and fabulously wealthy, nevertheless encountered hardships in finding his mate. His father, Abraham, commissioned Eliezer, the executor of his estate and his most trusted servant, to find Isaac a bride. Laden with great riches, Eliezer set forth on his mission, but even as he did so he prayed to G-d for guidance, for he was keenly aware that only with His help could Isaac's soul mate be found.

I relate this story of Isaac because very often I hear people say, "Nowadays it's difficult to find one's mate, but generations ago things were easier." Truth be told, it has never been easy. Even in biblical times there were obstacles to overcome. Admittedly, today it's even more difficult, because this is one area in which young people are very much left to fend for themselves, without guidance from anyone. They are expected to find love by chance—at a resort, on the street, in a restaurant, at a bar, a club, on campus, or in the workplace.

But what can you really know about the people you meet in such a fashion?

Yes, he may be good-looking, and there is instant chemistry between you. Yes, she may be beautiful, and there is an electricity that you feel. But what do you really know about one another, about your families, your backgrounds, your character, your goals, and your compatibility?

In the Torah world, things are somewhat easier because we have matchmakers to facilitate the process. Now the word *matchmaker* conjures up the image of Yente from *Fiddler on the Roof,* but such caricatures are not reality. Matchmaking is a *mitzvah,* a righteous deed, and G-d Himself is occupied with it.

It is related that a wealthy Roman matron once challenged a sage of Israel, "What does your G-d do the whole day?"

"He makes matches," the sage answered.

The matron started to laugh mockingly. "Well, in that case, I'm also G-d."

And she proceeded to assemble her male and female slaves,

paired them, and ordered them to be married to one another. The next day, bedlam broke out. They all complained bitterly that they couldn't stand their mates. Unable to deal with all this, the Roman matron conceded that indeed, matches are from G-d and can only be made in heaven.

Our tradition has always regarded matchmaking as an awesome responsibility, taken on mostly by rabbis, good friends of the family, *bubbies* and *zeides*, and sometimes moms and dads.

My father, a great Torah sage, never left the house without his little notebook. "You can never tell who you will meet," he would say. "Maybe G-d will grant that I succeed in making a *shidduch* [Hebrew word for match]."

My father attended every Hineni function just so that he might bring singles together. This was no small feat considering that his ghetto and concentration camp experiences had left him with severe leg injuries. As the years passed, and his illness became more debilitating, he was confined to a wheelchair. Time and again I tried to persuade him to cut back and not exert himself, but there was no dissuading him. He insisted on being at every class. "Of course I have to be there and give the confidence to our young people to go under the *chuppah* [marriage canopy]."

So it was that some of the young men from my class would go to my father's house, which was adjacent to the synagogue, and carry him down the steps in his wheelchair. When he was taken into the sanctuary, everyone rose in his honor, and the entire room lit up with his sanctity and his smile.

Long after my father had passed away, I was standing in line at JFK waiting for the El Al bus that would transport me to the aircraft, when I noticed a young couple who looked familiar standing nearby with four adorable children.

The father, holding a baby in his arms, turned to me. "Aren't you Rebbetzin Jungreis?" he asked.

"Yes, I am. Do I know you?"

"Before we moved to Boston, we used to attend your Hineni classes. I will never forget the night your father of blessed memory said, 'Look around. Maybe there is a girl in this room who is your *basherte* [destined one], and if she isn't, get to know her anyway. Maybe you can introduce her to one of your friends. Become a *shad-*

chan, and in that merit G-d will help you find your mate.' I took the Rabbi's message to heart. I looked around, and there was Regina. Six months later we were married, and this is the result!" he said, pointing to his children, his face beaming with pride.

My eyes filled with tears. I heard my father's voice, I saw him in his wheelchair, making his way through the crowd, stopping to speak to each and every person. My father, the great sage, was a *shadchan,* a matchmaker par excellence, who was committed to helping young people find their spouses and tried to encourage everyone to join him in this undertaking.

Indeed, matchmaking has always been part of our family's calling. I made my first match when I was sixteen, and today my children are making matches as well. To what extent this commitment has been a part of our lives can perhaps best be perceived through a story about my husband of blessed memory.

In a desperate attempt to save his life, he underwent a third and final procedure at Sloan Kettering. You can imagine our feelings as we sat in the waiting room reciting psalms. Every minute was an eternity. Time stood still. We were numb with apprehension. Every time the door opened we jumped, hoping it would be the doctor.

Finally the doctor appeared. We all rushed forward. Was the crown of our family still alive? The doctor was somber.

"The Rabbi survived the procedure, but he's very, very ill. A nurse will come to take you to see him, but don't stay longer than a minute," he announced in a grim voice.

As the nurse led me into recovery, she warned me not to be frightened if my husband didn't respond. He was under heavy sedation. I stood at my husband's bedside, holding his hand and weeping silently. Slowly he opened his eyes. He was in terrible pain, but as always, he smiled.

"The doctor assured me that with G-d's help you'll be alright," I said as bravely as I could. My husband just looked at me, and his eyes told me that he knew the truth. He tried to speak, and I lowered my head to hear his voice, which was barely audible. "There is a very fine resident here. He is single. You have to try to find him a *shidduch.*"

In the midst of my tears, I had to smile.

No, matchmaking is not Yente in *Fiddler on the Roof.* It is a *mitzvah*—a righteous deed, the greatest kindness you can render a

person, and my husband, a man of G-d, even as he was wrestling with the angel of death, never forgot his commitment. So it is that in our Hineni organization, matchmaking plays a major role. Each week thousands of young people gather at our Torah classes. After each session, my daughter Slovi and my daughter-in-law Yaffa get to work interviewing people, getting acquainted with them, and matching them up. Thank G-d they have been extremely successful, and we have had many happy endings. My sons, Rabbis Yisroel and Osher, officiate at the weddings.

To some singles, matchmaking was a foreign concept. They felt uncomfortable at the thought of being set up, so my daughter would tell them stories about Zeide, my father, and how he went about finding matches, not only for strangers but for his grandchildren as well.

Chaya Sora, my oldest daughter, was the first to benefit from Zeide's matchmaking talents. No sooner did she finish high school than Zeide got to work.

"Tatie," I protested, "she's so young, beautiful, and talented. What's our rush?"

"You're wrong, my child," my father answered calmly. "Our sages teach that we should marry off our children when they are young, when they can grow and develop together and adjust to one another with ease. Precisely because she is young and beautiful, she has the best opportunity now. The years go by very quickly, and she should never find herself in a position in which she feels pressured into settling."

Experience has borne out the wisdom of my father's words. When I see the countless young women who were told they had time to marry—that they should pursue their careers, have "relationships," and travel the world—overcome by anxiety as their biological clocks tick away, then I more than ever realize just how right my father was.

But my father didn't only theorize. He put his ideas into practice. Wherever he went, he kept his eyes open for eligible young men, and he made a point of letting people know he had a beautiful granddaughter of marriageable age. And it didn't stop there. My father was a rabbi who was loved by multitudes of people. Almost daily, wedding and bar mitzvah invitations arrived at the house, so he would call and ask to speak to Chaya Sora.

"My child, I have a great favor to ask of you. Mama and I have to go to a wedding. It's difficult for us to go alone. Could you please accompany us?"

Now Chaya Sora knew full well that this was a ploy to get her to that wedding so that she might be seen and introduced, and she was, to say the least, very reluctant to go. Sensing this, Zeide made his request impossible to turn down. "Do this as a *mitzvah* for my sake, my precious child," and that was an invitation she could not refuse!

As things turned out, it was at one of Zeide's celebrations that someone suggested that Chaya Sora meet Rabbi Shlomo Gertzwin, the terrific, bright, and talented young man who later became her husband. As each of my children reached marriageable age, my father was there for them, worrying about them, fussing over them, not resting until they had found their mates.

Unfortunately, there aren't too many *zeides* like that today, so at Hineni we try to follow his example and help people get to know one another. Thank G-d, the results have been very gratifying. It was at one of our Hineni Torah classes that Slovi introduced Cindy to Mark. She was a lovely, young, successful attorney, and he was a computer software designer.

"I think I have just the guy for you," Slovi said to Cindy, and she gave Cindy's number to Mark. They clicked from the start. Cindy and Mark fell in love.

Soon afterward Slovi was off to Israel with her family to visit her in-laws, but before she left, she asked Cindy if she would like to write a prayer to be inserted in the holy Wall in Jerusalem.

Gratefully Cindy accepted the offer and wrote a note asking G-d to grant her the privilege of marrying and bringing children into the world in her parents' lifetime.

When Slovi returned from Israel, Cindy greeted her with tears. She could hardly speak. "It's over," she said, "It's over. I cannot see Mark anymore."

"Why?" Slovi asked. "What happened?"

"The doctor found a lump in my breast," Cindy said, all choked up. "I don't think it's fair to burden Mark with something like this, so I told him to go out with other girls."

"Don't think that way!" Slovi protested. "I just placed your prayer in a crevice in the holy Wall. Perhaps it was in that merit that

you discovered the lump now, before, G-d forbid, it was too late. Let's just continue to pray, and we'll get everyone in the class to join us in prayer as well. G-d will surely help."

That evening after class, when Slovi and Yaffa were at their usual stations interviewing the many young people who can always be found there, they noticed Mark standing on line. He waited patiently until everyone had left. He wanted to talk to Slovi privately.

"No matter what," he declared, "I want to marry Cindy. I love her. You must convince her of that. If, G-d forbid, something is wrong, I want to be there for her."

When Slovi shared this with me, I told her to tell Cindy that in every difficult situation there is also a blessing. Perhaps this had to happen so that she might see how deep and genuine was Mark's love for her. Our sages teach that "a love that is contingent on something does not last," for once that something is lost, the love will also disappear. For example, if you fall in love with a girl for her looks, and she loses them, your love may also fade. Or if you are attracted to a man for his wealth, and then he has reversals, your love may also reverse itself. Therefore the perfect relationship exists when you love a person not for any one thing but rather for his or her *total self*. And that is what Mark proved. He loved Cindy unconditionally.

The following week, Cindy was scheduled for surgery. Mark sent her a magnificent bouquet of twenty flowers—sixteen white lilies and four red roses—never knowing that the doctor had removed twenty nodes for testing, sixteen from the upper level and four from the lower level. Thank G-d, the doctors were optimistic.

I have dubbed the story of Cindy and Mark the "Hineni Love Story," for it truly symbolizes what love should be. The Hebrew word for love is *ahavah*, which is derived from the root word *hav* (to give), teaching us that to love is to give. An added insight can be found through the cabalistic study of *gematria* (numerology). Each letter in the Hebrew alphabet has a numerical value, and the word *ahavah* adds up to thirteen, as does the word *echod*, which means "one." From this we learn that true love means to *give* and to feel a *oneness* with your mate. Mark wanted to give to Cindy, and Cindy was ready to sacrifice her heart's desire to protect Mark. In a home in which husband and wife are bonded by such love, peace and harmony will prevail.

This concept eludes many people. Our culture has taught us to equate love with gratification—with getting rather than with giving, with taking rather than sharing, with being our own persons rather than feeling a oneness with our mates. Therefore it's not surprising that people go in and out of relationships, since the returns are bound to fall short of their expectations.

There is a beautiful legend of two brothers that totally captures this Jewish view of true love.

It is related that at the beginning of time, the Almighty went forth in search of a place where He might build His Holy Temple.

Where should it be? Which city should He choose?

In Jerusalem there lived two brothers. Their houses were at opposite ends of the city, and they were separated by a great mountain. One brother was very poor but blessed with children, while the other possessed a great fortune but had no family.

One night the wealthy brother tossed and turned in his sleep. I have been so blessed, he thought to himself. G-d has been so good to me. He has given me so much, while my brother, who has a large family to support, has so little.

That same night, the poor brother also awoke from his sleep. I feel so much pain for my unfortunate brother, he thought to himself. Of what good is all his wealth? Without children, his life is empty and meaningless.

As the brothers lay awake thinking of how they might help one another, they each came up with an identical plan. In the darkness of the night, each would secretly leave a gift at the door of his brother.

And so the two brothers set out and began to climb the mountain from opposite directions. As they reached the top, they suddenly lighted upon one another. For a moment they just stood there, overwhelmed, and then, weeping with joy, they fell into each other's arms, saying, "But it's *your* happiness that I seek."

And as they embraced, a Heavenly voice was heard: "This ground has been sanctified by the love of brothers. It is here that I shall build My Holy Temple."

Every home can become a Temple if it is built on pillars of love.

I Love You, But . . .

"Reeebeeetzin." The voice at the other end of the line was hardly audible.

"Who is this?" I asked. But the only response was uncontrollable sobbing.

"Try to take a deep breath and get control of yourself," I said as gently as I could.

"It's me, Jackie Merling," she finally answered through a torrent of tears. "He broke it up. It's over, it's over! I want to die. Oooh, I want to die!"

Jackie attended my seminars from time to time. She and Brian had been seeing each other for three years and were to be married in less than two weeks. Although I didn't know them very well, they appeared to be a perfect couple. What on earth could have happened, I wondered.

"Where are you now?" I asked.

"In my sister's apartment."

"Is she there with you?"

"No, she's in Florida."

"Give me the address," I said, "and just hold tight. I'm coming right over." Jackie sounded so out of control that I feared for her.

When I told Barbara that we were going to Manhattan, she became upset.

"I can't believe you're doing this. You have so much work to do; you hardly know this girl; why doesn't her mother go?"

"I don't know why her mother's not going," I answered. "Maybe she's sick. Maybe there are other problems." And I reminded Barbara of the rabbinic dictum to "judge every person favorably" because you never really know what is happening in their lives. And while it was true that I didn't know Jackie all that well, that was all the more reason why I felt compelled to go. I had no way of judging whether she would harm herself. Under similar circumstances I have known girls to overdose, and I just couldn't take that chance. Since the hour was late, there was hardly any traffic. In no time at all, we made it to the city.

"She'll want some private time with you," Barbara said. "I'll go to the office. Call me when you're ready."

I found Jackie lying on a bed, moaning and crying. I rocked her in my arms and tried to assure her that it was going to be alright.

"Rebbetzin," she apologized, "I feel terrible dragging you out like this, but I'm so frightened. I just had to talk to someone."

"It's OK. That's why I'm here. Just calm down and tell me what happened."

"I don't know, I really don't know," she said, sobbing convulsively.

"Just tell me exactly what took place."

"We went out to dinner as we always do, and then he said, 'Let's take a ride. I have something to tell you.' We drove around for awhile, when suddenly he stopped the car, turned to me, and said something about loving me but there were many issues that were troubling him, and he just couldn't see us going ahead with our wedding plans. He kept repeating that this was the most painful thing he had ever had to do, and he was sorry. Can you imagine, Rebbetzin, he was sorry. Sorry!" she shrieked. "He puts a knife into my heart and then tells me he's sorry. Oh, Rebbetzin, do you think it's really over?"

Those two words *but* and *issues* struck a familiar chord in my mind. Time and again I have heard young people justify terminating their relationships with *but* and *issues*. In biblical Hebrew, the word for *but* is *efes*, which translated literally means "zero." So when someone says, "I love you, but . . . ," you know it's a polite way of saying it's over. *Issues* is one of those intangible concepts that permit people to ease out of sticky situations gracefully. Once you say *issues*, there is no need to elaborate.

"I want to die," Jackie wailed. "I can't go on living. I just want to die."

"Jackie," I said, putting my hands firmly on her shoulders and looking her straight in the eyes, "listen carefully to what I am going to tell you. You should never, but never, say such words, even in moments of hysteria. Our Torah teaches that what we say can become a self-fulfilling prophesy, so we have to be very careful with whatever comes forth from our lips. With the same energy that you wish yourself dead, wish for life and good things. Ask G-d to help you deal with this crisis, and in the interim, keep in mind that everything is divinely guided, and therefore there is meaning to everything that occurs, even if you can't make sense of it now. If Brian is the sort of person who can break an engagement two weeks before your

wedding, perhaps you're better off without him. This might just be a blessing in disguise."

"But I love him, and I can't live without him," she wailed.

"I know, sweetheart, I know, but that's how you feel now. In time you will feel differently. This may sound trite, but one of the greatest gifts that G-d has given us is time. Believe me, Jackie, I know what I am talking about. You must have heard that I have personally been through a lot in my own life—ghettos, the concentration camps, and the long and painful illness and subsequent death of my dear father. It hasn't been easy, but time does heal. Just hang in there."

"What am I going to say to my friends. I'm so mortified—they'll all be talking about me."

"That's the least of your problems, Jackie. In one day, all this will become yesterday's news, and if you hold your head high and demonstrate to everyone that you're OK, they'll have nothing to talk about."

"But what will I say?" she wailed.

"The less said, the better. The main thing is not to say anything disparaging about Brian, because if you do, it will come back to haunt you."

"What do you mean?" she asked indignantly. "I shouldn't tell anyone what a terrible thing he did, walking out on me two weeks before the wedding?"

"Jackie, if you sling mud, it will splatter right back on you. People love this type of thing. 'You know what Jackie told me?' And then they call Brian. 'Do you know what Jackie said about you?' And then he'll give his version of things, and before you know it you'll find yourself in the midst of an ugly war from which you won't be able to extricate yourself. You never gain anything by speaking *loshen hora*, but you will end up hurting *yourself*. So just tell people that the wedding is off, and don't allow yourself to be drawn into any further discussion."

"I'll try," Jackie said. "I hope I'll be able to do it, but the way I feel now, I would just like to slam him and ruin his reputation."

"Don't even think of that, because you'll end up ruining your reputation in the process. When the Torah tells us not to be vengeful and not to speak *loshen hora*, it is for our benefit that it does so."

Thank G-d, at least on this score it looked as though I had got-

ten through to Jackie—but still she just kept crying. It was almost 1:00 A.M. I didn't feel comfortable about leaving her alone in the apartment. "Jackie," I now asked. "Have you told your mom and dad?"

She nodded her head.

"Would you like me to take you home to them, or should they perhaps come here? I don't think you should stay by yourself tonight."

"No, no, please no!" she protested hysterically. "My mom wanted to come, but I told her not to."

"But why not, Jackie? It would be good for you to have your mom here. At times like this, you need your mother."

"You don't understand, Rebbetzin. My parents went through a lot this year. My father just came out of the hospital. He was operated on for cancer, and now he has to start chemo. My mom has all she can do just to cope. Even under the best of circumstances she has difficulty dealing with things. When I told her what happened, she became hysterical, and the worst was when she told me, 'I don't know how to break the news to your father. The wedding was the only thing that kept him going.' I just can't handle hearing that."

"Jackie dear, your mom may have been crying, and yes, your father is fighting for his life, but precisely because of that he will understand that this is nothing to collapse over. With all due respect, the problem that you have is not life-threatening, so don't be afraid of sharing it with them. When it comes to their children, parents have an incredible ability to tap into hidden resources of strength, like when you were sick as a child and your mom stayed up with you the entire night."

"This is different, Rebbetzin. I can't have my mother come here. I can't bear to see her suffer because of me. She is such a good woman. I don't know why this had to happen. It's not fair. It's just not fair," Jackie kept repeating as she hit the pillow with her fist.

"Fair, sweetheart? What's fair? What does that really mean? Did you know that in the Hebrew language, in which G-d gave the Torah, the word *fair* does not exist? As a matter of fact, in modern Hebrew, people have incorporated the English word *fair* into their vocabulary."

"What's wrong with wanting things to be fair?" Jackie asked, surprised.

"*Fair* is a limited, personal, and very biased way of looking at things. G-d wants us to measure the challenges of life by the standards of goodness, justice, truth, and responsibility, and that's an entirely different way of focusing. From our human perspective, things are not fair when we don't get our way, but what we may think is fair is not necessarily good for us. We have to trust G-d and know that whatever happens is for the best and that He would never burden us with something we can't handle.

"Think about it, Jackie. Would a good teacher give an assignment to his or her students that they would be incapable of fulfilling? Similarly, could you consider even for a moment that G-d would burden you or your parents with a load that you couldn't carry? Pray to Him, and He will give strength to you and to your parents as well."

But Jackie just wouldn't be consoled.

"You know what will kill your parents?" I asked in a stern voice. "Seeing their beautiful daughter fall apart. The fact that your wedding is off—that they will handle. But if, G-d forbid, you get sick, that will surely destroy them, and with your father's illness, they hardly need that right now."

Even as I spoke, I made a mental note to call her parents just to make certain that they were coping and that they understood that at this time Jackie needed strength and support rather than recrimination mingled with commiseration.

"Jackie, you are coming home with me," I told her. "Get your coat. You're sleeping in my house tonight."

"I couldn't do that. I'll be alright. I'll stay here."

But I wouldn't take no for an answer. I called Barbara and told her that we were ready to leave.

"I don't want anyone to see me this way," she protested.

"Don't worry, sweetheart. There is no one home except my husband and, as a rabbi, he is used to seeing people in all kinds of situations. Trust me, he'll be happy to welcome you."

I felt that if anyone could give strength to Jackie at this time, it would be my husband. I just knew that his wisdom and kindness would be very comforting to her. Jackie wept throughout the entire trip to Long Island. It was 2:15 A.M. by the time we got home. I knew my husband would be awake. In all the years of our marriage,

he never went to sleep until I came home, but would sit at his desk, pouring over his holy books. Many times in the past I had suggested that it was unnecessary for him to wait up for me, but he would only smile and say that the quiet of the night afforded him the best time for his Torah studies.

"I don't want to intrude," Jackie said between sobs.

"Intrude?" I told her. "You must be kidding. I am so confident that the Rabbi will be happy to see you that I didn't even bother to call ahead and tell him we were coming." I knew that as soon as he saw her he would understand the situation and know exactly what to say.

Sure enough, when my husband heard the car pull into the driveway, he came out to greet us. As soon as he saw Jackie, he welcomed her in his typical warm manner. "I'm so glad we have company," he said, a broad smile lighting up his face. "Come on in."

We told him what had happened. "So why are you crying?" he said to Jackie, in his sweet yet powerful voice, making everything that was complicated seem so simple. "A beautiful girl like you. You'll find your happiness with someone who will truly love and appreciate you. This young man was just not *basherte*, and I wouldn't waste even one tear on him. Give it some time, and the Rebbetzin will help you find your *basherte*, your destined one. Everyone has a *basherte*, Jackie. Even before we are born it is decided in the heavens above who our soul mate will be."

"But I did find him," she said, "and I lost him."

"If he had been the real one, he wouldn't have walked out on you less than two weeks before the wedding."

"Oh Rabbi," Jackie cried, "it's hopeless."

"It's never hopeless. You'll find him, but you will have to learn to do certain things."

"Like what?" she asked.

"Like smile again," my husband answered.

"Smile!" Jackie said incredulously. "How can I smile, Rabbi?"

"I'm going to teach you a secret, Jackie, wisdom from a great Hasidic sage called the Rabbi of Breslov. He taught that it is precisely when you have no reason to smile, when your heart is heavy and full of pain and everything appears to be falling apart, that you have to demonstrate your faith and *force yourself to smile*. And if you do

that, then G-d will give you every reason to smile. Now let's see, Jackie, just try. Give me a smile."

"I can't, Rabbi, I really can't," Jackie said, still crying.

"Come, I'll help you. Look at my face and smile for me."

It took a while and no little coaxing, but slowly, through her tears, Jackie managed a weak smile.

The next morning, my husband invited her to pray. "Come, Jackie," he said, "you'll pray and you'll feel better."

She resisted. "Rabbi, I don't want to pray. I can't pray."

"You can and you will," my husband insisted, "because it is only through prayer that you will gain strength and find your *basherte*. Do you know how our father Isaac met Rebecca? He went into the field and prayed, and when he concluded, Rebecca appeared."

And so Jackie stood before G-d and invoked His blessing and guidance. When she finished, my husband prevailed upon her to open the Book of Psalms. When she recited Psalm 118—"Out of the depths of distress I call upon the L-rd. He answered me by setting me free. The L-rd is with me, I have no fear. What can man do to me?"—she told me that she finally felt a measure of peace enter her soul.

I told Jackie that the Book of Psalms is my constant companion and that I carry it in my pocketbook at all times. It's like carrying a cellular phone that connects you directly to the Almighty G-d. Whenever you want to speak to Him, just call by opening the Book of Psalms, and you will immediately feel strengthened and invigorated.

Jackie stayed with us for the entire day. While my husband was talking to her, I called her parents. True to Jackie's description, Sally Merling was beside herself. In her own way, she was even more hysterical than her daughter. She wanted to know if I planned to speak to Brian. I assured her that I would but that I didn't have much hope that anything positive would accrue. Experience had taught me that most often when someone takes the route that Brian did, all attempts at patching things up are futile because the problem is one of *commitment* rather than a specific issue that would lend itself to compromise. I told Sally that right now her priority must be Jackie. She needed *strength* and not *tears*.

"You won't do her or yourself any good by crying," I told her. "I

know this may sound harsh, and please forgive me, but when our loved ones are hurting, we can't afford to fall apart. After what you went through with your husband, Sally, you know this better than anyone else. I agree that what happened is very sad," I continued, "but as I told Jackie, it may just be a blessing in disguise. It's not the end of the world. There are other boys out there, and you must assure her that with G-d's help, she will find the right one among them."

Sally insisted that that was exactly what she had been saying to Jackie, but even as she spoke she was sobbing uncontrollably. As I suspected, she was unaware how shattering her tears had been to her daughter. Most people never realize the impact they have on those who are near and dear to them. Gently I tried to explain once again that while I knew how difficult this was for her, by letting Jackie see how deeply she was affected she had unknowingly intensified Jackie's pain.

"Your daughter feels that the rug has been pulled out from under her, that her life is over. My husband and I have been trying to convince her that this is not the case at all. If you fall apart, she *will* believe that everything is over." I also cautioned Sally not to make her husband's illness a guilt trip for Jackie by suggesting that her canceled wedding was causing her sick father grief.

"So what would you have me do?" Sally wailed.

"Just take hold of your daughter's hand, look her straight in the eyes, and tell her, 'It will be alright. With G-d's help you will find your soul mate.' And say it like *you really mean it*, Sally," I added.

Still crying, Sally thanked me for my call. I could only hope that when she and Jackie next spoke, she would remember to be in control.

The following day Jackie returned to the city, but not before she promised to come to my seminar that evening with a smile on her face.

In time I got Jackie to date again. At first she resisted, claiming that she still wasn't ready, that she still hadn't gotten over Brian. Once again I pushed, and when she agreed, I briefed her before her first date.

"Don't talk about Brian, don't talk about your broken engagement—to do that is like going on a date carrying baggage. It just

doesn't work. And besides, no man is interested in his date's former boyfriend."

I pointed out to Jackie that one of the seven blessings recited under the marriage canopy is that G-d grant joy to the bride and groom in the same measure that He did to the first couple in the Garden of Eden. Why do you think Adam and Eve were chosen as the focus of this blessing? Why not Abraham and Sarah or Isaac and Rebecca? One of the answers suggested is that Adam and Eve were the only ones who didn't have a previous history, who didn't come with baggage.

To further substantiate this concept, I told Jackie that the word for happiness in Hebrew is *simcha*, which is derived from two words—*sheh mochah*—which literally translated mean "to erase." In order to find genuine happiness, you have to know how to erase, to start fresh, and not invite ghosts to accompany you on your dates. Talking about past relationships is an immediate turnoff.

"Jewish tradition," I continued, "teaches that on their wedding day, bride and groom fast, because for them that day is like Yom Kippur, the holiest day of the year, when all sins are forgiven and man is, so to speak, reborn. By making the day of the wedding like Yom Kippur, the young couple start their new life together unencumbered by their past, and that is the goal that you should strive for."

After reflecting for a few moments, Jackie echoed, "Erase the past and start all over again. If only I could do that."

"You will. With G-d's help, you'll make it."

"Rebbetzin, I'm nervous. I'm scared," she confided. "Look at the mistake I made with Brian. How do I avoid falling into the same trap?"

"There are no guarantees," I told her frankly, "but that's precisely why we have to pray and seek G-d's blessing and guidance. And when you pray," I cautioned Jackie, "be careful not to have any one specific person in mind, because for all you know, that person could be the *wrong one*. Leave it up to G-d and ask Him to guide you to the *right one*."

"It never ceases to amaze me," I told Jackie, "how bright young women, who are capable of making excellent decisions in every area of life, are so easily duped when it comes to choosing a mate. Invariably if a really handsome guy or someone who is very success-

ful comes along, dozens of girls ask me for an introduction. Do they know anything about him? Do they know whether he is kind or self-centered, wise or foolish, or do they consider what sort of father he will one day be to their children? The only thing they see are his looks and his money, never contemplating what he has in his mind or his heart."

I had touched upon a sensitive chord because that was exactly what had attracted Jackie to Brian. He was handsome and successful, and she had fallen for him hook, line, and sinker.

"But don't you have to have chemistry?" Jackie protested.

"Of course you do, but you yourself can testify that chemistry can very easily turn to resentment when you are hurt and disappointed. On the other hand, you might meet someone who is not that great-looking, but when you get to know him you discover some special qualities in him, and suddenly chemistry develops.

"What I'm suggesting to you, Jackie, is that you not fall into the foolish pattern of nixing boys because at first sight they are not cute. Give yourself a chance to get to know them, and you might just discover that kindness and a good mind are all the chemistry you need. So in response to your question of how to avoid making the same mistake you made with Brian, first and foremost look for a man who is a mensch (Yiddish for a real man).

"But Rebbetzin," Jackie asked, "how do I recognize a mensch?"

"For starters, consider the Talmudic three Ks which define character traits—*B'Kosso, B'Kisso,* and *B'Kasso*—his cups, his pockets, and his temper. Let's take each of these individually, Jackie. *B'Kosso*—his cups. There is a teaching in the Talmud: 'Wine goes in, and the truth emerges,' meaning that often the true character of a person is revealed when he has imbibed a bit too much. Does he get mean when he's had a few drinks, or is he sweet and loving? In general you can discern a lot from the way a man eats and drinks. Is he considerate, or is he a glutton who sees only to his own needs?

"*B'Kisso*—his pockets. Look for signs that will tell you if he is stingy or generous, selfish or considerate. You can tell a great deal about a man by the way he spends his money. There are some people who will not hesitate to splurge on themselves but become very tightfisted when money has to be spent on someone else. And this has nothing to do with being wealthy or poor.

"The way he handles his money reflects his priorities. Is he charitable? Does he regard helping others as his responsibility or does he try to avoid it? And charitableness is not limited to monetary gifts, for in our society, that in itself is not necessarily an indication of goodness. People give for many reasons, not the least of which are business, social, or political pressures. Genuine charitableness is the reflection of a person's character. It means giving from the heart, having a kind disposition, and judging people charitably. It's important that you keep this in mind because someone who is judgmental of others will eventually be judgmental of you.

"*B'Kasso*—his temper. Is he given to anger? Does he shout or curse? Does he lose himself easily and make painful jibes at others? Angry people terrorize their families. They destroy not only their children but future generations as well, so when dating, keep your eyes and ears open. There are always little telltale signs that can clue you in to your date's character. These little things are what constitute a mensch. Even the most handsome man can become ugly if there is no kindness in his eyes.

"Everything, Jackie, is negotiable. A man can become more educated, more prosperous, better dressed, but if goodness is missing, it's very difficult to acquire it."

Some time later, I introduced Jackie to Seth, a sweet and caring young man who had been studying with us. To my delight, they immediately connected. I reminded Jackie that even the most painful experience has a purpose if we learn from it, but if we repeat the mistakes of the past, we have no one to blame but ourselves. "Don't fall into the same trap as you did with Brian. Don't allow yourself to become enmeshed in a long-term relationship, because if you do, you will end up with no relationship."

"Rebbetzin, I agree with everything you say, but if I don't live with the person I'm seeing, I'm afraid he'll walk out on me."

"That's the big mistake all of you girls make. You're afraid, so you give the guy everything he wants without any commitment on his part. You move in with him, so now he has a girlfriend, a cook, a housekeeper, a companion—all free of charge with no responsibilities. You convince yourself that you can trust him when he says, 'Eventually we'll get married, honey. I'm just not ready yet.' A year goes by, then two, and then, as in your case, three years. Meanwhile,

your biological clock is ticking away, and with every year that passes, the prospect of having a family becomes more remote. Should you bring up the subject of marriage, he puts you off with 'Not yet!' Finally, if you really press, he may break up or agree, but even if he agrees, it doesn't mean a thing as you so well know. At the last minute, after living together for three years, he suddenly discovers that he loves you, *but* there are some *issues* that separate you."

"But Rebbetzin," Jackie pressed, "how will I know if we are compatible if we don't live together?"

"Jackie, that's one of those myths that has long been discredited. Everybody knows countless couples who lived together only to divorce after they were married. And besides, your own story is the best proof of how flawed that argument is. Here you lived together, everything was going well, but when it came to marriage, he passed!

"Do it the Torah way, Jackie. Don't move in with anyone. If he loves you, he has to marry you, and if he won't, and you lose him, so be it. Chances are you would have lost him anyway. This is the best time of your life to meet your *basherte*. Why allow someone to steal this time from you? You have to live by principles, principles that were given to us by G-d. If you follow them, you can't go wrong."

I went on to explain to Jackie that the Torah regards intimacy as holy, a gift from G-d through which new life is brought into the world, through which the essence of marriage is realized. In Torah language, intimacy between husband and wife is referred to as *knowing*—"And Adam *knew* his wife" (Genesis 4:1)—telling us that husband and wife must have a total knowledge of one another so that their physical union will be a *fusion of the heart, mind, and soul.* Such knowledge, such union can be realized only with G-d's help and achieved through the blessing of holy matrimony.

"It is written that there are three partners in the creation of every human being. When husband and wife love each other, G-d Himself joins them, and that's the relationship you should aim for, Jackie."

"It's funny. I never associated intimacy with holiness or spirituality," she said.

"I realize that," I said, "because in our world, in our culture, such concepts are foreign. We have debased G-d's gift. We have defiled the sanctity of intimacy. The higher, the loftier, the holier something is, the greater the destruction when it falls. Just look around you, Jackie,

and see what a sexually sick society we have created. I don't have to go into detail, the facts speak for themselves. If you want more than just a physical experience, if you want a relationship that is lasting and will not leave you feeling empty and scarred, then wait until you go under the marriage canopy and have G-d's blessing."

Jackie took my advice. Within a year she and Seth were married. Today they have two adorable children who are being raised in a home that is committed to the timeless values of our Torah.

If I were to ask Jackie about that episode with Brian, she would have difficulty comprehending how she could have been so foolish. Time is a Divine gift. That which only yesterday made her panic and weep has today passed into insignificance. When you have a situation in your life that seems so overwhelming that you feel you can no longer go on, just remember Jackie's story and hang in there.

There Are Issues . . .

True to my promise to Sally Merling, I called Brian and asked to meet with him. As I told her, I didn't have too much hope that our talk would reunite him with Jackie. Nevertheless, I wanted to speak to him because I was concerned. This was the second engagement he had broken, and my intuition told me that he had difficulty committing and needed help. In Judaism, marriage is not an option but a G-d-given command. A man is not considered complete until he takes a wife, for our rabbis teach that all goodness emanates from her.

There was a knock on my office door and Brian walked in. He was startlingly handsome, built like a football player, with a shock of thick black hair and flashing white teeth. I could see how Jackie had fallen for him.

"Thank you for taking an interest in our situation," he said politely.

"Not at all. I just hope that you will allow me to help you." In contrast to Jackie, he seemed to be cool and very much in control.

"That's very kind of you, but we have really made our decision, and at this point we just need time to get over things."

"Would you like to tell me what led to this breakup?" I asked, not willing to throw in the towel so easily.

"There is nothing much to tell. I guess G-d didn't want it to happen."

I found it ironic that Brian, who had never professed to be a believer, was suddenly bringing G-d into the picture.

"I don't think it's right to make G-d your scapegoat!" I said. "What you did was of your own free will."

"Excuse me, Rebbetzin, but I thought you believed in the concept of *basherte*—that matches are made by G-d."

"That's true, I do," I said, "but that does not absolve you from responsibility. If, of your own free will, you make a decision not to marry, it's somewhat incongruous to blame G-d for your action or inaction. Let me tell you a story that will illustrate my point.

"Some years ago, in the city of Bnei Brak in Israel, there lived a great Torah sage known as the Stipler, who was revered by the entire Jewish world. His wisdom and insights were legendary. People flocked to his home for advice and guidance. On one occasion, a

bachelor in his forties consulted him about his single state.

"'Rabbi,' he complained, 'I thought it is written that everyone has a *basherte*, a partner destined by heaven. Why have I never found mine?'

"The Stipler looked at him with his penetrating eyes and then said, 'You did find her, but when you saw her you thought her nose was too long and passed her up.'

"Yes, Brian, it is true that every person has a *basherte*, but that does not preclude us from making mistakes and misusing the opportunities that G-d sends our way."

"Well, in my case I didn't just reject Jackie frivolously. There were real issues that separated us, and lately we were fighting a lot."

"Would you like to discuss some of those issues?"

"It's too complicated . . . too many issues that we just couldn't resolve."

I knew that his answer would go something like that because in dealing with single people over the years I have discovered that their "issues" are very often nonissues. Buried beneath them is an underlying fear of commitment. It's a disease that hits many singles. It crosses gender lines but is more prevalent among males and is popularly referred to as commitment phobia. Looking at Brian, I felt pain for him. With all his achievements, he had nothing. Undoubtedly he would soon enter into a new relationship. There were many girls waiting in the wings to grab him. He had all the attributes they were looking for—looks, success, and charisma. He had it made in every way, but in a sense, that was also his undoing.

"Our sages teach," I now told Brian, "that 'a man who is single lacks joy, lacks blessing, and lacks good.' It is only through marriage that a man can become a complete being."

"I don't think I lack anything," Brian said dryly.

"I realize that you don't think so. Nevertheless, that's how G-d created the world, Brian. It is written in the Book of Genesis that the first man, Adam, was an androgynous being—male and female in one (Genesis 1:27). Only later did G-d divide Adam into two. 'And G-d caused a deep sleep to fall upon Adam . . . and He took one of his ribs . . . and the rib, which the L-rd G-d had taken from Adam, made He a woman and brought her unto Adam' (Genesis, 2:21-22).

"You might wonder, of course, why G-d did not create Adam

and Eve as separate entities to start with, but had He done so, Adam would never have felt the terrible sense of loneliness that comes with the realization that a part of him is missing. He would never have gone forth in search of his missing half. This, by the way," I added, "is one of the reasons why the commandment of marriage is an injunction upon the male rather than the female, for it was the male who lost a part of himself, and therefore it is his responsibility to recover it. Yes, Brian, a man who lacks a wife lacks everything because a part of himself is missing."

"But why does it have to be formalized through marriage?" Brian protested.

I tried to tell Brian that which I had explained to Jackie—"Finding your partner, Brian, doesn't entail only physical intimacy. That's easy. Animals can do that as well. Rather, it means the fusion of souls that were once united and then separated. Such oneness can only be realized through holy matrimony when the male and female union is blessed by G-d. It is G-d who separated them, and it is only G-d who can reunite them. That is the meaning of holy matrimony—that is the meaning of genuine happiness."

"But if what you say is so, why do we have so many unhappy marriages and divorces?" Brian asked, unwilling to concede.

"That's a valid question, Brian, and to answer you I'll share with you one more bit of wisdom from our sacred writings. Hebrew, as you know, is the language in which G-d created the universe. It is a holy tongue, laden with deep, hidden, mystical teachings. Just by studying Hebrew words and letters, you can discover great secrets that can be life-giving elixirs. Take, for example, the Hebrew word *eesh*, which means "man," and *eesha*, "woman." Both words are derived from *eish*, which means "fire." Now how is the word *fire* transformed into *eesh* (man) and *eesha* (woman)?

"And herein lies the secret. By adding the Hebrew letters *yud* and *hey* (which are the initials of the name of the Almighty G-d) to *eish* (fire), we get the words *eesh* (man) and *eesha* (woman), teaching us that unless the name of G-d is placed between them, male and female are two consuming fires. So in addition to getting married, husband and wife must invite G-d into their lives and live by His teachings."

"But surely there are religious people whose marriages are miserable, and others that end in divorce."

"Yes, there are," I agreed, "but just because someone says that he's religious, it doesn't mean that he understands or lives by G-d's laws. It's not just going to synagogue and observing certain rituals and ceremonies. What I am talking about, Brian, is a total way of life. The manner in which husband and wife speak to one another, the manner in which they conduct themselves in the privacy of their homes, all must reflect a commitment to G-d's teachings.

"Look, Brian," I continued, "the most important decision you can ever make is whom you will marry, and you owe it to yourself to be properly prepared and knowledgeable on the subject. I asked to see you because I am concerned about you. It's not Jackie but you whom we must discuss."

Somewhat taken aback, Brian said, "You don't have to be concerned about me, Rebbetzin, I'm fine. I'm working hard, making deals, working out, and seeing my friends. I'm handling this very well."

"I know, and that's what bothers me. You're handling it just a little bit too well. You're thirty-eight now, Brian. Tell me, how many relationships have you had over the years? How many 'almost' marriages? Where is your life at? Surely you must concede that life is more than making deals and working out. Do you for a moment think that when I asked about the issues that led to your breakup with Jackie, I was trying to pry or be meddlesome?"

Brian just looked at me silently, not reacting.

"I just wanted to help you see yourself so that you might break the pattern and find the strength and faith to commit to marriage one of these days."

"Don't worry about me, Rebbetzin. When the right girl comes along, I'll know it. I came close with Jackie, but of late there was just no electricity in our relationship, if you know what I mean. I just didn't feel anything."

"I know exactly what you mean, and that's what I'm afraid of, Brian. What you are looking for is not realistic. I hope you won't take offense, but I think that you have a touch of commitment phobia."

"How can you say that?" he protested, annoyed. "I think it's perfectly reasonable to desire that electricity, and I really don't think I am commitment phobic."

"Brian, you've had this electricity with more girls than I can

count on the fingers of both hands, and where did it get you? You were lovesick over those girls, you thought you couldn't live without them, and then, bang! The balloon burst with each and every one of them. What you are looking for is not real. More important than falling in love is maturing in love. Take your cue from the Torah—when our father Isaac married Rebecca, it is written, 'He brought her into his mother's tent, she became his wife,' and then, only at the end of the process does it say that he loved her.

"Genuine, lasting love cannot be based upon infatuation or passion. Rather, it must be built upon common aims, values, and goals shared by two people. It's easy enough to gaze into someone's eyes and feel electrified, but such emotions are fleeting. More important than looking into a girl's eyes, Brian, is gazing in the same direction with her. Such sharing is the foundation upon which marriages should be built. As I said earlier, marriage cannot be just the physical union of two people. Rather, it is a fusion of souls. It's easy enough to be lovers, but husband and wife must have a more exalted relationship than that. In the blessing recited under the marriage canopy, bride and groom are referred to as *loving, kind friends* who walk together on the road of life united by something bigger than they are."

"But Rebbetzin, I do want that in a relationship. That's what I'm looking for, but I still need that electricity."

"I understand that, Brian. In theory, it all makes sense, but reality demonstrates otherwise. You and countless others are just not getting married. Why? I'll tell you what my theory is, and you evaluate whether any of it is applicable to you.

"Singles today have made a niche for themselves socially and don't feel the loneliness that prompted previous generations to marry, so there are multitudes of older singles—a phenomenon that we have never before witnessed. Now this is a catch-22 situation because the longer they remain single, the more entrenched they become in their lifestyles, the more they cherish their privacy, the more difficult it becomes for them to share their lives with others.

"There is yet another factor—the older singles become, the more nervous they are about making that marital commitment. They become keenly aware that there are so many things that could go wrong. There are so many divorces, so many mishaps—so when push

comes to shove, panic sets in, and the most convenient, respectable excuse is to make some vague statement about *issues* or *electricity.*"

"Rebbetzin, you think I enjoy dating? You think I enjoy these relationships?"

"Not at all, Brian. I am very much aware of the pain that single people suffer. After a while, dates are no longer fun, trying to meet someone is a chore, getting in and out of relationships is painful and takes a terrible toll, and worst of all, there is a biological clock ticking away, which is especially frightening for females. But there is a time factor even for you, Brian. You want to be a young father, you want to enjoy your children, you want to see them married, and you may not realize it now, but you will one day want to see grandchildren. There is an innate desire within every human being to have offspring. Procreating is the first commandment with which G-d charged humanity, so having children is a built-in need, and when we deny that need, we are left feeling unfulfilled, restless, and frustrated."

"So what are you telling me, Rebbetzin?"

"I'm telling you that you and thousands like you would like to get married and have children but can't, because over the years you have accumulated a lot of baggage, and at the eleventh hour you run scared."

"What exactly do you mean by 'a lot of baggage'?" Brian asked.

"Let me tell you a story. When I was a teenager, there was a young man who was a member of my father's synagogue. He came from a good family, was successful, and in general was considered a good catch. Everyone had dates for him, but no one was good enough. With the passage of time I lost track of him, so you can imagine my shock when a few months ago he turned up at our Hineni seminar. He told me that he was still looking, so I pointed to a nice woman, close to his age, who happened to be at the class that evening.

"'Would you like to meet her?' I asked.

"'I didn't wait all these years for that,' he said. 'I passed up better opportunities years ago.'

"That's what I mean by baggage, Brian. Over the years you have had so many relationships that you cannot help comparing one girl to another. After a while, it becomes very confusing. So all these fac-

tors come into play, Brian, in generating the condition that we call commitment phobia."

"So what would you have me do?"

"Invite G-d into your life. If you do, you will acquire the necessary faith and confidence to discard your baggage and go under the marriage canopy."

"Isn't that just a little too pat, Rebbetzin? Invite G-d into your life and everything will be OK!"

"Admittedly, it does sound that way, but it works," I responded. "From the beginning of time, those who have anchored their lives to G-d have found the strength to respond to life's challenges. A person can study any number of subjects, but no matter what it is, it will not impact on his personality or change his character traits. You can go to medical school or, for that matter, for any professional training, but if you start out selfish, quick-tempered, and neurotic, after you graduate you will still be the same person, albeit with a degree. If you study Torah, G-d's Book, your entire focus in life shifts. You change your thought patterns, your emotions, your feelings as well as your actions and deeds. You discover that you have a soul, and overnight your personality and your character traits are altered. You become a person of faith and spiritual strength. Give it a try, Brian, give some serious thought to what I shared with you. It could make all the difference in your life."

"You've got it, Rebbetzin," Brian said. "I'll be at the next class."

Brian followed through. Today he is engaged to be married, and I hope and pray that he will make it.

❧ 16

The Sabbath

"The Holy One lends man an extra soul on the eve of the Sabbath."

—TALMUD

You Have to Live It

How do I describe *Shabbos*? How do I put the awesome sanctity of *Shabbos* on paper? The more I think about it, the more I realize that *Shabbos* cannot be written about—it must be lived. It must be experienced.

On *Shabbos*, we enter a different time zone. We are propelled onto another planet on which the usual earthly concerns vanish. On *Shabbos*, G-d endows us with an added soul and allows us to soar to spiritual heights. *Shabbos* is "a taste of the world to come" (Talmud).

Can you imagine a world in which one day in seven, everything stops and becomes silent? There are no shops open, no business transactions, no cars on the road. Instead, people stroll leisurely and discover the beauty of G-d's creation.

Can you imagine a world in which one day in seven, telephones stop ringing, TVs do not blare, computers are shut down, and people have the time to discover their inner souls and really talk to one another?

Can you imagine a world in which one day in seven, peace and harmony are so all-encompassing that even thoughts that might evoke sadness or worry are banished?

Can you imagine a world in which one day in seven, families bond in the glow of the Sabbath lights, no one rushes off anywhere, time stands still, and parents bless their children, sing songs, tell stories, study the Torah, and connect with G-d?

If you can imagine all that, then you have a glimpse of *Shabbos*.

Shabbos was always the highlight of my own existence. As a very young child in Hungary, I remember the excitement in our home that began on Thursday as we anticipated the advent of *Shabbos*. My mother would go to the marketplace and buy all kinds of delicacies in honor of the holy day. Friday mornings I would awaken to the most scintillating aromas—fresh challah and cake baking in the oven. As the day went on, these aromas became even richer and more enticing, as fish, kugel, *cholent*, chicken, and soup were prepared.

Now some of you might wonder what is so special about fish, chicken, and soup. They're part of most people's diets. But food cooked for *Shabbos* takes on a totally different dimension, and you cannot understand this unless you eat a *Shabbos* meal. There is a

famous story about a Roman who once partook of a *Shabbos* dinner. He was so taken by the incredibly delicious taste of the food that he ordered his servant to take the recipe from his Jewish host. But when his cook served the very same dish, he became furious. "That's not what I ate in the Jew's house. Either he didn't give you the right recipe, or you left something out," he shouted at his cook.

Upon investigation, he found that the recipe had been correct and his cook had followed all the directions, but there was one critical ingredient missing—*Shabbos!* The power of *Shabbos* is so awesome that it even changes the flavor of a dish!

Preparations for *Shabbos* were always feverish. The house had to be spotless, and we had to be bathed and dressed in our Sabbath best. I can still hear my father's voice joyously announcing, "The Sabbath Queen is on her way!" Finally the magic moment came, and my mother, garbed in her beautiful Sabbath dress, kindled the sacred lights and transformed our home into a magnificent palace of peace and tranquility.

The *Shabbos* table connected us with our past. It was set with a snowy white cloth to remind us of the dew that fell for our forefathers during their forty-year sojourn in the desert. The two challah loaves were in memory of the double portion of manna that was given on Friday, and the white cloth that covered them was a reminder of the second layer of dew that was there to protect the manna. The sparkling red wine was there for kiddush, to sanctify and to toast the holy day by recalling passages from the Torah: "Then G-d blessed the seventh day and hallowed it."

I would sit by the window waiting for my father to return from synagogue, and he always arrived with guests—people who were passing through our city or local residents who were in need. To have guests at the *Shabbos* table was a privilege and never a burden. We looked forward to our visitors, to hearing their stories and telling them ours.

There is a tradition that G-d sends two ministering angels to accompany every man on his way home from synagogue. When my father walked into the house, his face radiating light, his voice ringing out with a joyous "Good *Shabbos*," I actually saw those angels at his side. He would scoop my brothers and me up in his arms and then would take us by the hand and dance around the table singing

"Shalom Aleichem" (Welcome ye angels of Sabbath).

Can anyone understand the sheer joy, the exultation we children felt dancing with the angels of G-d? From week to week, I lived for those Sabbaths.

And then, overnight, our world collapsed. The Nazis occupied our city and our family was deported to Bergen-Belsen. But even there, in that hellhole on earth, the *Shabbos* saved us. Every day my father would hide some small pieces of his meager portion of bread. I cannot begin to tell you what sacrifice that entailed, but my father denied himself and went hungry to save those precious crumbs so that we might be able to experience *Shabbos.*

My father would teach us to count the days. "Don't worry, my precious little ones," he would say. "Four more days . . . three more days . . . two more days . . . *Shabbos* will soon come." And there, in the darkness of the barracks, while rats and vermin scurried about, he would hum to us the sweet melody of "Shalom Aleichem."

"Close your eyes, my precious children. Close your eyes, it's *Shabbos.* We are back home and Mommy has just baked fresh challah." And even as he spoke, he brought forth those stale morsels that he had so carefully saved for us. "Come now, let's sing, my precious little ones," and softly, we would join my father in "Shalom Aleichem."

On one occasion my younger brother, Binyamin, tugged at my father's hand and asked, "Tatie, where are the angels? I don't see any angels."

"You, my little ones, are the angels," my father answered, the tears rolling down his cheeks.

It was through counting the days that my father taught us the meaning of life. "The days of the week take on significance," he would tell us, "only in relation to *Shabbos,* when the goal of creation is realized." To be sure, we were little children and didn't quite understand, but my father's words gave us cause to hope and dream, and his example infused us with strength. Because my father found the courage to hide those dry morsels for *Shabbos,* because of that, the bread made from sawdust became challah, and we understood that there was a higher purpose to our lives. Because in the midst of darkness my father had the faith to hum the sweet melodies of *Shabbos,* because of that, we were able to find G-d and see angels in our midst, even in Bergen-Belsen.

In all languages and cultures, the days of the week are identified by independent names, very often connected to heavenly forces; for example, Sunday, the day of the sun, Monday, the day of the moon, and so on. In Hebrew, however, days do not have names. They are recognized only through their numbers in relation to *Shabbos*. Thus Sunday is the first day; Monday is the second day, and so on. At the time when the Holy Temple stood in Jerusalem, the Levites would introduce the psalm of the day with a proclamation: "Today is the first day toward Sabbath," "Today is the second day toward Sabbath," etc. This constant remembrance of Sabbath enabled our people to focus on that which is essential to life, and this constant remembrance of Sabbath shielded us from the onslaughts of evil and enabled me, a little girl, to dream of *Shabbos*, even in Bergen-Belsen.

It was *Shabbos* that brought healing to our broken hearts when we arrived in this country. We were here no more than a few months when we received a package containing a precious treasure from our past.

Before his deportation to Auschwitz, my grandfather of blessed memory, Rabbi Yisroel HaLevi Jungreis, gathered all the sacred vessels of the synagogue and his home and buried them in the courtyard. The Nazis, in their typical methodical manner, had their German shepherds sniff out any objects that may have been hidden there. They found and took everything—everything, that is, but a lone Sabbath candelabra, the only item that somehow escaped them. After the liberation, a survivor from my grandfather's congregation returned to the village and found the candelabra. He searched far and wide for a family member and discovered that my father, the only surviving son of my grandfather, was living in New York. And so it was that we received the package containing that precious treasure. The Nazis robbed us of our home. They took all our possessions. They tortured and killed our loved ones. But there was one thing they could never take away from us—*Shabbos*. That lone candelabra that came to us from the ashes was a symbol of that. "My precious little ones, do you know why this candelabra was saved for us?" my father asked. "So that we might teach our brethren to kindle the Sabbath lights."

Many years later, when my husband assumed his first pulpit, and I established Hineni, and we were confronted with the challenge of

teaching Judaism to a generation bereft of their heritage, once again we discovered that the magic of *Shabbos* could accomplish more than any sermons or classes. Over the years, countless people, young and old, visited us for *Shabbos*, and they emerged from that experience committed to Torah and the commandments. *Shabbos* touched their souls and changed them forever because *Shabbos* is more than a ritual, more than a tradition, more than a day of rest. *Shabbos* is the sign of the covenant that binds us eternally to G-d.

Shabbos accompanied us throughout the many passages of life, eased every transition and made it more meaningful. When our children grew up and married, we experienced that which all parents experience—the bittersweet joy of seeing them establish their own homes. I say bittersweet because, as happy as we were to see our children wed, it nevertheless meant a separation. But *Shabbos* resolved all that. On *Shabbos*, our children came home, and in time they brought grandchildren, and there can be no greater joy than having three generations gathered around the *Shabbos* table.

And just recently, when, after forty years of marriage, destiny rendered me a widow, and I went through that painful trauma that all those who lose their life partners suffer, *Shabbos* once again became my savior. "Eema, you cannot be alone for *Shabbos*," my children would protest, and so every *Shabbos* they came with the grandchildren and brought laughter back into my life.

I began my personal *Shabbos* saga by recalling how, in my early childhood, the mere anticipation of *Shabbos* filled me with joy. I have traveled many moons from those early years in Szeged, but it is still the anticipation of *Shabbos* that keeps me going and makes my heart sing. My life today is, thank G-d, incredibly pressured. I say thank G-d because I am grateful for the opportunity to serve. I do not take vacations. Whenever I travel, it is to speak and reach out. My family and my work are my life, and I get very little sleep—sometimes only two to three hours a night. People ask me, "How do you do it? Where do you get the energy? What is your secret?"

Well, there is no special secret. It is a blessing that is available to every person who desires to tap into it. It's *Shabbos*. "G-d blessed the seventh day and hallowed it." The day is laden with blessing, and because of that, everything you do on that day elevates you. It is written that G-d grants an extra soul to all those who observe the

Sabbath. The power of that soul is so awesome that it invigorates you and affects everything you do for the remainder of the week.

On Sabbath afternoons I take a nap, and that sleep is so sweet, so tranquil, that it lingers with me until the next Sabbath. The study of Torah always illuminates, but on the Sabbath, that extra soul sparks my heart and mind in a special way, enabling me to discover insights that normally might elude me. During the week, I hardly have time to see my children and grandchildren, but on Sabbath, we are together. We sing songs, share words of Torah, and I have an opportunity to bless them. That blessing bonds us in a way that no excursion, no dinner in a restaurant, could ever accomplish.

I share these personal experiences with you because in writing this book, my intent is not simply to impart information but rather to enable you, the reader, to experience the joy of Sabbath from which all blessings flow and through which, every week, man can renew himself.

"*Shabbos* is forever." "*Shabbos* is a taste of the world to come." "He who keeps *Shabbos*, it is accounted to him as if he would keep the entire Torah."

My father-in-law of blessed memory, Rabbi Osher Anshil HaLevi Jungreis, was born on the Sabbath and died on the Sabbath before the deportations to the concentration camps, in the year which in Hebrew spells Sabbath. I never had the privilege of meeting him, but I felt I knew him from the many wonderful stories my husband related about his life. He was noted for his Torah wisdom, his devotion to his flock, and his boundless love of the holy Sabbath. He wrote a scholarly book titled *Zachor V'Shamor* (*You Shall Remember and Observe*), in which he demonstrated that every portion of the Torah is somehow connected to Sabbath. The flames of Auschwitz enveloped my husband's entire family, leaving him and his older brother, Amram, the sole survivors of what was once the great rabbinic house of my father-in-law.

After that horrible conflagration, we had no desire to return to Hungary, yet the grave site of my husband's father was always on our minds. Some sixteen years ago, Larry, a member of our congregation, told us that he was going on a business trip to Hungary. "Could you go to Gyongyos [the city where my father-in-law served as rabbi for over forty years and where he was brought to his final rest]? Could

you visit the cemetery and look for his tombstone?" we asked.

Willingly, Larry undertook this mission, but little did he realize what it would entail. When he arrived in Gyongyos, no one seemed to know the location of the Jewish cemetery. After some inquiries, someone finally directed him there, but it was surrounded by an iron gate, which was locked. Having committed himself to locating that grave site, he wasn't about to give up, so he went to the town hall, where he was told that there was one lone Jew left in Gyongyos, and it was he who held the key to the cemetery. When Larry knocked on the old man's door and told him that he had come on behalf of Rabbi Jungreis, the son of the Chief Rabbi of Gyongyos, the old man's eyes filled with tears. "I've been waiting for this day for years—now I can die in peace."

Having said that, he climbed a step stool, reached up to the top shelf in the kitchen, and brought forth a little packet. "This belongs to your Rabbi. I kept it safe all these years, waiting and hoping that someone from the family would appear. You must give it to your Rabbi as soon as you get back to the States," he insisted. The old man took Larry to the cemetery, opened the iron gate, and pointed to an overturned tombstone hidden by weeds. "This is the Rabbi's grave."

"How can you know that?" Larry asked.

"I know. I remember when the Rabbi died and exactly where he was buried. Hoodlums overturned the tombstones and vandalized the cemetery, but I know that this is it."

Larry bent to lift the tombstone, and through some miracle, he was able to do so. And there, engraved on the stone in Hebrew, was my father-in-law's name and an inscription detailing his life of service to his people and to Torah. A week later, Larry delivered the package from the old man to my husband. It was the *only copy* of my father-in-law's book, *You Shall Remember and Observe*, written on the subject of the Sabbath.

My husband's family home was destroyed. All its contents were looted by the Nazis and the local residents. Nothing remained, but by some miracle, this lone book on *Shabbos* survived the flames and was waiting to return to its rightful heirs.

The story does not end here. Some years later, I was invited by the Hungarian government to address members of the Jewish com-

munity. After I fulfilled my official obligations, I visited the grave sites of my father-in-law and my great-great grandparents, who were all rabbis. I wept, I prayed, I poured my heart out and related to them all that had befallen us—the murder of our family in Auschwitz as well as our resurgence in America. I told them that blessed be G-d, I had children and grandchildren who carried their names and continue their lives of commitment to Torah.

Upon returning to the States, I received a mysterious phone call. Through yet another miracle, the Sabbath candelabras of my great grandparents and the *Shabbos* kiddush cup of my father-in-law, the Rabbi of Gyongyos, which had been buried during the war, had been found.

Today that kiddush cup and those candelabra grace my Sabbath table. I light each and every one of them, and my little grandchildren love to gaze at their sacred lights.

"Bubba," they plead, "could you tell us the story?"

"But I told you the story already. You know it."

"Please, Bubba, we want to hear it again."

So I tell them the story of the *Shabbos* candelabra that triumphed over the flames of Auschwitz, the *Shabbos* candelabra that are more powerful than any crematoria, the *Shabbos* candelabra that are a symbol of our eternity.

The Bakers had never given much thought to their Judaism. Belief in G-d was not something they ever took very seriously. At most their Judaism consisted of brief visits to the synagogue on the High Holy Days, family gatherings at the Passover Seder, and donations to popular causes. Norman and Marilyn Baker prided themselves on their open-mindedness, accepting all of their children's choices, but when their daughter Andrea announced that she had joined a cult, they couldn't handle it. How could their beautiful, intelligent daughter, a graduate of Barnard, succumb to such nonsense?

Someone told them about my work, and in sheer desperation they came to see me. "Could you help us with our daughter? We can't understand what happened to her. She talks about all this way-out religious stuff, and we don't know how to respond."

I tried to explain to them that Andrea was searching for G-d, for spirituality, and the reason she had fallen victim to a cult was that she had never been taught how to make that connection. "But it's not just this particular cult that is your problem," I told Marilyn and Norman. "If it weren't this group, it would be another. The problem is not the cult but the emptiness in her heart."

I saw from their expressions that they had difficulty accepting what I was telling them. "It's not only Andrea," I assured them. "There are many other young people like her. Just consider that Jews comprise less than two percent of the population of the United States, yet their representation in cults is totally disproportionate to their numbers."

"Why is that?" Marilyn asked.

"As I said before, they are searching for G-d, and because of that they are vulnerable and can be drawn to any movement that comes along."

"But aren't all people searching?" Norman interrupted.

"Yes, to some extent, but Jews a little bit more so. Jews are naturally Messianists. They stood at Sinai and sealed a covenant. They accepted the responsibility of bringing *tikun*—healing—to the world, and because of that they have this compulsion to create a better society."

"So what does that have to do with cults?" Marilyn asked.

"Everything," I said. "Most Jews, even as your Andrea, are spiritual orphans. They have expertise in every field, but they have no knowledge of their own Torah, their own heritage. And so they gravitate to anything that promises fulfillment, including cults. Just consider the past decades—the hippies, the yippies, the New Left—they were all dominated by assimilated Jews. And one can go back even further, to Karl Marx, Sigmund Freud, and others, all united by a common goal—the creation of a utopian world."

"So what can we do to help our Andrea?" Norman interjected.

"The best and quickest way would be to have her experience a *Shabbos*."

Andrea's parents looked at me uncomprehendingly. "But we're not religious," Marilyn protested. "We don't know anything about *Shabbos*."

"You're wrong, Marilyn, every person is religious. You may not as yet be observant, but in the soul of every individual is a yearning for G-d. So you *are* religious, although you are not familiar with our Torah way of life. But don't worry about that. It so happens that this weekend our Hineni organization is sponsoring a *Shabbaton* (Sabbath retreat). We will celebrate *Shabbos* at a hotel in the Catskills. In addition to the many young people who will be attending, my own family will be there. I think that that experience might just do the trick."

"But how will we get her there?" Norman asked. "She won't want to come."

"Tell her that you're going away for the weekend and insist that she join you."

Andrea and her parents arrived just as we were about to light the candles to usher in the holy Sabbath. As they entered the lobby, I immediately felt the tension exuding from them. Marilyn came running over and whispered, "Rebbetzin, you have to do something quickly. She didn't want to come. She's ready to run! You have no idea of what we had to do to get her here."

"Don't worry," I reassured her, taking hold of her hand. "*Shabbos* will open her heart, and with G-d's help, she'll be just fine."

How ironic it was, I thought to myself. Here are Marilyn and Norman, who had never given a second thought to their religion, yet the prospect of their daughter giving up Judaism was terrifying to them. How remarkable is that tie that connects us to Sinai.

I took Andrea over to my father and introduced her. My father took one look at her and understood everything. He knew exactly who she was and where she was coming from. His beautiful wise eyes filled with tears. "Andrea, my sweet child," he said, "what is your Jewish name?"

Overcome by the sanctity and kindness that emanated from this holy man, Andrea could not speak. My father's long white beard, the furrows on his forehead, and his penetrating but loving eyes made a very deep impression on her.

"Tell me," my father asked again.

"I don't have one. I was never given a Jewish name," she said haltingly.

"This *Shabbos* you will be given your Jewish name," my father said, his voice full of love. "Your name will be Chana, and my daughter, the Rebbetzin, will explain the meaning of that name to you."

I took Andrea by the arm, and as I walked her to the room where we would be lighting the Sabbath candles, I told her the story behind the glorious name that my father had chosen for her.

"Chana was the matriarch who taught our people the language of prayer—how to open the heavenly gates with our words and tears. More than anything Chana yearned for a child, but she could not conceive, and so she took the pain in her heart and wove it into a bouquet of prayers, and G-d accepted it. The Almighty blessed her with a son, Samuel, who became one of the greatest prophets of Israel. The name Chana portends blessing for you. If you will it, Andrea, through prayer, you too will be able to convert the pain that you have experienced into blessing. And this holds true not just for you but for your family as well. It is your struggle that has brought your parents here for the first real *Shabbos* of their lives. If not for you, they would never have come. Now then, Andrea, let's kindle the Sabbath lights."

As Andrea and the young people gathered around the table, I explained to them that Eve, the first woman, extinguished the light in the world through her sinful act in the Garden of Eden. But centuries later, our matriarch Sarah made *tikun*—brought healing to the world—by kindling the Sabbath lights. Since then, in every generation, the women of our people have banished the darkness by kindling those lights.

Those lights are symbolic of *shalom bayis*—peace and harmony in the home—and because of that, there is a very special way of kindling them. I explained to Andrea that there is a beautiful tradition, which enjoins the husband to prepare the *Shabbos* candles for their wives, so that through their joint effort, illumination and peace may reign in their home. We light at least two candles in honor of the two injunctions in the Ten Commandments: "Remember" and "Observe" the holy Sabbath.

"But in my family," I explained to Andrea, "as in many others, we also light candles in honor of each person in the household. And so, the hour of candle lighting becomes a very personal experience. It is the most auspicious time for prayer, the time when mothers beseech G-d on behalf of every member of their family."

And now the sacred moment came to kindle the Sabbath lights, to pronounce the blessing and gather its holy flames into our hearts. As I wished Andrea "Good *Shabbos*," I told her that she had just participated in one of the most awesome experiences that a human being can have—the sanctification of time. Through that sanctification, she had become one with her brethren throughout the world, who, even as we, kindled the lights, pronounced the blessing, and ushered in the holy Sabbath. "And that's not all, Andrea. By sanctifying this day, you bear witness to the Fourth Commandment, 'For in six days G-d created the heavens and the earth, and on the seventh day He rested. Therefore G-d blessed the seventh day and sanctified it' (Exodus 20:11).

"From this moment on, until *Shabbos* is over, you are endowed with an extra soul through which you will be able to make contact with G-d's spiritual universe. So take advantage, Andrea, of every moment of this day, and let its sanctity saturate your entire being."

As Andrea gazed at the sacred lights, her eyes became moist with tears. "How beautiful," she whispered.

"It's related in the Talmud," I told her, "that the sages would greet the Sabbath by calling out, 'Let us go to greet the Bride, the Queen.' In Safed, the city in Israel renowned for Cabala, the sages would actually go into the field to extend this greeting. So come, Andrea," I said, "let us pray and greet the Sabbath Bride, the Queen."

I guided Andrea through the Sabbath prayers, and the song of Sabbath touched her soul. After services, as we made our way to the

dining room, Andrea asked me why the Sabbath is called a Bride.

"Rabbi Shimon Bar Yochai, the great master of Cabala, taught that the Sabbath came before G-d's throne and pleaded, 'All the days of the week have a mate—Sunday has Monday, Tuesday—Wednesday, Thursday—Friday, but I have no one.'

"'The Jewish people shall be your mate,' G-d answered.

"So it is that on every Sabbath, we welcome our Bride, and to the extent that we rejoice with her, serenade her, romance her, and express our love for her, to that extent we come close to G-d. The magic of *Shabbos*," I told her, "is so powerful that if we really immerse ourselves in its sanctity, it dissolves all our sins. The word *Shabbos* testifies to this; its literal translation has a double meaning— 'to return' and 'to rest.' On *Shabbos*, we can return to the pristine innocence of our souls and find rest from the tumult in our hearts and minds.

"You know who was the first to discover this magic power of *Shabbos?*" I asked Andrea. "Cain—who was condemned by G-d to be a fugitive and a wanderer on earth.

"'How did you survive?' Adam asked his son Cain. 'What became of the judgment against you?'

"'I repented and was granted mercy,' he answered.

"When Adam heard those words, he struck himself on the face in amazement and exclaimed, 'I did not know that the power of repentance is so great!' And he immediately composed Psalm 92, 'A song in honor of the Sabbath,' for he understood that it was through the sanctity of *Shabbos* that Cain was able to find atonement for his troubled soul."

"I feel like doing the same thing," Andrea said. "I could strike my face a thousand times. To think that G-d gave us the Sabbath and I never knew it."

"Not just you, Andrea, but everyone. The magic of *Shabbos* is probably the best-kept secret of our generation. *Shabbos* is an island of holiness in our materialistic world, but incredibly, we don't know that it exists. We run from place to place, from one vacation spot to another, trying to find some peace for our troubled hearts, some rejuvenation for our tired bodies, never realizing that all that we seek can be found in *Shabbos*. We don't have to travel to far-off exotic places, to resorts or spas. We don't have to climb mountains or clois-

ter ourselves in monasteries. Through the magic of *Shabbos*, our kitchens, our living rooms, our dining rooms, our dens become islands of holiness that touch us with holiness and bring healing and new life to our souls.

"During the entire week we are identified by our occupations or professions, but on *Shabbos* we are ministers of G-d and are judged not by what we do but rather by how we live our lives."

Everyone was now assembled around the table, and as we sang "Shalom Aleichem" and bade welcome to G-d's angels, and the fusion of the heavenly with the earthly took place.

"*Aishes Chayil*" (A woman of valor, who can find, her price is far above rubies)—my father and my husband started to sing this beautiful ode to womanhood written by King Solomon.

"Every Sabbath, prior to dinner, tribute is rendered to women," I explained to Andrea.

"I find that amazing."

"Why?" I asked.

"Somehow I was always under the impression that Judaism is a patriarchal religion in which women are considered inferior."

"Well, as you can see, not only does that have no basis in fact, but most amazing is that many of our sages regard this song as allegorical, comparing the woman of valor with the *Shechina* (presence of G-d) and the Torah, and that is even a greater tribute to womanhood than if we understand this song in its literal sense."

As the last stanza was sung, I said, "Come, Andrea, let's stand up for the blessing of the children." And even as I spoke, our grandchildren lined up according to age to receive their blessing. "If we were celebrating a private family Sabbath," I told her, "my husband and I would approach my father and mother for a blessing as well. Children are children as long as they have parents, no matter how old they may be, but with a group as large as ours, we impart a symbolic blessing to everyone present through our little grandchildren."

"What is the meaning of these blessings?" Andrea asked.

"Since G-d blessed the seventh day, the day itself is laden with blessing, and therefore any blessing imparted on this day is very powerful. The blessings themselves go back thousands of years. They are the very same blessings with which the patriarch Jacob blessed his children (Genesis 48:20) and with which G-d commanded Aaron, the High

Priest (Numbers 6:22-27).[1] Can you imagine the miracle of that? Can you imagine that throughout the centuries, we have wandered from country to country, from continent to continent, but we never forgot the blessing of the patriarchs, the priests, or the holy Sabbath."

Andrea was silent, absorbing it all, and then she said, "People have no clue as to the meaning of this day. In my home, Friday night was like any night. Sometimes my mother lit candles, but even if she did, we would go off to do our own thing. I would go out with my friends, my parents usually had a card game with their friends. I never experienced a Sabbath like this. I cannot recall ever being blessed by my parents or even my grandparents, and I never knew that we could sanctify time and be united with all our people through that sanctification and thus bear witness to G-d's creation."

Shabbos afternoon, I invited Andrea to take a walk. As we passed the hotel tennis court, Andrea suddenly stopped. "I can't believe it," she said. "I never thought I could survive a Saturday without playing tennis, and I didn't even miss it." Andrea was a tennis buff, and her weekends were always devoted to the game.

"*Shabbos* freed you," I said.

"How do you mean that?"

"There are many forms of bondage. In Egypt we were slaves to Pharaoh. In the twentieth century we have psychological, emotional, and physical enslavements."

"But exercise is good for you," Andrea interrupted, picking up on my train of thought.

"Yes, it is," I agreed, "but if you can say to me that you never thought you could survive a Saturday without tennis, that must tell you something. You can became addicted to good things as well, you know."

"It's funny you say that, Rebbetzin, because I remember as a teenager thinking that my dad was addicted to golf. No matter what

[1]"And the L-rd spoke unto Moses saying: speak unto Aaron and unto his sons saying: This is the manner through which you shall bless the Children of Israél; you shall say unto them: the L-rd bless thee and keep thee; the L-rd make His face to shine upon thee and be gracious unto thee; The L-rd lift up His countenance upon thee and give thee peace."

happened, come hell or high water, every weekend he went to the club to play, and if not for the fact that he's worried about me, I can assure you that he'd be on the golf course now."

"There are people who cannot survive without their drink, their gambling, their soap operas, their cellular phones, their computer games, their cigarettes, their cars—the list is endless. What it amounts to is that the moment you state, 'I can't survive without it,' that moment you declare your dependency. And that's why I said *Shabbos* freed you."

"But Rebbetzin," she protested, "*Shabbos* is also full of restrictions. Isn't that also a form of enslavement?"

"Those restrictions, Andrea, are disciplines. Genuine freedom can only be attained through discipline, while indulgence leads to moral and emotional enslavement. When the Torah describes the Ten Commandments, it states that the commandments were *engraved* by G-d on the stone. The Hebrew word for *engrave* is *chorut*, which, if written without vowels, can be read as *cherut*, meaning "freedom." From this play on words, our sages deduce that *genuine freedom* can be attained only if we allow the words that were engraved by G-d on the stone to free us."

Andrea slowly repeated the words, "*Chorut*—engraved, *cherut*—freedom. I never thought about the commandments that way, but how true it is."

"Now you will understand, Andrea, why when the Ten Commandments were repeated in the Book of Deuteronomy, the reason for Sabbath observance was connected to our bondage and Exodus from Egypt, for if not for the laws of Sabbath, our Egyptian bondage would simply be exchanged for another form of enslavement. When G-d engraved *Shabbos* on the tablets, He engraved freedom in our hearts. Through the *Shabbos* restrictions, we take control of our lives, we master our emotions and our desires, and once we acquire that inner control, freedom is ours.

"The Cabalists describe the Sabbath as a precious gift hidden in G-d's treasure house. If we embrace the Sabbath, if we allow the Sabbath to take hold of our lives, then G-d lifts us up and invites us into His private chambers, and so every Sabbath that is truly observed is a 'taste of the world to come.'"

That Sabbath turned Andrea's life around, but still I was con-

cerned. Andrea insisted on returning to her old habitat, and I was worried that her friends might just undo the impact of the Sabbath. Many years of experience with cultist religious groups have taught me that they don't let go so easily, and Andrea was still very vulnerable.

Sunday morning resolved the matter unexpectedly. Andrea got up early to go jogging in the cool country air. She tripped on a tree root, fell, and broke her ankle. I found Andrea sitting in the car, terribly agitated, waiting for her parents to drive her to the hospital emergency room.

"Why did this have to happen to me, Rebbetzin?" she moaned. "Is this some sort of message?"

I took her hand in mine and said, "I cannot tell you exactly why this happened to you, but I do know that it's up to us to seek the positive in every situation. Since you broke your ankle and will be laid up for a while, take advantage of that opportunity to study and gain an understanding of your heritage."

During the next few weeks, I visited Andrea regularly and taught her the timeless wisdom of the Torah. By the time her ankle healed, she had lost all desire to return to her old way of life and decided to devote an entire year to intensive learning to make up for all the lost years.

"Which school would you recommend, Rebbetzin?"

"Well, the best thing would be for you to spend a year in Jerusalem," I told her.

"But I have never been to Israel. I wouldn't know where to go or what to do. I'd be nervous about going by myself."

"What if I were to ask my daughter Slovi to accompany you and help you to adjust?"

"Oh Rebbetzin, that would be perfect," Andrea said, her face lighting up.

And so it was that I prevailed upon my daughter Slovi, who at that time had just turned nineteen and had been to Israel a number of times, to settle Andrea into a school in Jerusalem. "Go for a week," I told Slovi, "be there for her, help her to adjust, and after a few days you can come home."

I felt it important for Slovi to accompany her not only to make certain that this transition period would be smooth but also to quell any anxiety that Andrea might have. And Slovi's going turned out to

be more important than I had initially thought, for if she hadn't been there to introduce Andrea and speak on her behalf, Andrea would have been regarded with suspicion because of her cult background.

During that year, Andrea met a young man from Chicago who was studying in Jerusalem for the rabbinate. Today they are married and are the parents of four adorable children, and their home is always open to *Shabbos* guests.

That trip also changed Slovi's life forever. Our sages teach that what one does for others comes back a thousandfold. Slovi was walking in Jerusalem when a young man who happened to be visiting from São Paulo, Brazil, noticed her. He made inquiries about who she was and subsequently came to the United States to seek her out. That wonderful young man, Mendy Wolff, became Slovi's husband. G-d's providence. Andrea's parents approached me for help with their daughter; we showed her a new way of life through the Sabbath and Torah study, and in the process both girls found their husbands and their happiness. The awesomeness of G-d's mysterious ways. They elude you until all the pieces of the puzzle fall into place.

✨ 17

Creating a Family

"He who loves his wife as himself and honors her more than himself, who guides his sons and daughters in the straight path . . . of him it is said, you shall know that your house is at peace."

—TALMUD

Do I Have to Honor My Father?

Holiday preparations are always hectic, but Passover is more so. Dishes have to be changed, and the whole house has to be turned upside down and meticulously cleaned. There is endless grocery shopping since all food items must be marked "kosher for Passover," and the pantry must be totally restocked from soup to nuts. While this is the case in most traditional Jewish households, in our home the pressures were multiplied. The phone and the doorbell would ring incessantly as people called and dropped by to ask myriad questions regarding the observance of the holiday and to extend Passover greetings. As if this were not sufficient, early on in our marriage my husband established a tradition of visiting the sick with special gifts of *charoses*, a food that is symbolic of sweetness and eaten at the Seder table. So every year I prepared huge bowls of this Seder speciality, which my husband and children would deliver not only to patients in hospitals but to members of our congregation as well.

In addition to all these personal and communal responsibilities, I also had to find time to conduct pre-Passover seminars, which I always concluded with a general announcement that we were prepared to accommodate anyone who did not have a place to go for Seder.

Unfortunately, the response to these announcements was always very strong. I say unfortunately because it verified the reality of the breakdown of the American Jewish family. Passover is not just another holiday. It is our anniversary celebration, the time when we commemorate our birth as a nation forged in *family life*. Early on in our history, we were taught that a strong, vital family is central to our survival as a nation. Abraham, our founding patriarch, was chosen by G-d precisely for that reason. Although he passed many tests at herculean sacrifice, it was his ability to transmit the teaching of G-d to his descendents that made him especially beloved by G-d. "For I have known him because he commanded his children and his household after him to keep the way of G-d, to do charity and justice" (Genesis 18:19). Still later, it was as a family unit that Jacob and his household descended to Egypt, and even later, when Pharaoh asked, "Who are those who are planning to leave?" Moses answered, "We shall go with our young people, with our elders, with

our sons, with our daughters. . . . It is the festival of our G-d"
(Exodus 10:9).

When Moses spoke those words, he taught mankind a timeless
lesson: The worship of G-d must unite sons and daughters with their
parents and grandparents. And so it was that on the eve of our
Exodus, we were commanded to eat the paschal lamb within the con-
fines of our family (Exodus 12). From that first family gathering in
Egypt, thousands of years ago, to this very moment in time, we cele-
brate our nationhood within our families, for that is the lifeline of
our people.

This family gathering has been so central to the existence of our
nation that even the most assimilated Jew would somehow come
home for Seder. The fact that today so many people are not going
home tells a sad story—*there is no home to go to.*

It was two days prior to the holiday. As I summed up at my final
Passover seminar, I once again made the announcement about Seder
accommodations. Roy and Linda had already made arrangements for
dozens of people, and I didn't think there was anyone left who hadn't
been spoken for. Still, I didn't want to take a chance, and sure
enough, Glenn, a good-looking young medical student who must
have been in his mid-twenties, came forward and asked if he could
join us for Seder. I assured him that he would be most welcome. Of
course, we already had a full house. In addition to my children and
grandchildren, who always come home for the holiday, my husband
had invited some widows and widowers from our community, and I
had invited some young people from our Hineni organization as
well—but on Passover the doors are open and there is room for
everyone.

The Seder has always been a great, joyous event in our home. The
most royal banquet cannot compare to the magnificence of a Seder
table set in accordance with our tradition. Because that night marks
our freedom, our birth as a nation, nothing is to be spared. We adorn
our tables lavishly with the best of our possessions, the finest cloths
and the most beautifully embroidered matzoh covers. Delicately
carved silver Seder plates, along with china, crystal, and sparkling red
wine, all glow in the candlelight and create the special setting that
marks the night. Passover dishes have a flavor all their own, which
cannot be duplicated at any other time of the year. Even as the chil-

dren anticipate those holiday delicacies, I must admit, so do we.

My husband had a very meaningful way of conducting the Seder. His sweet melodies would penetrate everyone's heart, and his love and warmth touched all those around our table. He encouraged our guests to ask questions, and best of all, he had answers for them. Our grandchildren brought their own excitement to the table. They came armed with many beautiful teachings. In yeshiva, the Haggadah (narration of the Passover story) is studied well before the holiday so that the children may make their own contribution to the Seder. Glenn was deeply moved as he watched our grandchildren reverently bring pitchers of water to the table for their grandfather and fathers for the ritual washing of their hands. When, a few minutes later, he heard even the two- and three-year-olds recite the four questions, he was totally blown away.

Traditionally, children precede the four questions with a Yiddish phrase, *Zeyde leyben, Tateh leyben* . . . (Grandfather dear, father dear, may G-d grant you long and healthy years, I would like to ask you the four questions). When I translated those words for Glenn, he became silent and contemplative. After awhile he turned to me and said, "I wonder, Rebbetzin, if your grandchildren realize how lucky they are to have such a relationship with their father and grandfather."

As the Seder moved on, lively discussions ensued, and Glenn really got into it. "I only wish that I had had Seders like this when I was a kid."

But I think he had the biggest thrill when one of our grandsons tugged at his sleeve and asked if he would like to help him hide the *afikomen* (ceremonial matzoh, which is symbolic of deep teachings). To keep the children alert and interested throughout the Seder, our sages devised a wonderful game of hiding this matzoh, which the father must find in order to conclude the Seder meal. Of course, he can never do so, and the children have the right to request a "ransom" for its return, creating a lot of exciting negotiation.

Seder night is compared with Yom Kippur, when through an intense spiritual experience, we can come closer to G-d. Therefore even as on Yom Kippur, it is customary at the Seder for a man to wear a *kittel*, a white robe that is symbolic of purification and a reminder of the world to come. Our sages teach that on this night, if

one truly follows the order of the Haggadah, which consists of fifteen parts, it is possible to become spiritually elevated, and I was hoping that Glenn, together with our other guests, would have that experience.

The hour was late, but no one was tired. There was a sense of elation as we came to the concluding song, *"Chad Gadyoh"* (*A Kid, A Kid*). This song is allegorical, and it reviews the history of our people, demonstrating that nothing happens at random, that divine providence guides our lives, and that one day, hopefully in our own time, history will reach its climax with the coming of the Messiah. The little ones had been nodding off despite their afternoon naps. As soon as they heard their Abba Zeide sing the familiar melody, they awakened and joined in with gusto. My husband had a very dramatic way of singing *"Chad Gadyoh,"* which made us all laugh with joy.

As our guests left, we wished them a sweet Passover, but Glenn insisted on staying to help with the cleanup. With all my children there I really didn't need any additional help, but I sensed that he wanted to talk, so I accepted his offer.

"Rebbetzin, you don't know what this Seder has meant to me. There is no way that I can ever thank you."

"It was our pleasure to have you, Glenn, and you are always welcome to join us, not only for Seder but for *Shabbos* as well."

"I might just take you up on that." Then suddenly out of the blue, he shot a question at me: "What does the Torah have to say about honoring a father who is not deserving of honor?"

"Every parent, Glenn, is deserving of honor," I answered.

"I don't think you'd say that if you knew Bill." And with that, Glenn related the painful tale of the bitter divorce of his parents.

"My father is a very wealthy man. When I was six years old, my mother discovered that he was having an affair. She sued for divorce, and the whole thing became very ugly, with my father hiding his assets. My mother told me that he was like Dr. Jekyll and Mr. Hyde. Until that time he had always been a devoted husband, a good father, but then, overnight, everything changed and fell apart. My father remarried, raised a second family, and spoiled my step-brother and step-sister rotten, while I had to struggle for every penny. It was really rough growing up, Rebbetzin. I took odd jobs here and there—delivering papers, waiting on tables in restaurants—just to

have a few dollars in my pocket because I knew that my mom was doing all she could. I put myself through college on student loans, and now I'm in my last year of medical school."

"Well, you certainly deserve a lot of credit," I said, as he paused.

"I don't know about that. I really had no options. But tell me, after hearing my story, are you still going to say that I have to honor him?"

"Yes, Glenn, I still maintain that. It's not my opinion, it's Torah law. And by the way, that same law mandates that you're not to refer to your father as 'him' or by his first name, Bill."

"Oh, give me a break!" Glenn said, his voice full of scorn. "What's the difference what I call him?"

"A big difference, Glenn. When you say 'him' or 'Bill,' that doesn't obligate you, but when you say 'my father,' it does."

"Obligate me to what?"

"Obligate you to show respect."

"But why should I show him respect?" he protested.

"Because that is the Fifth Commandment."

"But he doesn't deserve it."

"Well, if you studied the Fifth Commandment, Glenn, you would see that honoring parents is unequivocal and unconditional. Nowhere does it say that parents are to be honored only if we think they are deserving."

"Then why should we honor them?" he challenged.

"Because they are our parents, and that is why you must respect your father."

"Well, he hasn't acted like a father."

"In many ways he hasn't, but in the most important way he has."

"Oh yeah? How?"

"He gave you life."

"I'm sorry, I just can't relate to that!"

"Remember Glenn, during the Seder, we were singing '*Dayenu*'?"

"Yes, it's about the only song I recognized."

"In that song, we enumerated the many kindnesses of G-d, and said *dayenu*—'enough' after each stanza. The theme of that song is gratitude, meaning that if G-d had granted us just that one kindness, it would have been *enough*, it would have sufficed to earn our eternal indebtedness to Him. But since He bestowed so many favors upon us, how much more so must we be grateful?

"Have you ever wondered, Glenn, why our sages composed this song in such a way that they broke down all of G-d's kindnesses into their component parts? Why couldn't they have had us say one big general thank-you and with that proclaim '*dayenu*'—we are eternally grateful."

"Well, I guess that's the way of the rabbis—they drag everything out," Glenn said, trying to be funny.

"I know you're joking, but just for the record, our sages never dragged anything out. They were always very circumspect with their words, but they understood human nature. In order for man to fully appreciate the extent of the favors rendered to him, he must focus on each and every act separately. Otherwise he cannot absorb the enormity of the kindness." And to illustrate, I cited the example of a bar mitzvah boy at his celebration, who gets up and says, "I would like to thank my parents for everything they did for me."

"As sincere as that bar mitzvah boy may be, he doesn't even begin to fathom what his parents did for him. He doesn't begin to comprehend the extent of his indebtedness. But were this bar mitzvah boy to compose a *dayenu* song and cite each and every favor rendered on his behalf—for example, 'Thank-you, Mom and Dad, for nurturing me when I was a helpless infant, *dayenu*,' 'Thank-you, Mom and Dad, for staying up with me into the long hours of the night when I was sick, *dayenu*,' 'Thank-you, Mom and Dad, for your constant loving care, *dayenu*,' and so on—the list would be endless. Were this bar mitzvah boy to actually write such a song, he would have a much deeper appreciation of how much he owes his parents. And if you, Glenn, would do the same and make a *dayenu* song in honor of your father, I bet you would also find something to be grateful for."

"The only *dayenu* I can think of in connection to my father is that I had *enough* of him," Glenn said, dryly.

"Well, let me try then, because I can think of many," I said, bypassing his sarcasm. "One, he brought you into the world, and that's a big *dayenu*."

"Rebbetzin, you can't possibly mean this," Glenn interrupted before I could go on enumerating other *dayenus*.

"But I do mean it, Glenn. The Torah regards the gift of life as so precious that based on that alone, you are obligated to respect your father and relate to him with dignity."

"I can't believe this," Glenn protested. "I came to you to find out if I have to maintain a relationship with my father, and the next thing I know you're having me compose a *dayenu* song—a paean of thanks to him!"

"I'm not just telling you these things at random, Glenn. There is a deeper reason why I would like you to feel a sense of appreciation. Let's go back to the '*Dayenu*' song. Do you know how many stanzas, how many thank-yous, it consists of?"

"Frankly, Rebbetzin, I never counted."

"Well if you had, you would have found fifteen, and the number fifteen is very significant. There were fifteen steps leading to the upper level of the Holy Temple in Jerusalem, and on each step there were Levites singing psalms known as Songs of Ascent. Fifteen steps, Glenn, because fifteen in Hebrew (the letters *yud* and *hey*) spells the name of G-d. The Temple in Jerusalem no longer exists, but we have the fifteen Songs of Ascent, the fifteen orders of the Seder, the fifteen stanzas of '*Dayenu*,' all of which are expressions of praise and thanksgiving, teaching us that if we wish to find spirituality, if we wish to come closer to G-d, then a prerequisite is to develop the trait of appreciation. And that appreciation, Glenn, must start with *our parents*. Perhaps now you have a better understanding of why I feel it is so important for you to compose your own *dayenu* song of thanks to your father. You have to get rid of all this bitterness and allow gratitude to flow from your heart if you are to come close to your Heavenly Father."

"Gratitude?" Glenn said. "Why should I feel grateful? I didn't ask to be born. He brought me into this world—"

"That's precisely it," I said. "Your father brought you into this world, and with that, he bestowed upon you the most precious gift, the gift of life."

"What's so precious about life?"

"It affords you an opportunity to serve G-d."

"But what if you went through a lot of suffering and misery?"

"Then your service becomes even more meaningful."

And with that, I told him about the time that I accompanied my father on a hospital visit to a terminally ill patient.

"'Rabbi, I want to die!' the man cried as we walked into his room.

"My father did not answer him immediately but clasped his hand and held it for awhile. Then, sitting at his bedside, he related the story of Rabbi Judah the Prince, one of the most eminent sages of our people.

"'When Rabbi Judah was lying on his deathbed, he was visited by his disciples. "Why are you crying?" they asked their rabbi. "A man as saintly as you is surely not afraid of death." "It's not death that causes me to weep," Rabbi Judah answered, "but the knowledge that, with death, I will no longer be able to serve my G-d and fulfill His commandments."

"'So never ask for death,' my father concluded, 'because as long as you are alive, you can serve your Creator.'

"'What service can I perform from this bed?' the man protested bitterly.

"'You can reach beyond this bed by praying, by extending blessing to your visitors and to your roommates. Can you imagine the inspiration that you would impart if you transcended this bed with a smile and with words of prayer and hope?'

"And Glenn, can you imagine the impact that *you* could have if, despite everything that you experienced, you would nevertheless cling tenaciously to the Fifth Commandment and show respect to your father? So, yes, through your suffering, your service to G-d becomes even more meaningful.

"The Talmud cites the story of a non-Jew, Dama Ben Natina, who suffered terrible anguish because his mother was insane. One day Dama was at a meeting with Roman ministers and generals. He was attired for the occasion in silk and gold. His mother burst into the room, attacked him, tore his garments, and spat in his face, but Dama remained silent and did not put his mother to shame.

"It all happened thousands of years ago, but the story of Dama still continues to inspire our children. Obviously, had Dama's mother been a perfect caring and loving mom, his honoring her would not have made history and would have had no special significance.

"Take your cue from Dama, Glenn. Take all that negativity and convert it into something beautiful—a service to G-d that could serve as a role model to others."

Glenn was silent, and then he said, "I must admit, that's awesome! But Rebbetzin, even if somehow I can come to terms with the

situation with my father, don't I owe it to my mother to settle the score with him?"

"Glenn, you have to honor your mother in a positive way and not through harboring anger and hatred toward your father. Rejecting your father will not enhance your mother's position in life, but if you fulfill the Torah law in regard to honoring parents, you will bring her much happiness."

"I have a feeling that I'll be sorry for asking, but what are those laws?"

"Don't worry, I won't overwhelm you," I assured him. "I will just touch on a few: Call and visit your mother regularly. When she walks into a room, stand up in her honor. Do not sit in her chair. Don't call her by her first name. Don't speak arrogantly when addressing her. If she needs help or support in any way, be there for her. Don't be an absentee or once-a-year Mother's Day son."

"With my schedule, the program you are outlining will not be easy."

"I know, Glenn. The Talmud itself testifies that the most difficult commandment to fulfill is to honor parents, for no matter how hard we try, we can never quite realize our obligations in this regard.

"As the finest example of rendering honor to parents, our sages once again tell a story about Dama Ben Natina. He had in his possession a precious stone that was required for the service of the High Priest in the Holy Temple. A delegation from Jerusalem offered him a fabulous sum for the stone, but Dama refused to make the deal. No matter how much the sages offered, Dama would not budge, because the key to the safe in which the stone was kept was under the pillow on which his father was sleeping. No amount of money would make Dama disturb his father's sleep."

"If this had happened to me," Glenn interrupted, "my father would probably have cursed me out and called me the biggest idiot for not waking him up and making the deal."

"That, Glenn, just reinforces the message of the story. It's good for us to know that once there were people to whom money was not the be-all and end-all of everything, people who placed honoring parents above and beyond making a deal, and parents who appreciated that. And maybe, Glenn, just maybe, one day you will be able to impart those values to your own children.

"The Talmud is replete with inspirational stories about the devotion of our sages to the *mitzvah* of honoring parents, but strangely enough the most popular and oft-quoted examples are about the non-Jew Dama. There is a teaching inherent in this, and that is that even if you never studied the Torah, honoring parents should be such an integral part of you, it should be so natural to you, that your heart, your very being, should prompt you to do so.

"The Fifth Commandment is one of the two places in the Torah where 'the reward of a good, long life is promised for its observance.' But we both know that there are people who revere their parents and yet die young.

"Obviously the Torah is not referring to the physical life span of an individual, because in the end that's not how life is measured. Whether we live to the age of sixty or ninety will not grant us immortality, but if we have descendants who will cherish our names, who will continue our lives, then our *families* will live on. In families in which parents are honored, families endure and have 'length of days.' Where there is disrespect, there is also dysfunction, and such families disintegrate and disappear.

"You have a choice, Glenn. You can go around angry and bitter, nursing this hatred, or you can summon the inner strength to say, 'The buck stops here. I'm going to free myself of this sickness. I will choose the Torah way. I will redeem myself, and in the process I will redeem my past and my future as well.'

"How do I do that?"

"There is a teaching for everything in the Torah. In the Book of Numbers, we find the story of Korach, a man consumed by jealousy and arrogance. He led a rebellion against Moses and brought disaster upon himself and his followers. His sons recognized the folly of their father's way and repented, and through their repentance made *tikun*. Every Rosh Hashana when we come to the holiest moment of the service—the blowing of the shofar—we recite Psalm 47, a psalm composed by the *sons of Korach*. Think about it. Isn't that incredible? Isn't it awesome what *tikun* can do? Not only did the sons redeem themselves, but through their repentance they saved their father's name from extinction. Again, the choice is yours, Glenn. Will you live with anger, or will you opt for the Torah way and one day become an example for your children of how to honor parents. If

you opt for the latter, your family will endure and have length of days."

"That's a tall order, Rebbetzin," Glenn said pensively. "Are you telling me that I should just forget the past and embrace this man as a father?"

"Yes, Glenn, I'm saying just that. Do this not only for your father's sake but for your own sake as well lest you be forever saddled with this terrible burden. It's not the place of children to sit in judgment on their parents. You studied the Bible. Remember the story of Noah—how after the flood he planted a vineyard, became drunk, and debased himself? One of his children, Ham, exposed his father's shameful state, and for that he was cursed. His son Shem, on the other hand, prevailed upon his brother Yafet to join him in covering their father's nakedness, and they did so *without ever looking at their father*.

"You must do the same Glenn. For your own sake, cover your father's nakedness."

"I don't know if I can do that."

"It's your only hope if you want to build a good family. This problem is not yours alone, Glenn. Sadly, it is reflective of our entire generation. One of the greatest ills of our society is the breakdown of family values. Escalating divorce rates, single-parent homes, children born out of wedlock, children who have to deal with step-parents, latch-key children, dysfunctional and abusive families are all part of this very tragic mosaic. How can we overcome this problem? How can we re-create the stable families of yesteryear?

"First and foremost, by returning to basics—'Honor thy father and mother,' the Fifth Commandment. Bottom line—you can't second-guess G-d's Word."

"Rebbetzin, I can't dispute what you are saying. I promise I will try. But I must tell you that before I came to your house for Seder I was planning to legally change my family name so that I would have no memory of my father."

"Well, I agree with part of that. You should forget your father's follies but never your father. You *should* change your family's name, Glenn, but not by going to an attorney. Change your family's name by charting a different course, by creating a *good* name, so that instead of people saying, 'Oh yes, that's the family where the father walked out,' they will say, 'Oh yes, that's the family where the son brought the father home. One

day your children will ask you about grandpa. What will you tell them? That he abandoned grandma? Or will grandpa be there for them, telling them stories?'

"So instead of cursing your father and obliterating his name, redeem him, and in the process you will redeem yourself. Make a commitment, Glenn, to create a beautiful family, and if you do that, G-d will help you achieve it. It's a promise from G-d. It's the promise of 'length of days.'"

MAKING MARRIAGE WORK

Almost two years to the day after Glenn spent Seder with us, he called in great excitement. "Rebbetzin, Bobbie and I would like to come over. We have some good news for you!"

"Oh Glenn, I'm so thrilled—you and Bobbie are engaged—right?"

"Yes!" came the happy confirmation. "But we would really like to tell you in person."

"I think that's wonderful. I can't tell you how happy I am. Why don't you come right over?"

I couldn't have been more delighted. After his Seder visit, Glenn had started to attend classes regularly, and he and Bobbie had met at one of our sessions. They had been seeing each other for almost a year and made an adorable couple. Where he was tall and athletic, she was slender and petite, with sparkling green eyes. They were both children of divorced parents, and I was heartened to see that they were seeking Torah wisdom to set their new life into motion.

"Well, this is exciting news!" I told them as they settled down in my office. "Do you have a date for the wedding yet?"

"We're thinking of June."

"A June bride, how beautiful. Your families must be thrilled."

"Yes, but there are some conflicts," Bobbie volunteered.

"I'm sorry to hear that. Would you like to tell me about it?"

"Well, my mom and dad are having this major battle on who will walk me down the aisle and who will stand under the *chuppah* [marriage canopy]. My father insists on having his new wife at his side throughout the entire ceremony, and my mother said that if he does that, she won't walk down at all. Additionally, there are money problems—like who pays for what, and how many couples are to be invited. The whole thing is one big mess."

"What about your family, Glenn?"

"They haven't given me any ultimatums yet, but they're also jockeying for position, so I said, 'No one walks me down the aisle. I'll just stand under the *chuppah* and that will be that.' To tell you the truth, Rebbetzin, if they continue to drive us crazy, we'll just elope."

"Oh we can't do that," Bobbie interrupted, "I always dreamed of a wedding."

"Don't worry, sweetheart, with G-d's help you'll have one," I assured her, "and we'll settle this the Torah way."

"That's what I love about coming here, Rebbetzin, you always have a Torah way of settling everything," Glenn said.

"It's true. Our sages teach that we have only to turn the pages of the Book to find an answer for everything."

"Well, what's the answer to this problem?"

"The answer is that *it's not your problem.* Torah law decrees that the happiness of a bride and groom is not to be marred by family squabbles, so why don't you let me handle this? I'll speak to your parents and we'll work it out. Put this entire matter out of your minds, and let's move on to discussing really important things, like your future life together."

Glenn and Bobbie gave a sigh of relief and thanked me profusely. My heart went out to these two sweet kids trying to make a go of it. Why do parents do this to their children? Why do they insist on inflicting their personal problems on them? Don't they realize that they have enough to contend with? Planning a new life should be a joyous, happy time without any pressures from family or friends, and it's very sad when people do not understand this.

Turning my attention back to Bobbie and Glenn, I told them about our Bride and Groom Marriage Preparatory Seminars and invited them to participate.

There was a time in our not-too-distant past when such seminars were unnecessary, when parents were able to transmit this knowledge to their children, but today the average person doesn't have a clue that such wisdom exists, that there are tractates in the Talmud devoted to every aspect of the husband—wife relationship. It's ironic, I thought to myself, that we teach our children everything but the one subject that could make a real difference in their lives. Knowledge that could enable them to be better husbands and wives, mothers and fathers, we never impart. And as if Bobbie and Glenn had read my thoughts, they assured me that the seminars would be a priority for them.

"Rebbetzin, do you remember the talk we had right after the Seder two years ago?" Glenn now asked.

"Of course I do. How could I forget?"

"Well, it worked. I was telling Bobbie that it changed my entire relationship with my father."

"I'm so glad to hear that," I assured him, "and that's the beauty of Torah knowledge. It helps you focus. It's like having a program in a computer that you can pull out at any time to give you answers to all kinds of life situations. So let's give you a passage in honor of your engagement that will help you to make it in marriage."

The teaching I shared with them was from the Talmud: 'He who loves his wife as himself and respects her more than himself, who guides his sons and daughters on the straight path, of him it is said, you shall know that your home is at peace.'

Glenn repeated the words to himself and then said, "I have no problem with loving Bobbie as myself, because I do, but why do I have to respect her more than myself? Isn't that rather one-sided?"

"At first glance it may be. But let's not jump to conclusions. Let's review this Talmudic teaching in its proper sequence, and hopefully everything will be clarified. You said you have no problem loving Bobbie as yourself. I know that you meant that with all your heart, but I would like you to consider how our tradition views such love." And to illustrate, I related a well-known story about one of our modern-day sages, Rabbi Aryeh Levin, who lived in Jerusalem and died in the late sixties. The Rabbi's wife was having difficulty walking, so he took her to a physician and said, "Doctor, my wife's foot is hurting us."

"That," I told Glenn is probably the best interpretation of loving your wife as yourself. It's never *me*, it's never *my*, it's *we*, it's *us*, it's a feeling of total oneness. Perhaps it was Adam who best expressed this love. Upon seeing Eve for the first time, he proclaimed, 'This is bone of my bone, flesh of my flesh' (Genesis 2:23).

"The implications of this teaching go very deep, for if indeed your wife is 'bone of your bone, flesh of your flesh,' then you will feel her every pain, understand her every sigh, and anticipate her every need. Even as no one would have to tell you that your finger hurts, because you feel it, so no one should have to tell you what she feels. Most significantly, if it's 'bone of my bone and flesh of my flesh,' you will not harbor resentment against her but will readily forgive her lapses, even as you would forgive your own failures. It's like your left hand accidentally striking your right. Are you going to take vengeance on your hand? Similarly, are you going to take vengeance on your wife? For sure, there will be times when you are angry, even

very angry, but then if you will recall the passage, 'This is bone of my bone, flesh of my flesh,' your anger will automatically diffuse, and that's what focusing the Torah way is all about."

"It sounds beautiful, Rebbetzin, but is such love possible?" Bobbie asked.

"Not only is it possible, but that's the only way marital love can endure. The Cabala teaches that even as Adam and Eve were one entity that G-d split into two, so every husband and wife were originally one soul. Upon entering this world, they are split, but they become reunited through marriage. And that's the oneness that I was talking about. This cohesiveness is unique to humans. Male and female animals were created separately; consequently they have no desire for oneness outside of procreation. Human beings, however, yearn to find completion through connecting with their soul mates, their other halves.

"This need is an innate desire embedded in our souls, and it is only because of our cultural biases that we distrust this natural instinct. We are taught to safeguard our independence zealously, to look with suspicion at any request as a form of manipulation, and to regard giving as 'being had.' Under such circumstances, the demands of marriage—giving, sharing—become burdensome and are offered only grudgingly. If you love your spouse as yourself, you will never feel put upon, because if it's good for your mate, it's good for you as well. It's 'bone of my bone, flesh of my flesh.' If your marriage is built on this type of love, you will discover that you receive much more than you give.

"Now I will tell you something, Glenn, that most men are unaware of. Despite the Madison Avenue hype that would have us believe that 'diamonds are a girl's best friend,' a girl's best friend is a husband who 'loves her as himself.' More than money and more than that which glitters, girls yearn for a true partner in life, someone they can talk to, someone they can respect, someone who is kind and gentle, someone who has wisdom to impart."

"It's true," Bobbie agreed.

"I know that that holds true for you, honey," said Glenn, "and that's what makes you so special, but I have difficulty believing it about other girls."

"Because that's the world we live in," I explained. "We have been

led to believe that money is the magic panacea, the ultimate goal to strive for, so women whose lives are empty, whose boyfriends or husbands are not capable of transmitting wisdom or relating with sensitivity, try to compensate for the emptiness in their lives with material possessions and money. But they would give it all up for a man who is a loving, kind friend."

"Rebbetzin, what you said is so, so true. All my friends feel this way, but I would also like to know how to make Glenn happy. What constitutes 'a loving, kind friend' for a man?"

"I'm glad you asked that, because although what I said can be reciprocal, males and females do have different needs. Some are basic, and others are more complex. Let's tackle the basics first. For a man it is very important that his wife be as attractive as possible, that she smile easily, that she be a good listener, that she be supportive, and that she create a warm, loving place for him to come home to. Now all this sounds simple enough, but if it were that simple, we wouldn't have so many divorces. Let's just focus on some of these ideas, such as providing a warm, loving home, and smiling easily.

"Nowadays, young people remain single for so many years that they become accustomed to bachelorlike lifestyles. Their daily activities are *outside* rather than *home* oriented. Eating out every night and relegating social engagements to restaurants has made apartments more like hotel rooms than homes. So start out on the right foot, Bobbie, and rediscover the lost art of homemaking. Your home should feel like a home—warmth and graciousness should emanate from it. It's the little things that create that ambience, little things like food simmering on the stove or cookies baking in the oven.

"Don't make your kitchen into one of those antiseptically sterile places in which everything is packed into the freezer and there is nothing much around but bottled water. Eating is something that we share with all of G-d's creations, but we humans are the only ones who can convert that physical act into a spiritually uplifting experience. By thanking G-d for His bounty, by saying grace, by adhering to our dietary laws, our tables are transformed into altars.

"Well, we're planning to have a Kosher home and invite people over for *Shabbos* dinners," Bobbie said.

"That's wonderful. It will help create that ambience. Your Sabbaths and holidays will be enhanced if you have guests sitting at

your table. Hospitality is a commandment of G-d, a way of life that has been transmitted to us by our father Abraham, and I don't mean just inviting people for dinner but making our homes gathering places for Torah study and worthy causes. When you host such gatherings, your home takes on an entirely different character. Even as you cannot enter a perfumery without being affected by the aroma, if Torah is taught in your home, it will surely affect you.

"One more thought, Bobbie. Remember I told you that it's important for a man that his wife smile easily? Over the years I have found that more than beautiful women, it is the sweet, kind, smiling ones who hold a man. Get into the habit of greeting Glenn with a warm, loving smile, because that's what makes a man feel 'This is my home, this is where I belong.'

"Machismo makes a man naturally resistant to criticism, so it's important that if conflicts arise, you try to convey *concern* rather than *recrimination*, that you couch your comments in such a way that there is no possibility of Glenn interpreting your words as a rejection of himself."

"How do I do that?" Bobbie asked.

"That's easy. Every female, if she cares enough, knows how to reach her man. Our sages teach that 'G-d gave extra intuitive wisdom to women,' so if you make a conscious effort, Bobbie, you'll know exactly how to get to Glenn."

"She already does," Glenn laughed.

"I'm sure she does," I agreed. "But it doesn't end there. Even as a husband has to love his wife more than himself, so our sages call upon the wife to honor her husband. Now I know that all this honoring may smack of servility and sound outdated, but mutual respect is the foundation upon which marriage should be built. If respect is lacking in a relationship, love will quickly dissipate, but when honor and respect prevail, love will grow and flourish.

"And now let's get back to you, Glenn."

"I thought I was off the hook," he answered jokingly.

"Not by a long shot," I laughed. "I'm just getting started. Our sages' requirement that a man honor his wife more than himself has many implications, and I will discuss just a few. A husband is to consult his wife, respect her wisdom, and never act independently, and there are many examples of this in the Torah.

"When the patriarch Abraham finds himself in a quandary over what to do with Ishmael, G-d directs him to listen to his wife, Sara (Genesis 21:12). The Midrash teaches that Abraham's wealth and success were solely due to his adhering to his wife's advice. When Jacob, the patriarch, was instructed by G-d to return to the promised land, he did not proceed until he had consulted with his wives, Rachel and Leah. And when the Talmudic sage Rabbi Eliezer Ben Azariah was invited to become the Nasi, the prince of the Sanhedrin, the highest Jewish court, he unashamedly responded that he would first have to discuss it with his wife.

"As a young girl I recall that my own father would not permit any discussion of significance to take place if my mother was not present, and if some major question came up, my father, an eminent sage, had no compunctions about saying, 'We'll ask Mommy.'

"Honoring your wife more than yourself is not limited to the cerebral. It also encompasses emotions—to be supersensitive to her feelings, to realize that what you, as a man, would regard as a harmless joke could be very painful to her. It's never funny to be the butt of jibes from your mate, and it's mortifying when it's done in the presence of others. And then there are all the little things, like complimenting her for everything she does, from the food that she prepares to the way she arranges the house to the manner in which she dresses, calling in the middle of the day just to say, 'Hello, honey,' lending a helping hand with household chores. In this connection, I must tell you a wonderful story.

"There was a rabbinic student in Jerusalem who some time after his marriage got into a fight with his wife because she asked him to take out the garbage. He felt offended and demeaned by her request.

"He arrived at his yeshiva in a foul mood, and the revered dean of the rabbinic academy immediately sensed his tension. Concerned about the *shalom bayis* (peace and harmony in the marriage) of his students, he inquired whether something was wrong.

"'Yes, there is,' his student admitted.

"'Would you like to tell me about it?'

"The young man hesitated for a moment, then decided to confide in his rabbi and seek his guidance. 'My wife doesn't know how to respect a husband. She tells me to take out the garbage and forgets it's not appropriate for me to do that.'

"'This could be a serious problem. Let me think about it, and I will give you an answer tomorrow morning,' the dean said.

"The next morning the dean knocked on the door of his disciple's apartment. Dumbstruck at the appearance of his rabbi, the student hastened to invite him in. 'I didn't come to visit, my son,' the rabbi said. 'I just came to take out the garbage.'

"Rebbetzin, where do you get all these great stories?" Bobbie asked.

"That's being Jewish—one big story! The Torah, the Talmud, the Midrash, all abound with stories, and they make a point much better than any discussion. So let me tell you one more story from the Talmud. It's about a righteous couple who would have been very happy were it not for the fact that they were childless. After many years they decided to divorce, hoping that in a new marriage they might be blessed with children. As things turned out, the man married a wicked woman, and in time he himself became wicked, and the woman married a wicked man, but through her inspiration, she made him righteous and compassionate. That's how powerful a woman is—she can make or break a man.

"This teaching is reinforced throughout our history. It was by the merit of the righteous women that our forefathers were saved from Egypt. It was women who resisted the sin of the golden calf. It was women who were willing to enter the promised land just as their husbands were plotting to return to Egypt. It was women in every generation who were powerhouses of inspiration, who molded and shaped our families and our people. And perhaps it was because of this that at Sinai G-d instructed Moses to teach the Torah to women first.

"One of the greatest of all sages was Rabbi Akiva, who until the age of forty was totally illiterate. Rachel, a noble and beautiful daughter of Jerusalem, recognized his potential and consented to marry him on condition that he become a Torah scholar. She did this knowing full well that her wealthy father would totally disown her if she went ahead with this plan. Akiva was overwhelmed. How could he, at the age of forty, start studying with little children? But Rachel's faith and inspiration made the impossible possible, and he became the most illustrious Torah scholar of all time, establishing an academy with twenty-four thousand disciples. In the presence of a great

assembly, Rabbi Akiva unhesitatingly proclaimed, 'My Torah, your Torah, are all from her.' And that's the greatness of a woman, Glenn. Not only can she make a home, but the Talmud teaches us that she *is* man's home, so of course you'd want to cherish her and honor her more than yourself. Everything depends on her.

"Now all this places an awesome responsibility upon the female, for if she misuses the power that G-d gave her, she can destroy her family and society as well. It will be up to you, Bobbie, whether you spend your evenings looking for fun or whether you will inspire Glenn to study Torah and devote time to spiritual development. It will be up to you, Bobbie, whether you give to charity or opt to splurge on pleasure. It will be up to you, Bobbie, whether the doors of your home will be open and welcoming or closed and forbidding.

"After the destruction of the Holy Temple in Jerusalem, our sages designated the home as the new Temple, with husbands and wives acting as priests and priestesses. I know it sounds a bit much, but if you try to think of your home as a temple, and yourselves as servants of G-d, you will conduct yourselves differently, your marriage will be solidified, and G-d's presence will dwell in your midst.

"If you make a commitment to build that type of home, then surely, you will succeed, and your marriage will endure."

18

The Legacy of Grandparents

"Ask . . . your elders, and they will tell you."
—DEUTERONOMY 32:7

The rabbi of a prestigious New York congregation called me. "Rebbetzin, we need your help. The daughter of one of our members joined a cult. Would you talk to her?"

"I will certainly try. Why don't you tell her to come to my class this Thursday night?" I said.

"Oh, that would never work. She's just here for the day. You'd have to see her immediately."

Young people who are in cults are usually programmed, and they tune you out. To reach them you need more than just a one-on-one discussion. I tried to explain all this to the rabbi, and although he understood, we were nontheless faced with the problem of her returning to school, so having no recourse, I suggested that the girl come right over.

As I anticipated, she had that beatific smile pasted on her face and had obviously steeled herself to resist my words. I asked her for her Jewish name. She hesitated for a moment and then in a whisper said, "Rivka."

"Rivkele," I repeated.

Suddenly her expression changed. Her eyes became moist, and in a voice full of emotion she said, "That's what my *zeide* [grandfather] used to call me."

From that moment on, it was smooth sailing. She stayed with me late into the night and spoke about her relationship with her grandfather, who had lived with her family for the last three years of his life.

That night I discovered that the memory of a loving grandparent could reach a lost soul.

The love that grandparents impart is unique and special. Unfortunately, in our mobile society, job opportunities, social pressures, and the desire for independence often cause young couples to uproot themselves and move far away from their parental homes. Additionally, it has become a way of life for grandparents to relocate to sunnier climes and retirement villages. All this has weakened that precious bond that once united children with Grandma and Grandpa.

Getting together with grandparents for special occasions—

Father's Day, Mother's Day, and holidays—is not quite the same as being in contact with them on a regular basis. Hearing their stories, basking in their love, and benefiting from their wisdom are precious, nurturing experiences that cannot be duplicated. King Solomon taught that "a threefold cord is not easily broken." If your family is so blessed as to have three generations living at the same time, keep them together.

My husband had the most incredible relationship with his grand-children. When my children eulogized him at his funeral, they all said that what hurt the most was the thought that their little ones and the grandchildren who were yet to be born would never experience that special joy, that special love that was unique to Abba Zeide.

When this loving relationship between grandparents and grandchildren prevails, even the grave cannot sever it—the memory remains forever. Our tradition teaches that on the *yahrzeit* (anniversary) of the death of a parent or grandparent, the family gathers to recite prayers, study Torah, and recall the life of the deceased. These gatherings are not morbid occasions; rather they are celebrations of the life of the departed and inspire the children to live a more committed life.

When, in my own family, we gathered for the *yahrzeit* of my husband, our grandchildren recalled their cherished memories, and those recollections made their grandfather more alive than ever before. Though all their testimonies, from the youngest to the oldest, were most eloquent statements of what grandparents can mean to the lives of their grandchildren, I have chosen to share just four with you.

From Yosef Dov, Our Oldest Grandson, Who Was Seventeen at the Time of This Writing

As a toddler I started calling my grandfather Abba Zeide because that is what he was, a father and grandfather all rolled up into one. The name stuck, and all the future grandchildren adopted it. Abba Zeide was very special, and he had a unique relationship with each of us.

Abba Zeide's last Sabbaths were spent in Sloan Kettering. As the oldest grandchild, I was privileged, together with Bubba (my grand-mother) and my uncle, to spend those Sabbaths with him. No matter how much pain he was in, Abba Zeide always put a smile on his face when I came into the room, never wanting to upset me. As Abba

Zeide's illness progressed, he couldn't have anything to eat or drink, not even a sip of water. Nevertheless, he would always ask Bubba to make certain that I had something good to eat, something he knew I liked. He was always thinking of others, never of himself.

While Abba Zeide was in the hospital, he became friendly with everyone on the floor. Whenever he would leave the room to take a short walk up and down the corridor, he would greet all who passed by. Abba Zeide was known to everyone on the floor as the Rabbi, and people would give him their names to say prayers.

There was one man who was always walking the halls. He was a loner and wouldn't allow himself to get close to anyone, but Abba Zeide never gave up on greeting him, and after several attempts, won him over. The man was a veteran of several surgical procedures and would proudly boast that he had licked cancer. Abba Zeide asked him for his Jewish name. After a long silence, he said that yes, he was Jewish, but he wasn't a believer. Abba Zeide told him that we were all believers and that he wanted to pray for him. He gave his Jewish name—Feivel.

One Sabbath afternoon, when I was walking down the corridor with Abba Zeide, Feivel joined us. Abba Zeide was in much pain (a week later, he passed away). Each step was difficult, but when Abba Zeide saw the torment on Feivel's face, he forgot his own suffering. Feivel was in bad shape. In fact, I had never seen him look so miserable. Finally we reached the solarium, and slowly, with the help of the nurse, Abba Zeide and Feivel sat down.

Abba Zeide asked me to go back to the room to check if any visitors had come. I didn't want to leave Abba Zeide and said that I could see the room from where I was and that no one had come. Still Abba Zeide insisted that I check the room, and then it hit me that Abba Zeide wanted to speak to Feivel alone. I should have known. I should have remembered that Abba Zeide would never embarrass anyone by telling him to leave a room. He would just hint. So I left and a short while later returned to the solarium.

From the doorway I saw Feivel crying on Abba Zeide's shoulder and Abba Zeide hugging and comforting him. I later learned that Feivel had been told by the doctors that there was no more hope. They had tried, but they could no longer do anything for him and were sending him home to die.

Only a man like Abba Zeide could comfort someone else in the midst of his own suffering. Abba Zeide taught me that no matter how difficult or unbearable our personal situation might be, we must always remain sensitive to the needs of others and feel for them. It has occurred to me that if I hadn't been there, none of us would have known this story, and who knows how many more stories there are about Abba Zeide that we'll never know.

From Tziri, Our Fifteen-Year-Old Granddaughter

I always thought my Abba Zeide would be here forever. It's so hard to believe he's gone. I remember my bas mitzvah—how Abba Zeide made a speech. He always knew how to find the appropriate words from the Torah for every occasion. No one could speak like Abba Zeide, and I was sure he would speak at my wedding as well.

I have so many wonderful memories that will always stay with me. When I went to my grandparents' house for *Shabbos*, Abba Zeide and I used to walk home together from synagogue. I loved it when Abba would say to me, "Good *Shabbos*, Tziri. I was just waiting for you to walk with me," and then I used to hold Abba Zeide's hand and we would walk home together. Abba Zeide had such big hands, the biggest hands I ever held. Holding his hand, I felt strong and protected. This past year, when I went to my Bubba's home, there was no strong hand to hold onto, and there was no gentle voice saying I was just the one he was waiting for.

When I was graduated from kindergarten, Abba Zeide told me that I could have whatever I wished for a graduation present. I should just tell him whatever toy I wanted. I remember telling Abba Zeide that I didn't want a toy; I only wanted him to come to my graduation in his police uniform (in addition to being the rabbi of a congregation, Abba Zeide was the chaplain of the Nassau County Police Force). Abba Zeide said fine, without a second's hesitation. I remember being so proud of my Abba Zeide in his police uniform. He went to such extents for us, and he did it all so effortlessly.

I would eagerly await our "cousins club." Abba Zeide and Bubba would invite all the grandchildren for a *Shabbos* without any parents. We had such fun together. Bubba would tell us stories, and Abba Zeide would take us to the park and play with us. On one such

Shabbos, I slept on the couch in the living room. At 4:30 in the morning, the sound of footsteps woke me. I began to panic. Who would be walking around at this hour? It was Abba Zeide preparing cereal, cookies, cake, and chocolate milk for us. Abba Zeide got up at 4:30 so that when his grandchildren woke up (some of the cousins woke up real early) everything would be ready. Abba Zeide always wanted everything to be perfect for his grandchildren.

This past summer, like others before it, I went to camp. After a few days, I felt something was missing. It didn't take long to realize what it was—Abba Zeide's mail. Abba Zeide sent all his grandchildren mail, not weekly but daily. There was always a letter waiting for us when we arrived. It wasn't your ordinary mail, either, it was special. Abba Zeide sent the mail in large manila envelopes with our names written in bold letters "so everyone should know who you are." Abba Zeide sent a combination of newspaper articles, jokes, pictures, and of course, a long letter, and quite often they would be accompanied by a few dollars for a "treat from the canteen."

Abba Zeide taught me how to live a good Torah life by living one himself. I hope that with G-d's help, I will be a source of joy to him in the heavens above by trying to live up to what he taught and expected of me.

From Yaakov, Our Twelve-Year-Old Grandson

On Yom Kippur we would be in synagogue for the entire day, and Abba Zeide would lead the concluding prayers. I would stand next to him. I remember seeing him pray with his eyes closed and his face turned upward. It was the most unbelievable feeling to stand next to Abba Zeide on Yom Kippur, to see and hear his prayers.

On *Shabbos* afternoons, Abba Zeide would teach me, and his voice was always full of kindness. I remember the very last *Shabbos* before Abba Zeide went for surgery. He was already very sick, in much pain, but he wouldn't let on and spent the afternoon studying with me. I was so glad that I was able to recite passages from the Talmud by heart, because it made Abba Zeide happy.

When we would come for *Shabbos*, Abba Zeide had a special way of greeting us. He would always ask personal questions about school, our learning, our friends. He was always interested in every-

thing we did, and when it was time to go home, he didn't just say good-bye. He walked us to the car and waved until it turned the corner and even now, I see him waving.

From Our Granddaughter Shaindy, Age Nine

Abba Zeide knew how to take care of each and every one of us in his own special way. When we would come on Friday afternoons to say good *Shabbos*, Abba Zeide would be waiting for us at the top of the stairs. He would hold out his hands wide and say, "Gooorgeoous children, come to Abba Zeide." He would sit us down with a piece of Bubba's hot gefilte fish and spread crayons and papers out on the table. "I have wonderful arts and crafts for you," Abba Zeide would smile. Then he would take our baby brother, Eli, on his big strong shoulders. Together they would go out for one of their special walks. Abba Zeide would pull the leaves down from the trees and collect flowers. They would smell the flowers together and laugh, and then they would go to the lake and feed challah to the ducks. Together they would return to the house laughing out loud. Abba Zeide was always smiling and laughing. He taught us never to be depressed. Even when he answered the phone, it was with a big hello and cheer.

If you look outside tonight, you will see that there is snow falling. Last year, when Abba Zeide was sick, the winter was a very difficult one. There were heavy snowflakes. We were wondering why there was so much snow that winter. And now again, on the *yahrzeit*, it is snowing.

I think that Abba Zeide is giving us a message tonight. Snow seems so strong. It covers the ground and seems endless. It looks permanent, but in an instant it disappears. Snow is symbolic of this world. It may seem permanent, but it melts so quickly. Abba Zeide is telling us tonight—don't put all your efforts into this life. It's over in a moment. Put your energies into that which is everlasting. Live your life through Torah and *mitzvos* (commandments). That's what counts, and that is how we can best remember Abba Zeide.

I once read a Hasidic *sefer* (book) that asked, "How will

we recognize those we loved when we meet them in the world to come? Will they have grown older? Or if they had wounds, will they be healed? How will we know them?"

The answer is that we *will* know them, we *will* recognize them, because they will be cloaked in the good deeds that we do *zecher nishmas* (in their memory).

It brings a smile to my face to think of Abba Zeide draped in the Torah that we are studying for him, or draped in the Hineni *Shabbatons* held in his memory, or draped in the *Sefer Torah* (Torah scroll) that we dedicated to him, and draped in the many acts of *chesed* (kindness) and *tzedukah* (charity) that are being given for him, but best of all, I think of how Abba Zeide will look draped in the changes that will take place in the hearts of all the people who will read Bubba's new book, *The Committed Life*.

In My Grandfather's Footsteps

For as long as I can remember there was anti-Semitism in Hungary, but even as people learn to adjust to bad weather, we learned to live with it. When Hitler came to power, however, our situation changed radically; Jew baiting became a popular sport. We could hardly venture into the streets without being attacked, and as country after country fell to the Nazis, the assaults on us became more and more vicious. We had no one to complain to; there was no one to come to our defense; the police were as brutal as our attackers, and survival itself became a struggle. And yet we would have been grateful to go on this way, for we knew that once the Nazis invaded, much worse awaited us.

My parents made a weighty decision. We would visit my grandparents for one last time before the inevitable Nazi occupation. This was no simple matter, since my maternal and paternal grandfathers were rabbis of towns at the other end of Hungary, and travel for Jews was fraught with danger. My father, with his long beard and rabbinic frock, could hardly hide his identity, making us ready bait for hoodlums. Nevertheless, my parents were determined to go. It was a long trip. We had to change trains and then proceed by horse and buggy, but miraculously, we made it.

It was a cold, wintry day when we arrived in Nadudvar, the village where my paternal grandfather, Rabbi Yisroel HaLevi Jungreis, was the spiritual leader. Snow was falling, but my Zeide and my Bubbie stood outside at the gate of their house, waiting for us. I cannot tell you how long they stood there, watching the road for a sign of our coming. There were no phones to call ahead. They just knew from a letter we had sent that we were coming, and even that information my father wrote in code because our mail was censored. To this day I can hear them calling out in the cold air, "*Teire kinderlach*" (precious childen), as they scooped us up in their arms and rushed us into their warm house where the most delicious meal awaited us. I don't know how my Bubbie managed it, because even under the best of circumstances, the poverty in Nadudvar was very great, and in those days it was virtually impossible for Jews to obtain anything. We could only imagine what my grandparents had to do to prepare that beautiful table for us. I remember my mother commenting on it and

my Bubbie answering, "When my precious children come home, should I not greet them with a feast?"

We had no toys to play with. My grandparents couldn't afford them, but my Bubbie collected the most wonderful buttons for us and we played with them for hours on end. I often think how those buttons made us happier than all the toys that children receive nowadays and discard in minutes.

As great as the poverty was in Nadudvar, there was one thing that every Jewish family possessed, and that was our Holy Books. My grandfather's study was lined with books from floor to ceiling, and there he would sit, engrossed in the study of the Torah, swaying to and fro and chanting the ancient melodies from the Talmud. We children were the apples of my grandparents' eyes, and there was no room in their home that was off limits to us, so I would wander off to my favorite place, my grandfather's study. He would lift me up onto his knee, and my grandmother would come in with a glass of hot tea and a small plate filled with cubes of sugar. Zeide would dip them into the hot liquid and offer them to me. Those cubes of sugar were more delicious than any candy, and I savored those moments of sharing with my Zeide.

As the time approached for us to return to Szeged, I sensed a change of mood in the house. Nothing much was said, but I felt the sadness in the air. On the day before our departure, I once again ventured into my Zeide's study, never knowing that that would be the last time I would ever be able to go there.

"Come, my precious child," Zeide greeted me with his loving, soft voice as he lifted me up. I felt so secure sitting on his knee, so protected . . . and then, suddenly, I felt my Zeide tremble. I looked up. My Zeide was crying. I became frightened. I ran to my father. "Tatie, Tatie," I said, "Zeide is crying!" And even as I uttered these words, my father also started to cry.

"Come," my father said, "let's take a walk outside, and I'll explain to you why Zeide is crying." My father dressed me in my winter coat and boots. The snow had stopped falling, but in the yard it was still quite deep, and walking was difficult. "I will walk ahead," my father said, "and you, my precious child, be sure to follow in my footsteps."

We had walked only a short way when my father paused and pointed to the path he had made in the fresh, clean snow. Bending

over me, he asked gently, "Do you know why I walked ahead of you?"

"Yes," I readily replied, "so that I could follow in your footsteps and not fall."

My father nodded, his eyes expressing satisfaction with my answer. "But it is not only in deep snow that a parent must make a path for his children. There is another road, a road that you, my child, do not understand as yet. It is that road which your Zeide is preparing for us with his tears. When your Zeide studies the Holy Books, he not only studies to acquire knowledge for himself, but he studies in order to make a path for you, my child, and for all his children. As Zeide pronounces each word, he prays that we may be able to withstand the terrible trials that loom ahead. We don't know, my child, where destiny will take us. The snow, my child, will be very deep, and very often, you will find it difficult to walk; you may even fall. But then you will have to remember that, beneath the snow is a path that Zeide blazed for you with his tears. You need only search for it to find it. G-d will give you the strength to stand up, to continue on the path that Zeide is paving for you with his tears."

I was a little girl at the time. I did not fully understand the import of my father's words. But the memory of my Zeide's tears never left me, and when destiny called upon me to walk through deep snow, snow that was deeper than I could ever have imagined, I heard my father's voice whispering, prodding me on: "Your Zeide made the way for you. You have only to follow in his footsteps."

My beloved Zeide and Bubbie, together with my little cousins, aunts, and uncles, were deported to Auschwitz and cast into the flames. The first to be taken to the gas chambers were the elderly and the little ones. A survivor related to us that he last saw my Zeide being herded into the gas chambers with my baby cousin in his arms. He tried to shield the baby from the terror of the moment by softly crooning to him and hugging and kissing him. And I am certain that as he did so, his tears continued to fall, and he thought of us all, his precious little ones, and he paved the way for yet another generation.

When the war was over, we learned that my father was the only surviving son of my grandfather. In 1947, broken and scarred, we made our way to these blessed shores. With the passage of time the Almighty G-d in His infinite mercy granted me the privilege of rais-

ing my own family and bringing children into the world who would follow in the path that my Zeide made for us.

I never had any desire to return to Hungary—the memories were just too painful—but then an invitation was extended to address the remnants of the Hungarian Jewish community. I suggested to my parents that they join us, but my father was too ill to travel. Nevertheless, he insisted that my mother accompany us. After my programs in Budapest and other major cities, we engaged a driver to take us to Nadudvar.

In Hungary, rabbinic positions were most often passed on from father to son, so in addition to once again seeing my grandparents' home, I was hoping to find the graves of my great grandparents.

It was a warm July day when we arrived. Boys and girls were playing in the street, which was little more than a dirt road. Where do we go? Where do we look? Who can we ask for directions?

I quickly realized that it would be pointless to ask young people for information. They wouldn't even know what Jews are, let alone where they once lived. We spotted an elderly peasant. I approached him and asked if he remembered the Jews.

"Of course I do," he said.

"Do you remember the Rabbi?"

"Sure," was the ready response. "He was a good man. He used to give me the chickens that weren't kosher."

"I am his only surviving granddaughter," I said.

I thought that he would say something warm and welcoming, but there was only silence, and his eyes seemed to ask, "How come you're still alive?"

"Is the house where the Rabbi lived still there?"

"Oh sure," he said.

"Is the grave of the old Rabbi (my great-grandfather) still in place?"

"Yes," he answered. "It's in the field of ___."

"Could you take me there?"

He hesitated before answering, but I assured him that I would pay him well for his time. And so we set out to my Zeide and Bubbie's home. My heart was beating so loudly that I was certain everyone could hear it. I held onto my mother's hand, and for a moment I was a little girl again. We were coming home to Nadudvar.

My mother and I did not trust ourselves to speak. Would the house still look as we remembered it? Perhaps I should have left it buried in my heart. Perhaps I shouldn't have come.

"It's down this street," I heard the old man say. And there in front of us stood the house, just as I remembered it. A thousand and one memories flooded into my mind. I saw my Zeide and Bubbie standing with open arms at the front door, their kindly faces glowing with love.

Suddenly my thoughts were interrupted by an anguished cry from my mother, "*Angyuka, Angyuka* [Hungarian for mother dear], please, please open the door." We broke down and wept uncontrollably. A peasant man opened the door.

"What are you looking for?" he asked.

What are we looking for? The question resounded in our hearts.

"Nothing," we answered. "Nothing."

Now that we were there, we couldn't bear the pain of going inside. I didn't want to see my Zeide's study without his Holy Books, and my mother was certainly in no condition to enter the house, so I turned to the old man who had brought us there and asked if he could take us to the graves of my great grandparents.

We walked quite a distance, fighting our way through overgrown weeds and brambles, and there, looming ahead of us, we saw a little hut. My mother and I entered, and there, staring at us, were the gravestones of my great grandparents; their names engraved in the stone called out to me and bade me welcome. I poured out my heart and related to them everything that had happened—the fire, the flames, the thousand and one deaths that our family had suffered. But I also told them about our new life and asked them to tell my Zeide, the Rabbi of Nadudvar, that his tears were not in vain, that I had walked in deep snow and fell many times, but I stood up again and found the path that he had prepared for me. I asked them to tell my Zeide that I had children and grandchildren who carry his name and the names of my ancestors, children and grandchildren who study the Torah, who live by the commandments, who are walking in his footsteps.

Somewhere, someplace in our past, each and every one of us had a grandfather or a grandmother who made a path for us. By committing ourselves to our timeless values, we can uncover that path blazed for us so long ago at Sinai when G-d proclaimed His Word.

Epilogue ↝

I remember the day when, as a little girl, I discovered the teaching of our sages which promises that, if all our people would observe just two Sabbaths, or perhaps even one, Messiah would immediately come. Peace would reign on earth and all mankind would be blessed.

I ran to my father with my newfound information. "It's so simple," I said excitedly, "we could have a perfect world! We just have to convince everyone to keep the Sabbath."

My father smiled, and I detected a trace of sadness on his face. He sighed deeply, and said, "I wish it were so easy, my precious child."

I didn't fully understand the depth of my father's sigh or the difficulties that he alluded to. . . . I found out soon enough, because, in time, I too, came to sigh; but even as I did so, I remembered that my father never gave up; with infinite patience and love, he continued to help people and teach the word of G-d.

It was this commitment to reach out that impelled me to write this book, and if, after reading it, just one person rethinks his life and becomes a more spiritual being; if just one person overcomes his fears, banishes anger and jealousy from his heart; if just one person learns to appreciate the preciousness of time and becomes a wiser parent, a more devoted child, it will have all been worthwhile, and the coming of Messiah—that perfect day, will be that much closer to us.

It took me about a year to complete this book. No matter where I went, the manuscript traveled with me. During this period, I also made a major decision. Almost two years had gone by since my husband's passing, and I now felt that I wanted to live near my children. As I mentioned in my chapter on gratitude, it was no simple matter to pack thirty-four years into a box, but destiny dictated that I do so.

It was a bitter cold December morning when the moving van

pulled up. As the men started to dismantle my home, an icy rain began to fall. I stepped outside to speak to the movers, and my tears mingled with the raindrops. My son, Osher, prodded me. "Eema, let me drive you to your new house. There's nothing more for you to do here."

I allowed Oshie to prevail upon me. Slowly, I got into the car and put my children, who had come to help, and Barbara in charge. The only thing I carried with me was my manuscript and a prayer book, and it was with that in hand that I entered my new life . . .

To start anew is no simple matter. I have gone through many transitions in my life—deportation from our home in Hungary to Bergen-Belsen; to a displaced persons camp in Switzerland; to the United States, where I had to learn a new language and adjust to a new culture. And now I had to learn to live without my life partner, who throughout the forty years of our marriage was my best friend, my confidant, my tower of strength, my rabbi.

But even as the wisdom of the Torah sustained me in the past, I knew that it would enable me to make this new transition as well. No sooner did I move in, then I took pen in hand and continued to write. I was infused with newfound energy, for each story, each chapter, reminded me once again of that infinite font of wisdom that G-d had bestowed upon us at Sinai, a font of wisdom that offers a solution for every problem and guides us through the turbulent waters of life.

To be sure, life is cyclic. At one time or another, every one of us will be confronted by difficult and painful challenges. Our reactions and how well we cope will depend upon our spiritual resources. Please do not consider however, that it is only in times of crisis that we require G-d's guiding hand. In moments of triumph, in the hour of our greatest achievement, we need him as well. Without G-d, we are left empty. Our successes leave us with the taste of ashes in our mouths and we sense that there must be something more to life . . . but what?

There is a charming story about an exchange that took place between a rabbi and a little boy.

"Tell me, my son," the rabbi asked, "where is G-d?"

"That's easy," came the ready reply. "G-d is everywhere."

"No, my son," the rabbi said, "G-d is not everywhere. G-d is only where man allows Him to enter."

It is for this reason that I have written this book—so that we might open our hearts to G-d, invite Him into our lives and discover the blessings that will enhance our days, the blessings that are our rightful spiritual inheritance.

When I started out, I had no idea how many chapters this book would encompass, or for that matter, what the subjects of my stories would be. As it turned out, my final chapter was number eighteen, which, in Hebrew, means " life," and the subject was the impact of grandparents. Perhaps there is a message inherent in this, for, as we come to the close of the twentieth century, we see the collapse of the icons of our contemporary world: atheism, communism, secular humanism, are just a few of the casualties. We enter the twenty-first century with a yearning in our hearts to experience G-d on a very visceral and personal level. I hope and pray that my book will facilitate that spiritual quest.

There's a teaching in our tradition, "Words that emanate from the heart must enter another heart." It was with my heart that I wrote this book, and as I wrote, I prayed that my words would enter your hearts, my dear readers . . .

I extend to you my blessings and my love. . . . May G-d be with you and grant you the privilege of living a committed life.

Rebbetzin Esther Jungreis may be reached at:

The Hineni Heritage Center
232 West End Avenue
New York, NY 10023
telephone: (212) 496–1660
fax: (212) 496–1908
e-mail: hineni@hineni.org